- ORANGE
- DARK NAVY

CRIMSON RED

COBALT

GRASS

SAPPHIRE

BLUE IRIS

RED

Emerald

KIWI

POST IT YELLOW

NAVY

SAPPHIRE

SPRING GREEN

BUBBLEGUM

MIDNIGHT

CORAL

CHERRY

BARBIE

PINK PANTHER

NAVY

FUXIA

COTTON CANDY

FLUO PINK

BLUEBERRY MILKSHAKE

Sies Marjan

For Nancy Marks

Dedicated to Joey Laurenti, Nirva Derbekyan, Isaac Raine, and everyone who worked at Sies Marjan, including: Alexandra Vizzi, Alyssa Paparatto, Antonella Sacco, Autie Carlisle, Brie Hawkins, Carlos Belmonte, Christine von Aesch, Christopher Rao, Cornelia Moore, Daniel DuGoff, Daniel Santana, David Thompson, Dhaval Patel, Diana Soto, Dorli Jorge, Emily Kroll, Emma Mulligan, Fiana Keleta, Gabby Bennett, Gahee Lim, Halina Wit, Harish Damwani, Irina Atanasov, Isabella Isbiroglu, Janet Simancas, Jenn Levy, Justin Stutzman, Kristina Markovic, Lanae Anderson, Larissa Ryzhova, Larry Liebman, Lisa Roopnarine, Liz Patelski, Louise Allen, Louise Du Toit, Lucila Miori, Luz Maria Gualli, Manuel (Guido) Mendez, Marie Charensol, Michael Crooks, Michael Ragen, Monica (Hee Jung) Yang, Natalie Proctor, Oksana Butsenko, Patricia St Louis, Rachel Iwaniec, Ryan Bongo, Sam Carron-Schuler, Samantha Stern, Sara Johenning, Selene Collins, Sharrie Huang, Tran Nguyen, and all the freelancers and consultants who have helped along the way.

The Colors of

Sies Marjan

by Sander Lak

New York · Paris · London · Milan

First published in the United States of America in 2022 by
Rizzoli International Publications, Inc.
300 Park Avenue South
New York, NY 10010
www.rizzoliusa.com

The Colors of Sies Marjan
Copyright © 2022 Sander Lak

Creative Direction: Sander Lak
Art Direction: 2x4/Michael Rock with Giacomo Moroso
Designer: Language Arts/Claudia Brandenburg
Project Manager: Nirva Derbekyan
Editorial Consultant: Dan Thawley
Copy Editor: Isaac Raine
www.sanderlak.com

For Rizzoli:
Publisher: Charles Miers
Editor: Ian Luna
Project Editor: Meaghan McGovern
Production Manager: Barbara Sadick
Production Coordinator: Olivia Russin
Image Coordination: Alec Castillo
Copy Editor: Angela Taormina
Proofreader: Mimi Hannon

Printed in Hong Kong
2022 2023 2024 2025 / 10 9 8 7 6 5 4 3 2 1

ISBN: 978-0-8478-7220-6
Library of Congress Control Number: 2022937355

Visit us online:
Facebook.com/RizzoliNewYork
Twitter: @Rizzoli_Books
Instagram.com/RizzoliBooks
Pinterest.com/RizzoliBooks
Youtube.com/user/RizzoliNY
Issuu.com/Rizzoli

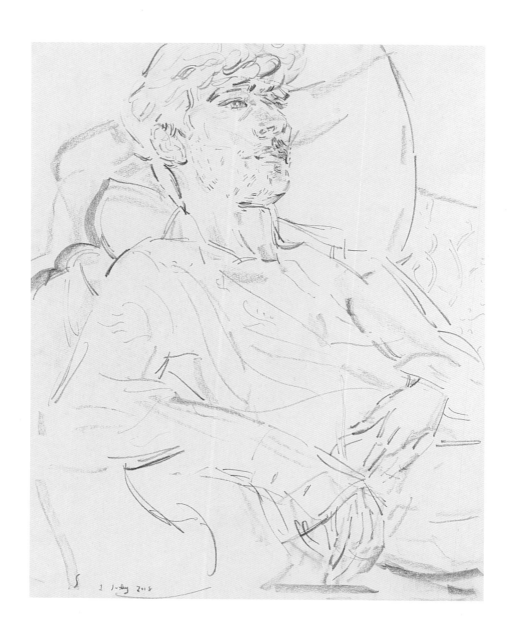

Elizabeth Peyton, *Sander (Sander Lak)*, 2018.

Foreword

by Elizabeth Peyton

I met Sander because of color: a pair of pale lime trousers, light in feeling, serious in intent. It went on to a flame orange dress, this one dramatically pleated into a coiling flower; a brilliant pale rose silk boiler suit to even more revelatory colors; red, red, and red; burgundy, brown, mustard, and magenta! So many colors that should be wrong but turned out so right.

I suppose this is why I am here at the beginning of this book—color, color, color. I interpret the world into color. It's mysterious to me how this happens— a distillation of a kaleidoscope of impressions—internal, external, up close, and half-heard, making emotional equivalences in color.

One blue afternoon I got an unexpected garment bag from Sander, a pale dirty pink fur with a fluorescent pink stripe running through it. How lucky I was to live in the same world as someone who thought to make this. I began a self-portrait that afternoon, trying to capture all the comings-together from these colors and this gesture.

When Sander once told me his mother dressed him in bright colors in some of the exotic places he grew up in, I thought he meant to match the tropical feeling of wherever they were but, no, he meant so she could see him—so she wouldn't lose him!!! I had never thought of this safety—saving through color. When we did an interview together in 2018, he said, "There is definitely something very gloomy and very heavy and dark happening in our world. And nobody can deny it.

And I think that there is also something where a lot of people don't want to look like they're going to a funeral as well. They want to wear color. And they want to wear things that have a positive note and show beauty as opposed to darkness. Because if you want darkness, you can just open up your news app…. You'll get it in boatloads!"

To feel the thing that is missing—to make things feel better with a visual as easy to see as a shirt on someone walking down the street—is a huge gift. And Sander's gift is ever-giving; through his work he has put forward a vision of how one can be with color—liberated, elevated, celebratory, defiant … safe….

Walking down Hudson River Park, when I see someone dressed in bright monochrome, Sander is present just as Whistler was at the silver view of the Thames at twilight.

This book both celebrates and closes a chapter of Sies Marjan, but happily it is also just the beginning of Sander's conversation with the world.

Sies Lak

Sies Galjart

Sies Van Elderen

Sies Sol

Sol Sies

Gerard Sies

Sies Gerard

Sies Marjan

Sies Marjan

SIES MARJAN

Sies Marjan

Sies Marjan

Sies Marjan

SIES MARJAN

Sies Marjan

Sies Marjan

Sies Marjan

Sies Marjan

Sies Marjan

Sies Marjan

SiesMarjan

sies marjan

Sies + Marjan = Sander

Sies
a very distinct northern Dutch or Friese name,
pronounced "Sees" and sounding non-specific
to gender or origin. It could be anything
and from anywhere.

Marjan
a modern version of "Maria" used in Holland
and Iran, and the surrounding areas of those
countries. It is pronounced "Marzjahn."

Statement

by Sander Lak

If I were to summarize Sies Marjan,
I would borrow the words
my friend Donna Tartt once wrote:
"Colors so bright, they nearly broke my heart."

It took us nine months to come up with the name Sies Marjan.

Our company was being shaped and formed, every day getting closer and closer to becoming something real, yet we couldn't figure out what to call it. I wanted to avoid using my own name, but I still wanted it to be personal. The idea of calling it the name of an object or a random word didn't connect with my vision.

Together with our branding agency, 2x4, we threw thousands of names and ideas back and forth. Nothing fit. As a last resort, our CEO and "partner in crime," Joey Laurenti and I decided to lock ourselves in a hotel with a 24-hour deadline to come up with a name. With scattered room service trays and the same movie playing on the TV for the third time, Joey suddenly asked me what my dad's name was. Sies. Very personal and not my name. After I said my mom's name, Marjan, it was obvious. The company had a name, and came into being.

There were many spectacular "fashion moments" that I will never forget. Coming out for my bow at our first show and seeing the front row was incredible. Doing a show that mixed some of my closest friends, colleagues—and even my mom—all walking the runway with my favorite models. Beyoncé being the first celebrity to wear Sies Marjan. The show about my experience of falling in love with my partner, Nathan, suddenly believing the impossible clichés, from starry lights to a floor covered with Swarovski crystals. The show attended by Courtney Love, my idol for so long. Our final collection, when I had the incredible honor to collaborate with Rem Koolhaas.

But those were some of the grand and glitzy moments; the truly spectacular times always happened inside the studio, with no press or social media or even a finished collection. Those moments with my team. Working on creating the brand, the clothes, the finishings.... Laughing, crying, succeeding, failing, achieving, and creating. The work that happened every day! The shows and the attention were the cherry on top. The actual cake was the team who dedicated their time and talent and passion to making it happen. I would be nowhere without them.... The brand couldn't have existed without them.

The collections at Sies Marjan were completely driven by color. Before using any references, inspiration, or vintage garments we would look at hundreds of colors, discovering what does and doesn't make sense together. From the design team to the merchandisers and

marketers, we would all look at the care-fully selected colors and give our input. Not just what felt right but also what the colors reminded us of, what we'd never wear and why. This is how we made the color card.

From this we would explore mate-rials and references. If a color felt cold or harsh, we'd disrupt it: dyeing the softest fabric—cashmere or wool—with that Pink Panther Pink; taking a natural rough linen and recasting it in Highlighter Yellow. Is a certain color better as an accent or as a full look? Does a color combination remind you of the McDonald's logo or a Stanley Kubrick title card? Is that blue Yves Klein or "Dory" from *Finding Nemo*? It was this search of association and disruption that told us which colors to use on which fabrics.

From there on we would start to create the collections, with only colors, fabrics, and shapes to guide us. It was like making a meal with no recipe—just a fridge full of food. Although scary and extremely hard to plan, it was exciting and dynamic. We never knew how the collection would reveal itself. But it always found its way.

Monet said, *"Color is my daily obses-sion, joy, and torment."* I think I truly understand what he meant. *Torment* is the right word. The struggle to get the exact shade in the perfect fabric that then becomes the one garment that ties the whole collection together and makes both an artistic expression—and then sells! You hope. Sometimes

yes, sometimes no; perhaps this time, this way.... You are drawn back again and again.... You are drawn back again and again. The daily obsession for that perfect Bitter Lemon or Cookie Monster Blue was always the engine of it all.

I have thought a lot about what "belonging" means. My dad, Sies, took our family around the world for his work, moving every four years to a new post. I was born in Brunei and had lived in Malaysia, Gabon, and Scotland by the time I was 10. It was during our time stationed in Aberdeen that my dad died and all of a sudden our lives changed. We moved to Holland for a more "traditional" life. I had a lot of trouble adjusting to this, always with a feeling of not belonging anywhere. Sometimes I've enjoyed this aspect, observing from a distance. At other times it's been harder to deal with, when I'm craving movement and change.

As a teenager in Holland, I was convinced I was going to be a film director, film being my first love, but ended up studying at ArtEZ University of the Arts, in Arnhem, where I was introduced to fashion and fell in love with it. Then I moved on to do my master's in menswear at Central Saint Martins, in London. From there I found my way to New York and my first job. Within a year I was in Paris for my second job and then on to Antwerp for my third. Constantly moving, I was always able to adjust to wherever work or life took me to learn the basics of the language, the culture, the rhythm: to adjust and adapt. This came as

second nature, something my dad was very good at, something he passed on to me. But I was never able to belong completely anywhere.... I was always an outsider, an expat, a foreigner.

I returned to New York in 2015. It was while setting up Sies Marjan that I realized the people we hired and attracted were what gave me a sense of belonging. Our chairman Nancy Marks, Joey, and I were all looking for people who could not only do the job but also were people we wanted to spend time with, people we wanted to know, who brought the fabric of their lives into the studio. We wanted an environment that was truthful, connected—grounded even. We were craving a place we could all call home. Sies Marjan truly was a home for me.

As with the philosophy behind Sies Marjan, I wanted color to guide this book. I started by making folders of images, without considering chronology. I just selected and filed by color. I knew that I needed to start with burgundy, the color of our logo, the color I think works with everything. I started putting images of this color together and naturally that bled into orange, then yellow, after that navy, and so on and on. The book was coming alive as I followed the color. What surprised me was that the chronological order of the seasons didn't even matter. It all looks like Sies Marjan: whether it's the first collection or the last, it all connects.

I also wanted the book to include works from those whom I admire and who have inspired me. I wanted to have a *dialogue* about color: how they use it and what it means to them. I have read studies about the history of color by philosophers, artists, and scientists—Aristotle, Goethe, and Albers—and also the incredible investigative works by Dr. James Fox and Edith Young. These, and other thinkers, introduced me to the many theories of color and I could never pretend to have the same knowledge or insight into this subject as any of these … giants. I am not a scholar in color; I am merely a fashion designer, and all I know is what I know. This book is my personal account of color through the lens of Sies Marjan.

Color Names

Baskin Blue	Feta	Periwinkle
Baskin Pink	Flour	Peyton Pink
Beer	Fuxia	Pink Panther Pink
Bitter Lemon	Green Smoothie	Post-it Yellow
Blonde	Hay	Praline
Blood Orange	Highlighter Green	Reese's Orange
Blue Iris	Highlighter Yellow	Rhubarb
Brick	Hilton Blue	Rose
Cake	Hot Pink	Rose Bud
Camel	Ketchup	Salt
Candy Cotton	Lakers Purple	Sangria
Cartland Pink	Lapis Blue	Sapphire
Cedar	Lavender	Scarlet
Chalk	Lemon	Seaweed
Charcoal	Lilac	Smoke
Cheese	Lotus	Smoked Salmon
Cherry	Marine	Snow
Chocolate	McYellow	Soba
Cinnamon	Miso	Stone
Clay	Morandi Blue	Strawberry Milkshake
Cloud	Morandi Cream	Sugar
Coffee	Morandi Green	Sun Bleached Pink
Coke Red	Mussels	Sun Bleached Yellow
Cookie Monster Blue	Mustard	Tabasco
Coral	Neel Navy	Tangerine
Corn	Neo Green	Tar
Deep Sea	Neon	Tofu
Denim	Nutella	Tootsie Brown
Dried Grass	Ocean Blue	Tortilla
Dumas Red	Oil Stain	Twizzler Red
Dunkin' Cherry	Olive Oil	Vanilla Milkshake
Dunkin' Orange	Olympic Blue	Violette
Dusty Lilac	Oreo Black	Wheat
Dutch Orange	Paper	White Cream
Emerald	Peach	Wine
Escargots	Pepper	Yoghurt

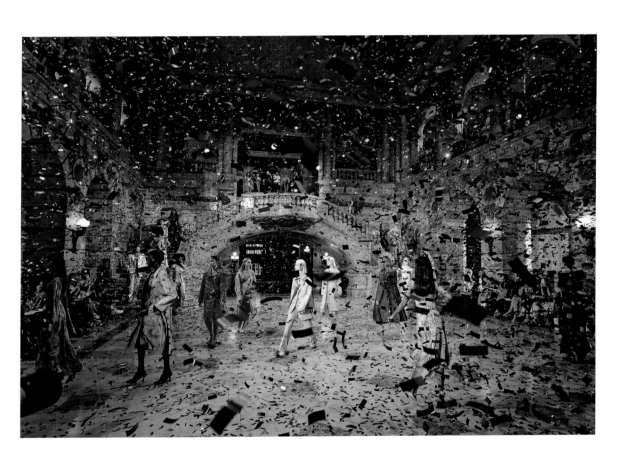

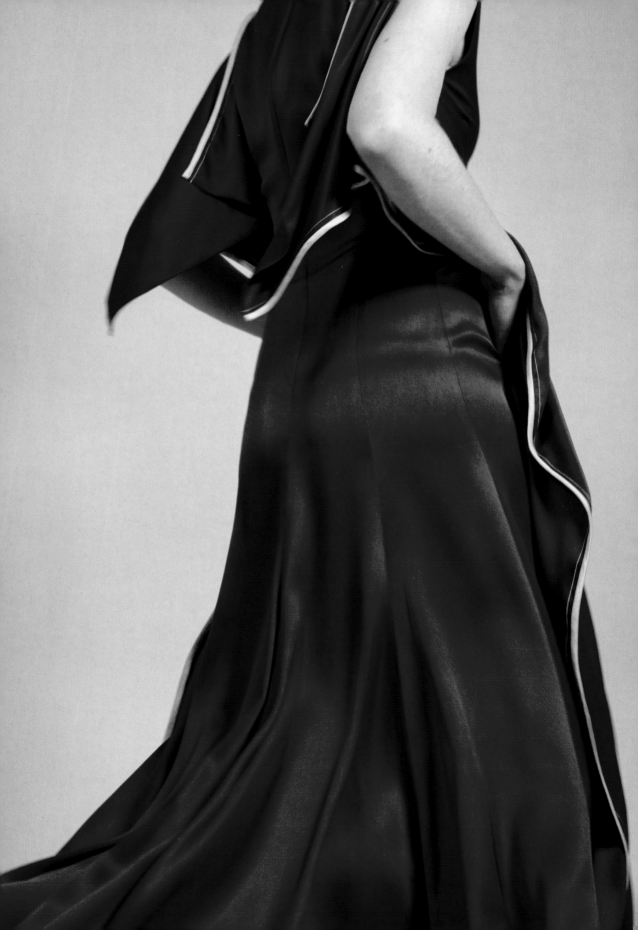

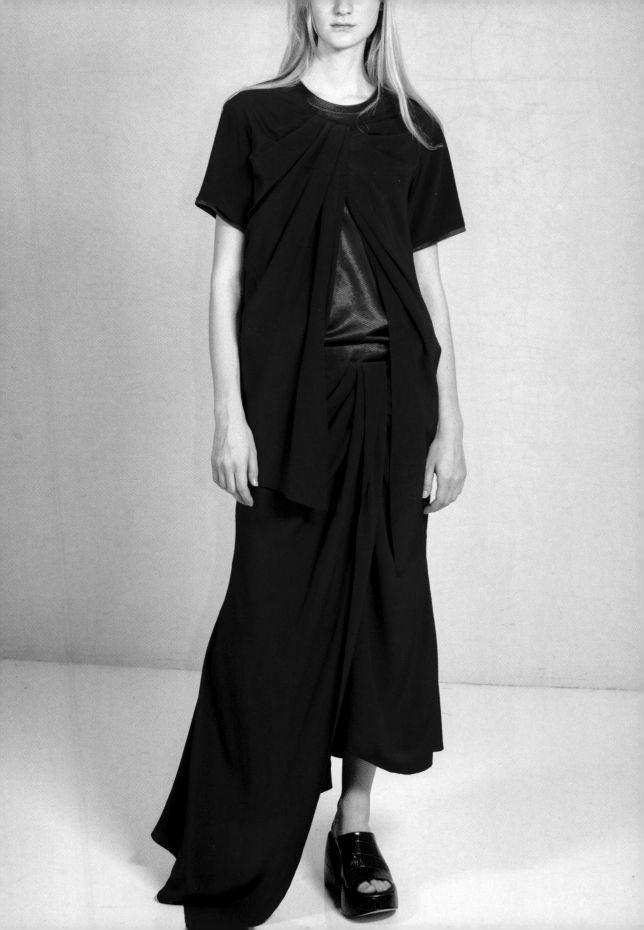

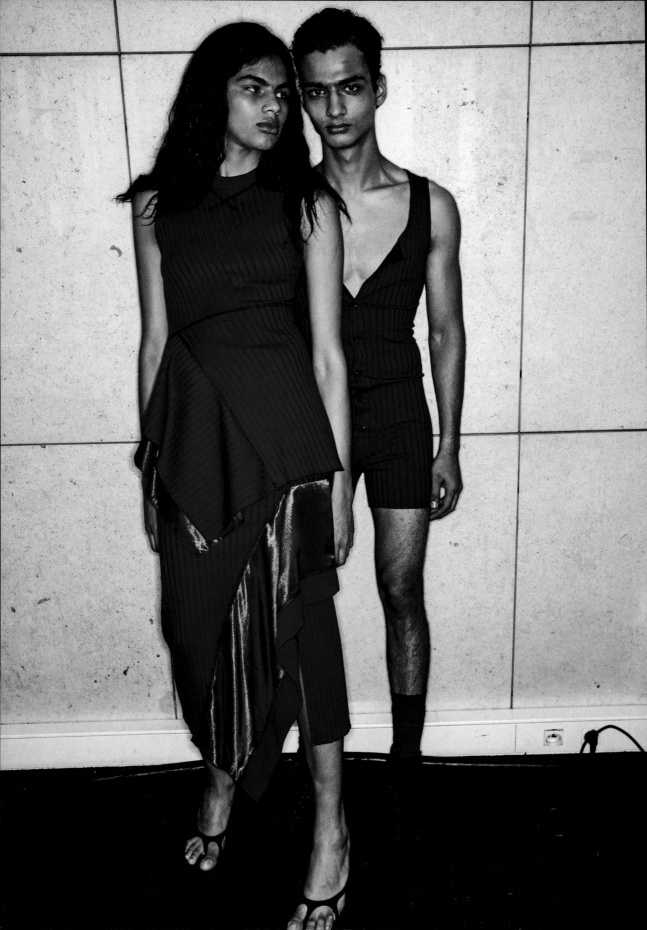

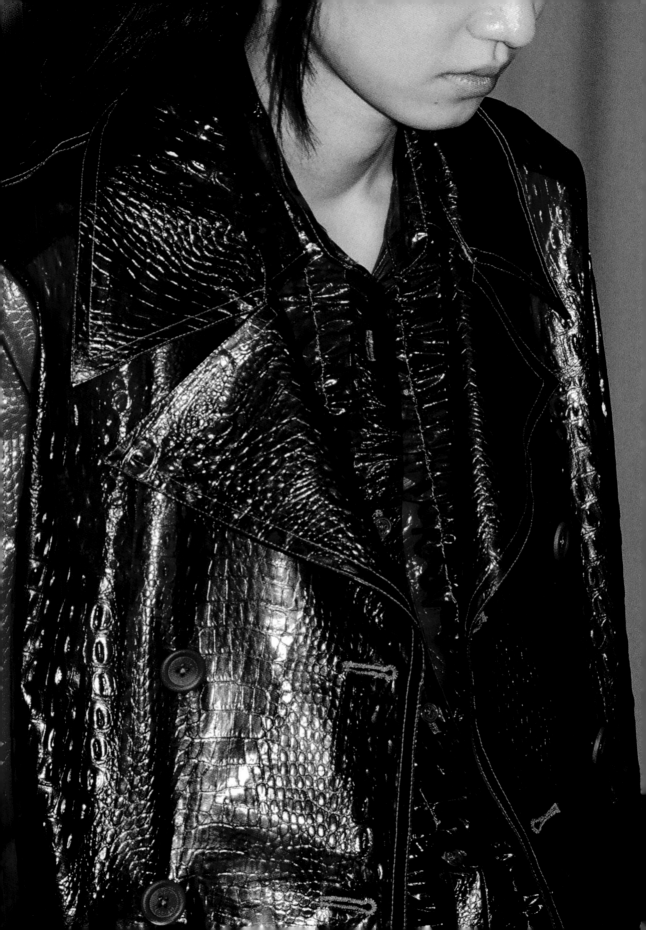

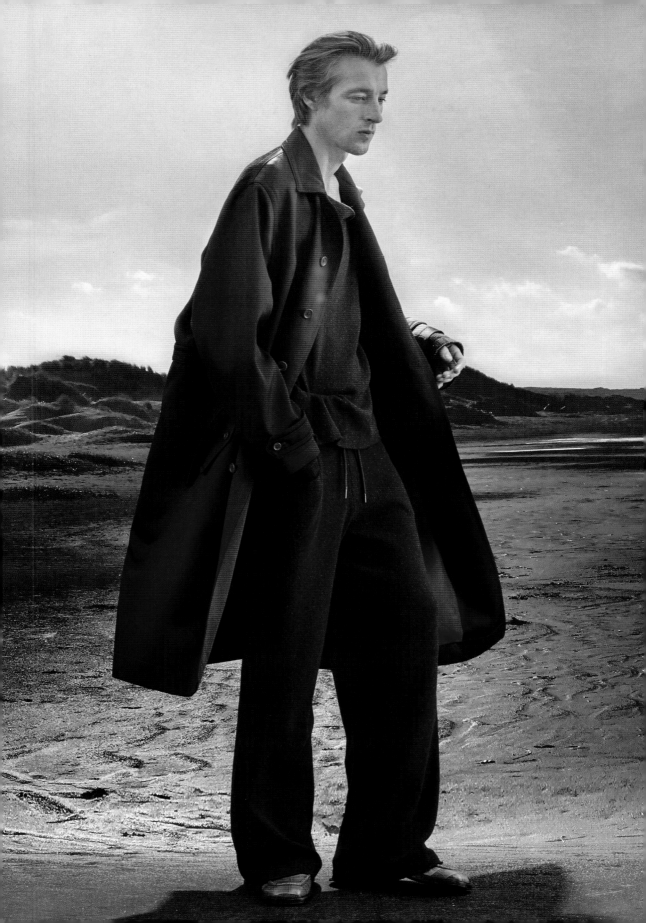

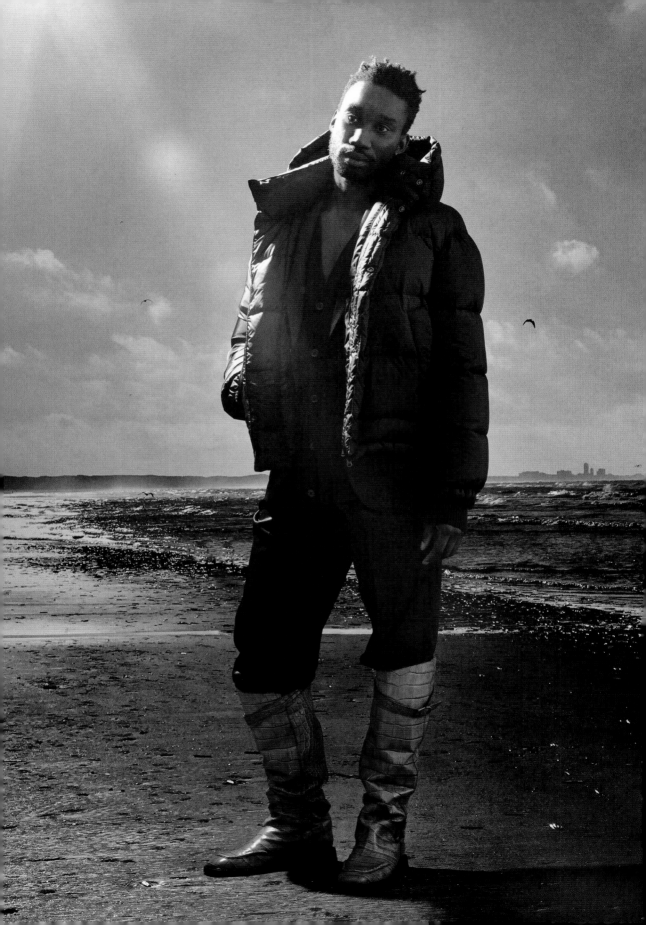

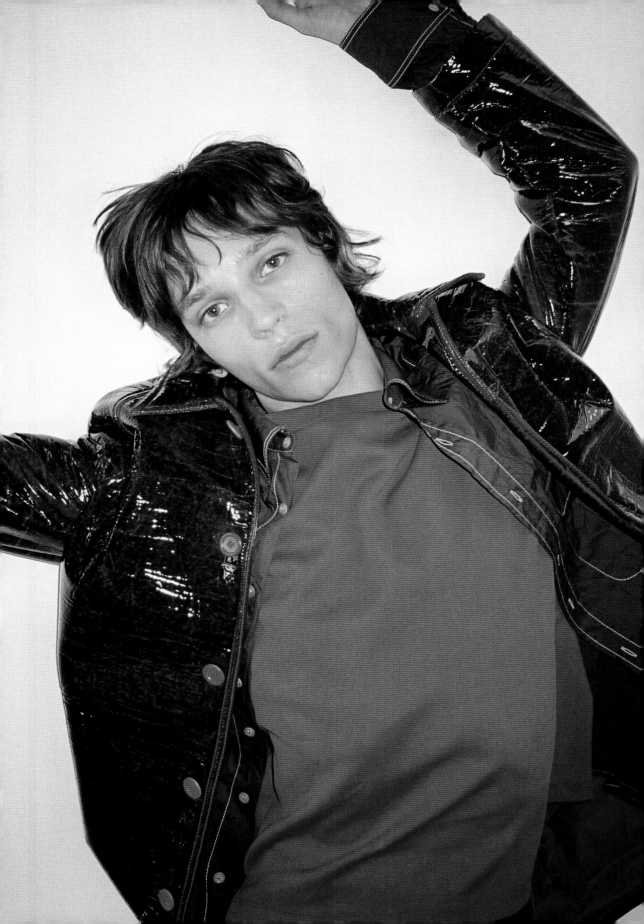

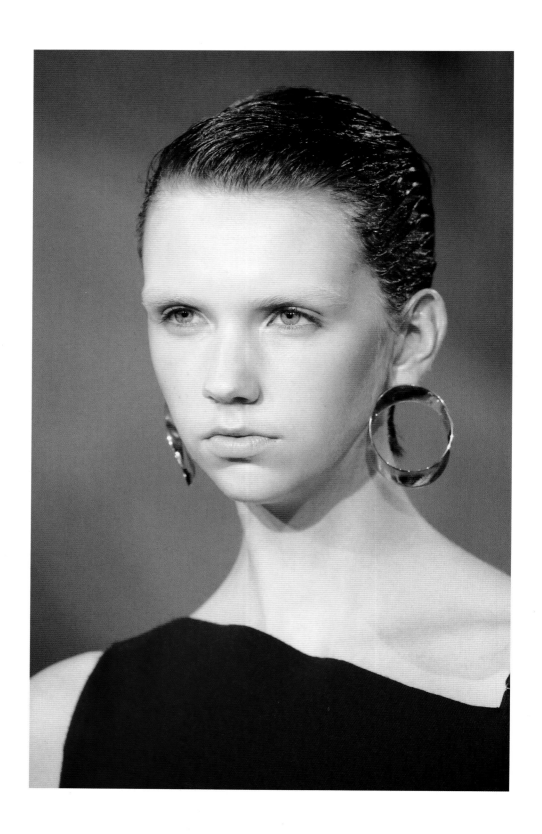

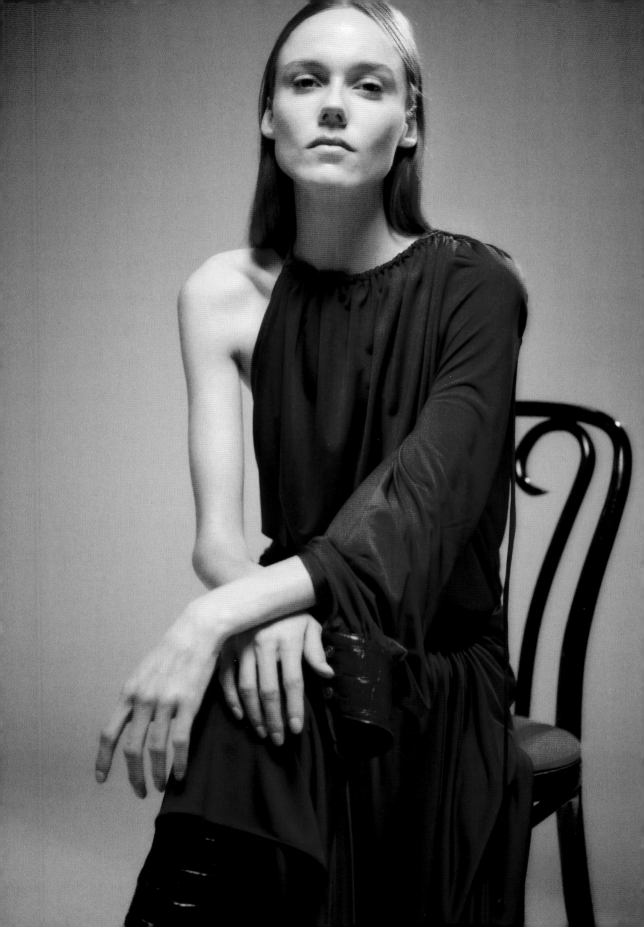

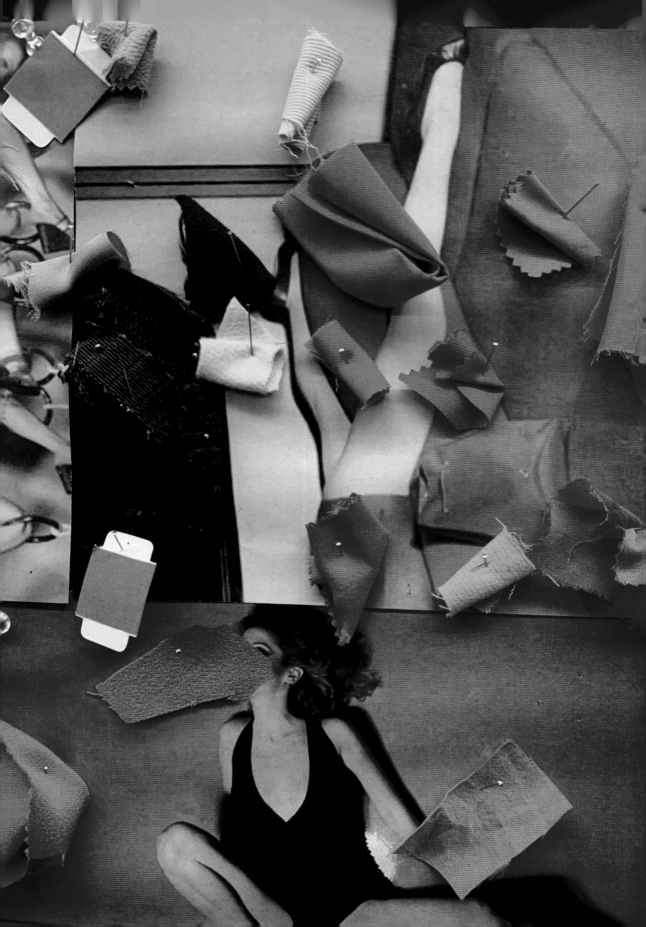

Thomas Ruff, *Porträt (E. Denda)*, 1984.

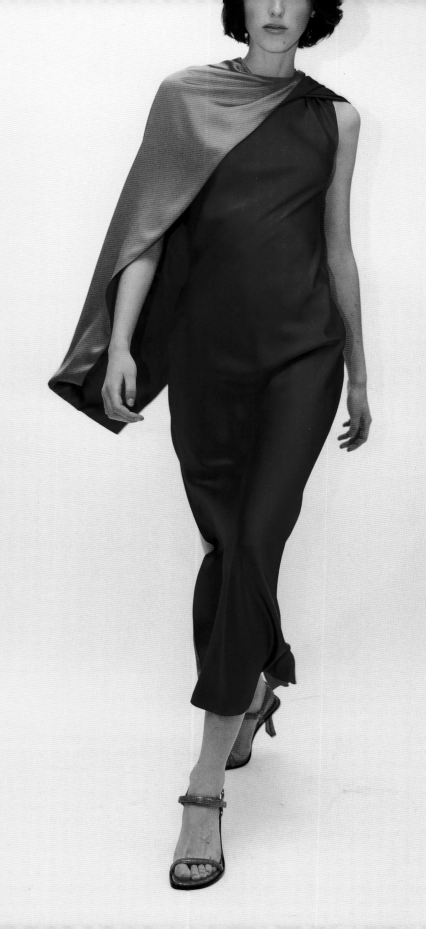

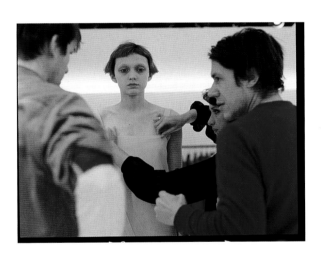

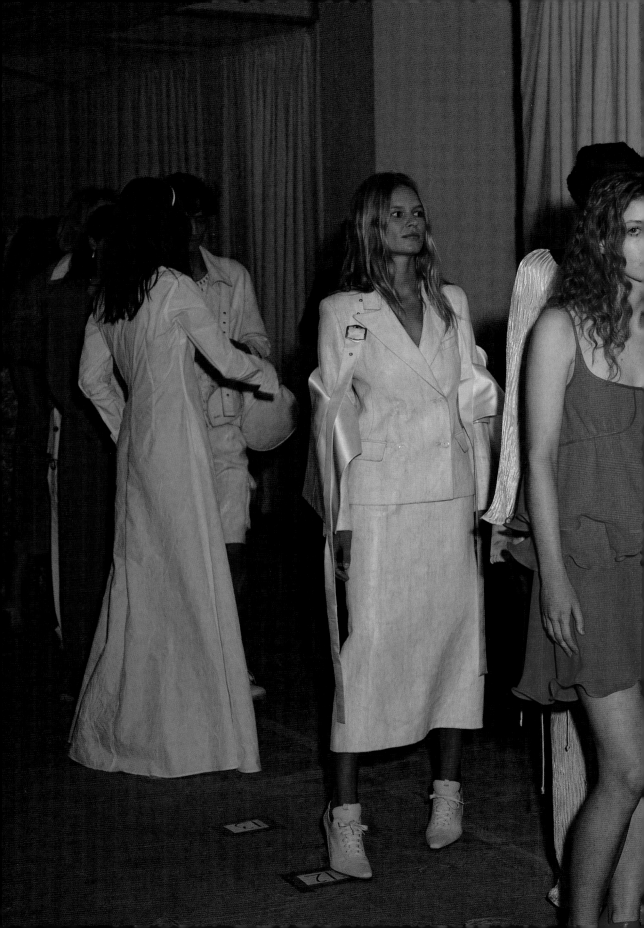

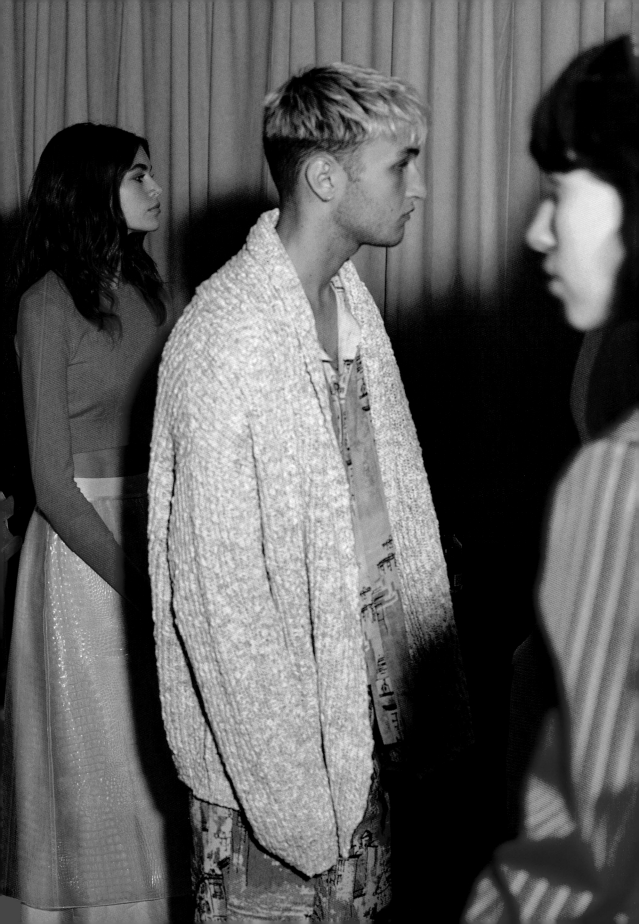

„Rosas" vier wehen vakomtie . . .

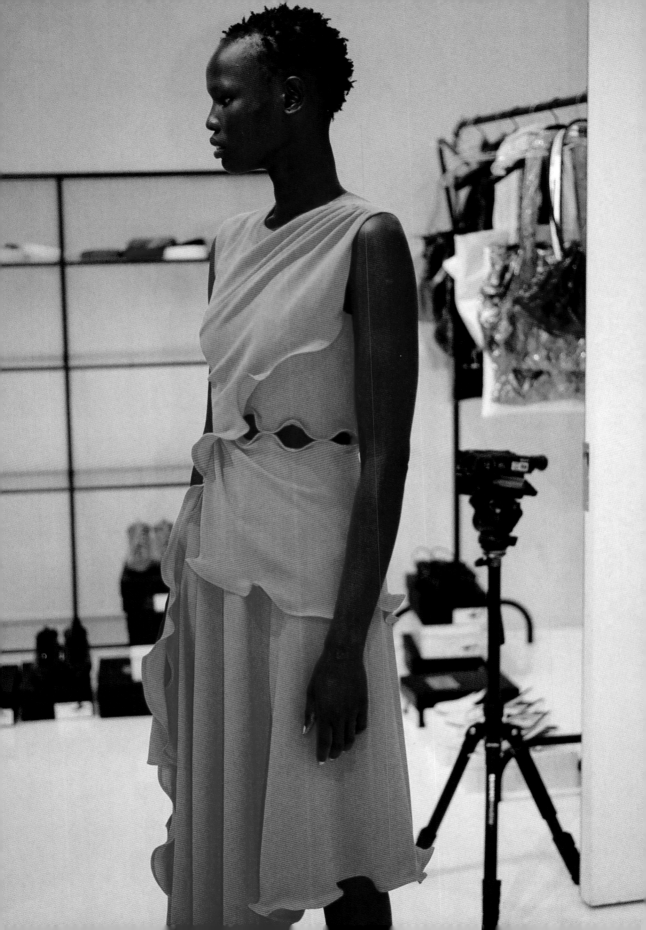

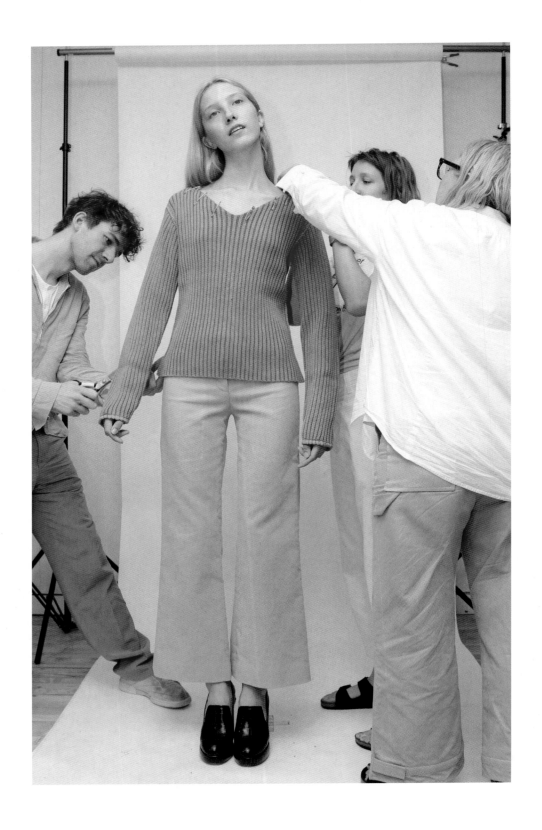

Sies Marjan

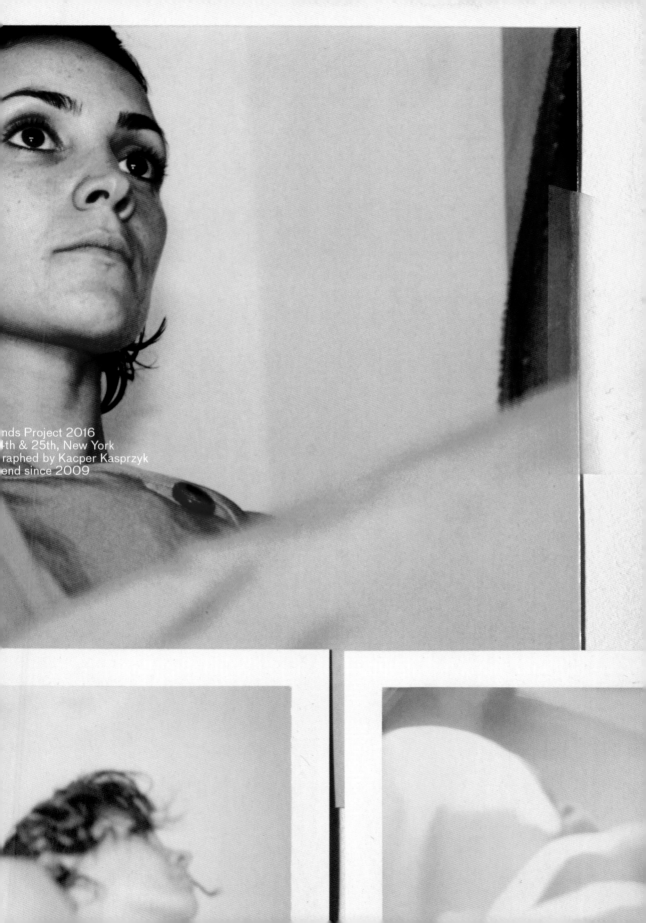

nds Project 2016
4th & 25th, New York
raphed by Kacper Kasprzyk
end since 2009

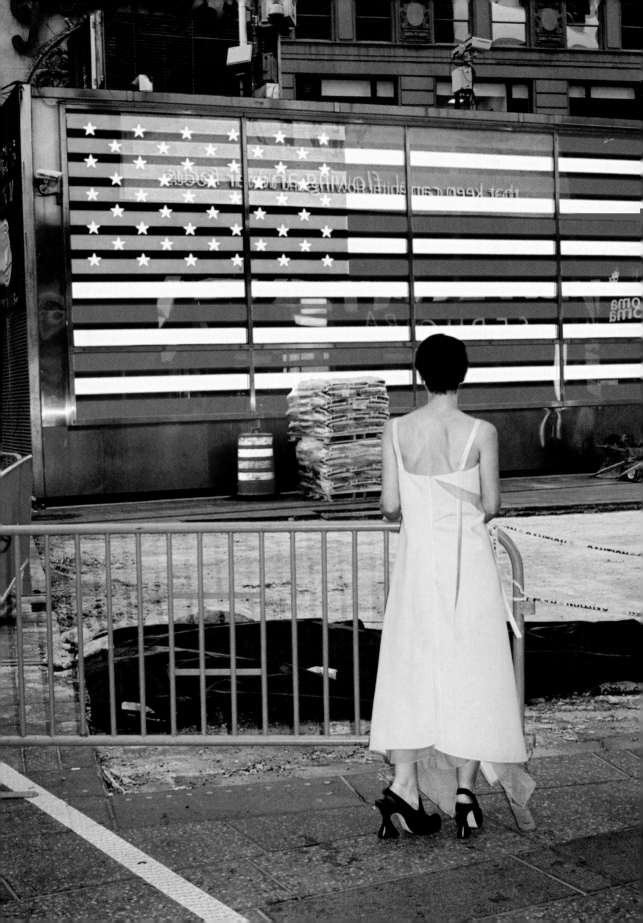

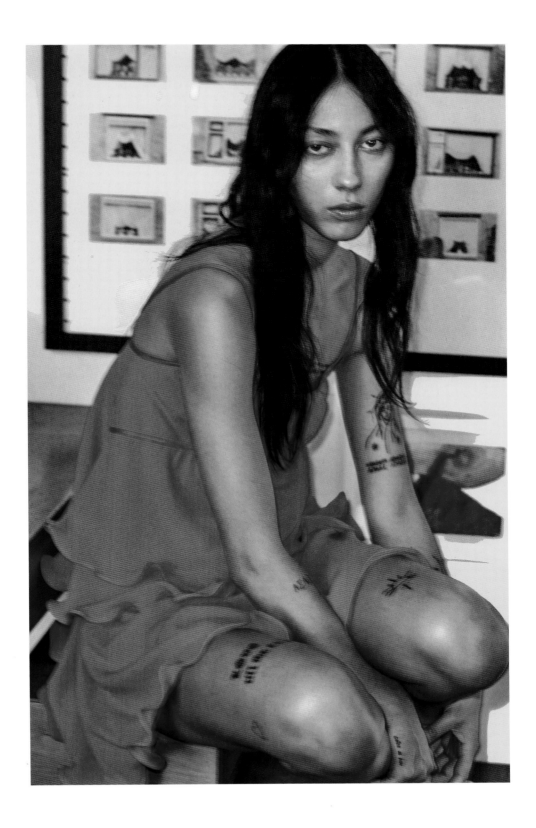

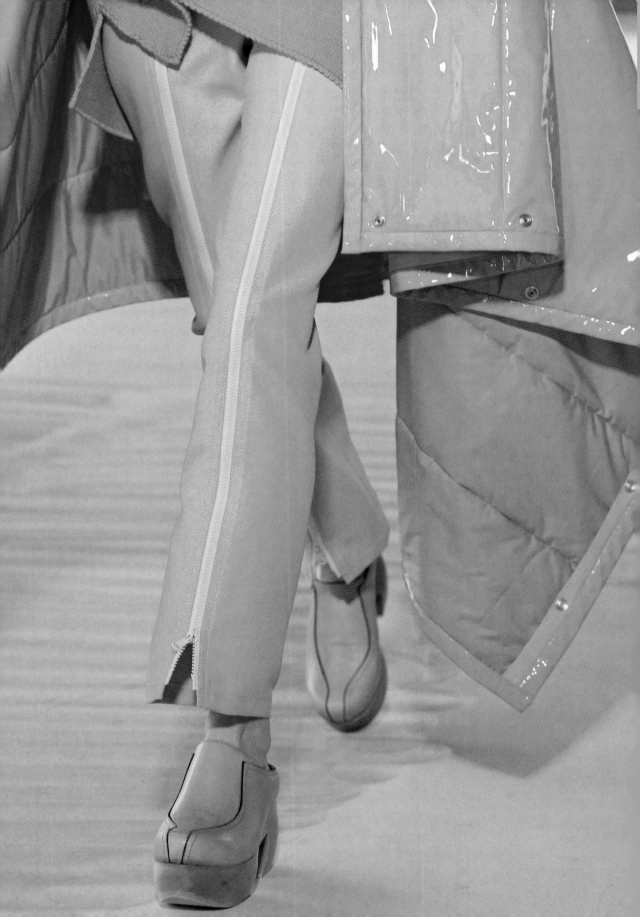

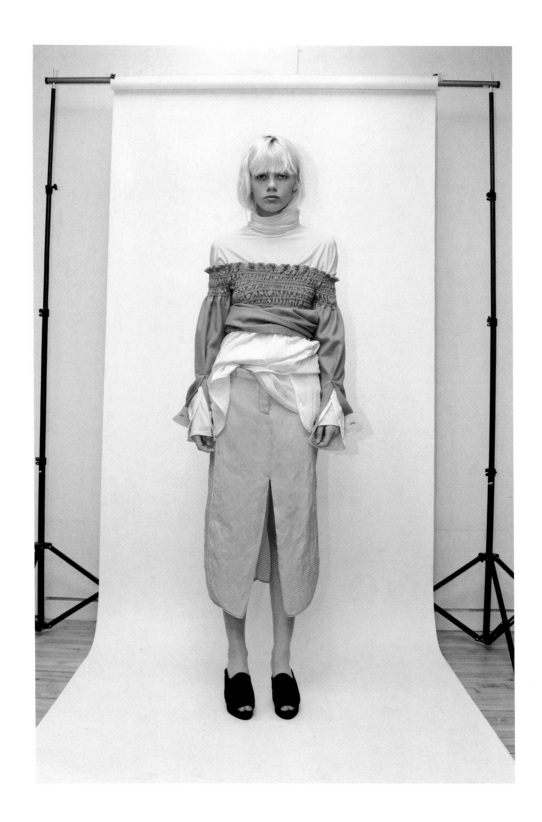

Over the Rainbow and Back Again: Tracing Sies Marjan's Colors Through Fashion History

by Karen Van Godtsenhoven

When Sander Lak debuted his Sies Marjan collection, on Valentine's Day of 2016, blasting its acid yellows, bright oranges, mauve pastels, and hot pinks, he started a chromatic revolution. Color was the driving force behind the silhouettes, turning women into beacons of vivid hues in a New York fashion landscape dominated by shades of black, gray, and white. Nowadays, it is normal to see New Yorkers wearing vibrant colors year-round, pounding the sidewalks and riding subway escalators in neon-yellow SpongeBob-like parkas with blue silk pajama trousers. Sporting a bright orange shirt with a hot pink skirt no longer defies the rules of good taste.

A worldly maverick and lover of pop culture, Lak is not unlike the connoisseur of Susan Sontag's *Notes on Camp* (1964); he "does not hold up his handkerchief but sniffs the stink." The colors worn by the *Real Housewives of Beverly Hills*—the aggressive red heels, the pink bandeau dresses, and the gaudy jewelry—inspire him just as much as do the tonal colors in a painting by Julie Mehretu. Inspiration is everywhere: the saturated orange and pink of America's *Dunkin' Donuts* evokes the orange mania of his Dutch motherland, informing the designer's cinematic mood board.

Lak's work for Sies Marjan always started from a color card, a palimpsest of impressions, moods, and memories. Tracing the importance of color in the history of modern fashion helps us decipher some of these connotations and situate them in the larger story of fashion. Issues surrounding class, taste, gender, and sexuality all speak to why people wore what they wore, when, and in which color, and what those colors meant at different times. The following journey through some of the most colorful moments in modern fashion history is like a color card of moods and moments that come together in Lak's work. Let's start with the final color of the ROYGBIV rainbow spectrum: violet.

It was to the swelling tones of Hole's grunge anthem "Violet" that I met Sander in Antwerp, about a decade ago. In an electric moment, an instant friendship was forged, robust enough to be woven into the fabric of two peripatetic lives across continents. Years later, I wore a violet twisted sweater with hot pink trousers by Sies Marjan to a book launch in New York City and recalled our shared love of Courtney Love and the color violet.

The ancient symbolism of violet in Christian traditions, representing the humility of Mother Mary, is quite different from its equivalent in Native American thought, in which the color is seen as a mediator between heaven and earth, indicating spirituality and clarity. The contemporary queer association of violet originates in the "violet tiaras" of the 7th-century poet Sappho's lovers on the Greek island of Lesbos. Violet's bigger sister, purple, has long been associated with kings, nobility, and upper-class prosperity. In Renaissance Florence, the Medici family

wore purple because the scarcity of its dye ingredients put it at a premium, turning the color into a sign of absolute wealth. In his seminal *Theory of Color* (1810), Goethe associates purple with the "unnecessary," connecting it to a fantastical sense and esoteric taste, as opposed to the "reasonable" red and orange, the "intellectual" yellow, and the "sensual" blue and green. Thanks to the accidental discovery of synthetic dyes by British chemist William Perkin, in 1856, purple in all its hues became so fashionable for both men and women that, two years later, *Punch* magazine ridiculed the vogue as the "mauve measles." But toward the late nineteenth century, purple once again became associated with sophistication by the Aesthetic Movement and its motto, "Art for art's sake." Dandy aesthete par excellence Oscar Wilde reminisced about his "purple hours" spent with young, ephebic boys for hire. Purple thus acted as a cover, or rather, a signpost for those in the know, for the coming-into-discourse of the queer type in the late 19th century, an association reclaimed by the LGBTQ movement dating back to the 1960s. This brief odyssey of the meandering symbolism of violet gives just a glimpse of the connotations a single color can accumulate over time.

Sies Marjan's burgundy garment label leads us to the Burgundian rulers of the Low Countries in the 15th and 16th centuries, who brought cultural blossoming paired with a joyful "Southern" lifestyle, one connected to ease, luxury, and a good time. It is around this point in the Renaissance that the early modern fashion system appeared in Europe, with its ever-changing colors, rules, and seasons. Medieval fashions had been quite stable; dark woolen garments were worn by most of the population, with certain exemptions for special occasions and social classes. During the 15th century, the lower and middle classes started to wear more bright colors, such as yellow and orange gold, in imitation of the red worn by the upper class. Deep reds had long been associated with high social status, representing justice, power, and prestige, nobility, and royalty. By the late 15th century, bright colors had evolved into deeper tones of red, black, and gold, with contrasting colors for linings, shown through the "slashes" in the fabric. However, an opposite mood appeared, too, favoring black as the color of nobility and discretion. At the Italian Renaissance Court, Baldassare Castiglione wrote his famous manifesto, *Il Cortegiano* (1528), whose hero expresses his studied nonchalance by wearing black to prove his inner worth. 16th- and 17th-century Golden Age paintings show us the growing importance of black as a color of respectability, religious piety, and sobriety under the influence of the dark fashions of the Catholic Spanish Court, when wearing black was mandatory for both sexes. The complex dyeing process, mixing red and blue, made black into a signifier of sophistication and wealth, as seen in the lustrous black garments of the wealthy burghers painted by Rembrandt and Rubens.

Gradually, black came to be associated with the Enlightenment and rationalism; colorful garments were seen as too decorative, effeminate, and undesirable. The last of the colorful men, at least for the following century or two, were the flamboyant French aristocrats at Versailles. Rococo men dressed dazzlingly in pink,

mauve, burgundy, brown, yellow, green, or gold silk, often embroidered more ornately than the women's dresses. As the French Revolution of 1789 introduced (among other things) a somber palette, men's fashion would remain in the blacks and grays, ossifying into the uniform of the black three-piece suit, an enduring symbol of middle-class respectability. Psychoanalyst John Flügel called this phenomenon the "great male renunciation," a process in which men would abstain from fashion while women engaged with it. It was not until the hippies and the Peacock Revolution of the 1960s and '70s that a new generation of men would dress colorfully again.

During the 19th century, womenswear saw many changes in terms of silhouette and color, as middle-class women and their dress came to be seen as indicators of their husband's wealth. Black was reserved for mourning attire and, color-wise, the first decades saw women's fashion evolve from a soft and romantic palette of yellows, blues, and pinks into more brilliant shades of blues, greens, reds, and yellows in the middle of the century. Between 1860 and 1880, colors became lighter again, with white, blue, gray, lilac, and pink often used in two-tone fabrics for greater subtlety. Roman Polanski's *Tess* (1979)—a movie adaptation of Thomas Hardy's novel *Tess of the d'Urbervilles* set in the 1870s—shows Nastassja Kinski alternately in summer dresses in light colors and pastel blues and fawn dresses and brown cloaks for winter— an inspiration for many Sies Marjan collections. The 1870s saw the reintroduction of darker colors such as green, mauve, fawn, blue, purple, brown, red, and black, until coming to its apotheosis

in the harsh, electric colors of the 1880s, hues with names such as "acid magenta," "aldehyde green," "Verguin's fuchsine" (fuchsia), "Martius yellow," and "Magdela red."

Modern painters such as Matisse and Mondrian pushed the possibilities of colors in early 20th-century art, treating them as autonomous entities independent of form or figuration. Matisse likened dipping a paintbrush into color to a sculptor carving into stone. Contemporaneous color experiments by Robert and Sonia Delaunay drew on Michel Eugène Chevreul's theories of 1839, which posited that colors placed next to each other acquire more vibrant or intense hues. In fashion, Paul Poiret's "Thousand and Second Night" balls evoked Asian opulence with purple, gold lamé, and green, before sobriety returned with World War I and Chanel's subsequent liberation of black from the shackles of mourning dress, catapulting it into becoming the preferred color of industrial modernity, Parisian elegance, and chic, as exemplified by her little black dress.

Jeanne Lanvin's well-kept art deco office and personal library on Rue St. Honoré in Paris still contains a wealth of the fabric swatches, travel diaries, and art references that fed her curiosity and inspired her artistic creations. One of her most astounding works is a light blue silk crepe georgette dress from 1939, echoing the capes of Fra Angelico's angels. Lanvin eventually invented her own peculiar shade of blue, Fra Angelico blue, that guarantees to flatter most skin and hair types; the hue was inspired by the blue skies of his home city of Florence. In Sies Marjan's world as well, blue exemplifies natural

elements. For his 2017 Fall/Winter collection, Lak used the bright royal blue of KLM airlines, associated with a cloudless blue sky, and for Spring/Summer 2020, he produced dresses in an electric blue, which seemed to drip from the body like water.

Since the age of Madame de Pompadour, with her appetite for pink clothes and porcelain, pink had been largely neglected for two centuries. In the 19th century, pink was used for boys' clothes, as a watered-down version of a more manly red. When pink returned in the form of its brightest magenta expression, in 1937—dubbed "shocking pink" by Elsa Schiaparelli in an act of Surrealist magic—it juxtaposed her imaginative fashion with the conflict and austerity leading up to WWII. Two decades later, Diana Vreeland famously observed that "pink is the navy blue of India," pointing out the color as symbolic of respectability. The history of pink, which fashion historian Valerie Steele has called a "powerful, pretty, and punk color," shows us that context is everything: the meaning of a color often lies in the eye of the beholder.

Red—the color of power, prestige, sensuality, and passion—was a favorite of couturiers from Balenciaga to Valentino. Similarly, the poetic, kaleidoscopic, and Mediterranean-inspired designs by Christian Lacroix, "the man with the magic brush," often featured red-hued silhouettes, inspired by both the regional dress of his hometown of Arles, in Provence, and the paint strokes of Pablo Picasso and Joan Miró.

The 1990s saw the avant-garde fashion palette grow a tone darker, with deconstructed looks by Belgian and Japanese designers in minimalist and androgynous silhouettes in variations of black, gray, and white. However, subcultural styles did not follow this trend: indeed, goths and punks splattered their mainly black looks with techno acid colors. The rave underground also made its appearance in the collections of Walter Van Beirendonck and Helmut Lang. Kurt Cobain's mauve cardigans and floral print dresses blurred gender boundaries along color lines; the grunge uniform du jour for both men and women consisted of faded blue jeans and plaid shirts in pastel colors. Shirley Manson's iconic red hair, and the 1998 film *Run Lola Run* made the sales of henna hair-coloring products soar, while the success of the Spice Girls ensured that teenage girls would dress according to their color type. The theatrical and flamboyant shows of John Galliano and Gianni Versace and the explosion of colors from around the world in the work of Dries Van Noten and Jean Paul Gaultier created an extravaganza that left an indelible imprint on the minds of the "'90s kids."

Sander Lak noted that his debut collection for Sies Marjan was indebted to the cool girl wearing cargo pants and chunky platform wedges he admired as a young boy in the 1990s and early 2000s. The collection was also a tribute to the colors that defined the era: acid yellow, safety orange, soft mauve, pink, and light blue. He looked back with innocence at the colors of his youth, like the artist in Charles Baudelaire's *The Painter of Modern Life* (1863): "The child sees everything in a state of newness; he is always drunk. Nothing more resembles what we call inspiration than the delight with which a child absorbs form and color."

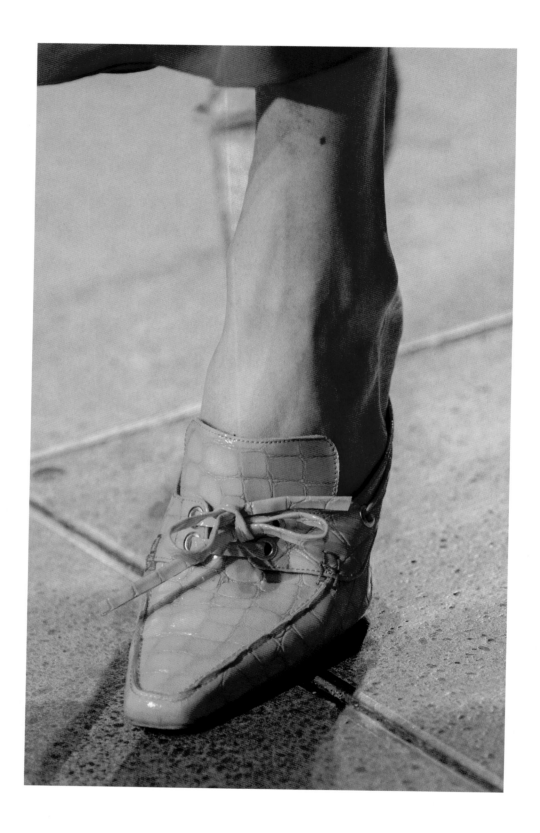

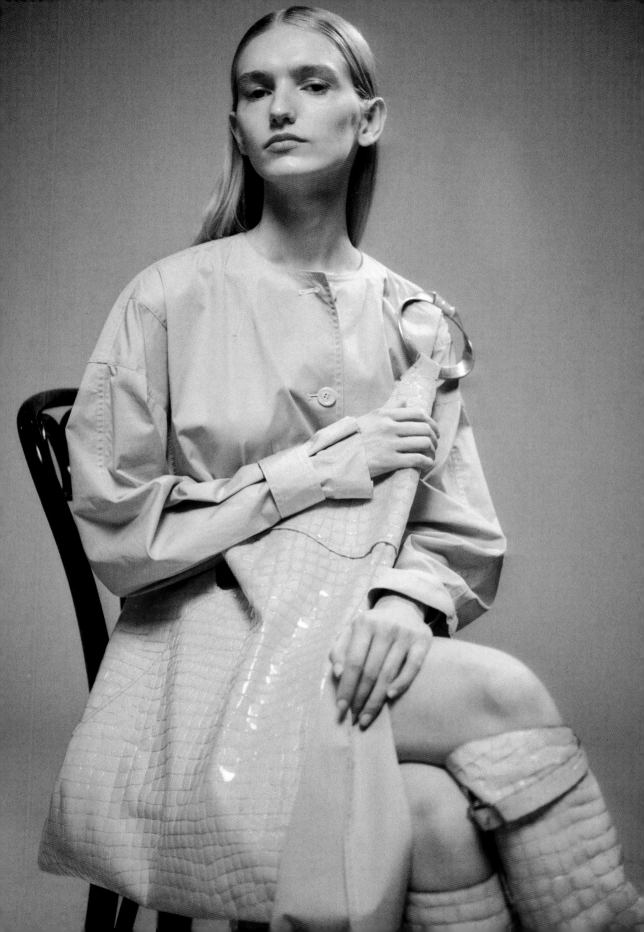

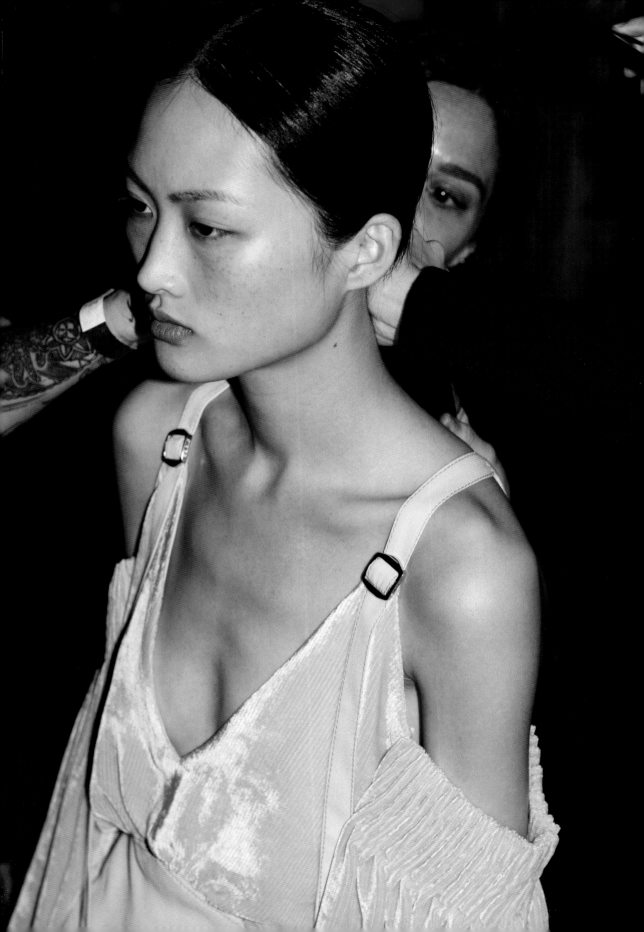

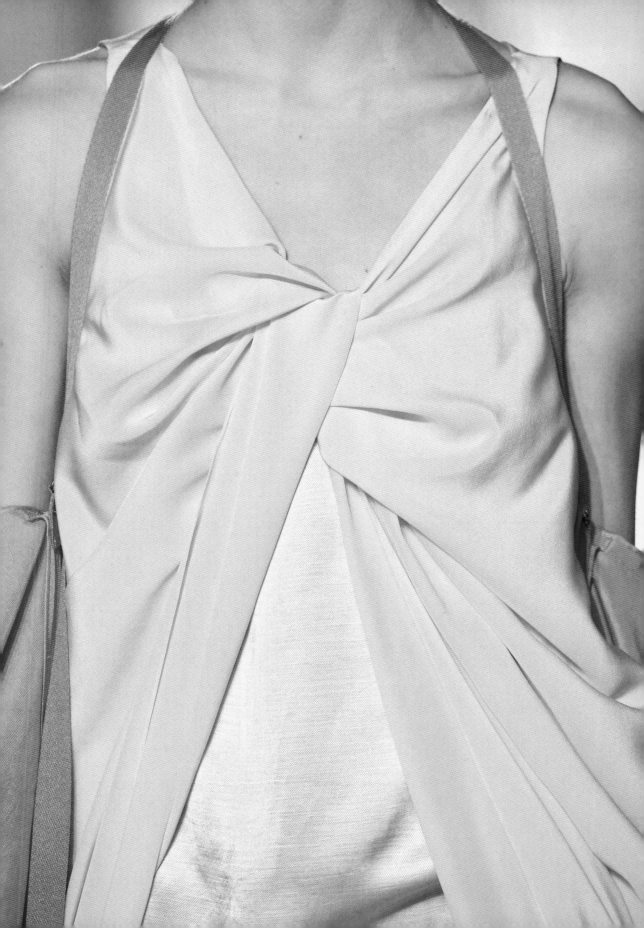

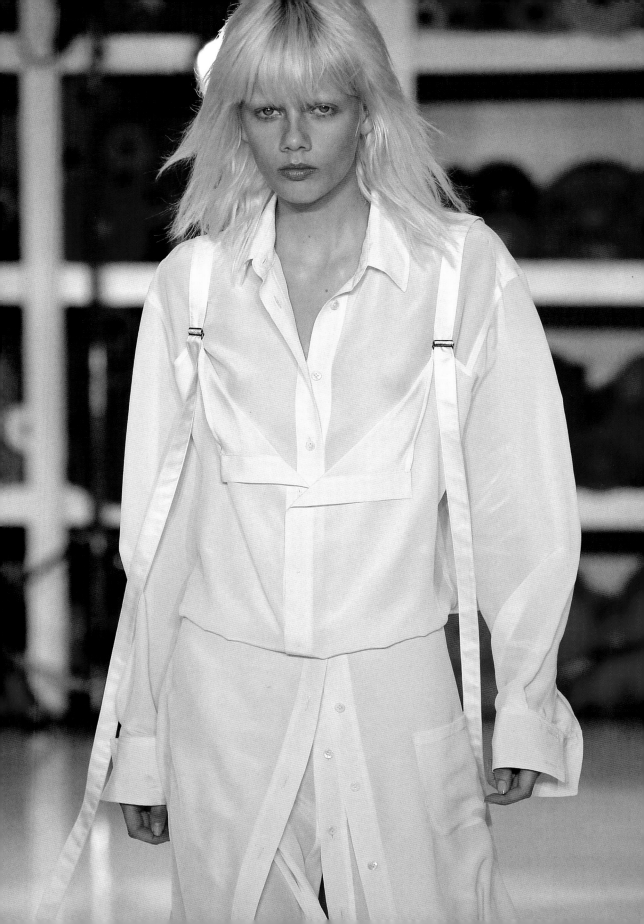

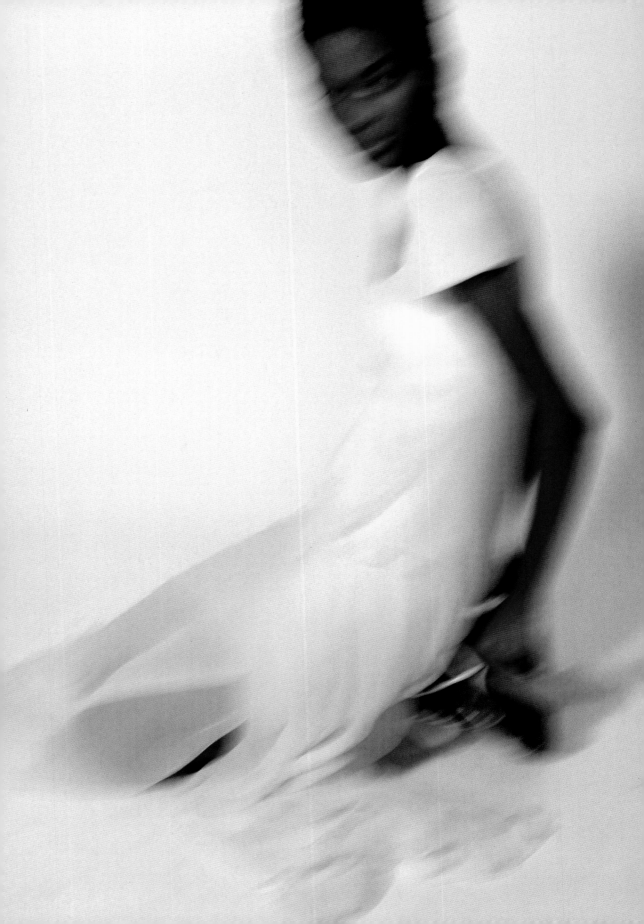

"Sander of course is a master of color—everyone talks about that—
but he's a master of fabric and of drape as well. His clothes hit a rare mark:
intuitive but formal, easy but precise, the silky comforting garment
one locates in the closet as much by the pleasure of touch as by sight.
His work, with its flowing ease, reminds me of some of the great Hollywood
designers of the 1930s. Translate those delicious pastel silks to
black or white and they're still just as delicious."

Donna Tartt

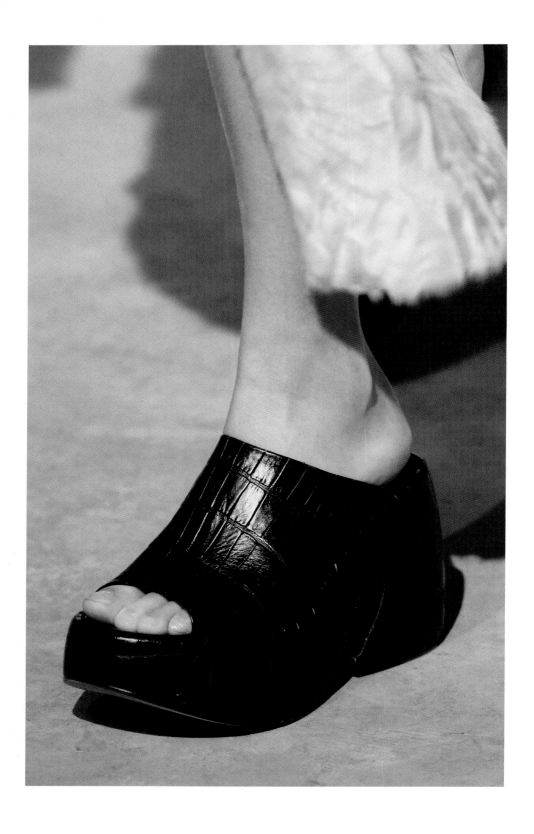

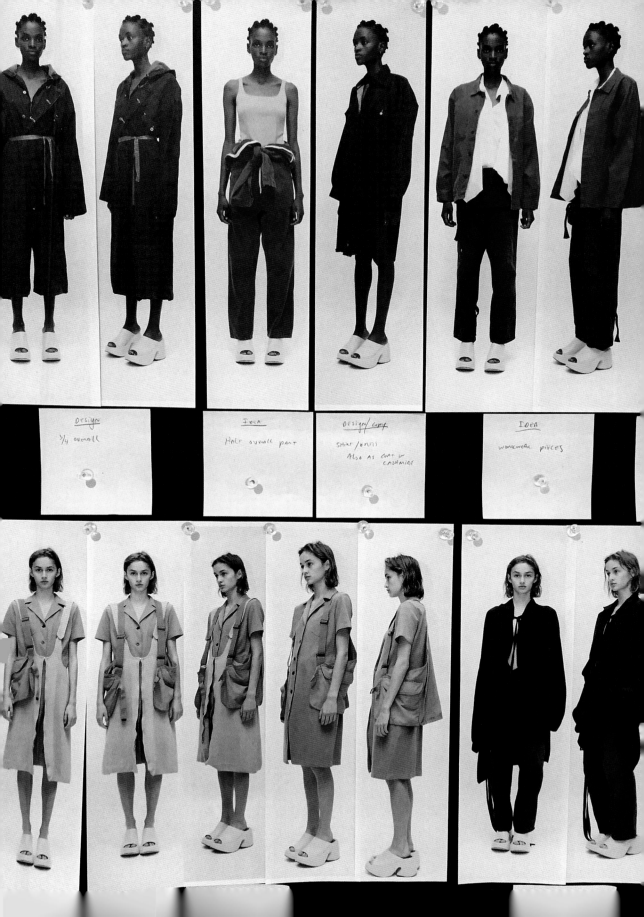

Design
3/4 overall

Idea
Half overall pant

Design/copy
Shirt/dress
Also as coat in cashmire

Idea
Workwear pieces

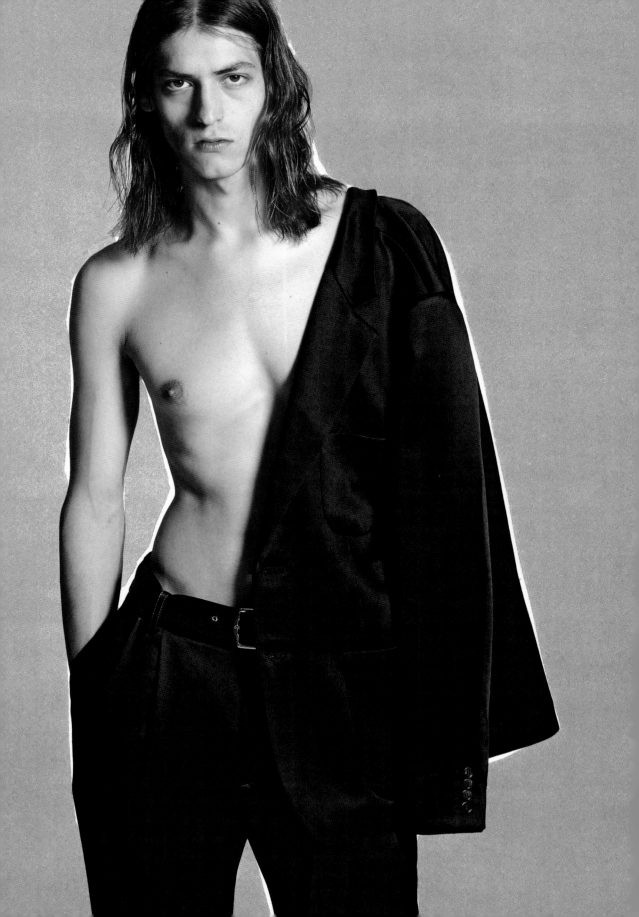

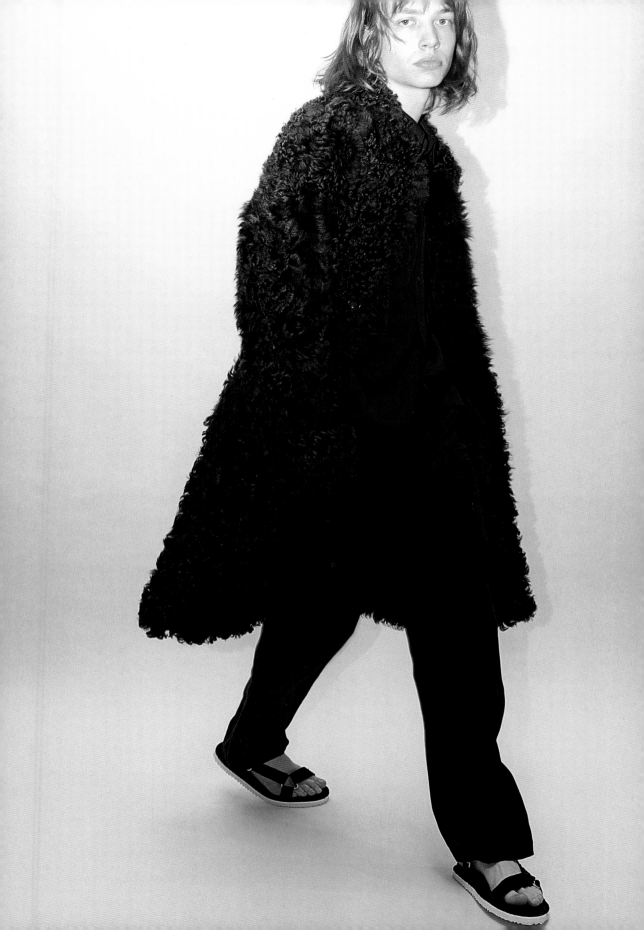

Sies Marjan

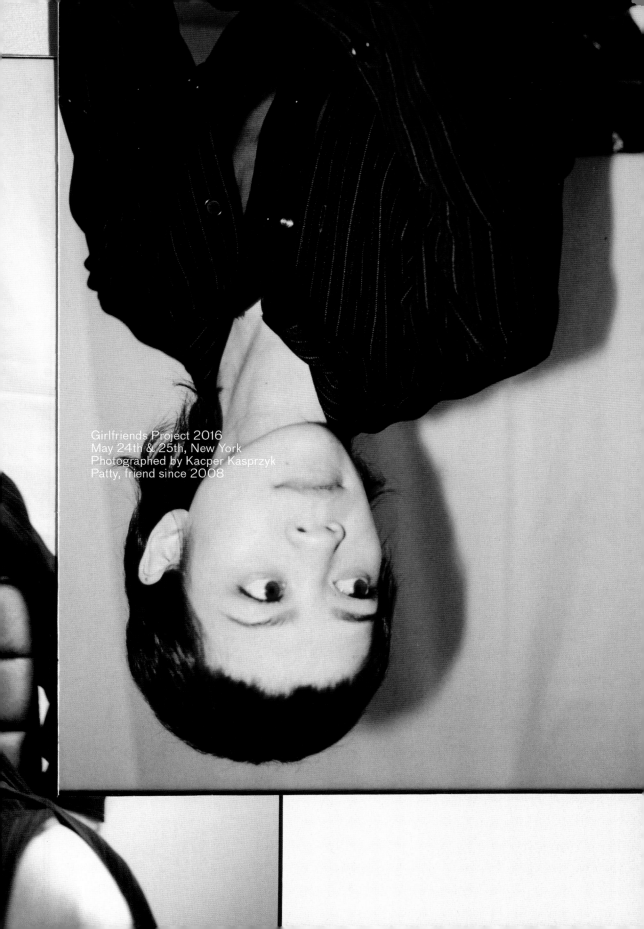

Girlfriends Project 2016
May 24th & 25th, New York
Photographed by Kacper Kasprzyk
Patty, friend since 2008

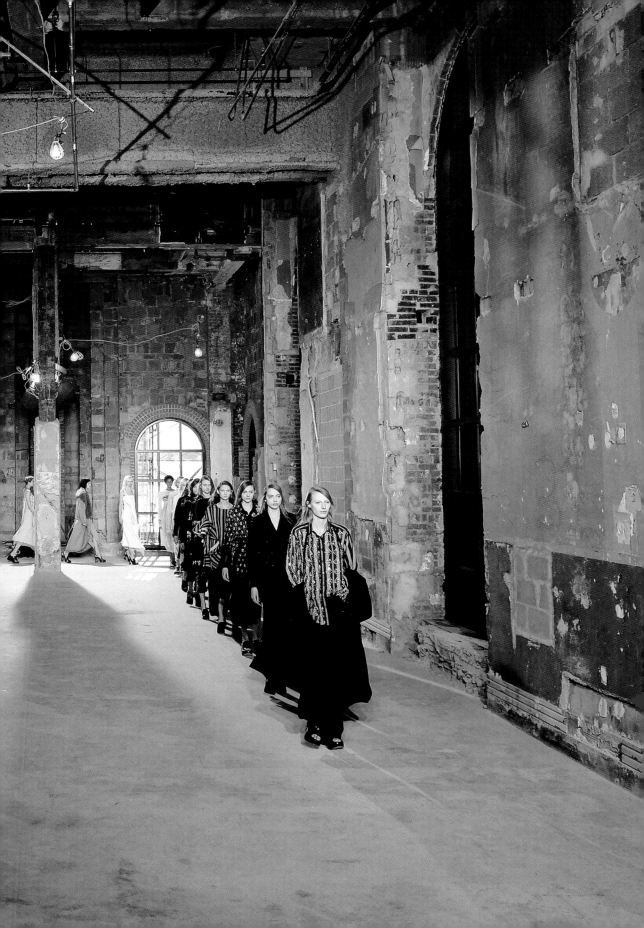

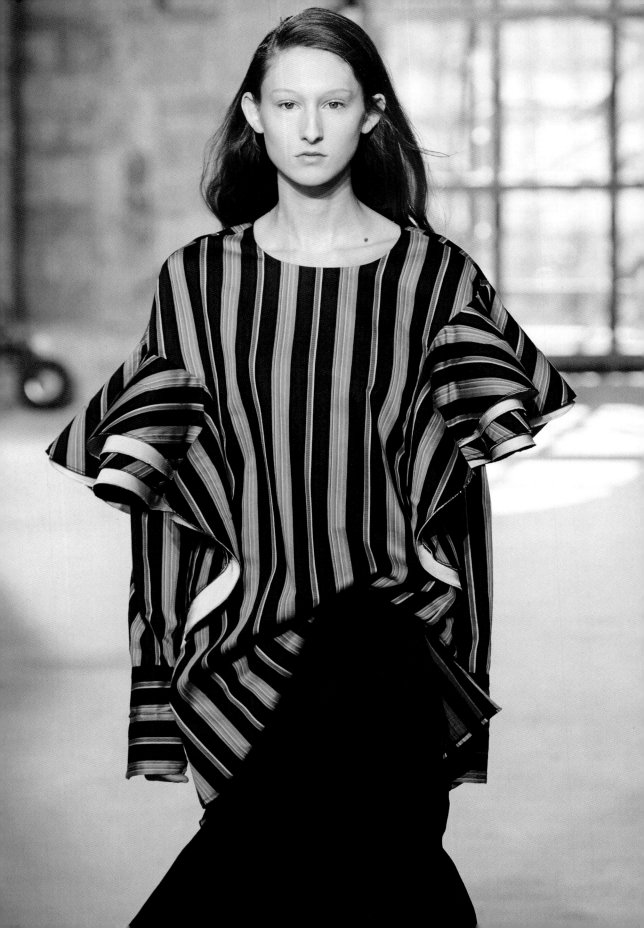

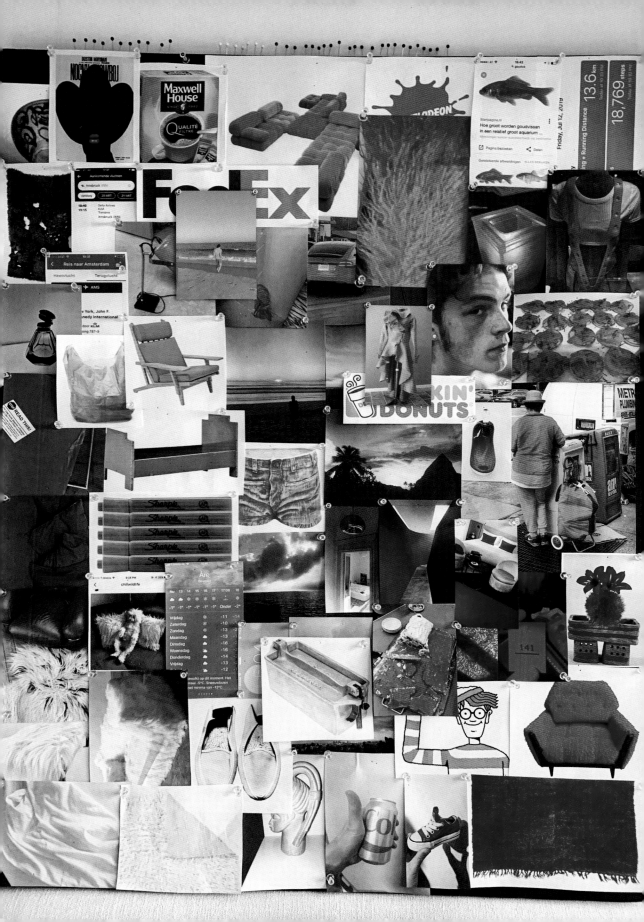

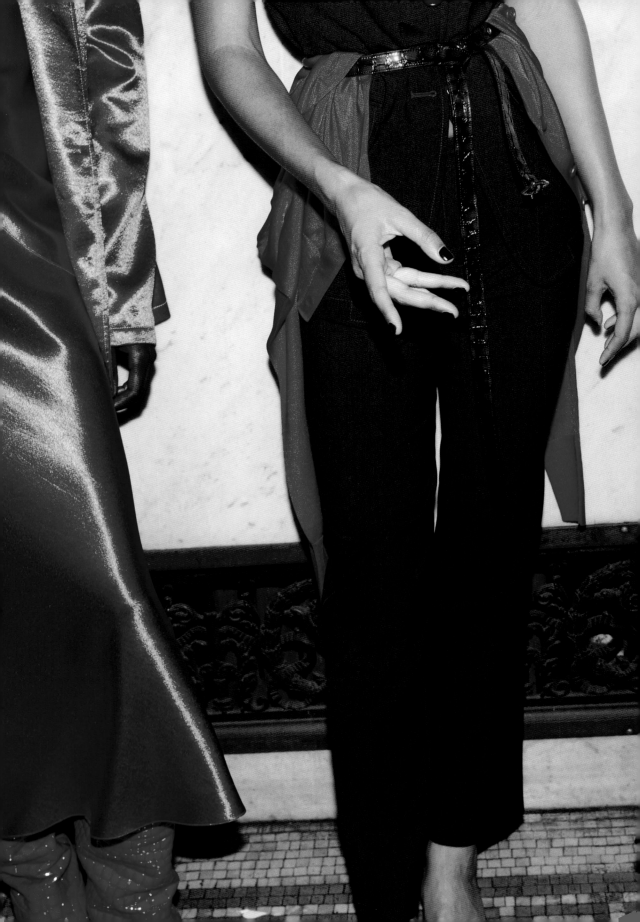

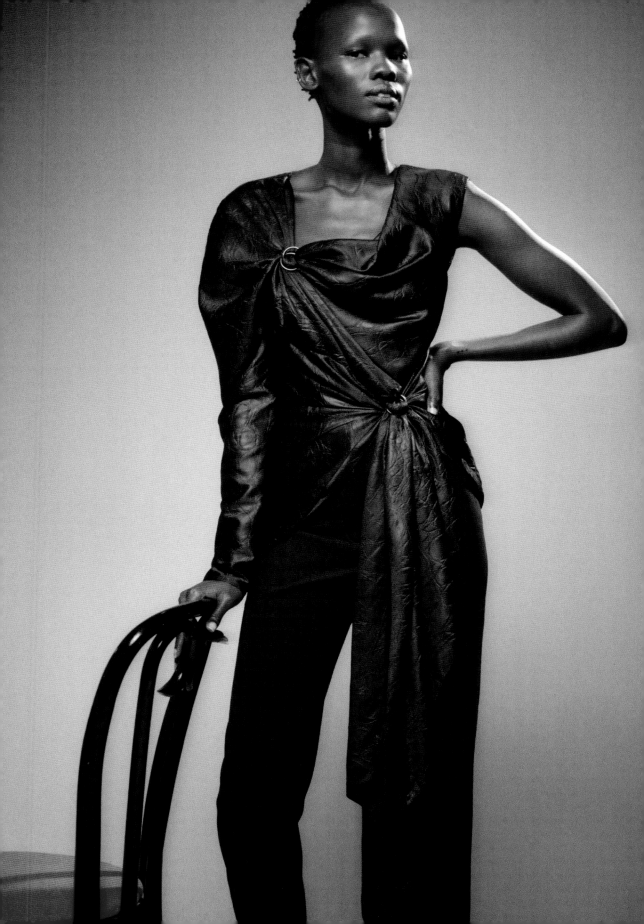

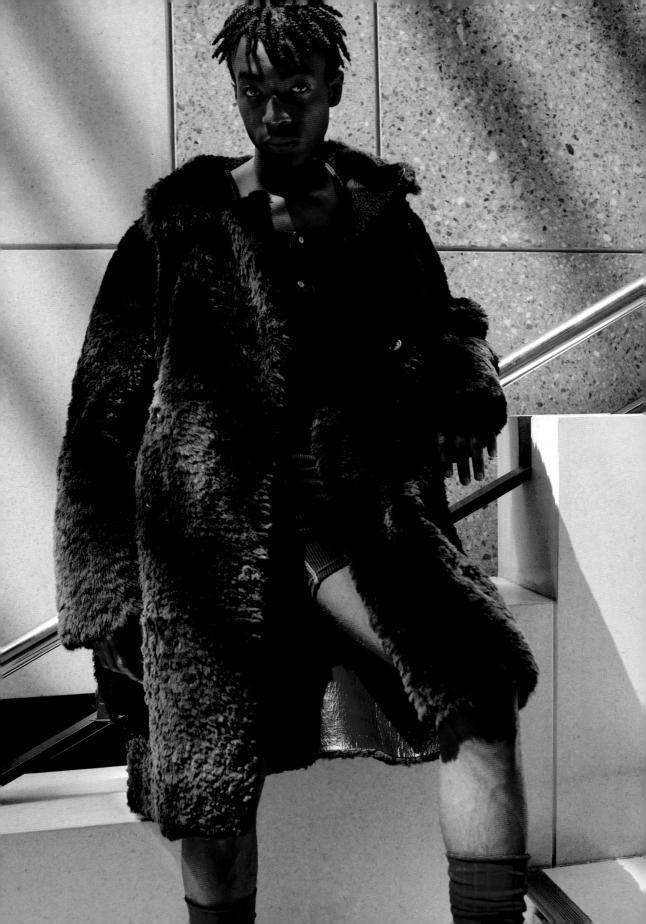

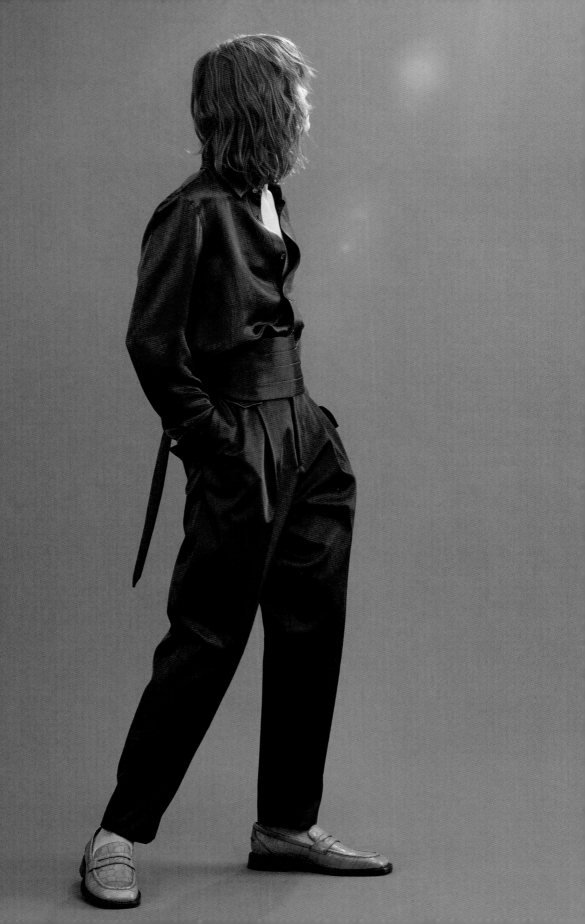

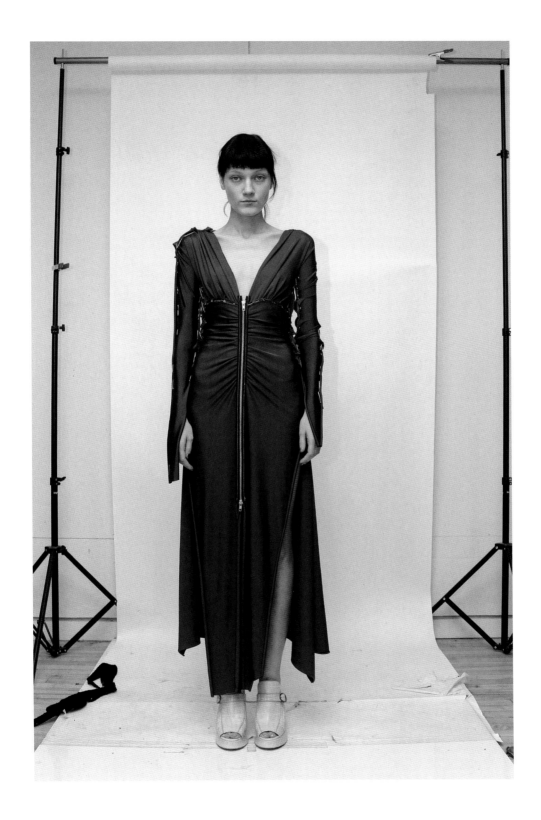

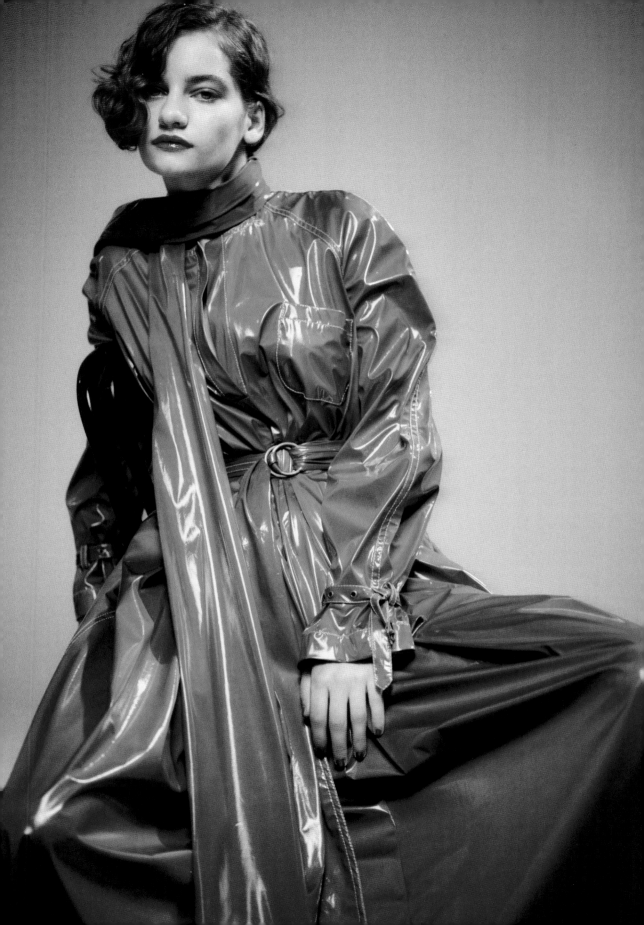

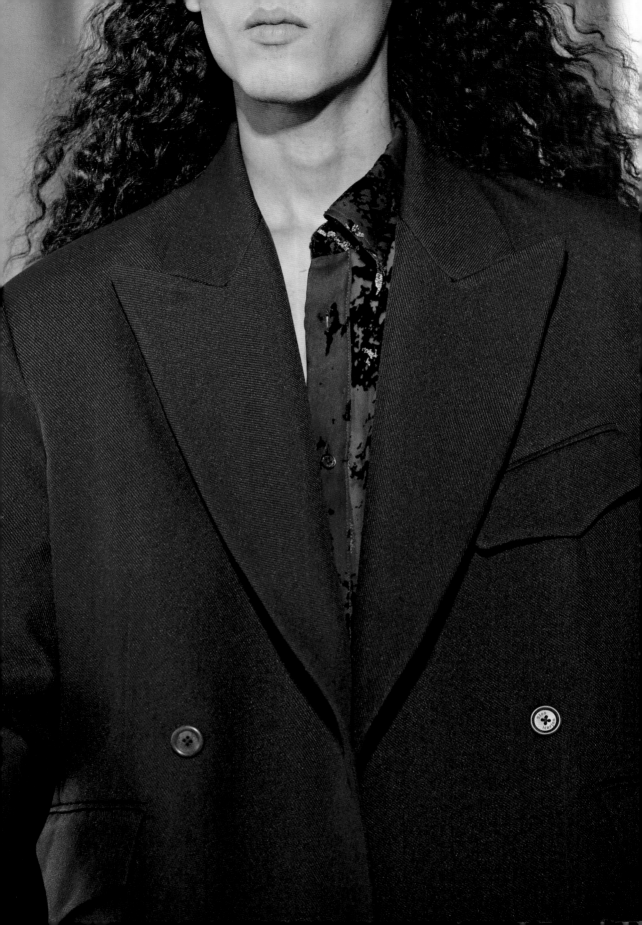

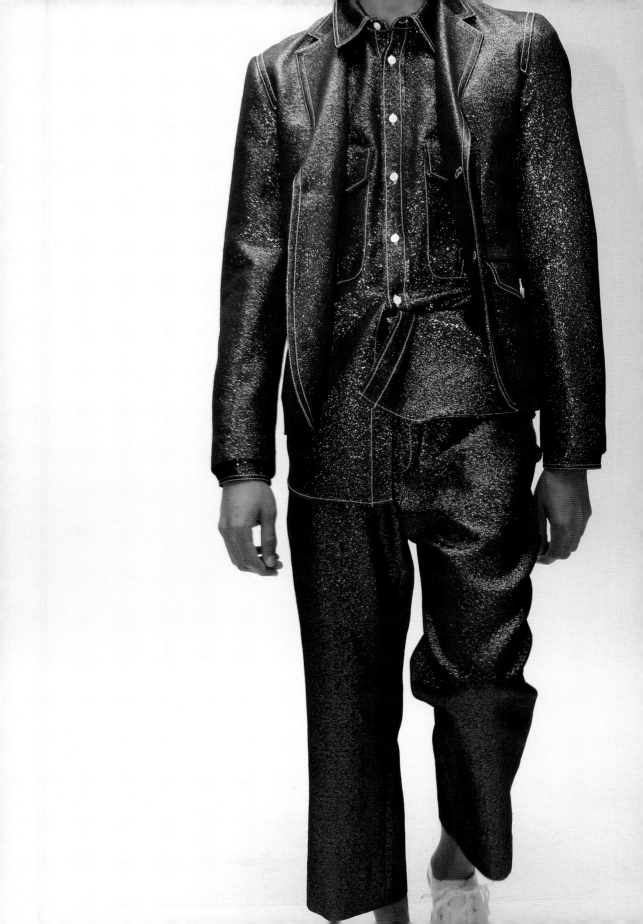

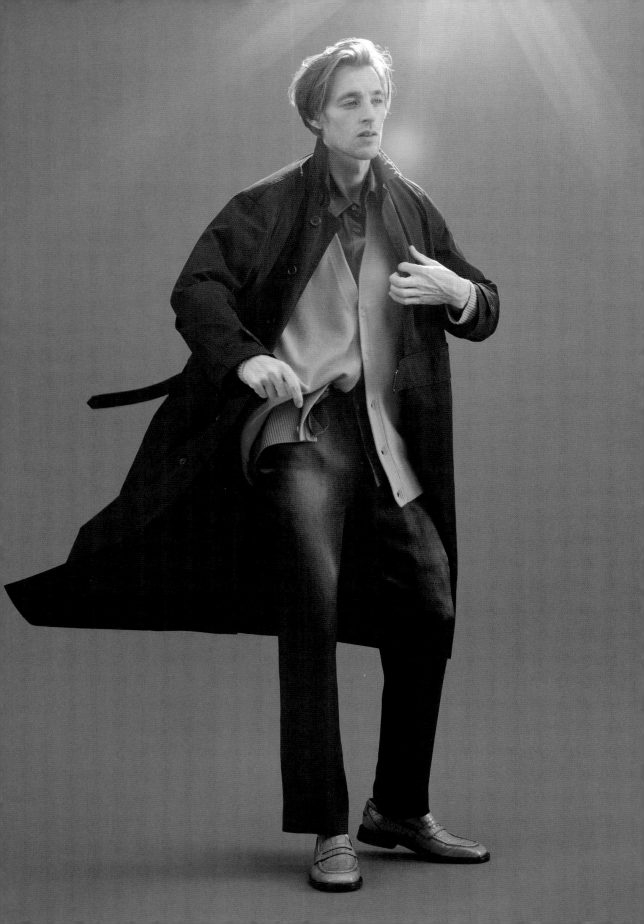

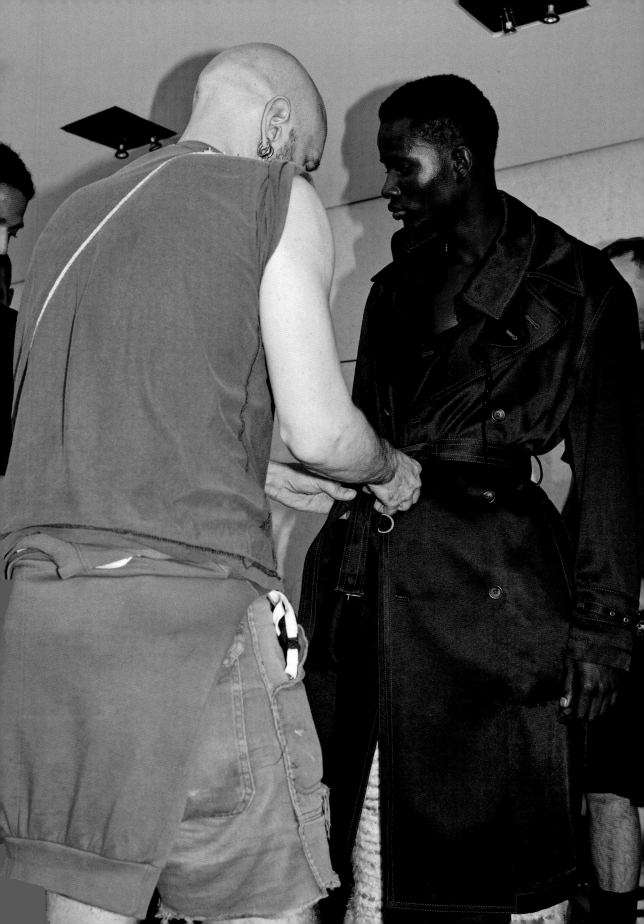

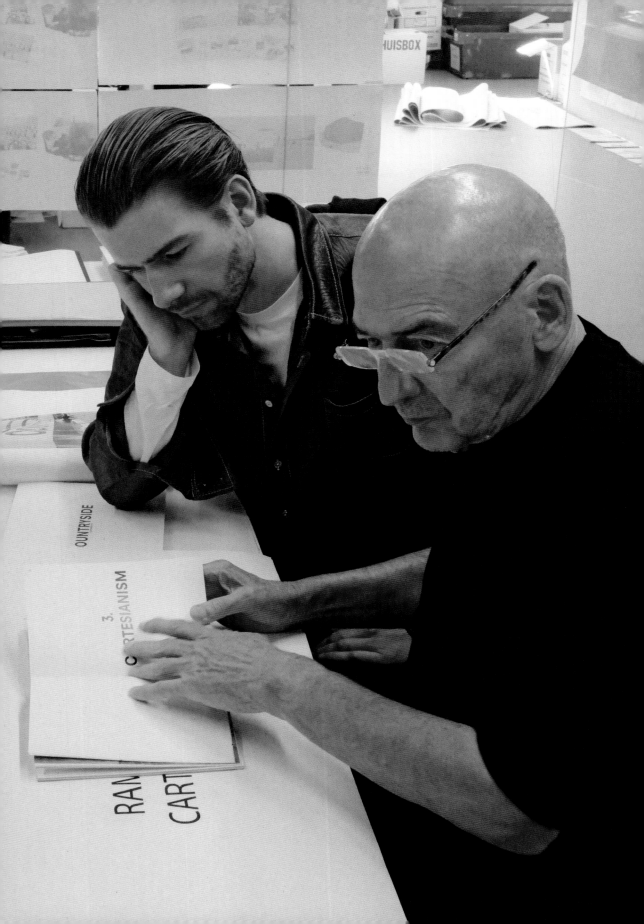

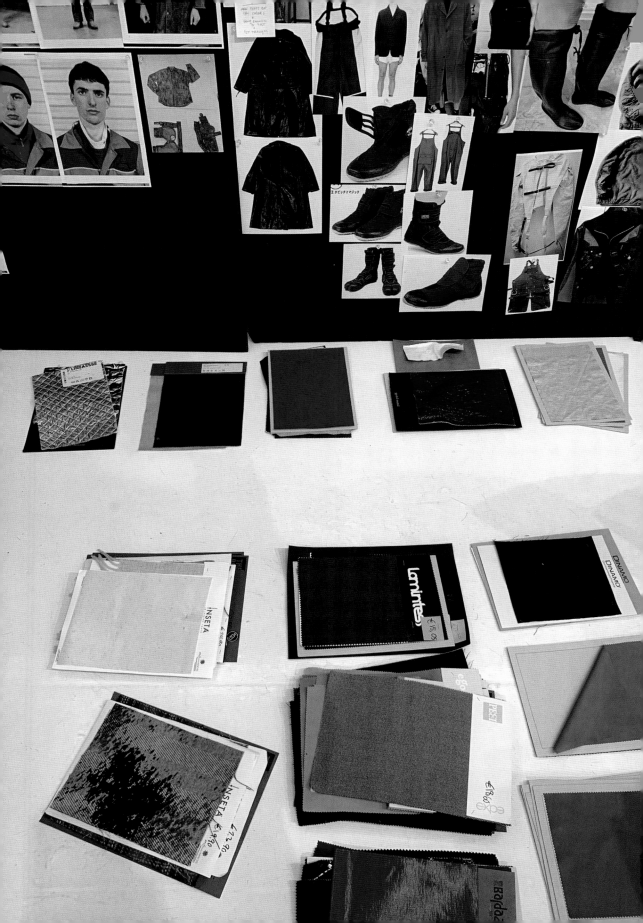

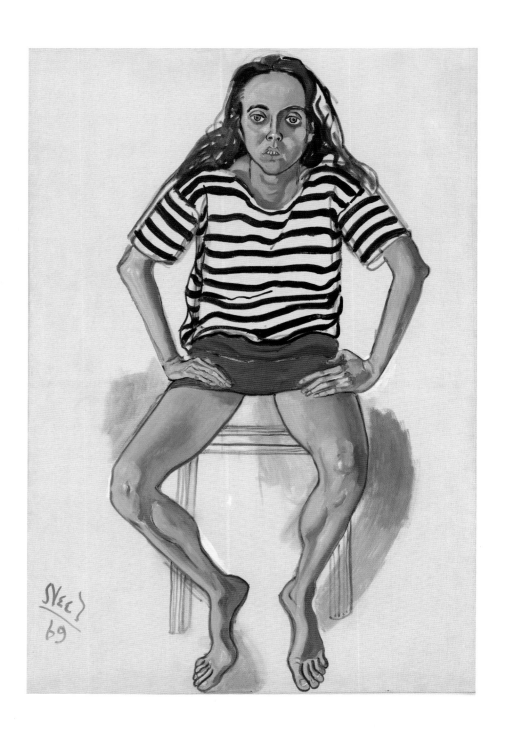

Alice Neel, *Ginny in Striped Shirt*, 1969.

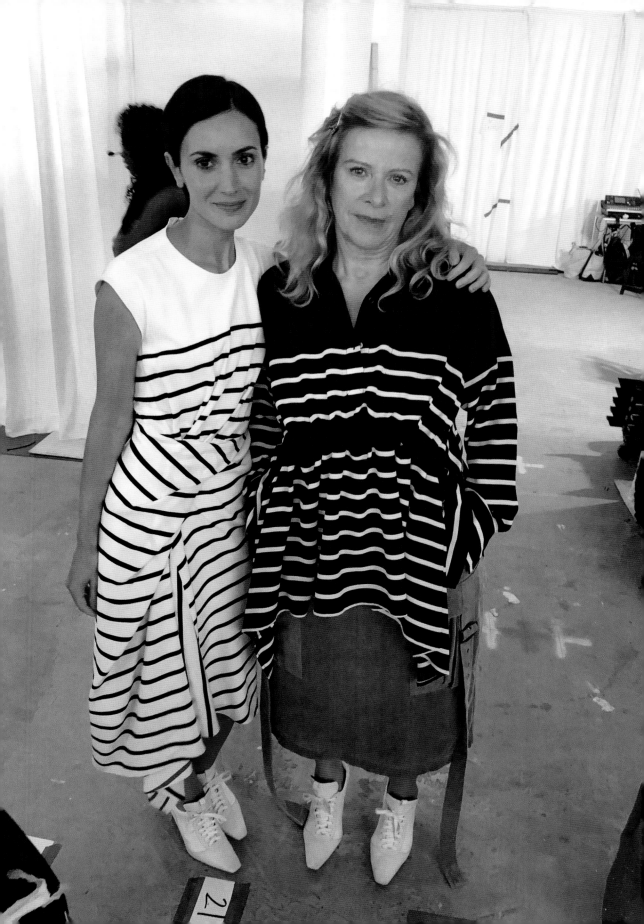

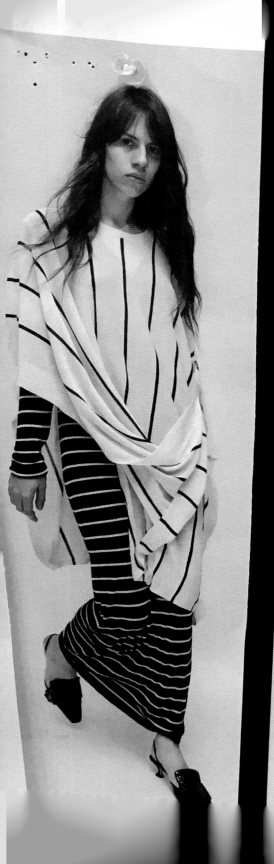
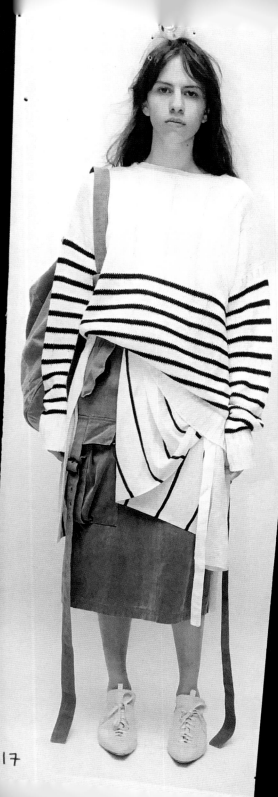

17

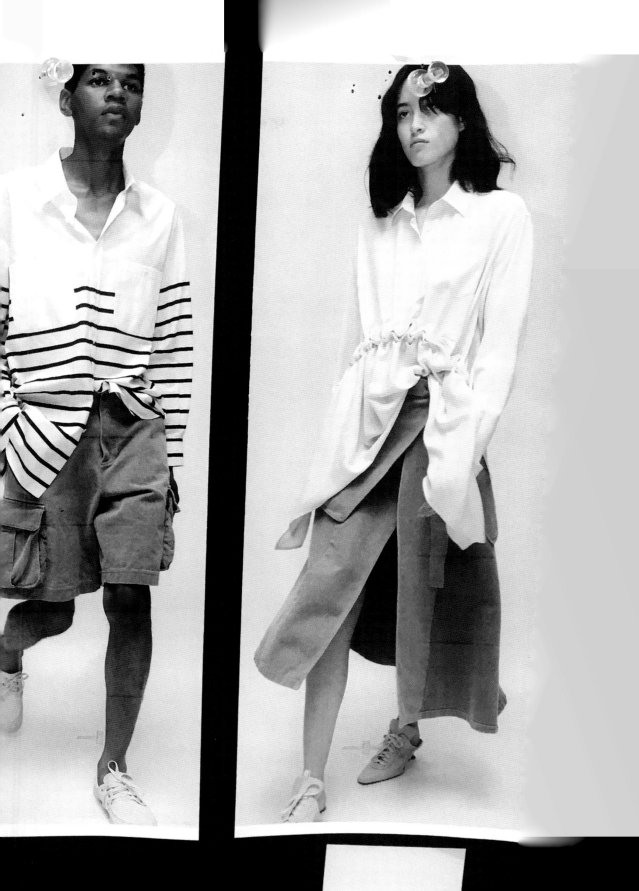

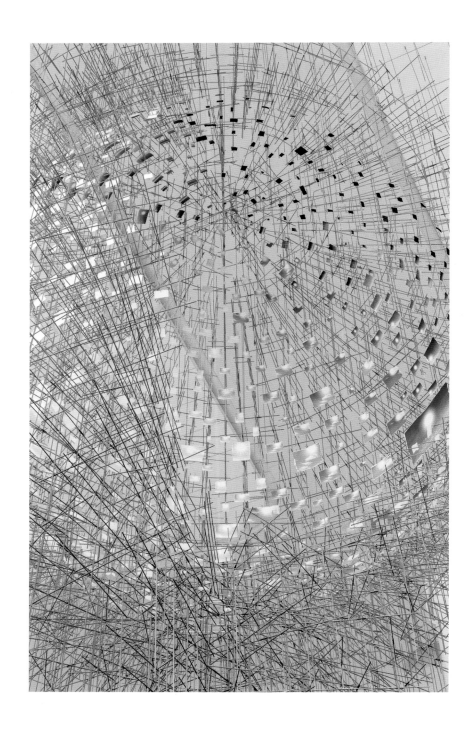

Sarah Sze, *Shorter than the Day*, 2020.

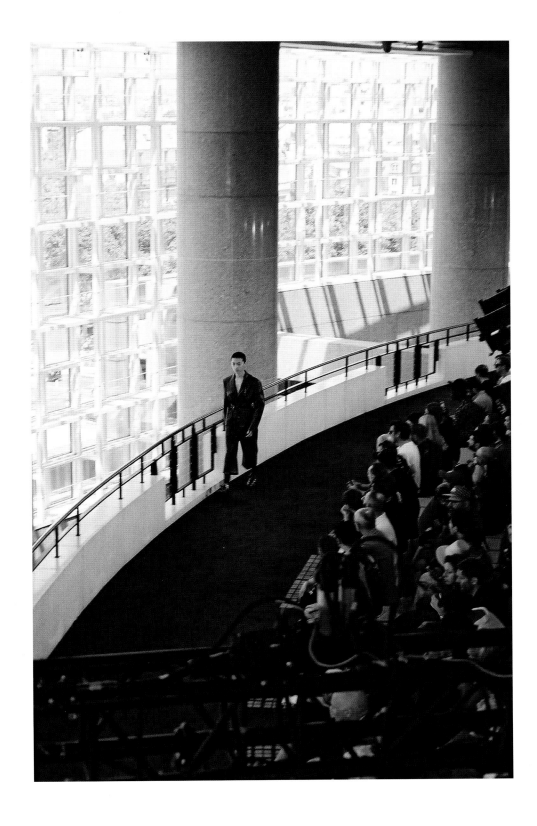

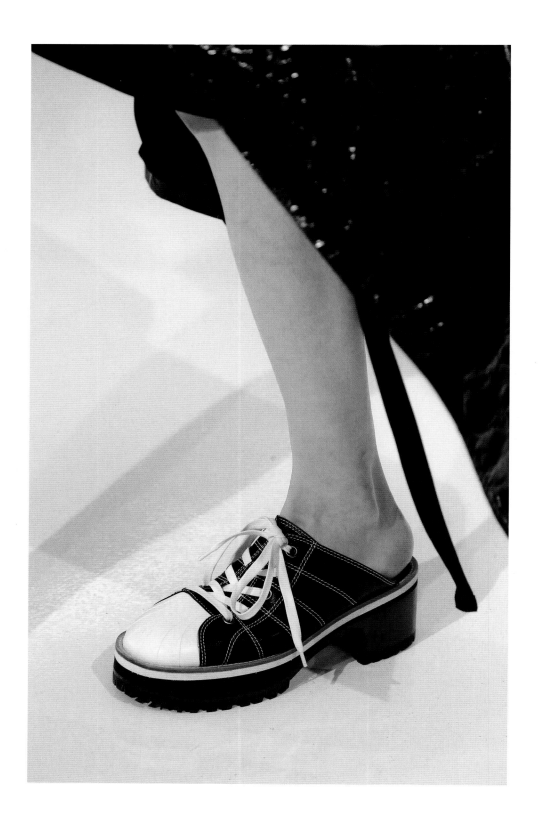

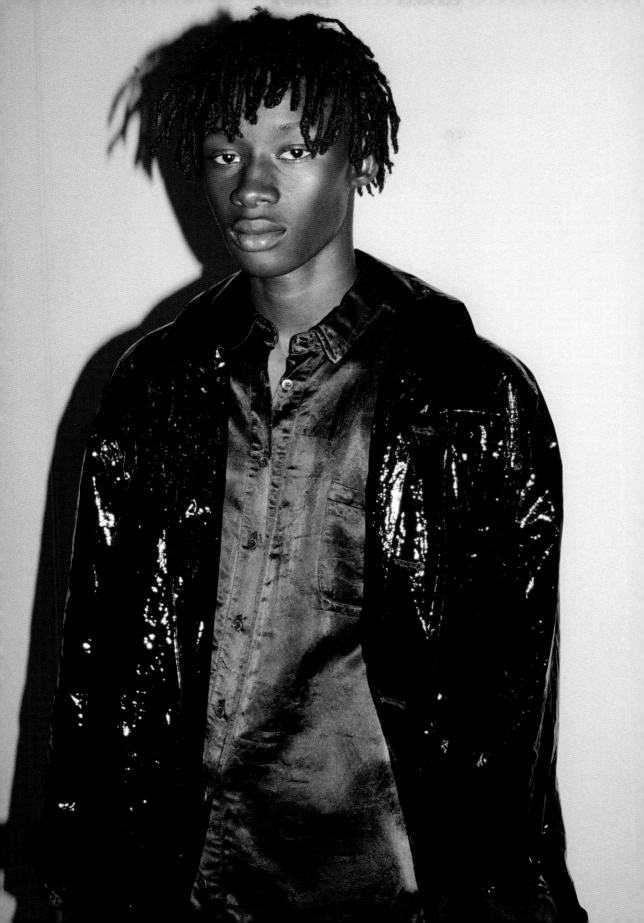

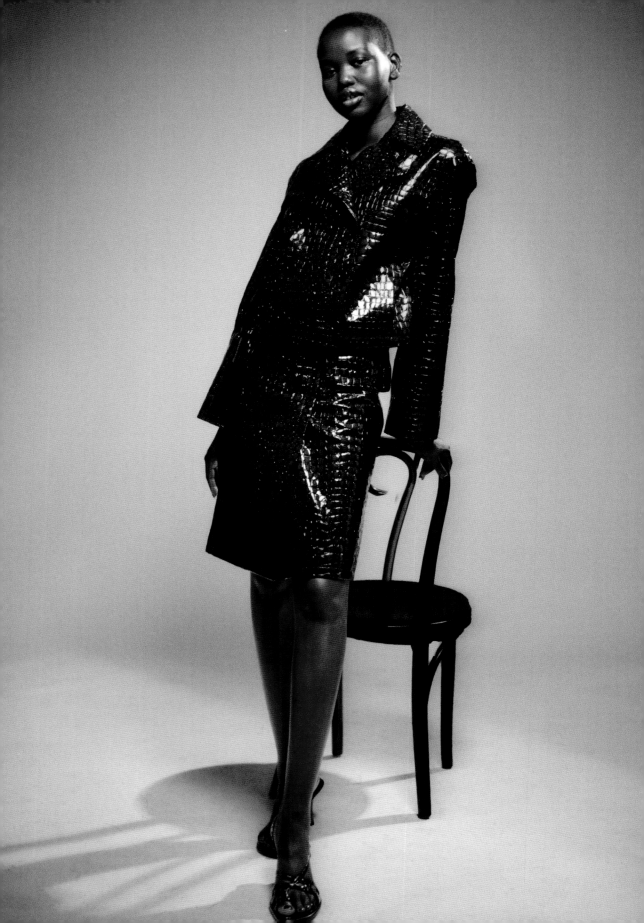

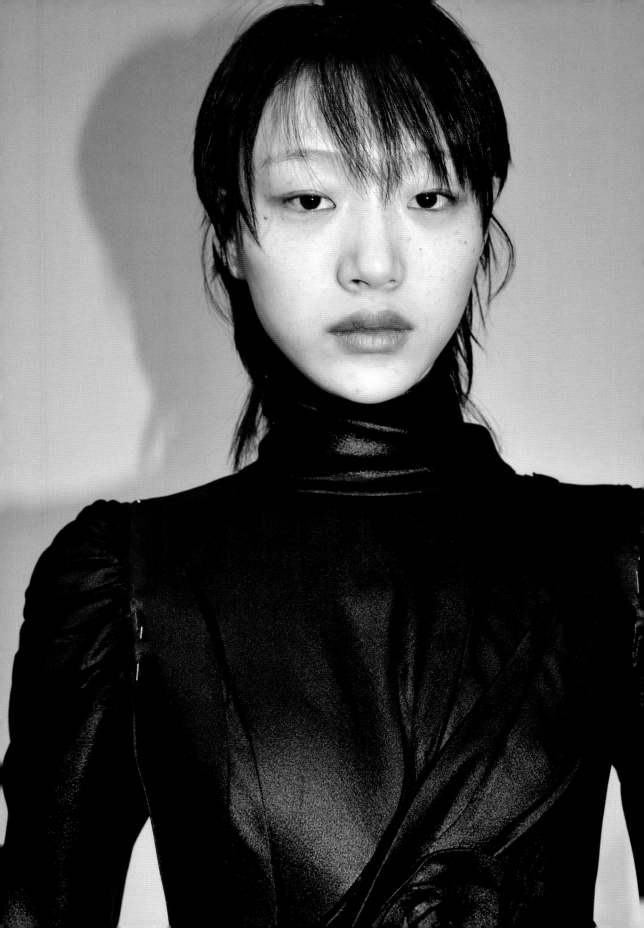

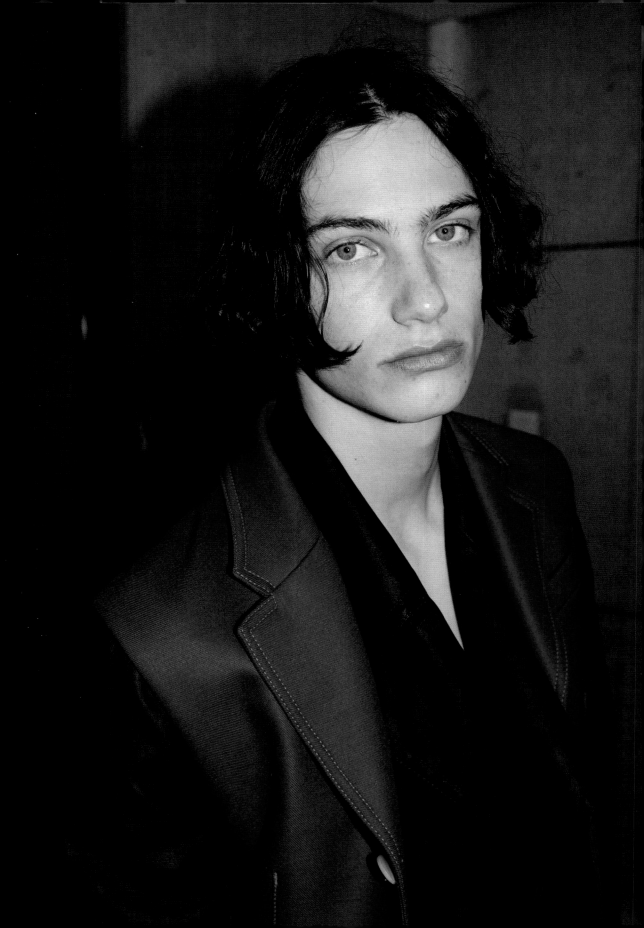

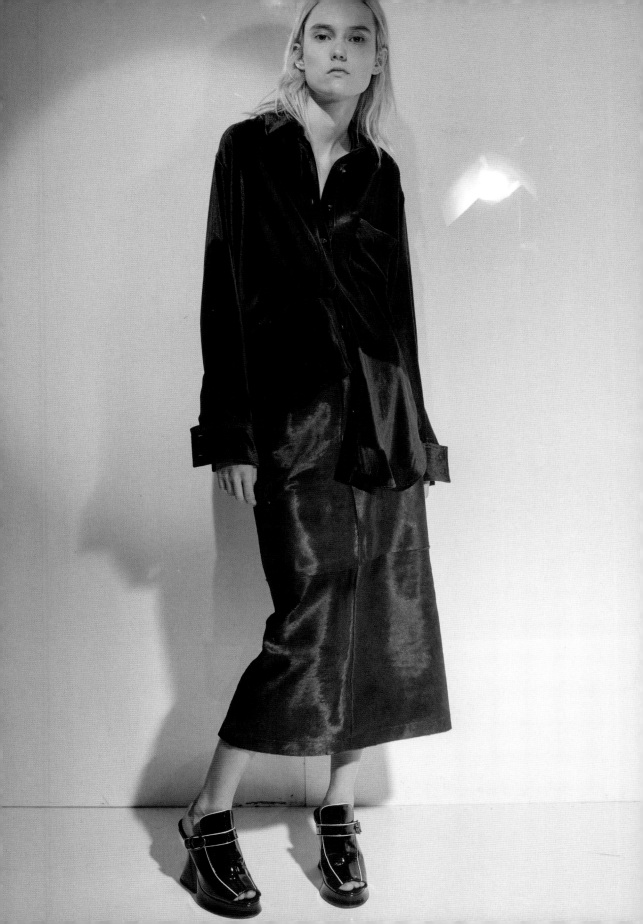

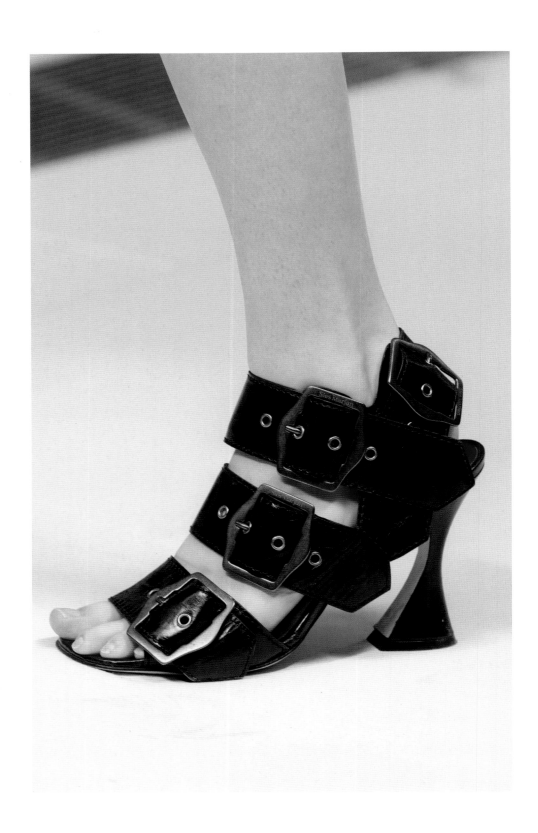

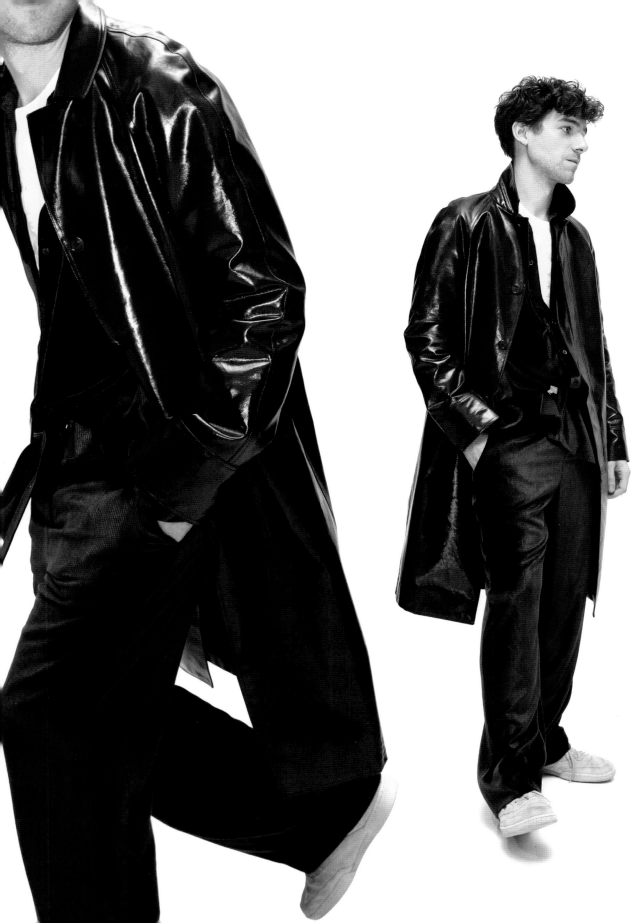

Sies Marjan

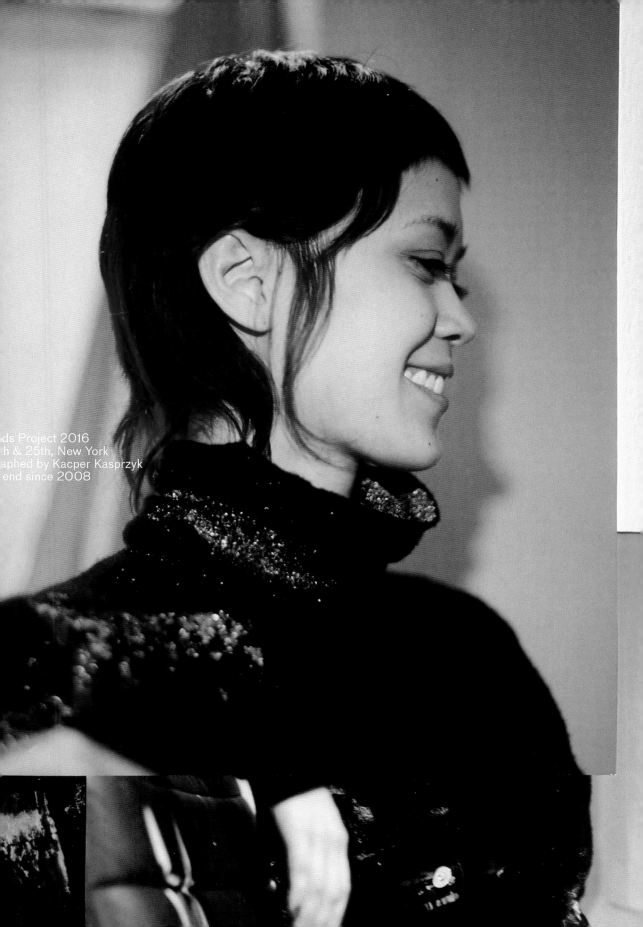

ds Project 2016
h & 25th, New York
aphed by Kacper Kasprzyk
end since 2008

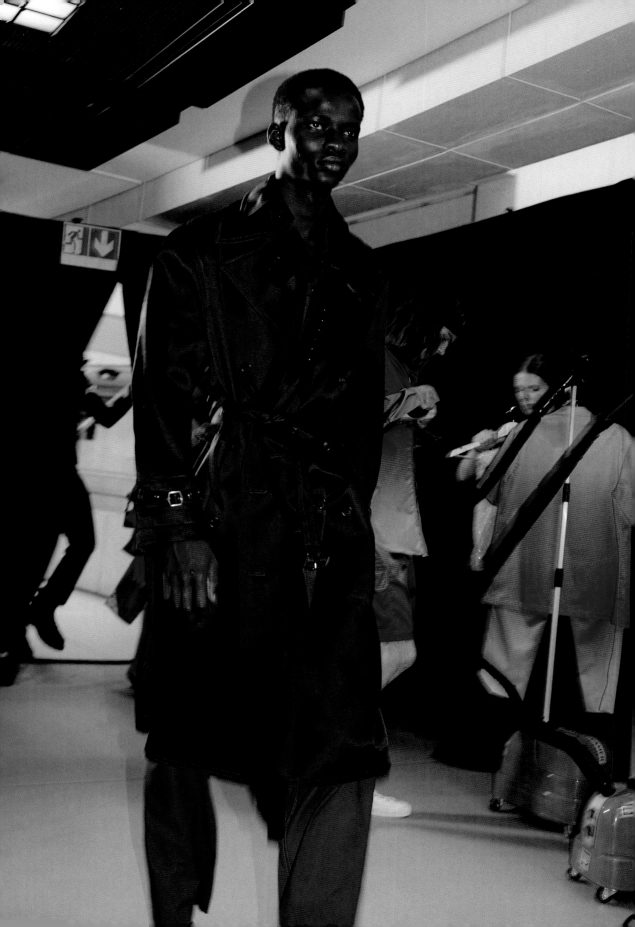

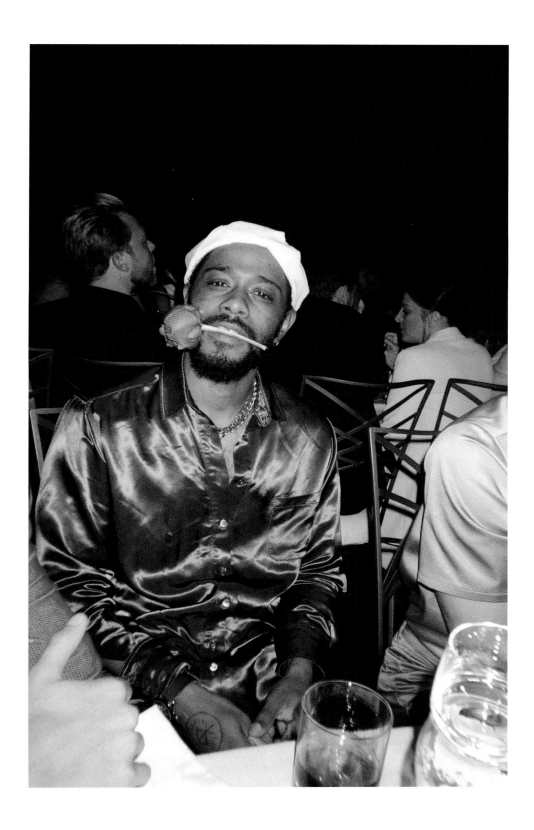

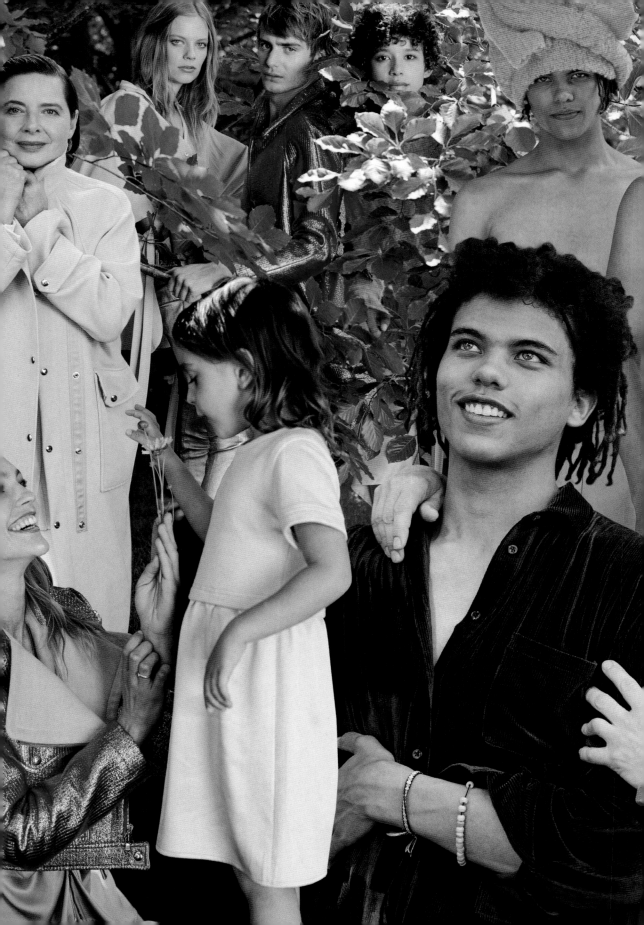

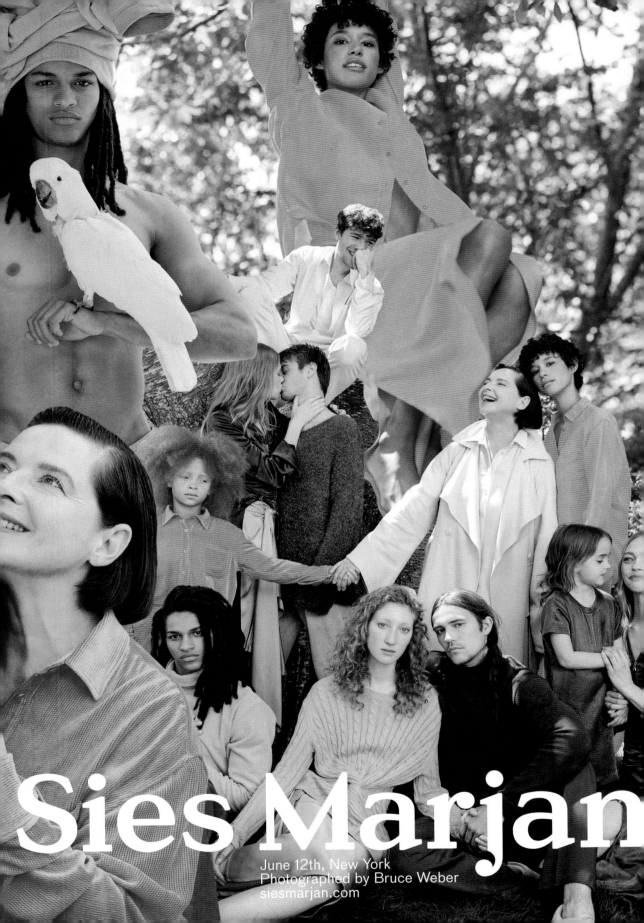

Sies Marjan

June 12th, New York
Photographed by Bruce Weber
siesmarjan.com

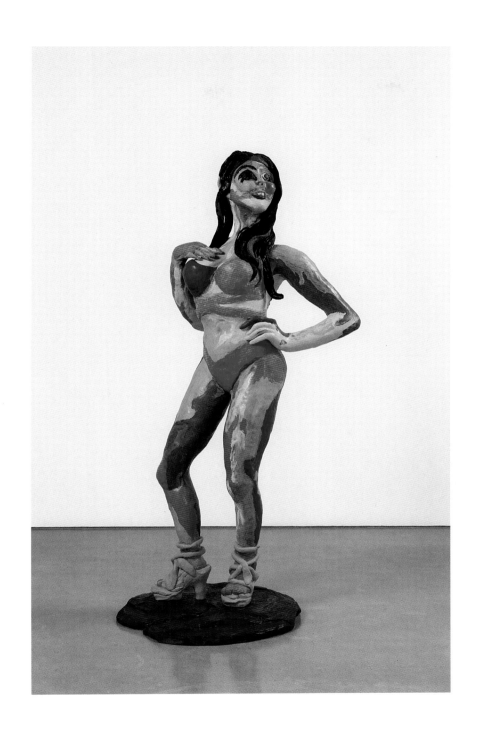

Rachel Feinstein, *Feathers*, 2018.

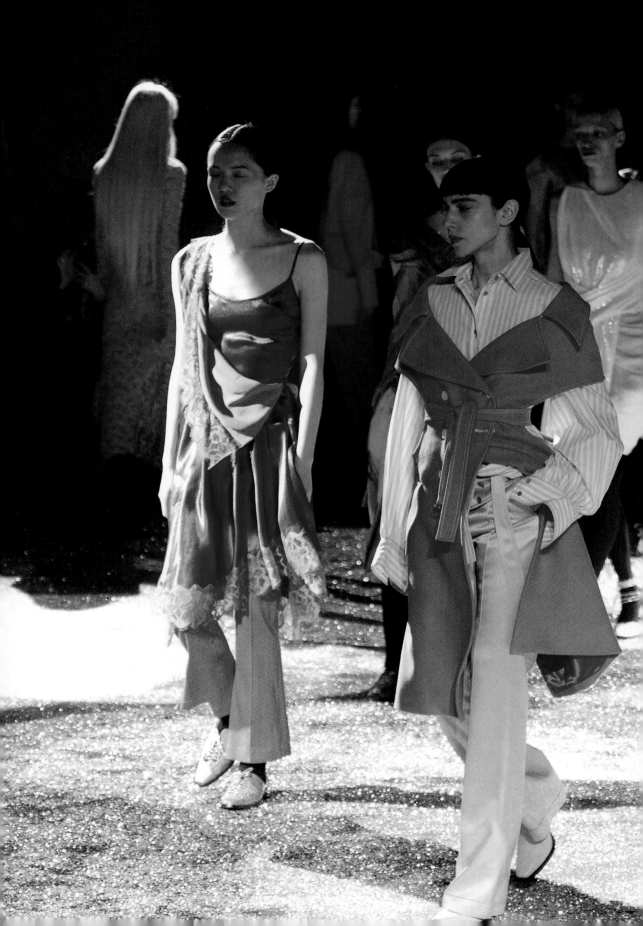

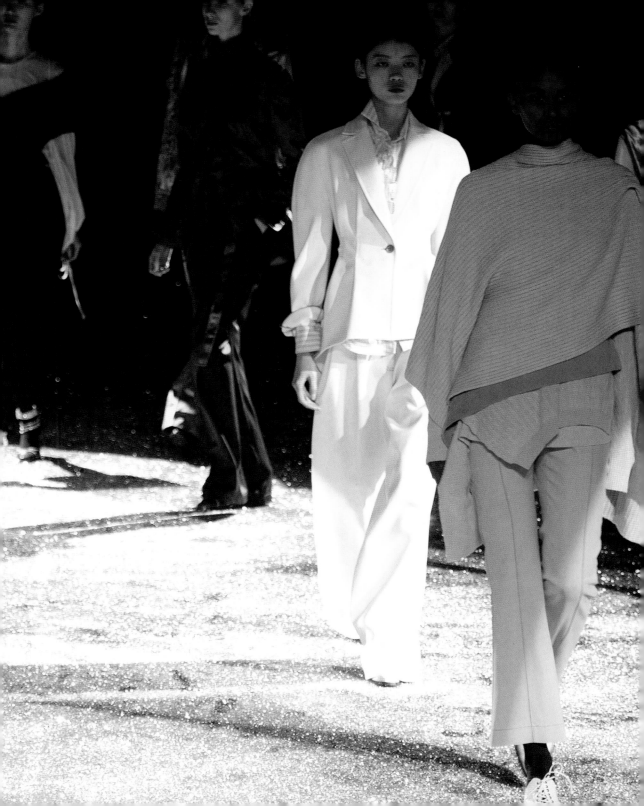

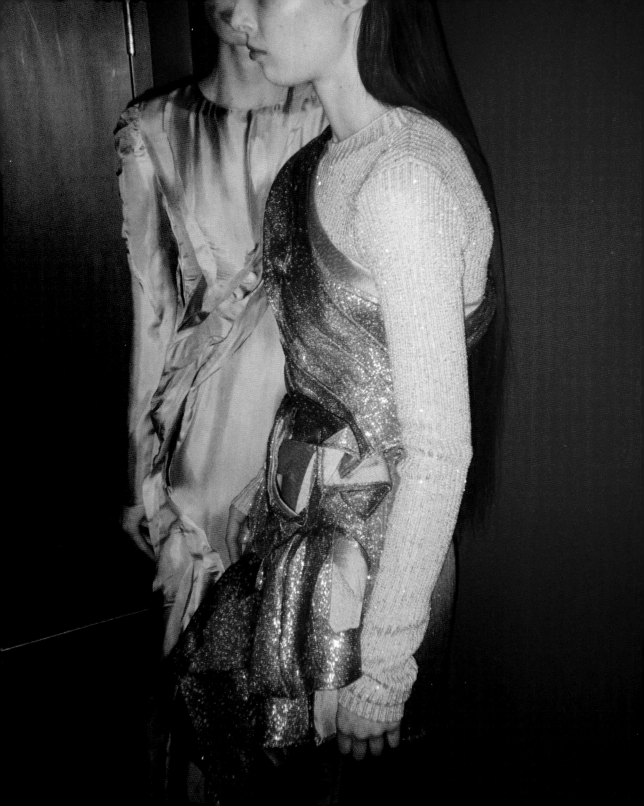

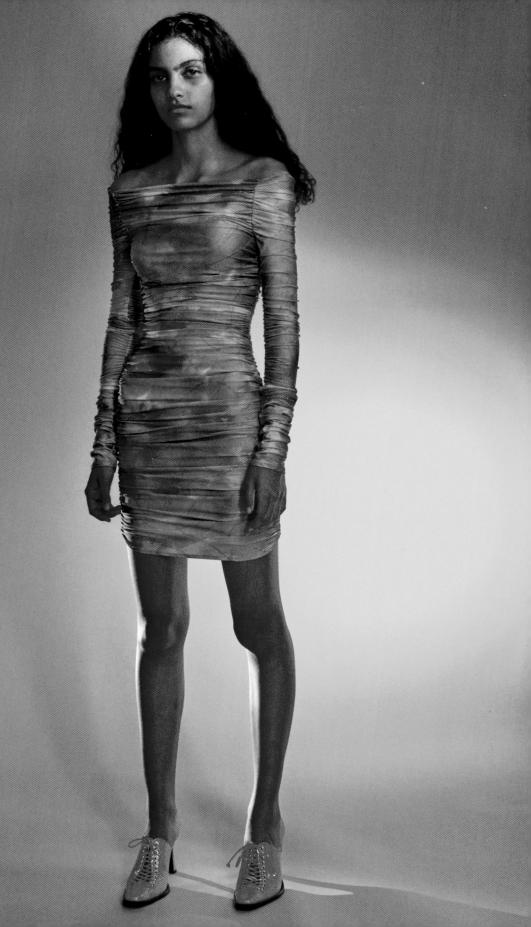

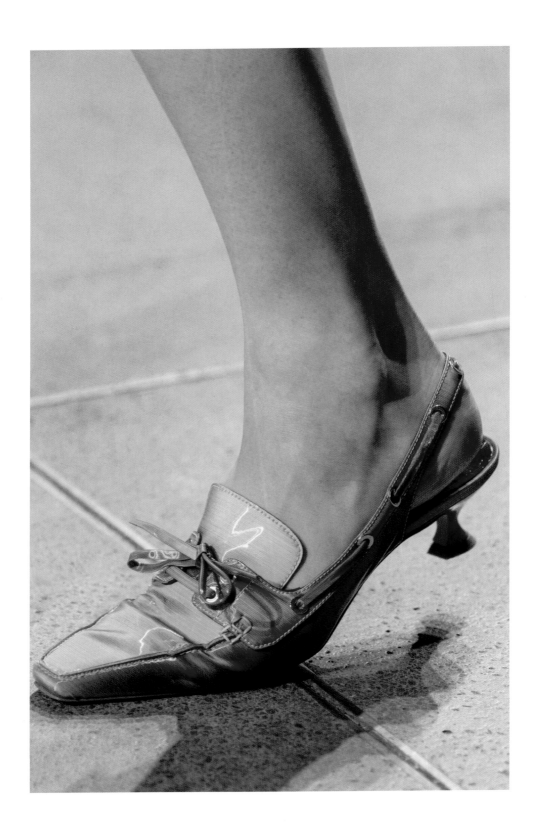

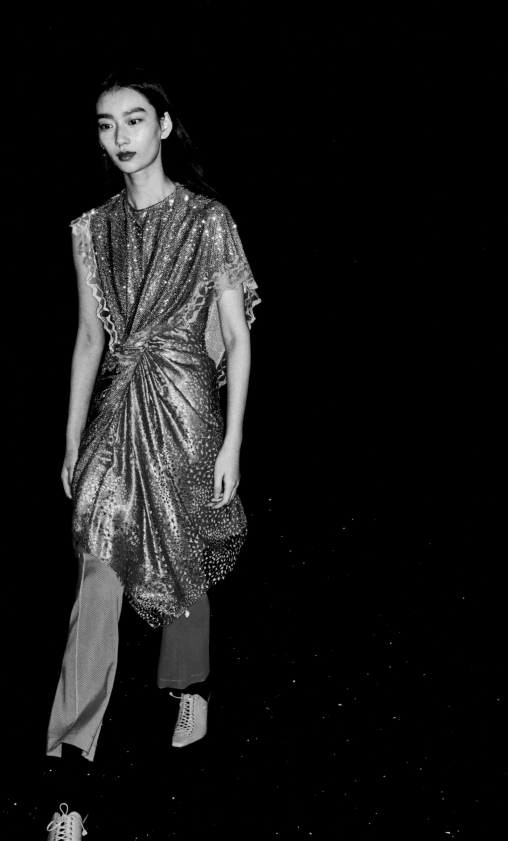

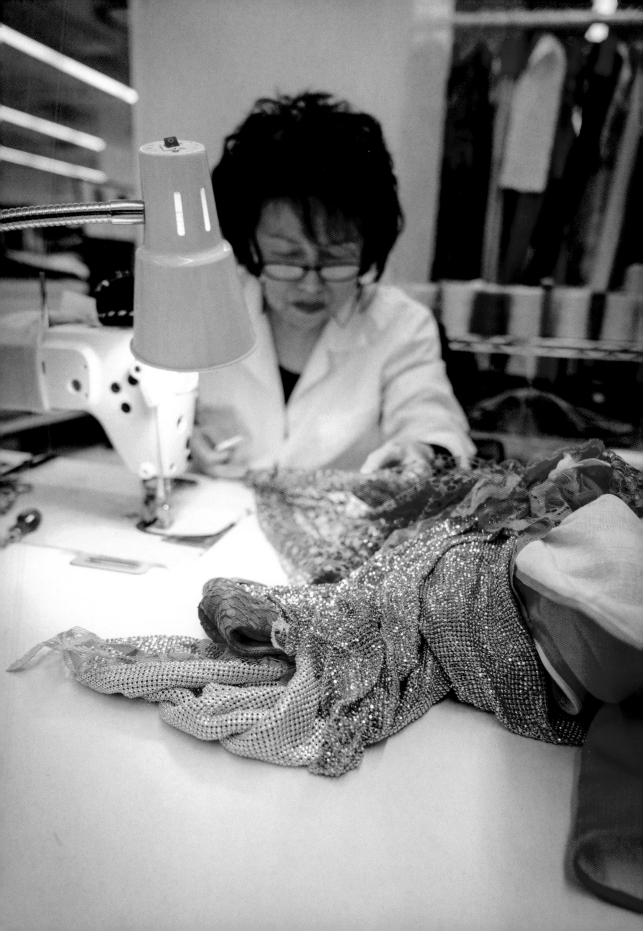

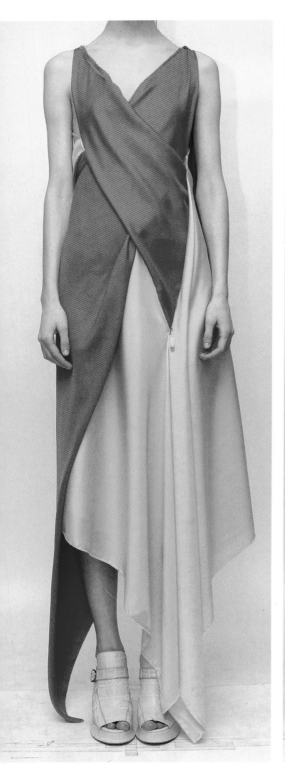
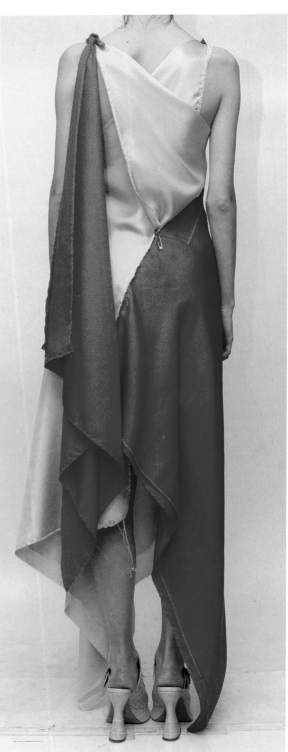

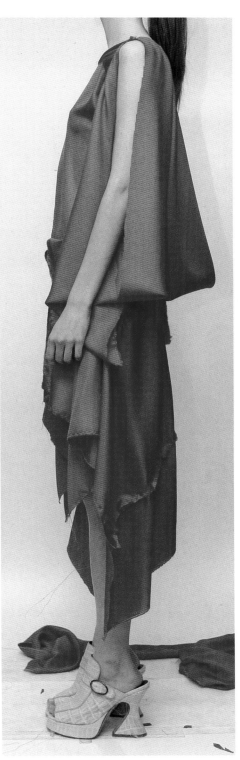
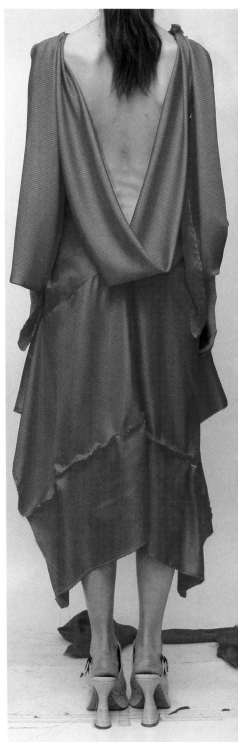

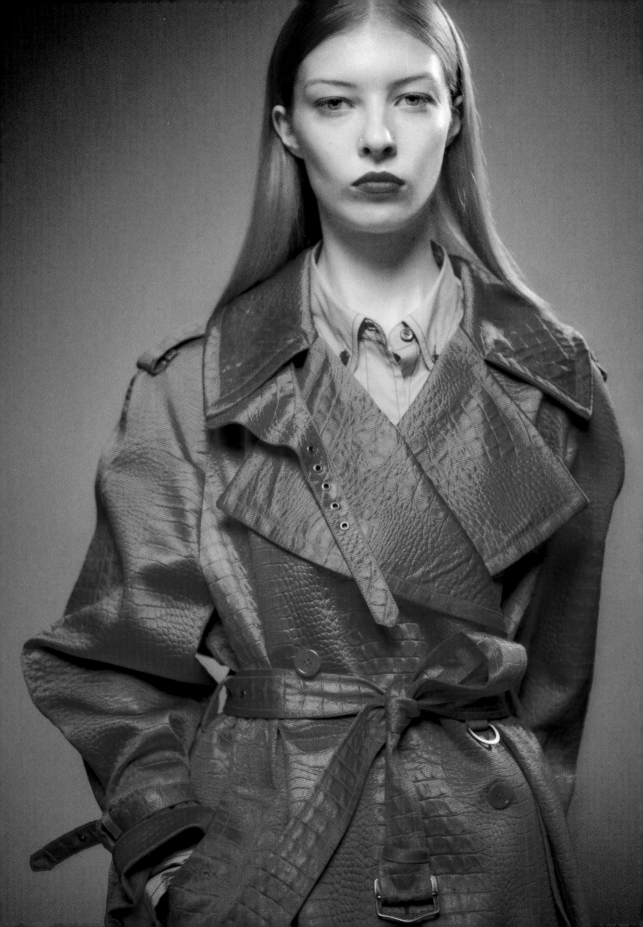

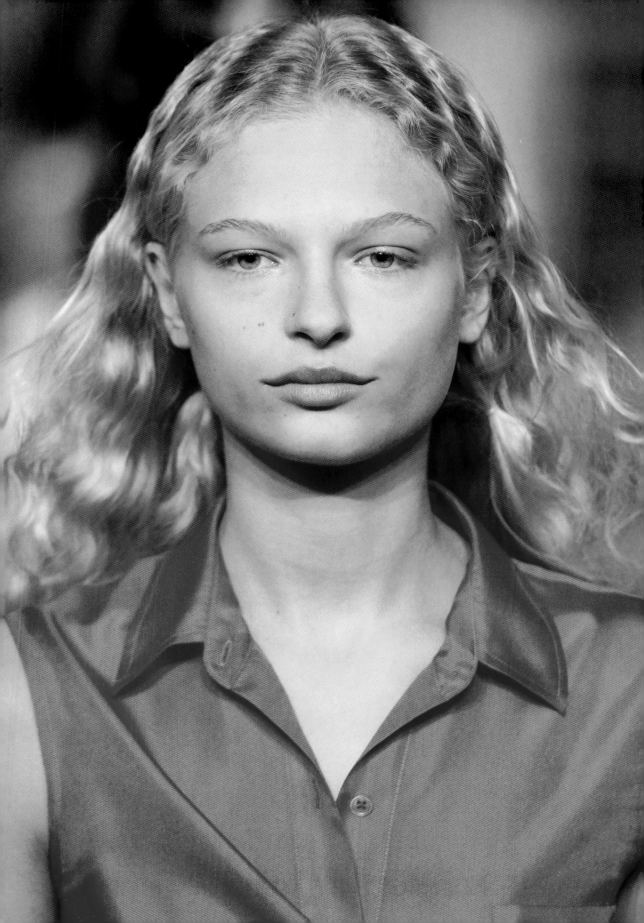

Conversations about color with...

Part 1: Architect Rem Koolhaas, painter Julie Mehretu, and bookmaker Irma Boom.

Rem Koolhaas

Remment Lucas Koolhaas is an architect, architectural theorist, and urbanist. He is Professor in Practice of Architecture and Urban Design at the Graduate School of Design at Harvard University. Rem and I met when collaborating on the Fall/Winter 2020 collection based on his exhibition *Countryside, the Future*, at the Guggenheim Museum.

Sander Lak: Do you have any specific color memories of your childhood?
Rem Koolhaas: Gray in the first part, after the war. And then a lot more color in Indonesia. Yet the crucial color in Indonesia for me was brown: the landscape, the ground. And then there was, of course, a lot of green. Dark green tea plantations or mountains without any kind of color other than green. So, it's a bit of a monotone, but then there are flashes of incredible color based on these varieties of batik everywhere. Blue seems to be absent too, for some reason, although there were just the most beautiful indigo colors. And then I go back to Holland, and it becomes about the colors of the modern '60s. Antonioni, Fellini, and a lot of American sugar-coated popular culture colors, like pastels but in a more authentic spectrum of materials.
SL: When does color come into play in the process of your work?
RK: Well, I have been practicing architecture since the '80s and our work was being influenced by modernism and it

took us about ten years to disconnect from that. Modernism has a particular color palette and uses color in a kind of important way. So, this was the time I was choosing to make this wall red, with that column in blue or green. We also used black and gold in crucial ways, always painted. This was also because we did not have a lot of money to actually invest in materials and paint was the only thing available to us to give some "effects." Then, in the '90s, I became more independent of modernism and also lost some interest in paint because we were starting to use real materials. So then it became more important to think about what the effect is of combining authentic materials in a particular building, relying in the first place on the aesthetic of the materials instead of color. Although we did use green and purple as simulations of nature in the Central Library in Seattle.

Fondazione Prada in Milan is a good example of trying to not work with explicit color but instead showing the color through materials. So the gold comes from real gold leaf, the white is white concrete, and the gray is a particular kind of aluminum. We also used a lot of the actual colors of the primers on materials. I was kind of fascinated by how beautiful the primer was. Many times we tried to use the orange shade of primer or the stone red of primer. So my color use shifted to materials. Even though my use of explicit colors has been reduced, the overall spectrum remains, of course, extremely important

to assert itself in a certain mood or quality or level of security.

SL: In your opinion, how has our relationship to color changed over time?

RK: I would say that in the last ten to fifteen years, the tolerance of explicit colors has been drastically reduced. Explicit color being a red, blue, green, and colors of a certain intensity. if you look at car magazines and car commercials in the '50s, '60s, '70s, they all are very colorful. But if you look around today, you see that the vast majority of cars are white or black. There are a few attempts, usually connected to small cars, to reintroduce color. But by far the large majority of cars are colorless. And if you look at anything to do with sustainability, you will see that there is seemingly a resistance to explicit color. For example in interiors, architecture, and in advertisement, everything is basically reduced to a green-ish, natural kind of color palette rather than the chemical colors. In 2014 I was the director of the Biennale in Venice. Internally we tried to connect a number of things that we were observing. One of the things we observed was the security regulations in architecture getting more and more intense. For instance, height requirements in railings used to be 75 centimeters, then it became 100 centimeters and then 110, and now it's 120 already. So here you see a very systematic elimination of risk. You can also see that the more affluence there is, the more aversion of risk and challenge.

There was a progressive notion that life was about equality, fraternity and freedom (from the French Revolution's "Liberté, Egalité, Fraternité"), and that has now become "comfort, security, and sustainability." In this I believe

the aversion of color can be explained, because color represents a risk and challenge. You have to be daring to handle certain colors.

Maybe it also has to do with globalization. For instance, if you take Finland in the '60s and you look at Marimekko, it's very colorful, very cheerful, very explicit and fun. Then imagine the import of Marimekko in China or Dubai of the 2010s—it has a totally different effect. So, the aversion to color is probably also connected to the fact that cultures went beyond their own base and that some kind of exchange or import became more important rather than the extension of the culture's own sense of color—and that has led to a kind of reduction.

You know, even if I'm pessimistic, I've always noticed that at some point a certain mentality is replaced by another so, yes, I am sure this too will change. Our own work has also definitely changed. Partly because of our work in different contexts, we learned to appreciate different color sensibilities, and particularly working in the Arab world. Initially having an incredible, almost contempt for beige, I became a lover of different colors of beige because when you are in the desert, you see the incredible range and subtlety of earth colors.

SL: I want to talk a little bit about color and space. Do you see color without form or form without color?

RK: Form without color never!

SL: In your work, do you have some examples of specific human behaviors caused by a color in a space or a room?

RK: Yes, I have. A good example is the windows of Chartres, the cathedral in France. It's very clear that the colors in there have an incredible impact on people. And I have seen it in terms of

neon lights, or electronic lights, where your immersive environment is entirely defined by artificial colors. Color, of course, is deeply connected to light.

What is also happening in the last twenty years or so is that the digital colors have become more intense and, in parallel, the colors of our actual environment are becoming more neutral. The fact that digital color and any kind of digital rendering is presented on a screen means that you look at those colors, whatever they are—even black, white and grays—with light behind them. That in itself gives an added intensity or attraction. Reality is by definition flat in comparison to the experience of seeing colors on a screen. There is an almost disappointing dimension to reality.

SL: Do you notice color as much in the real world as you do when you are working on a project?

RK: Yes, if not more! I'm incredibly invested in the real world. It really never ends in terms of interrogating it and trying to understand it and capturing new things—even seemingly familiar things.

SL: Do you use color to manipulate dimensions?

RK: No, I use materials. So, for instance, the Qatar National Library in Doha is mostly white with the color of aluminum. Everything is contemporary, with modern materials. Then there is the ancient part of the library with ancient books and manuscripts, where we were able to import this extremely colorful ancient marble from Iran covering the floors, walls, and shelves. So again, it's the material that provides the color, and it has nothing to do with manipulation…. Maybe to some extent it's a semi-metaphorical manipulation.

SL: Maybe I thought you would use color to manipulate because that's what I do as a fashion designer. The color and the material is what you manipulate shape with, in a way.

RK: That is the interesting thing about fashion: you get the opportunity maybe not so much to manipulate, but to experiment and change. So, you have a red trouser and then next year a green trouser and obviously they have a totally different effect. In architecture, you always make a single prototype that you never repeat, so it's a weird form of experimentation because it doesn't allow you to ever use the conclusions in the next iteration like you can in fashion.

SL: Whose use of color do you respect, in any medium?

RK: I'm extremely impressed by color in the Renaissance. Maybe it is because a lot of Renaissance art has been cleaned up in my lifetime, so everything that was once kind of grayish is now completely garish in terms of colors. You can see that clearly in the Sistine Chapel or in the work of El Greco.

I am a total Yves Klein fan, even though his palette is very limited. His use of color is amazing partly because of the extreme limitations, but also because of the combination of texture and color. I have always been impressed by the use and meaning of color in the films of Antonioni, in films of Godard and the films of David Lynch. Obviously also Almodóvar—I think he is constantly discovering new rules for color.

I have an incredible respect for the color use of Prada. And respect is not the only word—simply affinity. Making the kind of difficult combinations and using the eloquence of supposedly wrong colors.

I also think that popular culture is fantastic for color, and graphic novels is a domain that is constantly changing and inventive, which is really exciting! I also really liked your color sense. I think you showed in a compelling way how relevant color can be even in a period that is not particularly open to color.

Julie Mehretu

Julie Mehretu is a contemporary visual artist, best known for her large, multi-layered abstracted landscapes. Her work depicts the cumulative effects of urban sociopolitical changes. Julie and I met in 2018, when we dressed her for the New Museum Spring Gala where she was being honored that year.

Sander Lak: When you are working, do you see color without form or form without color?

Julie Mehretu: Yes, I see color without form *and* I see form without color. For a long time, it was very difficult for me to work with color, I think that it was because when I was younger, it was easy. I made colorful paintings—very intuitive. And then the more that I started to try to figure out what I wanted to do— and we're in this process of constantly trying to figure out who we are and what we're doing—working in color for me became more complicated.

But eventually, I think the way that I came back around to color after I left it for so long, was through the photographs I was using. A lot of the photographs that I'm using show specific events and those events have a very particular palette to them,

depending on what that event is. So that has been really formative. And looking at those different palettes in comparison to one another has also been interesting because they're often very different, like a very violent muted palette to a very fuchsia-and-pink protest image like some of the images that I play with. Or you look at the migrant caravan images that I had, and the images of these different border conflicts and you'll see [that in] these migrant camps, the colors of what everyone is wearing tends to be this kind of mixed palette based on fabrics and clothing. And then the landscapes of course. But funny that you mentioned that I have a good use of color because it really comes from, well, the images themselves.

SL: Yes, but I think you're also being extremely humble because picking certain colors from all the different shades within the pictures requires a selection process. So, there's something specific and intuitive that you do that creates the color card or scheme of the final work. For example, the two works of yours in this book could have ended up in a lot of different variations based on the original source images they have started from, but they ended up the way they did. Is there anything in this selecting process that you are conscious of? Or is it purely intuitive?

JM: I feel like the reason that these photos become interesting is because there's a hauntingness to them, right? And you can still see the color and see the light through what emerges from the blur. There's a haunting sense of what's happening and in the direction of what it's pointing to. The words that came to my mind looking at the two works in this book are the colors of alert

and a sense of possibility! They're not just colors of hazard.

SL: No, they're not. There is such a beauty to it as well, especially the use of that orangey pink and the hints of bright green in the *Conjured Parts* piece. There's something quite hopeful in that, too.

JM: Yes, and it's coming out of a tear-gas-and-smoke kind of situation. A moment of this intense uprising and a battle between protesters in the street and the police in Ferguson, which is an extremely militarized force. It's an image taken at night and the color in that case did not necessarily come from the image because I made it a black-and-white image that I then put those colors into. But there is that sense of optimism or possibility. But there's also this kind of haunting, weird halogen glare. Like, the sublime, the desire of something and the kind of possibility that is embedded in it. But there's also embedded in it a form of terror, a form of fear, a form of subconscious, or whatever you want to call it.

SL: Your work sometimes gives me the same response as I get from Turner. For me, it's about the use and application of color. Are there any painters or artists whose color use you love specifically?

JM: Yes, it's so interesting you brought this up because I wrote this small text on Frank Bowling and I mean, I can imagine your work and his work together! He's also a great intuitive colorist.

I was trying to understand something in his paintings that keeps moving me. And it's a sense of emanating light. And I think that's what you also pick up with Turner. Even in the painting of the slaves being thrown overboard, there's this eminence of light. And so, it's color that plays with light or radiance,

and there's something that happens in that glow, or the afterglow, and that's why I mentioned halogen light, where you get these different senses of atmosphere or space or possibility because of that aspect. And, of course, there are others who worked with this, such as Caravaggio or Rembrandt. I think that's what's so moving about Rembrandt portraits. When you get up close, the abstraction—what happens to color on the palette.

What's also interesting about color is how much it is a culturally commodified issue. Even though it's kind of a fundamental aspect of culture and who we are! I went to Dunhuang, in China, and I saw these third- and fourth-century cave paintings and you'll see the kind of lapis lazuli that was used for the blues. I've also been to the ochre mines in Australia, where they used to mine the ochre for body painting, and it's incredible the kind of rich reds and yellows that come right out of the ground! And yet color is this thing that is so specific, right? If I were to say, you know, the modernist yellow. We know what that is; you have a sense of that. But then when you live it, when you've lived as we've lived in other cultures and other places, color is ubiquitous. In Dakar, for example, it's constant! You can't walk down the street and not have color. It is part of the daily experience. It's the entire plethora of color you see constantly there. I think it's really interesting that we live in a way where a lot of that is controlled. Even in the way the kids dress and go to school, you think there would be this kind of immense vibrancy and exuberant way to dress kids but generally, the palettes are pretty subdued.

Irma Boom

Irma Boom is a graphic designer, specializing in bookmaking. Described as the "queen of books," she has created more than 300 of them, and is celebrated for her artistic autonomy. I met Irma through Rem Koolhaas when she was working on the *Countryside, the Future* catalog in 2019.

Sander Lak: Can you talk about color in your work?

Irma Boom: In 1987 I made a book for the annual report for the Arts Council (Raad voor de Kunsten) using only yellow, red, and blue—or yellow, magenta, cyan, in printing terms. Everything I did was based on these three colors. It was the first book I've made where color played a crucial role—the whole concept was color! All the text was built up from the colors yellow, red, and blue. For example, the headings were in green, which is, of course, yellow and blue. Even the divisions between the topics of the report were divided by the several color combinations that can be made with yellow, red, and blue. And this was all done without the use of computers. It's a very conceptual piece. If I look back on my whole career, which is almost four hundred books now, I think that specific annual report is one of my favorite projects.

SL: Can you tell me more about book-making before the use of computers?

IB: What I really liked about the B.C. (Before Computer) books is that it's all about the concept. And, of course, it still is, but back then it was much stronger because you only had your table and a piece of paper and some pens and that was it. And if you wanted to research something, you would have to go to a library—everything was slower. Now it's super-fast, I'm always working on fifteen books at the same time and [with] all these deadlines, everything is faster! So, for me, I'm happy that I'm a designer who knows what it was like before the computer arrived in every office. Both have advantages.

SL: Every project is different, but can you tell something about when color comes into play, when you work on a new book or project?

IB: Color can be autonomous, or it can be a navigation, the organization or the subject of the book. I like to use color together with a concept, an idea. I made two books where color is the subject. One based on art, and one based on nature. In 2004, I made a book based on five centuries of art. From eighty art pieces I made color DNAs by picking one color that represented each art piece. This color was a special mix made especially for this book. The pages have vertical perforation so that you could deconstruct the book easily. The text in the book contained all the book titles from the Faber Birren collection at Yale University. For the *Color, Based on Nature* book I did the same. Eighty UNESCO World Heritage sites were the basis of this book.

SL: Those two books are my favorite books about color ever made! Can you tell me about their creation?

IB: At first, I made a color-coded DNA from the highlights of the Rijksmuseum in Amsterdam, including famous paintings like *The Milkmaid* by Vermeer and, of course, *The Night Watch* by Rembrandt. Standing in front of these paintings, I chose six colors to represent them. Many of the paintings I was deconstructing to six colors were very brown; even *The Night Watch* is a very brown painting. But if you look carefully at every single detail you'll see the use of specific yellows, blues,

and greens. To represent a painting in six specific colors you have to know the importance of each color in the painting. It can be one tiny bit, a smudge of a color, placed somewhere that is absolutely crucial for the whole experience of the painting. After studying the paintings at the Rijksmuseum I can never look at a painting without looking at the specific colors; it changed my perception of art. The exhibition of my work at Institut Néerlandais in Paris (*Irma Boom: The Architecture of the Book*, 2013) was organized by color. I realized I don't make many blue books. Red books are very present, and black books, white books, and even yellow books, but some colors don't appear at all. Although I love blue so much, blue is not a very strong color for a book, I think.

SL: What is your process like of choosing a color?

IB: Why is something suddenly better in white or red or blue? It's mostly intuition and instinct for me. I once made a yellow book for a commissioner. This person was a bit aggressive and yellow for me is a very aggressive color, so I could not think of anything other than making a yellow book for this project.

SL: What colors are complicated to print or don't take paper very well? Are there any limitations when it comes to color and printing?

IB: It all depends on with which printer you work! To print a good black is difficult, and printing Yves Klein blue is even more difficult. I go to the press when a book of mine is printed and I always ask for more density because if you use color, then it should be very well printed. For example, a neon orange can be very pale on paper. All neon colors need high density. So, I always ask for

more density, more ink, more ink, and they always say, no, this is the maximum! "The maximum of what? The machine or your eyes?" There's always a discussion with the printer to get more density to really have a strong, truer color, especially orange … pink as well actually.

SL: That's roughly the same experience that I have in dyeing fabrics. Obviously, natural fibers take colors very differently than synthetic fibers and sometimes one is better than the other, depending on the color. But there are certain shades you have to really push the mills. It's like that kind of neon-ish color, when you really go into that brightness, you have to almost push the machine to its limit to give it that little bit extra to get to that perfect shade.

IB: Yes! Indeed, the same. And I also realized that when I push to get the color right it's because the color really has a reason or function for being. I never just choose that orange because I think it's pretty. I want to use it, for example, to navigate or to highlight something specific. I only use colors when it's appropriate, functional even, never just for fun. Color is a concept!

SL: Do you see form without color or color without form?

IB: I think I see color as flat shapes. I see it as a piece of paper I think in [terms of] printing on paper.

SL: Can you talk about the printing process in digital and paper, the time before digital and today?

IB: The printers I personally work with haven't changed a lot in the past thirty years. They don't have the most advanced printing machines. Nowadays printers work with LED drying. This means that whatever paper you are using, whether it's matte or glossy, the ink sits on the surface. And I like printing where the ink goes into

the paper. And it's a much more exciting process of printing, of course, that's why you need all these densities. For me, it's very important where the book is printed. The new models of printers make everything look the same. It's all super quality printing and I don't think that I'm looking for super quality, I want to smell the ink. Sometimes colors are not matching, which I like. The imperfection, the coincidence. With these new machines, it's impossible to have colors not match, it doesn't make these kinds of happy accidents.

SL: Is there a material that is really hard to print color on?

IB: We recently used wrapping paper as cover material. It was almost impossible! This type of paper is super curly; the printer had to de-curl all the sheets beforehand to be able to print on it, and it took ages. We printed a neon orange on it, we needed so much ink to be able to even see the color.… I also once used coffee-filter paper, which is very porous—not made to put in a printing machine! Water and paper are enemies, but coffee-filter paper is strong enough to have water come through without ruining it. A very interesting concept but a complete disaster to get through the press and very hard to get ink on. The printer said it wouldn't work, but I'm very stubborn. So, I said, let's just try it! In the end it had to do with the humidity level in the factory and we made it work somehow. For me, it's these kinds of challenges that makes making books fun! Doing a lot of experimentation.

SL: Is color truly abstract?

IB: When it's a single color, it's abstract. If I see an orange color, then I see the orange in my brain. One color is one color. But a combination of colors is an image! So, for me a combination of colors is never abstract.

SL: Do you see words in black and white?

IB: I see typography as something very black and white. I don't like colored typography. Printing text should be black on white, or tinted paper. It has to do with the content. Typography in color for me becomes something playful and childish even. I almost never do text in color, even if I think of the word "color," I see it in black type, in sans serif.

SL: And if you think of the word *red*, for example, do you see that in black as well?

IB: Yes, I do! What about you?

SL: I see the word *color* in red somehow, or a pinkish red. I don't see it in black. If I think of words in general, I do see them as black. But if I think of the word *purple*, I see that word in *purple*. It's just incredible how many books about color exist. Are there any that come to mind that you really admire?

IB: I have quite a few books on color, but what I mainly like are the 18th- and 19th-century scientific books on color and experimentation with color. They do these experiments with a dot, with another dot in it. Something that Johannes Itten made years later as art, but in these old books they are purely scientific. I also have a book where a professor experiments with text in two colors in order to use paper more efficiently.

SL: Is there anyone's color use you admire?

IB: It's a cliché, but Yves Klein, I really love his use of the specific blue color he uses. This powdery matte blue, which Klein uses thick on the canvas. It is fantastic that you can recognize an artist just by seeing the color. Dutch artist Jan Schoonhoven made many works in white papier-mâché. The works show many shades of white because they are sculptural. Or think of Richard Serra—the rusty brown corten steel.

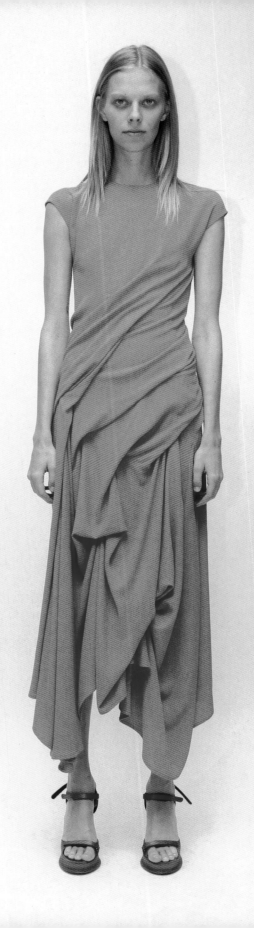

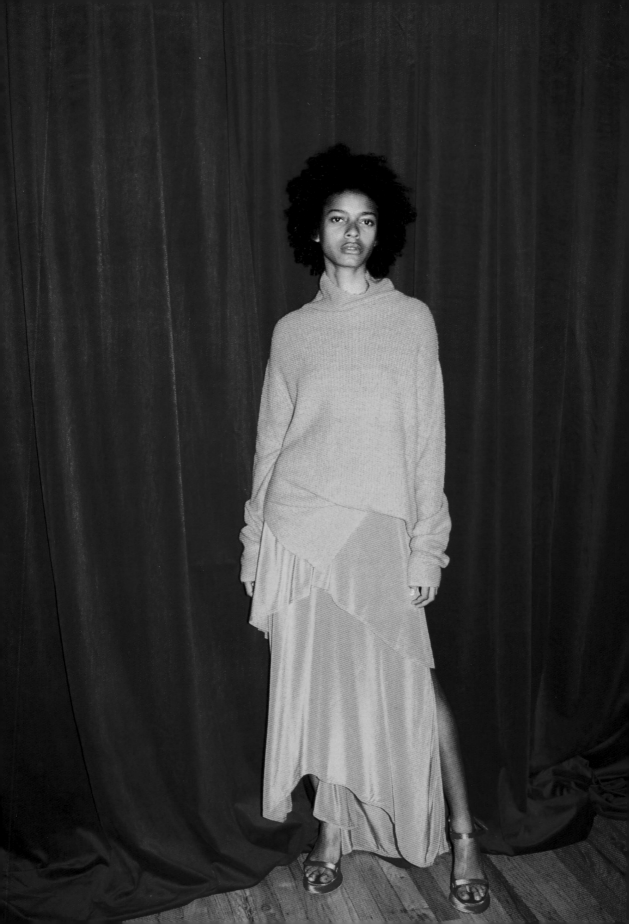

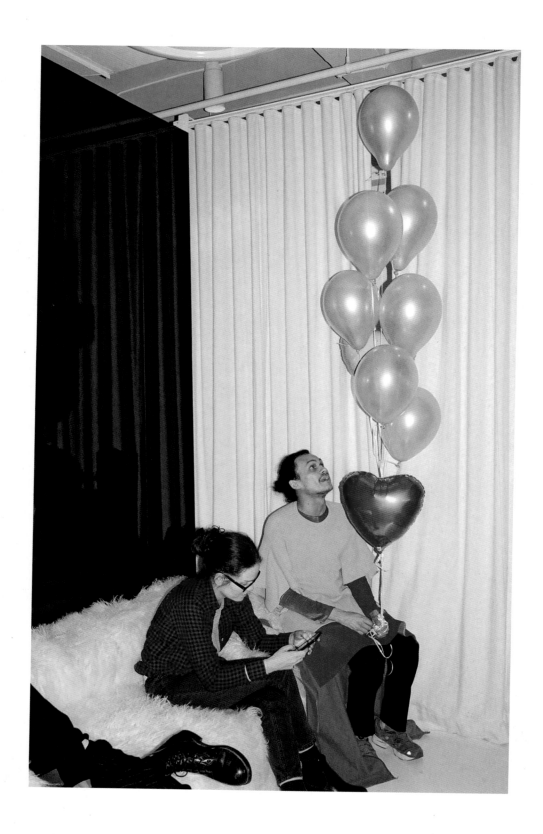

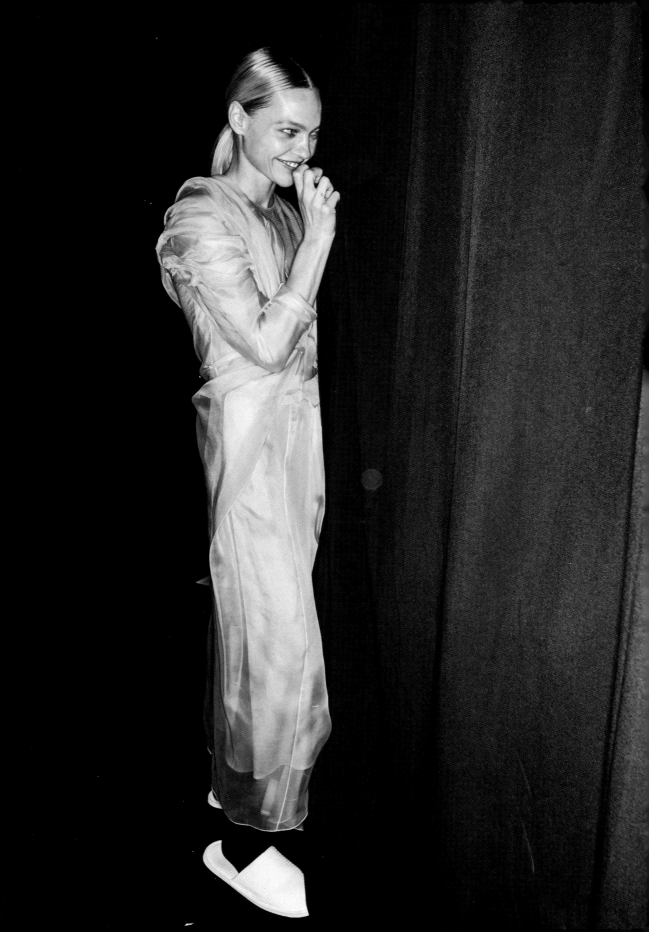

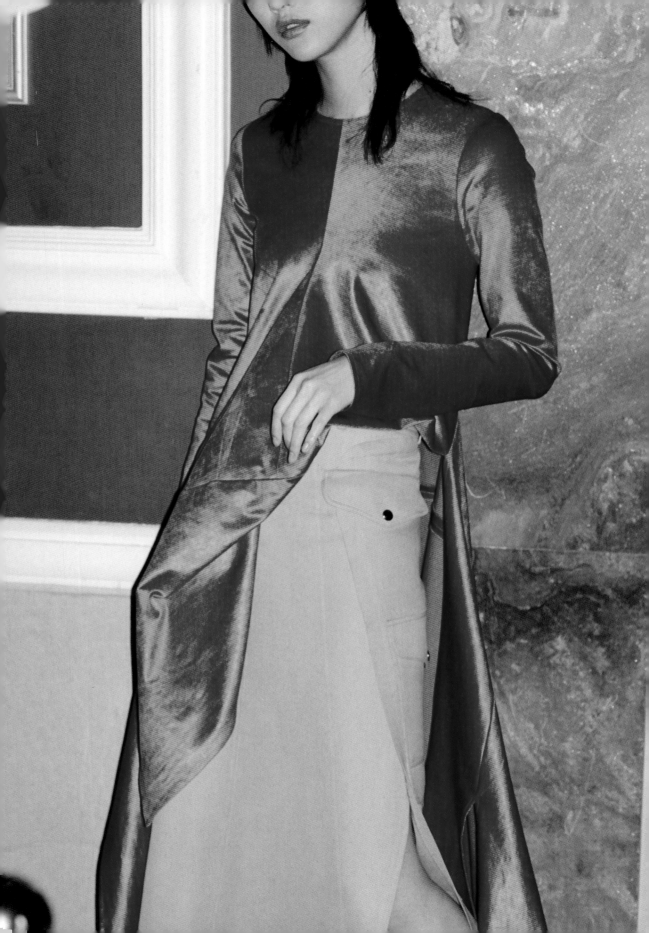

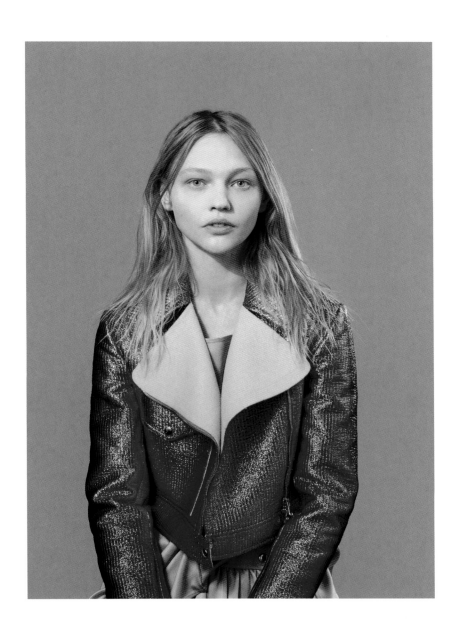

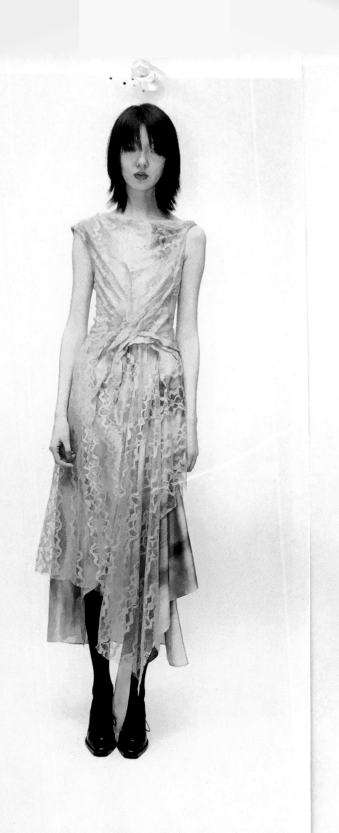
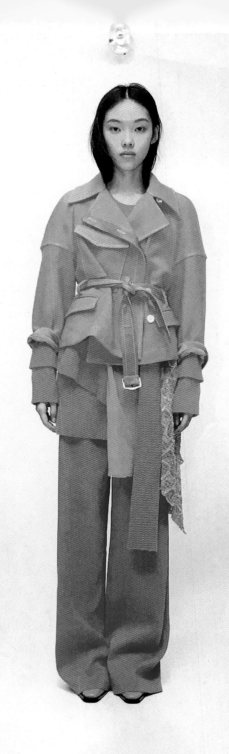

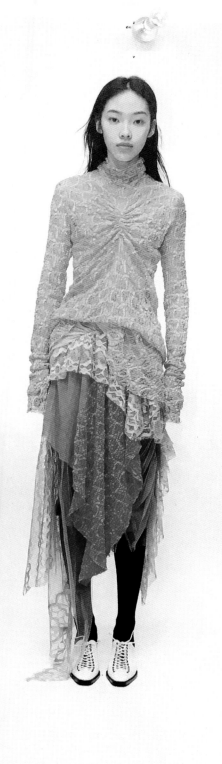
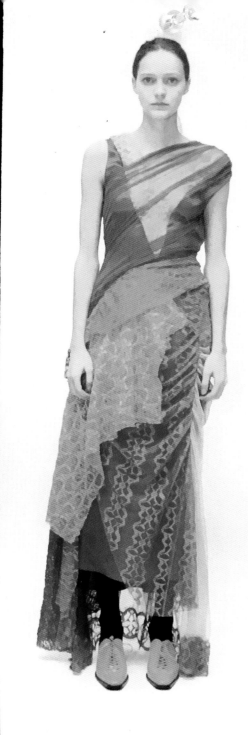

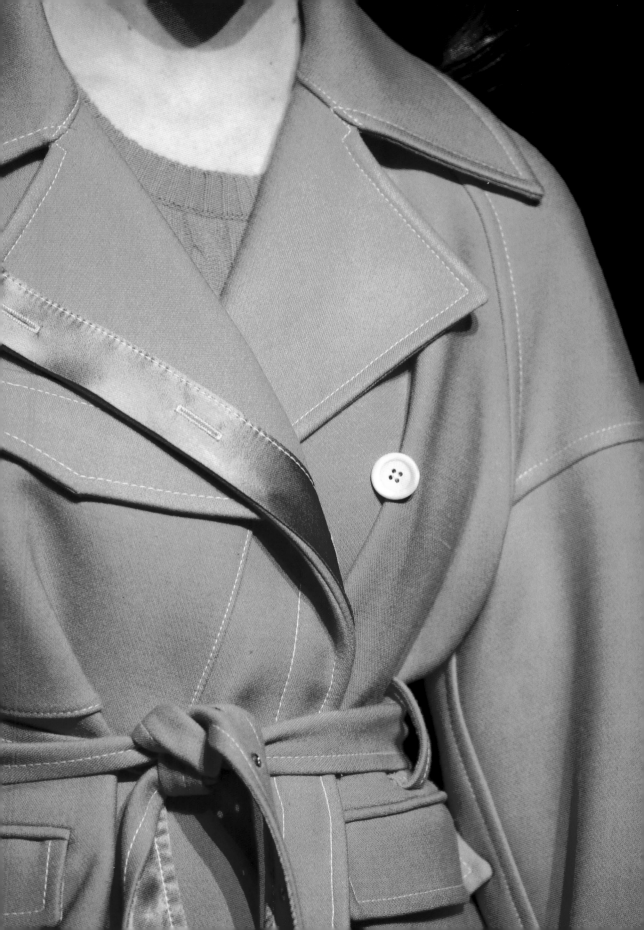

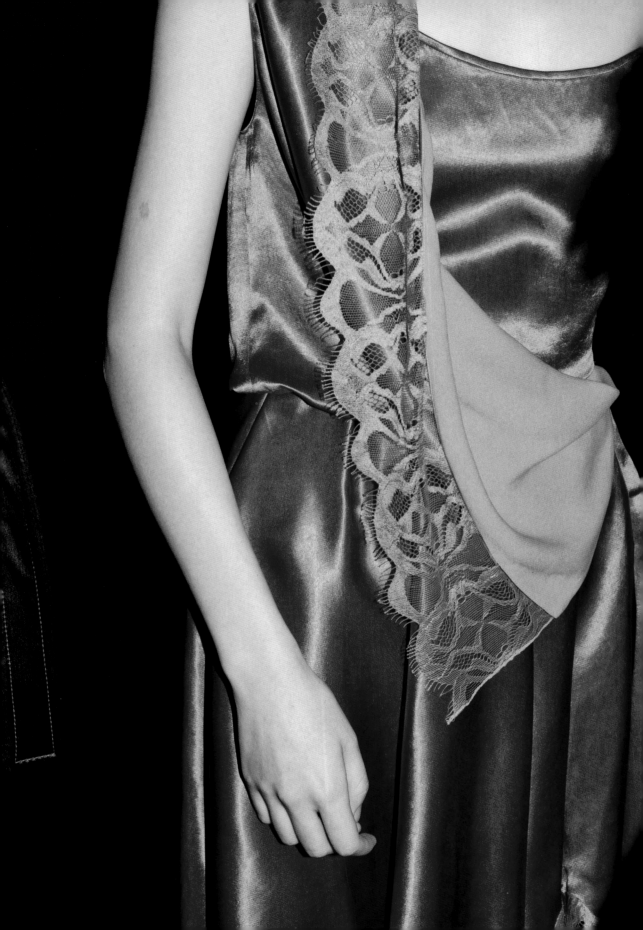

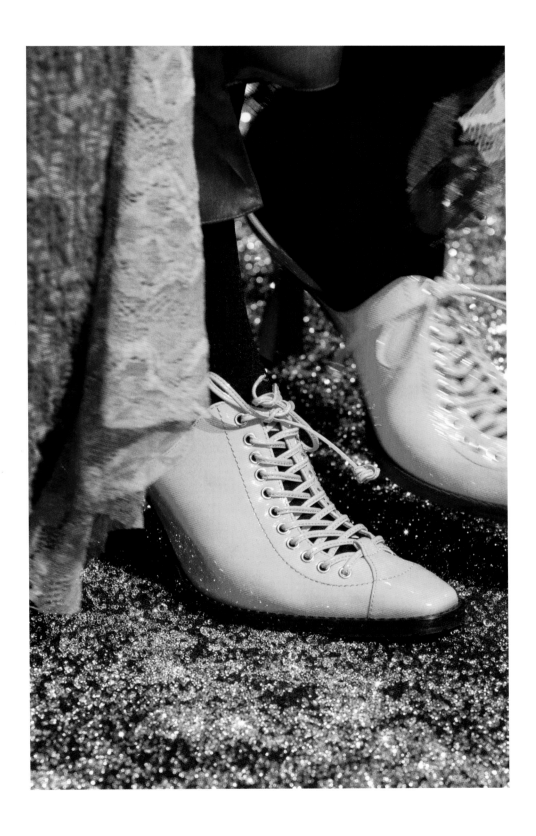

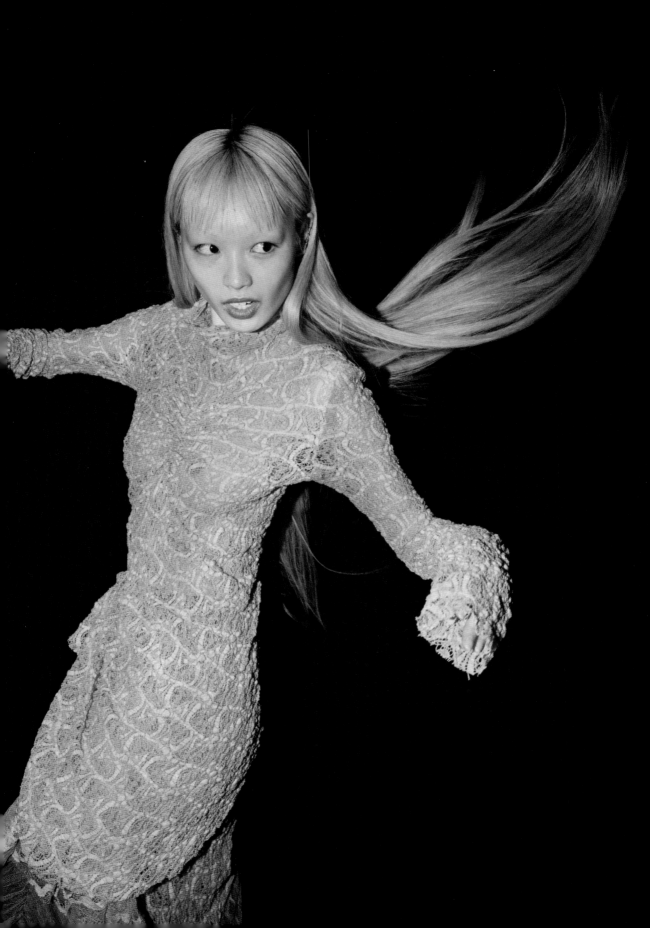

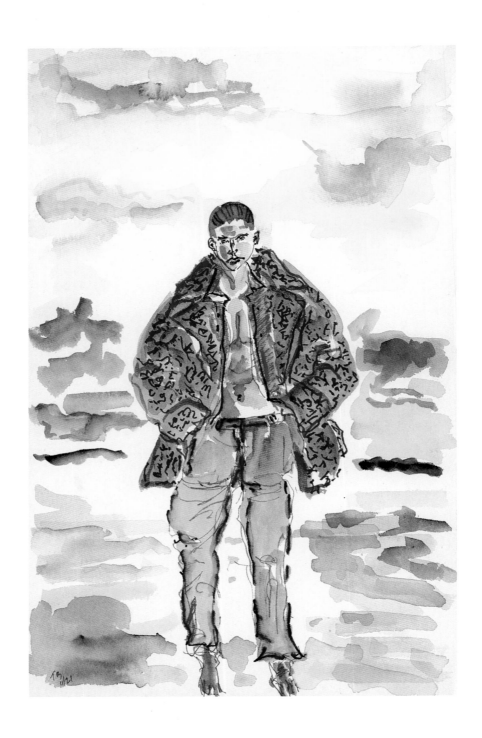

Tina Barney, *Man on Beach in Sies Marjan*, **2021.**

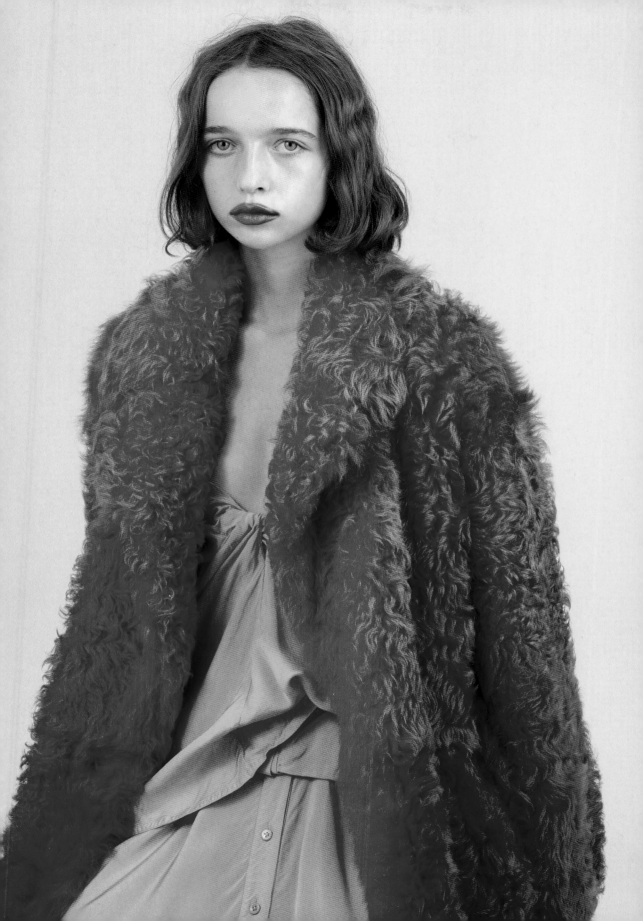

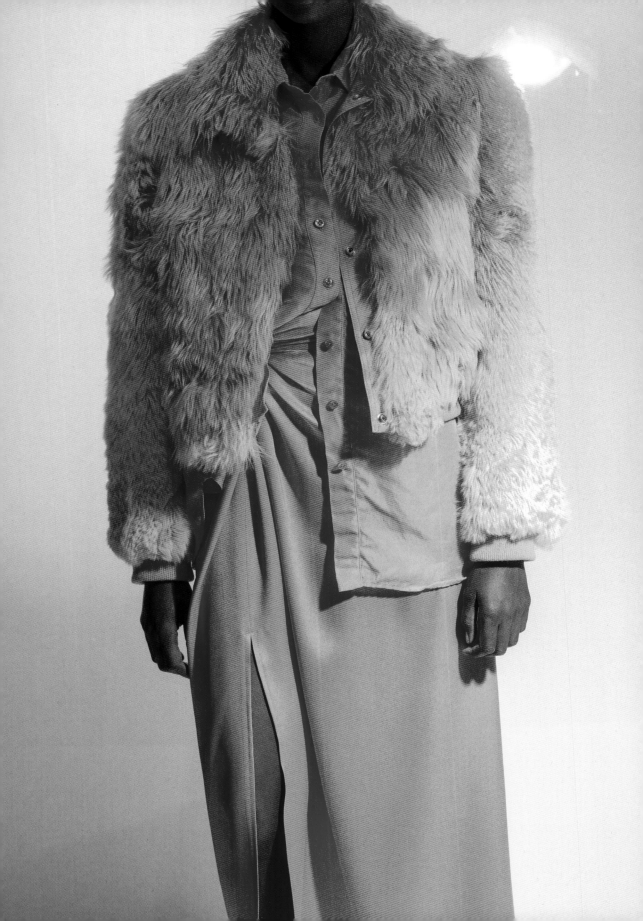

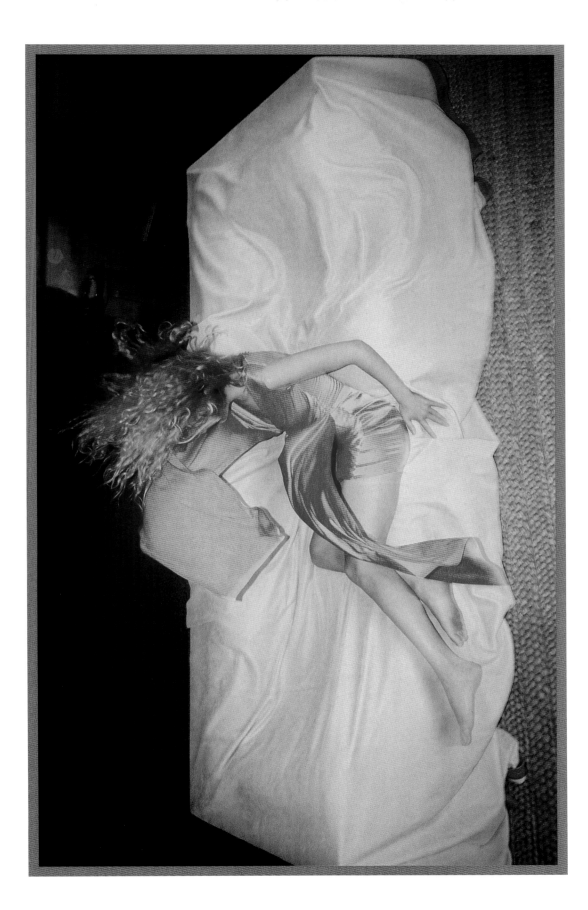

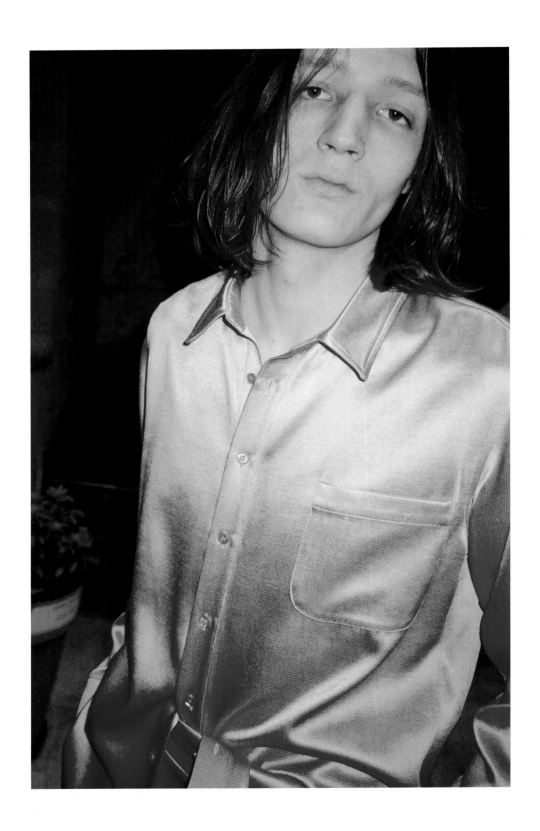

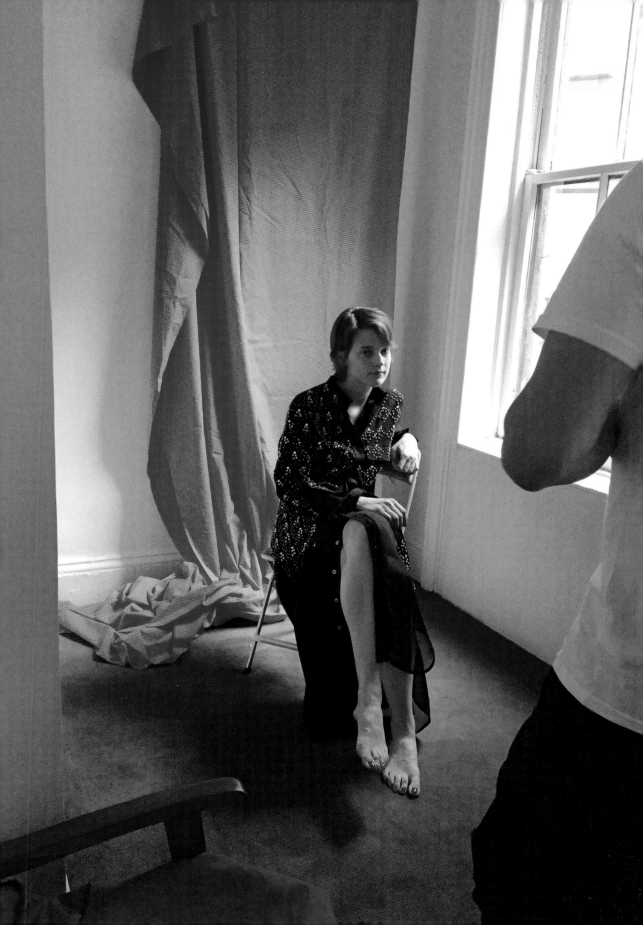

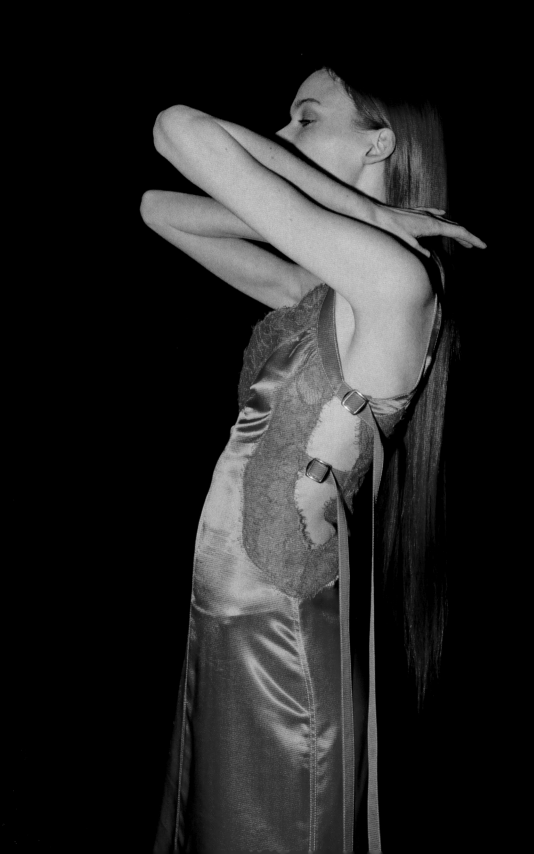

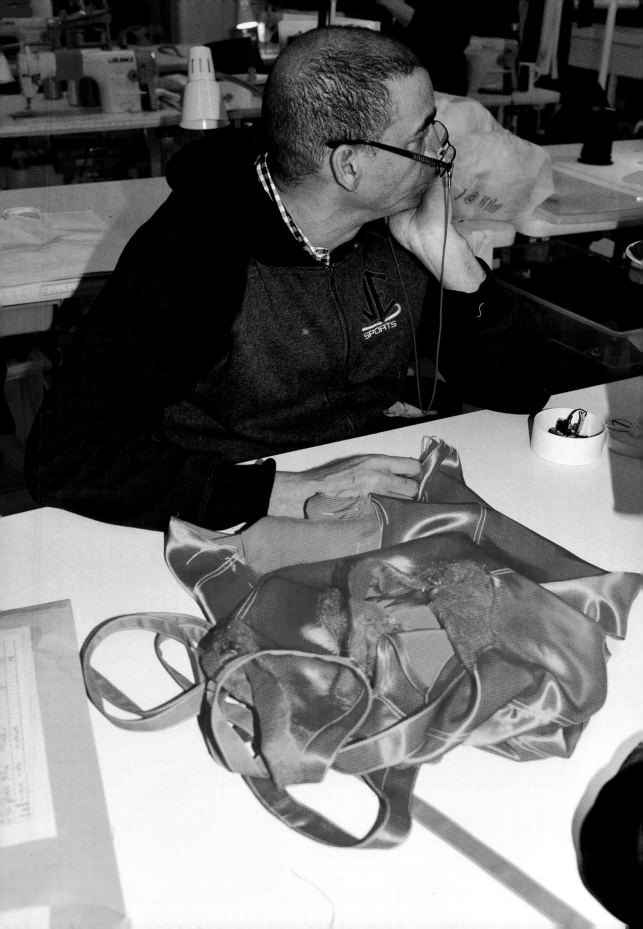

Sies Marjan

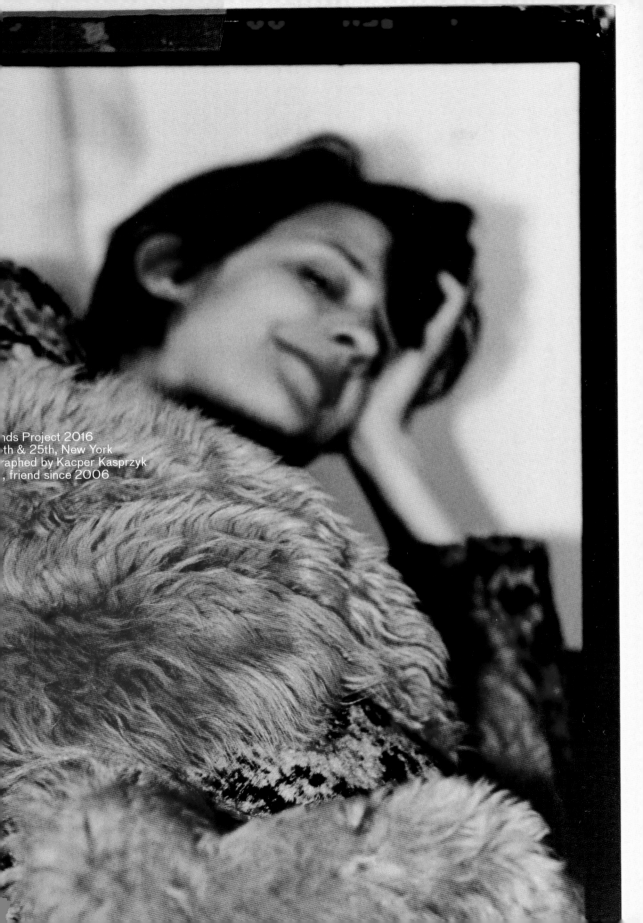

nds Project 2016
th & 25th, New York
raphed by Kacper Kasprzyk
, friend since 2006

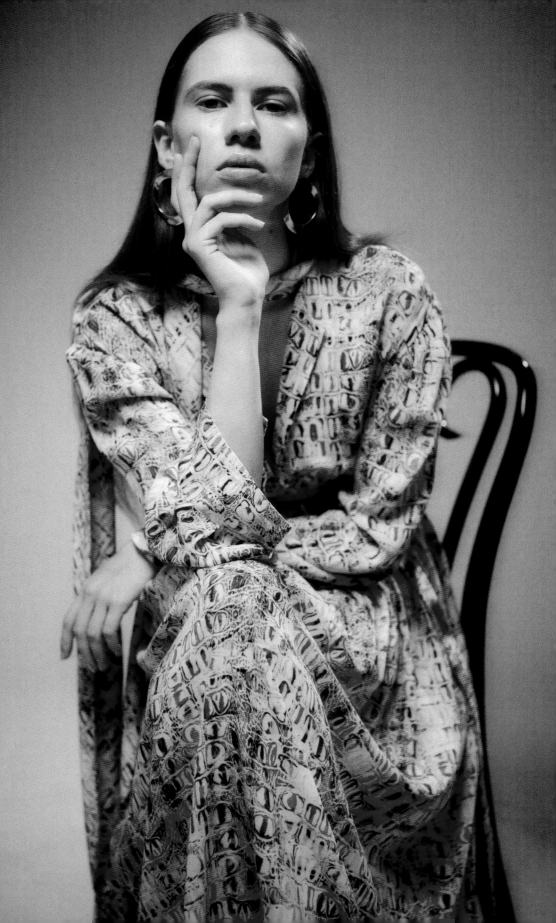

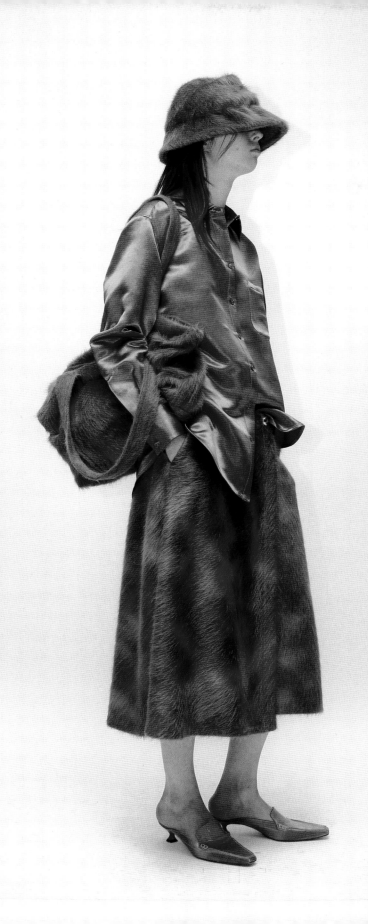

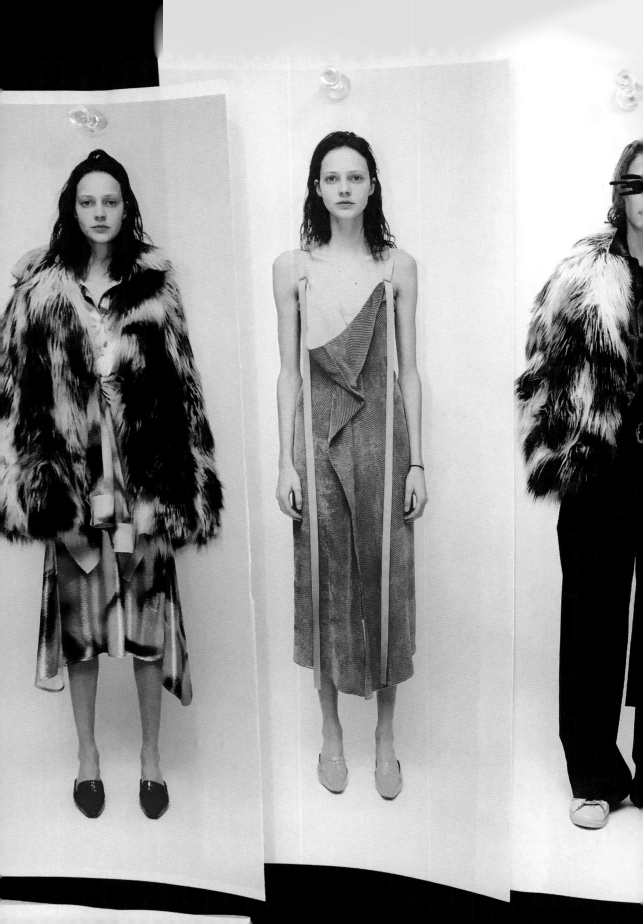

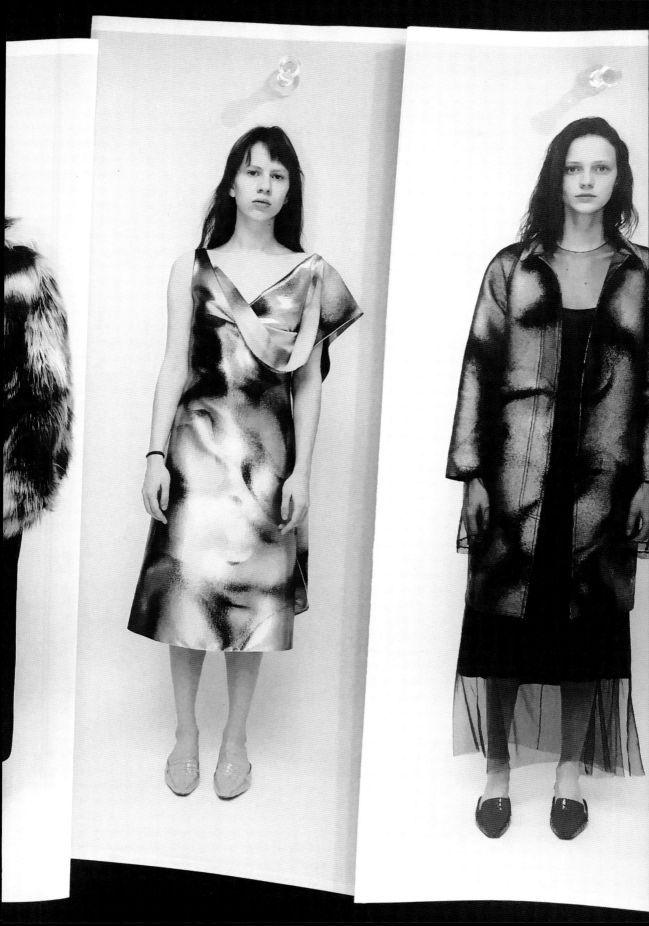

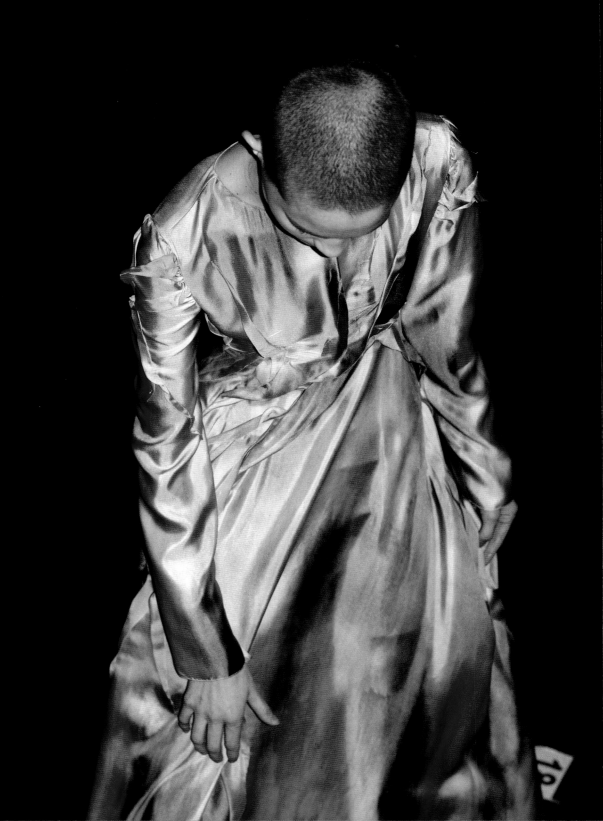

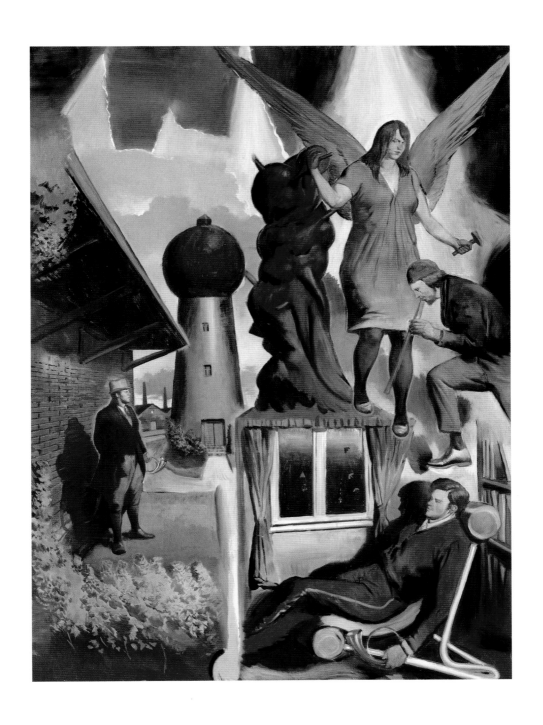

Neo Rauch, *Der Türmer*, 2017.

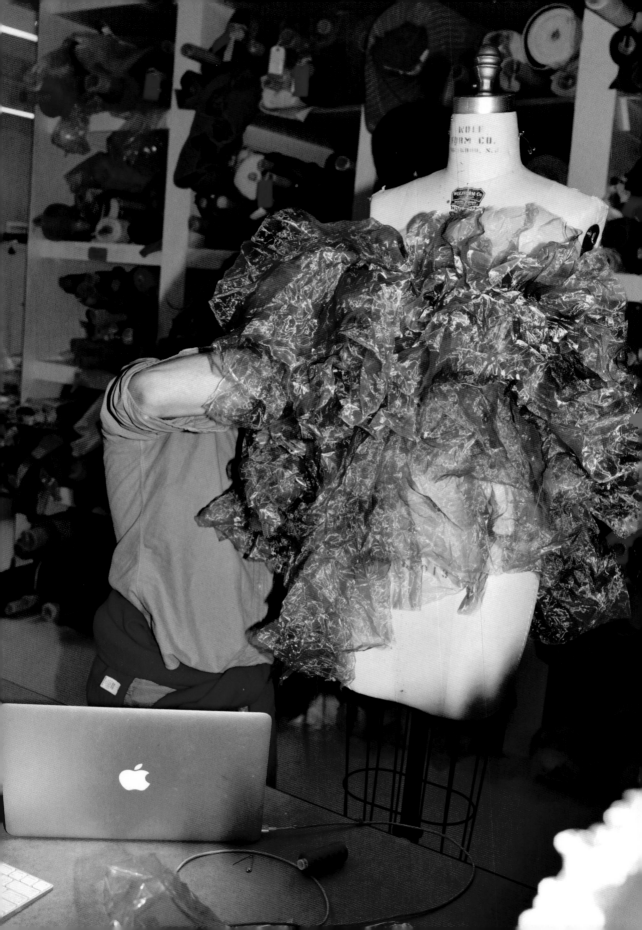

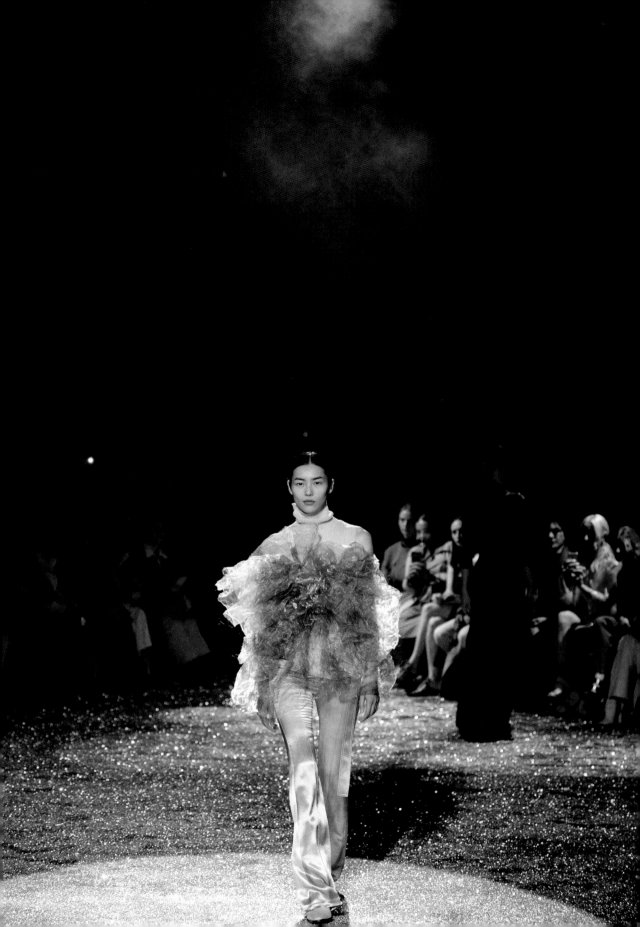

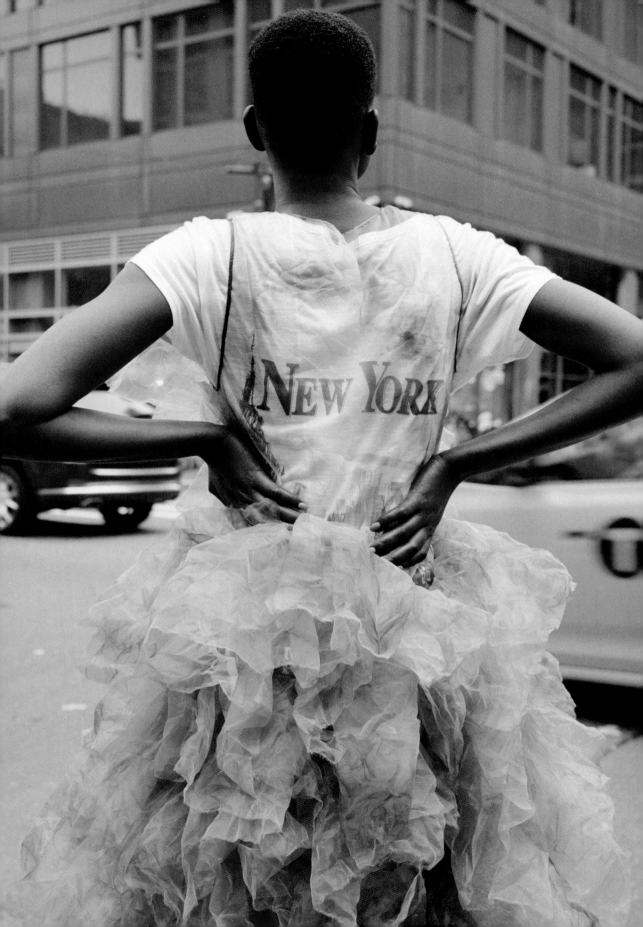

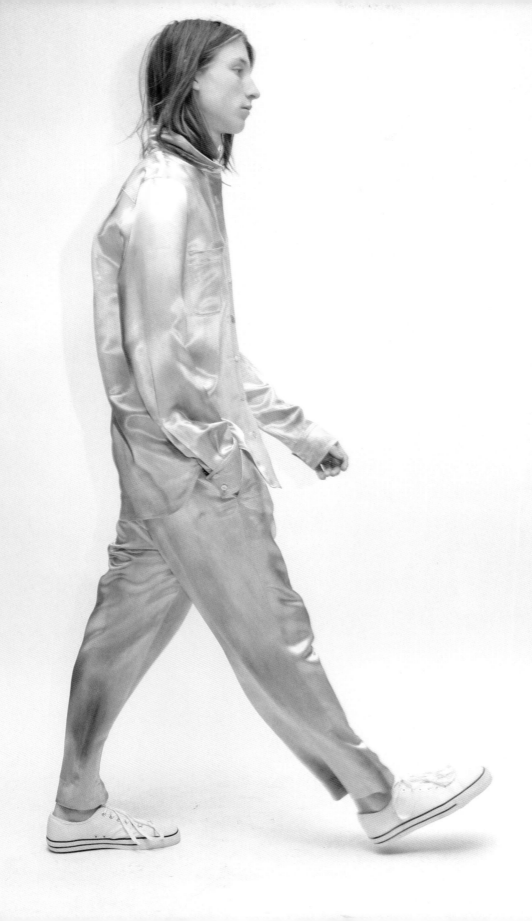

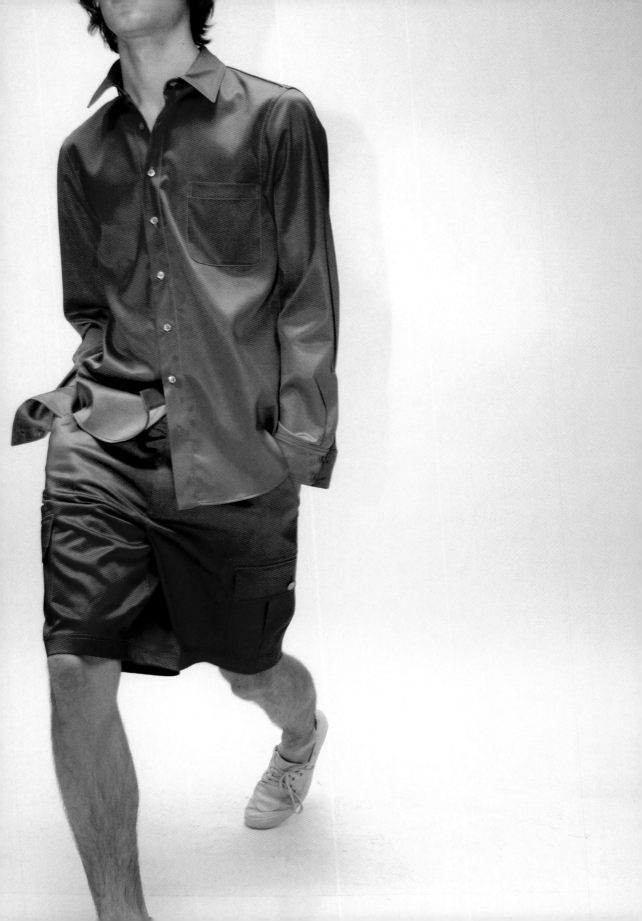

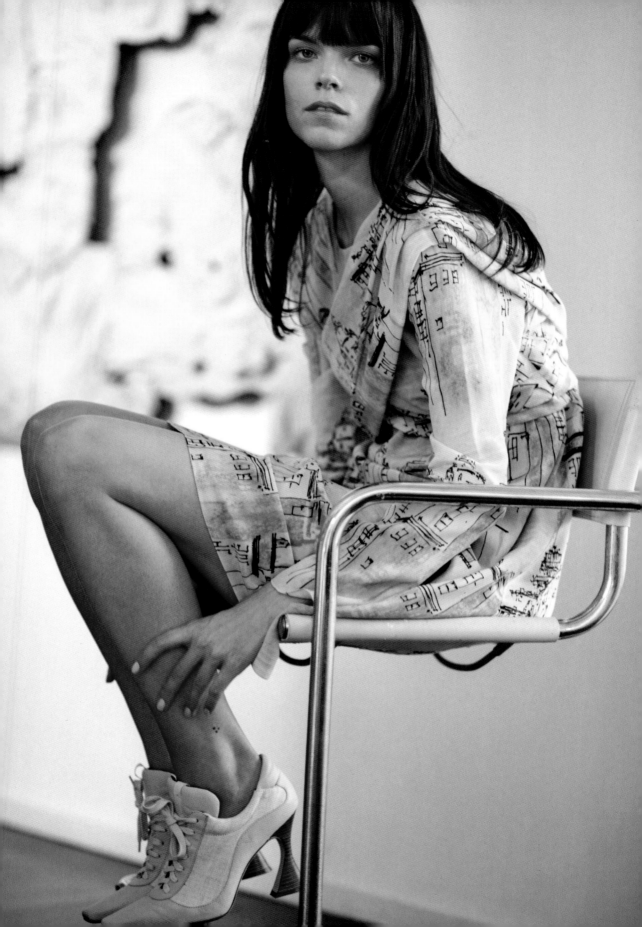

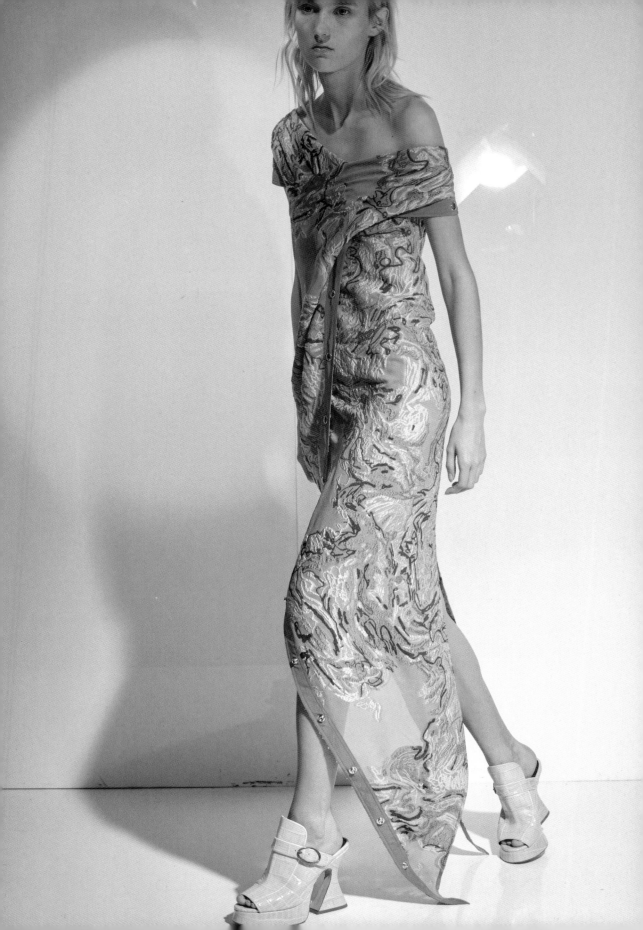

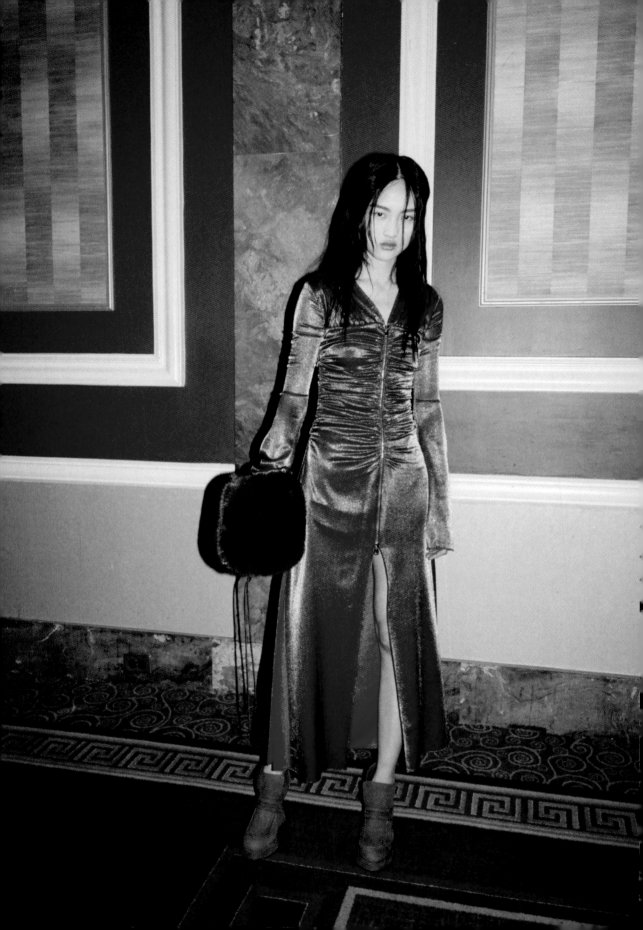

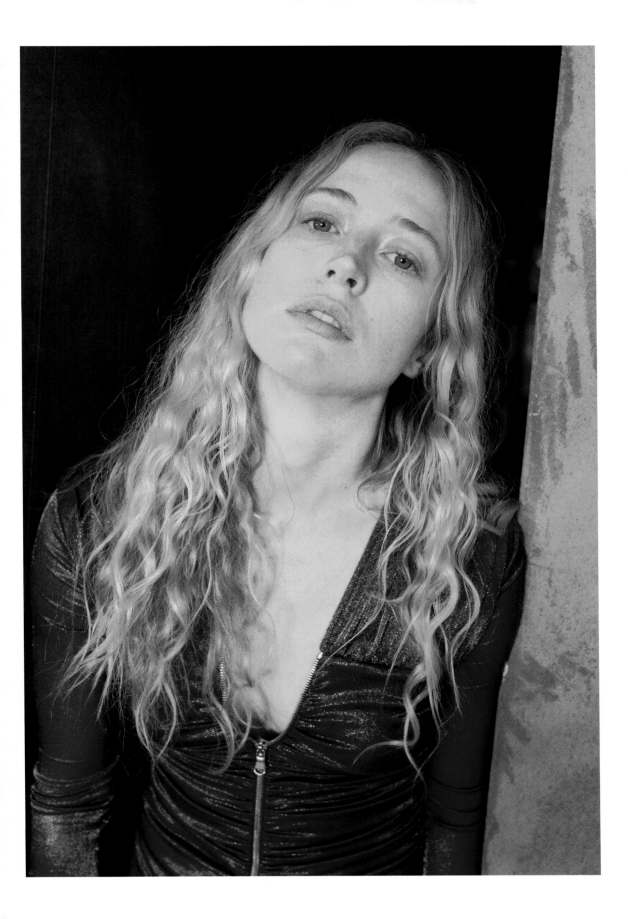

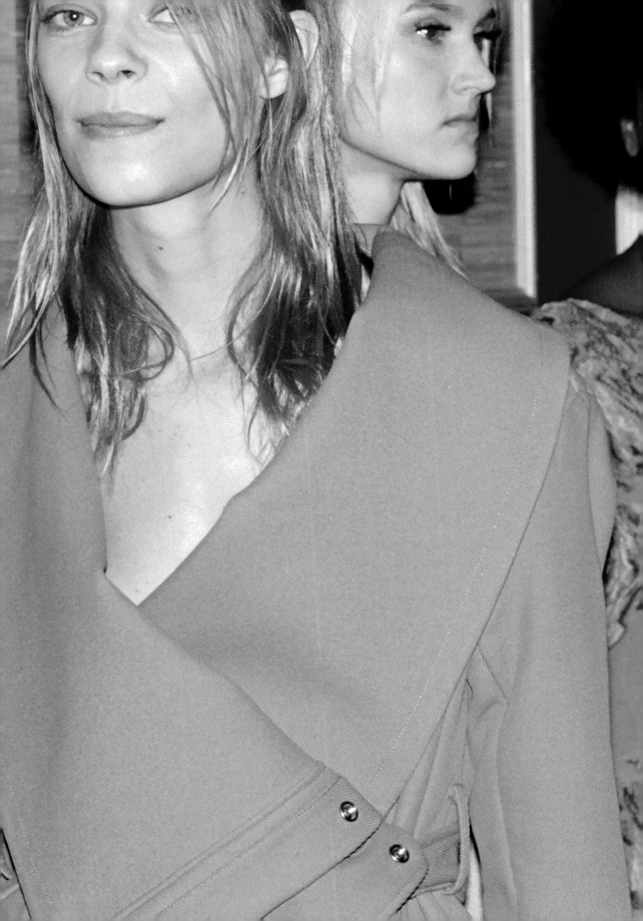

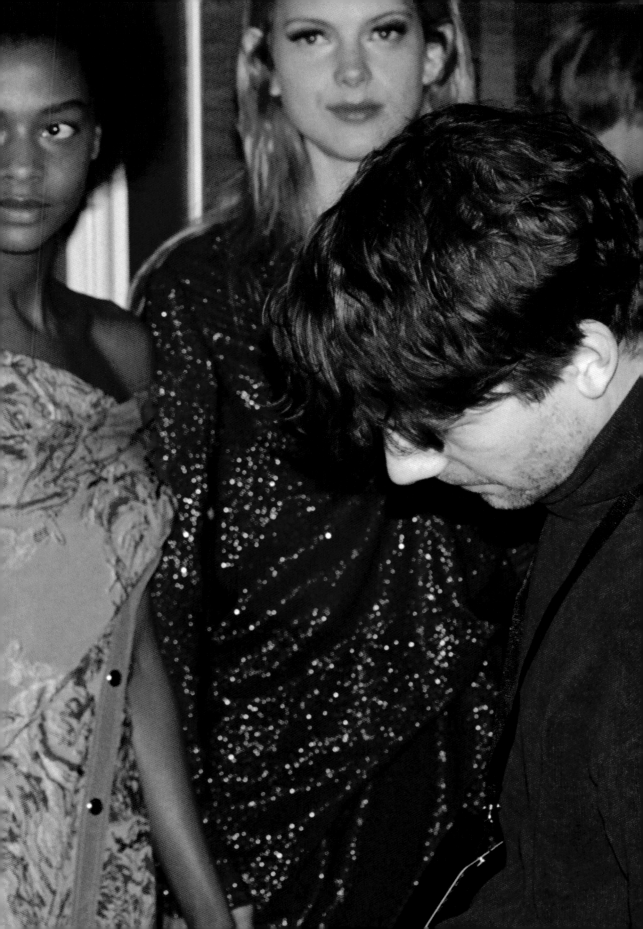

KIR

KURT

Cobalas

7/9/15

Don Lawson

I WAS
GONNA WRITE
A LOX, but
NEVERMIND

RIP
KURT
-@YUMM

Round 2
R.I.P ♡
Kurt!
-Saladboard
(Don't PAINT
OVER THE
SUPPORT!!!)

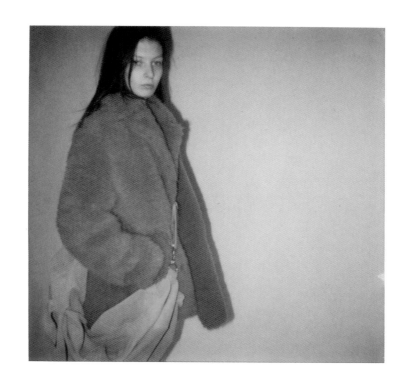

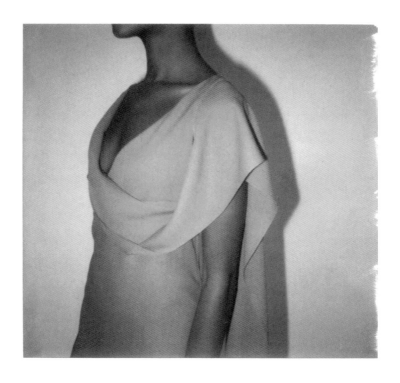

Conversations about color with...

Part 2: Composer Ludwig Göransson, sculptor Sarah Sze, and cinematographer James Laxton.

Ludwig Göransson

Ludwig Göransson is a record producer and multi-instrumentalist, songwriter, and composer of film and television scores. Best known for his work with Childish Gambino and American film directors Ryan Coogler and Christopher Nolan, he has won multiple Grammys and an Academy Award for his work on *Black Panther*. Ludwig was one of the first Sies Marjan menswear fans.

Sander Lak: Do colors make you think of music—does music make you think of colors?

Ludwig Göransson: Music makes me think of colors, mainly. And I'm not talking about specific instruments and colors, but more like the tone of the music—if something is organic or if it's electronic. How these two different elements blend into each other I find fascinating. For example, an organic sound is like a guitar or a piano, something that we've heard many times and so for me that's like a color that we're familiar with: a red, a blue, or a yellow. But I like to take that organic instrument, and its familiar color, and use an electronic manipulation, turn it into something different. Something that you have to use your imagination to understand, it's almost like making that familiar color into an iridescent or an ultraviolet color that we can't perceive as humans or have trouble seeing clearly. It's almost like trying to create that with music!

SL: When you are composing a piece of music specifically created for a movie or a scene, do the colors of that movie or scene inform your musical choices?

LG: Yes, absolutely. When I start getting into the process, there is a lot of visual work put in front of me that has been created to set the mood or give an idea of what the movie will look and feel like. Hours and hours of thought have already gone into the color scheme by the cinematographer. I've also been fortunate enough to work with directors who have very distinctive ways of working with colors. So, for me, I'm doing the easy part, which is just translating the colors and transcribing what I'm seeing into music. Normally this is not a direct transaction—like, I see a lot of blue and this sound is something that sounds blue. It's more intuitive. But there are rare cases where the direct color I am seeing actually is influencing me. There is this scene in *Tenet* where we switch between red and blue; they're doing an interrogation scene and seeing the colors will help you narrate where you are in time. So specifically for that scene, for that project, that was something where color had such a clear purpose and I wanted to also work that purpose into the music, so the scenes where everything was blue, the music was played in reverse, and the scenes where everything was in red, the same music was played forward. We also had the effect of Travis Scott's voice coming into the blue scene. His voice was being processed through a bunch of different effects. So, it felt icy and very cold, like the blue color.

SL: There are tonalities of sound that have color equivalences. So, for example, dull, clear, sharp, soft, quiet and loud. There are dull colors, and there are dull sounds; there are clear colors and clear sounds and so on. Do you play with any of these equivalences?

LG: Yes. When something that looks dull on screen or something that has a faded tone or grayness to it, it might need something completely different from the music. It's that juxtaposition you can use to change the color or tonality of a scene or movie.

SL: Music is sound, and color is light. Light is everywhere. Do you hear music everywhere?

LG: I feel like I do. Whenever I go around to different environments and talk to people, a lot of those inputs of sounds and conversations turn into music or give me musical thoughts. On the other hand, there's music being played everywhere you go. That can be too much input for me. I am surrounded by music and sounds all day long in my work so in real life that sometimes becomes too much....

SL: The same here! Going into a flower shop is like a nightmare for me. There is just too much color everywhere! Has a color in a scene of a movie you have worked on directly linked to a sound for you?

LG: There's a fight scene in *Black Panther* with Danai Gurira, who plays Wakanda warrior Okoye, and she is wearing this big red dress. There's that incredible moment where she's jumping from a balcony and the whole dress takes up the entire screen for like a split second. And there was something in that energy and something with the way that the color was moving around that was just so beautiful, but also passionate and so energetic. I knew immediately that for that scene and for that color it needed a specific element, and the element was this vocal chant done by a group of Senegalese women. This chant became that character's theme [music] throughout the movie. This all came to me seeing this red dress moving around.

SL: When you are working on a project with a musician do you ever talk about color?

LG: Color is definitely part of the language that I use when I work with artists. For example, when I work with Donald Glover (Childish Gambino) in the studio, we always talk a lot about moods and colors, that's just the way for us to open up ideas for experimentation. Because we have similar taste in music—a similar idea of what we want to create—before we start, colors are something that we talk about. And it's nothing super color specific, it's more about creating a narrative, a story or a mood to the song we are creating. And so color is an important part of that conversation. When we were working on the album *Awaken My Love*, Donald already had the cover artwork, the now-famous image created by Ibra Ake with the dark face surrounded by the neon blue lights. So, we had that photograph before we even started making the music. Every time we were in the studio, anytime we started making a song, we would always look at

this image; its colors really influenced the music we were making.

SL: Are there any movies you remember clearly for their use of color in combination with the music score?

LG: Yes, there are a couple, actually. The first one that I noticed was *Edward Scissorhands*. I noticed how color and music were being used to create the contrast between the world of Edward, which was dark and moody, and the fantastical suburbs where everything was pastel-colored. The score, done by the great Danny Elfman, reflects this change of moods and colors perfectly. It was one of the first movies that made me love film scores. Another good one is *Amélie*, with the warmth of those colors, like the greens and those reds, and that beautiful score by Yann Tiersen. And then more recently, I thought *Moonlight* was incredible, with its dreamlike neons and glowing colors.

James Laxton

James Laxton is a cinematographer best known for his collaborations with filmmaker Barry Jenkins, specifically the 2016 film *Moonlight*, for which James received his first Academy Award nomination. James and I met through mutual friends.

Sander Lak: Do you notice color as much in the real world as you do when you are working?

James Laxton: Yes, but because my job has these different components or parts, the answer varies. I would say that in the pre-production portion, where you're in this kind of design mode, you have a lot of color conversations. And then in the production portion, where the actual filming happens, I tend to focus more on capturing the performances—the actors on set and their faces is where my mind goes—and so color takes a backseat. Then there is the post-production portion, where you get into the editing and color correction part, where color takes a front seat again. So, it depends on what moment of my work I'm referring to, but yes, I tend to be really sensitive to color at different times of my life and in different times of my work process as well.

SL: Two of your movies—*Moonlight* and *If Beale Street Could Talk*—have very different color schemes. The first one has a colder tone and the second a warmer. Can you tell me more about how those choices came about?

JL: *If Beale Street Could Talk*, for me, is about familial love, like a romantic love or a family love. Love is this ever-present concept, even within the darkness of what this story is depicting. And while there are subtleties of spectrums in warm colors, I couldn't think of a better tone to start with than that warm yellow kind of orange that plays throughout that film. And I guess the reason is, for all the subtleties in that film, we just felt like LOVE wanted to be that big statement throughout. There's a line in the film:

"Love was what brought you here"—and that concept remains solid and pure. And in *Moonlight*, love is a tremendous and important concept as well, but there's a subtlety to it that feels more complex. Love is a complex concept in that film, more than it is a statement. Looking back now, I do think some of these choices came about more subconsciously when we were actually making these films.

SL: There are countless theories and examples of how color is used in film to set a mood or emotion. Can you give any examples of this in your work?

JL: I have a hard time with these definitions. The reason why I love color so much is because it's such a personal experience. If you grew up in India and you have fluorescent lighting in your dining room, you then associate certain colors with love and sharing meals with your family. And if you, like me, grew up in San Francisco and there were more warm lights and colors around the dinner table, you might associate love and sharing meals with your family in a very different color palette. There's uniqueness to color, and I think it's subconsciously created within how we love our family and how we love romantically. It changes according to where and how you grew up. So, I have a hard time making definitions about the general emotions of colors. And when I'm designing or choosing a color for a particular scene, it has so much more to do with subconscious decisions; less meaningful in terms of definitions.

SL: What colors are hard to capture on camera?

JL: Most digital cameras tend to struggle with certain reds, but that can be solved by working around them creatively. There are more technical colors that I think still have a challenging time going through a digital sensor. But I shouldn't be too negative about digital. I think film also has a hard time with certain colors, deep reds again, for example, often just become big, blotchy things. And also, different film stocks you might use have different color challenges. Fuji tends to enhance greens, and Kodak enhances more reds and warm colors. And it actually has a lot to do with where these things are made, which I think is quite interesting. If a product is made in a certain country and culture, will they have their own intonations of what they tend to push through their sensors of their film stocks? So, there's actual intent behind some of these decisions. How colors are rendered through different camera systems has everything to do with, I think, the culture where they are created.

SL: Can you talk about the process of color correction?

JL: It's photo editing for motion pictures—that's how I generally describe it. And so once the edit of the movie is finished, it gets handed back to someone like myself who works with a colorist and the director, or possibly even the editor, to go through every single shot in the entire movie and refine the color in an effort to tell a better story—technically, to make the edit feel smoother when colors don't match. But creatively,

what we're also doing is trying to fine-tune a tone for the piece that can enhance the story. Tone is obviously created in many ways, with costume design, set design, the performances, and the music, but of course, also with color. I try very hard to not just make an image that looks strong to me, but also to pay particular attention to the story and the tonality of the story. Like, how can I turn a certain kind of blue, that maybe is more navy blue, into a more aqua blue because the tone of the scene might have an eerie note and shifting from that navy to aqua might strike that eerie note for the audience. You can do this in lots of different ways, and that's basically what color correction is. It's trying to find a way to move colors to a place where they are enhancing tone, tempo, and story. I think at this point we consume images so frequently that we are now hyper-attuned to images that carry a certain amount of memory. And so sometimes when I'm color correcting, I might even reference something in the subconscious as audiences that can quickly tap into a tone or mood that might have been evoked by a previously created work, like a commercial. It could be from a painting or a video. That's often how I'm thinking about things. I will often reference films or photography or even music.

SL: That's interesting because at Sies Marjan we always played with the ideas of color as well, color references and color memory. Like, let's take that really cheap-looking orange and pink that is being used in the Dunkin' Donuts logo but then make this beautiful, luxurious drapey dress in it. Something strange happens when people see these colors together because it references something obvious, but most won't know what exactly—they have seen it before but never in the context of a draped silk dress. There is something really exciting with playing with these kinds of high- and lowbrow color references. So—do you see color without form or form without color?

JL: I'm starting with color without form. I'm reading the script and I'm trying to understand what it might make me feel. Very often I'm thinking about a certain color for a certain scene. And then the next step is usually to get in touch with the production designer or the art director to talk about how we can achieve the color schemes. I can give you an example from *If Beale Street Could Talk*. The early scenes in that film, I just had this sense of a gold-ness to them. I wanted to have this kind of golden, warm, yellow feeling. So, we were talking about how we could achieve this gold- ness. There's light, wall colors, lamps, and costumes but there's also curtains. That was the first idea: to find ways to bring curtains into the scenes so that when the sun came through them, they would bring a certain golden hue onto people's faces and into the scene in general. So, at first, I thought about the color without its form, and then the second step was to find a form to match or create the color.

Sarah Sze

Sarah Sze is an artist known for sculpture and installation works that employ everyday objects to create multimedia landscapes. Her work explores the role of technology and information in contemporary life utilizing everyday materials. Through Sarah's love for the Sies Marjan pieces she owns, we met each other in 2018.

SL: Show me the following colors through imagery: Deep purple.

SL: Hot pink.

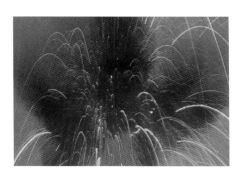

SL: Green.

SL: Orange.

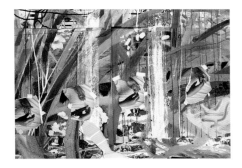

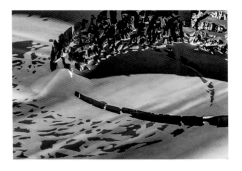

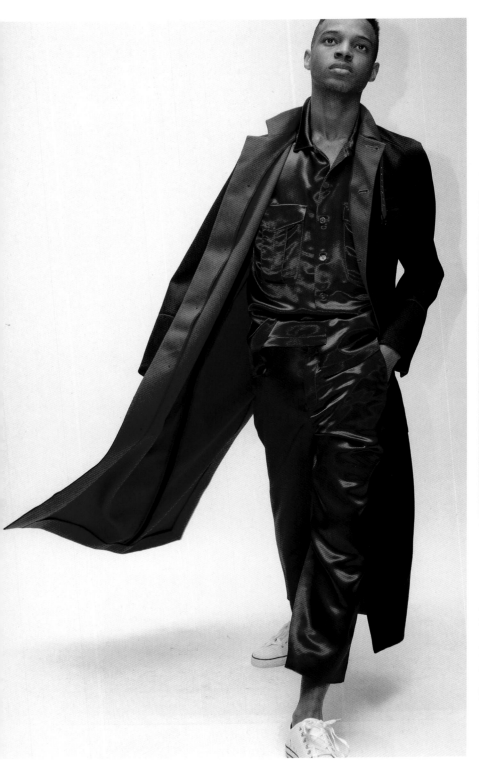

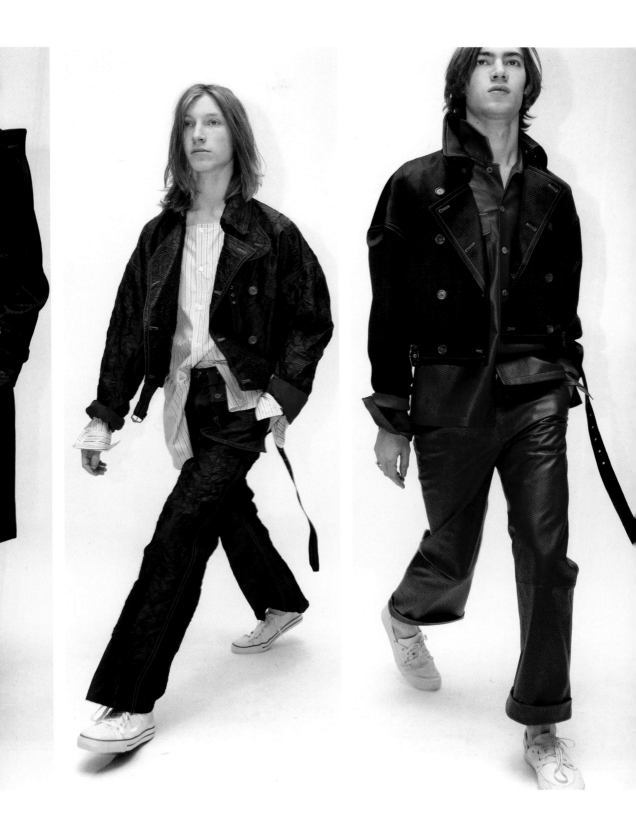

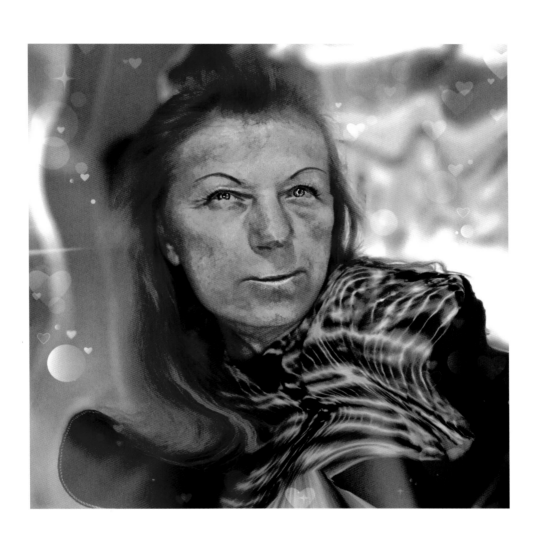

Cindy Sherman, *High on Life*, 2017.

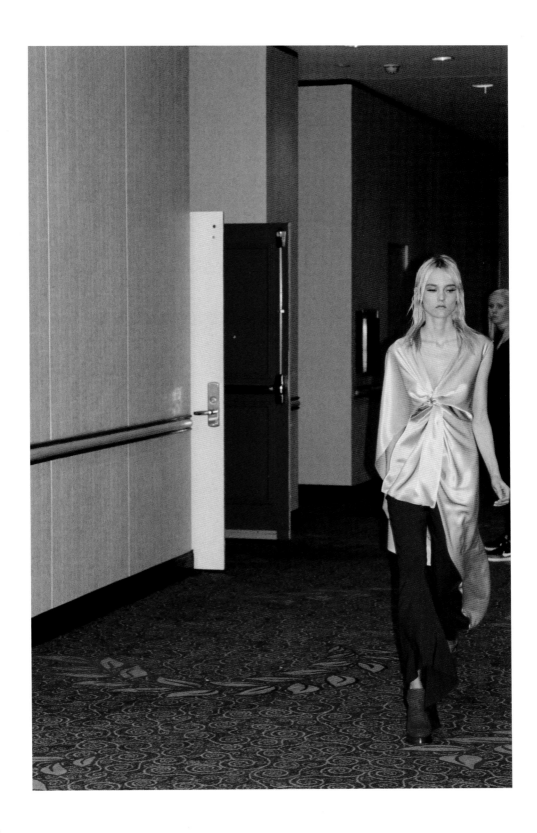

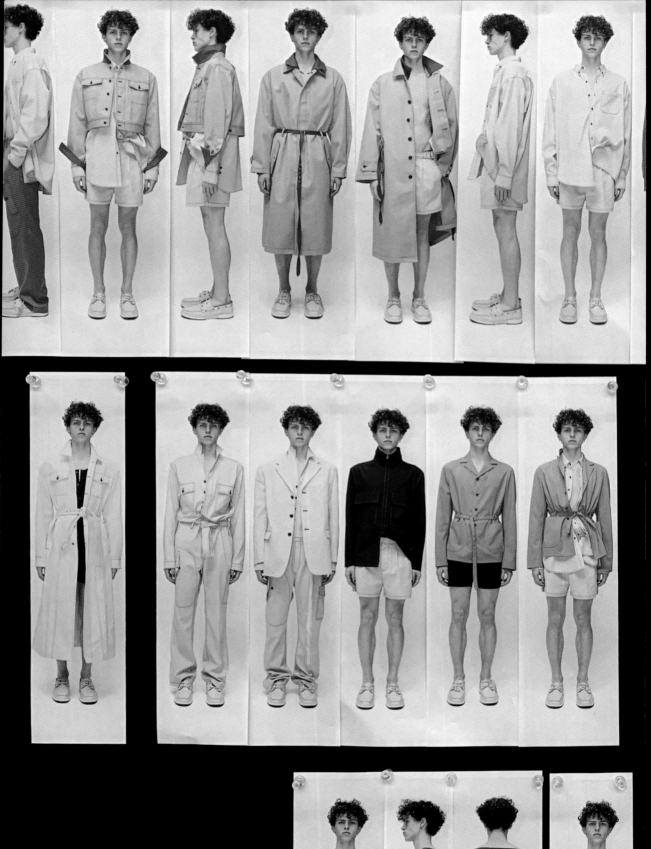

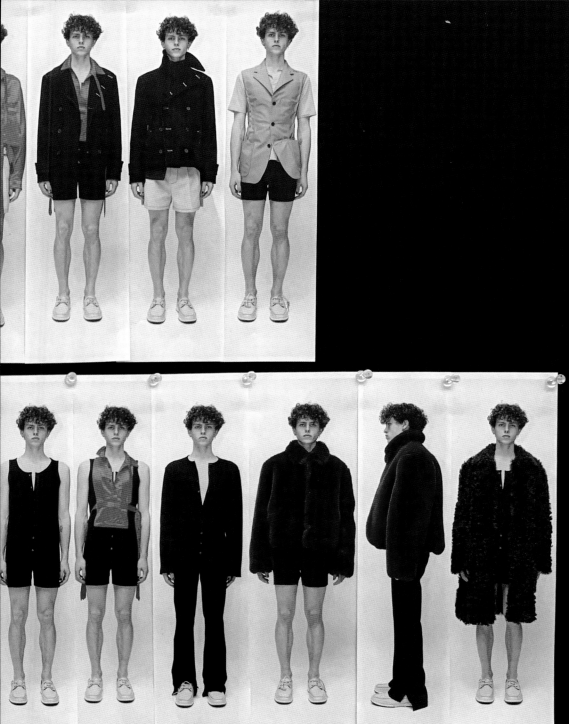

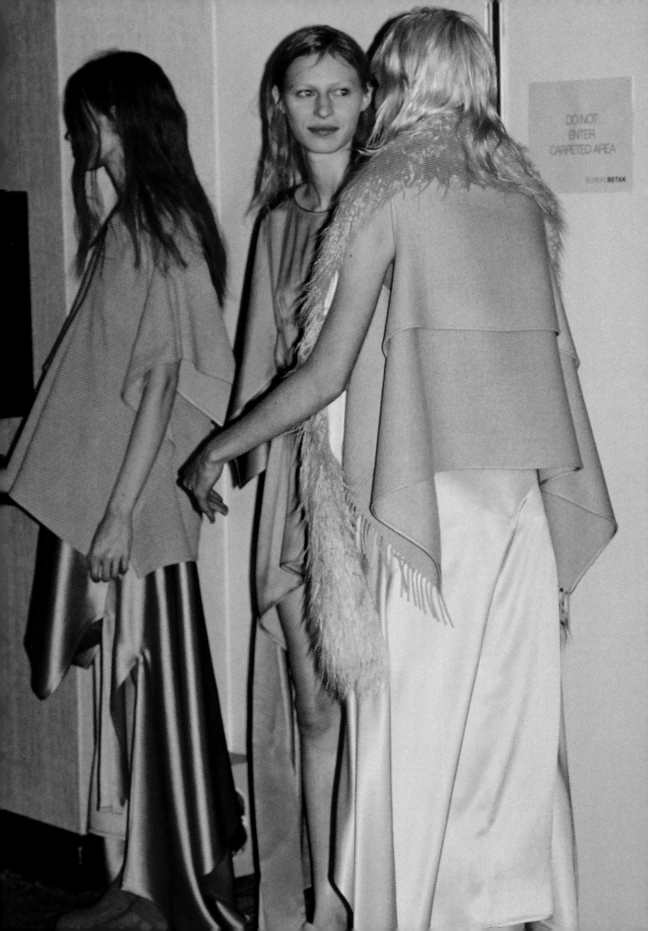

DO NOT
ENTER
CARPETED AREA

BUREAU BETAK

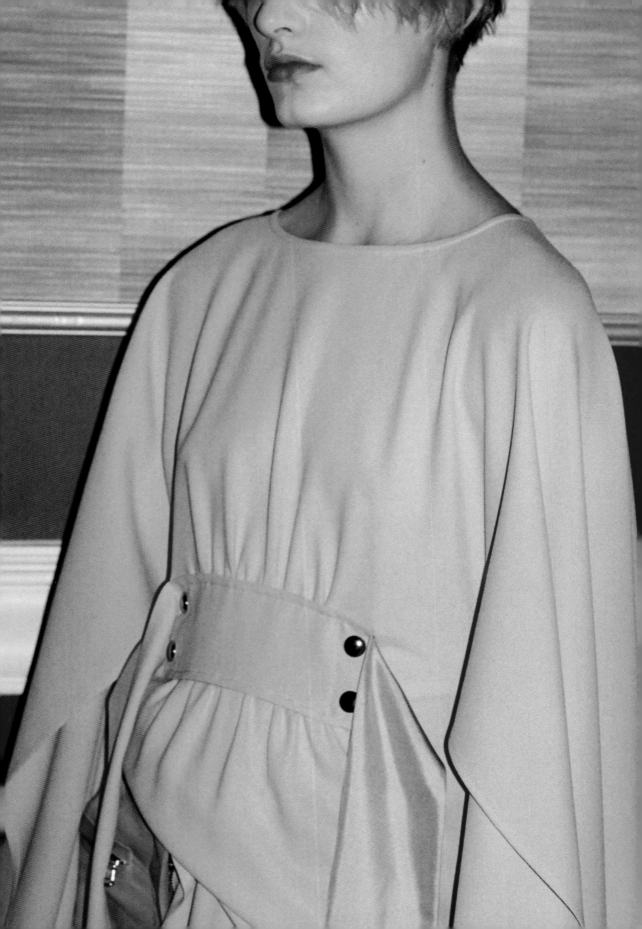

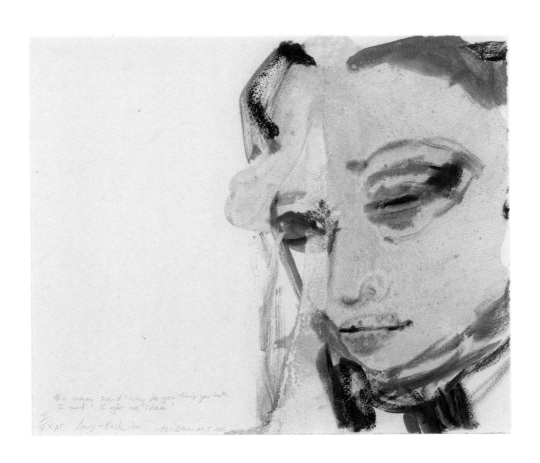

Marlene Dumas, *Amy—Back to*, 2015.

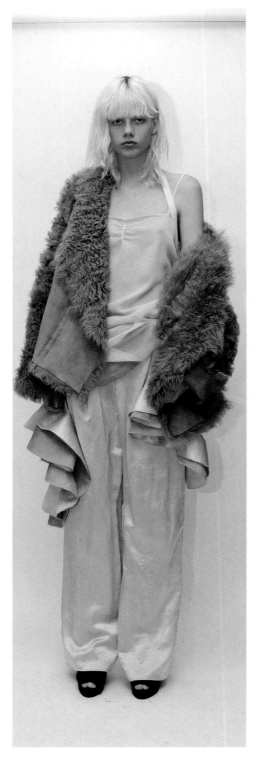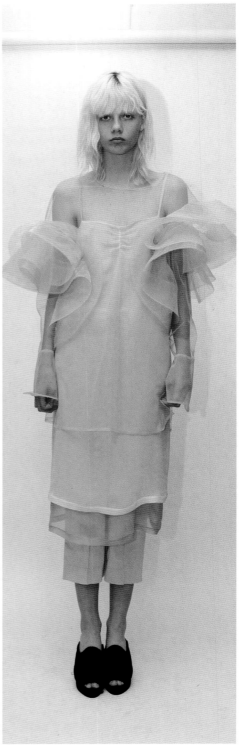

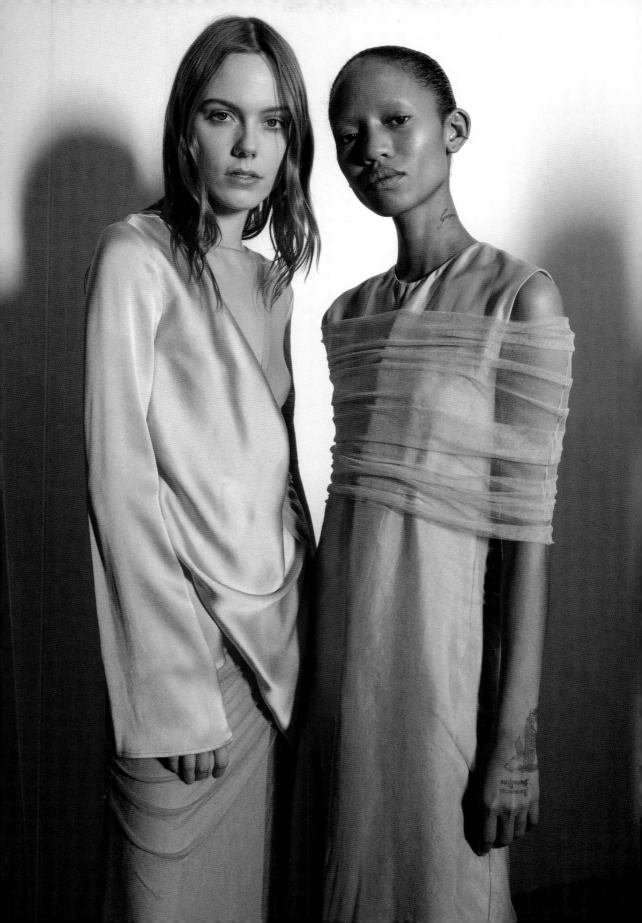

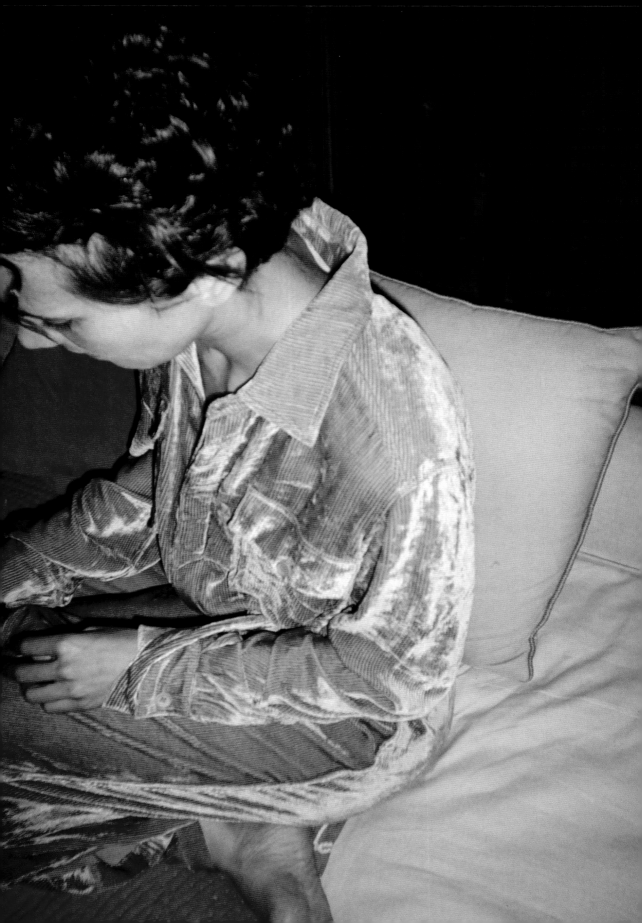

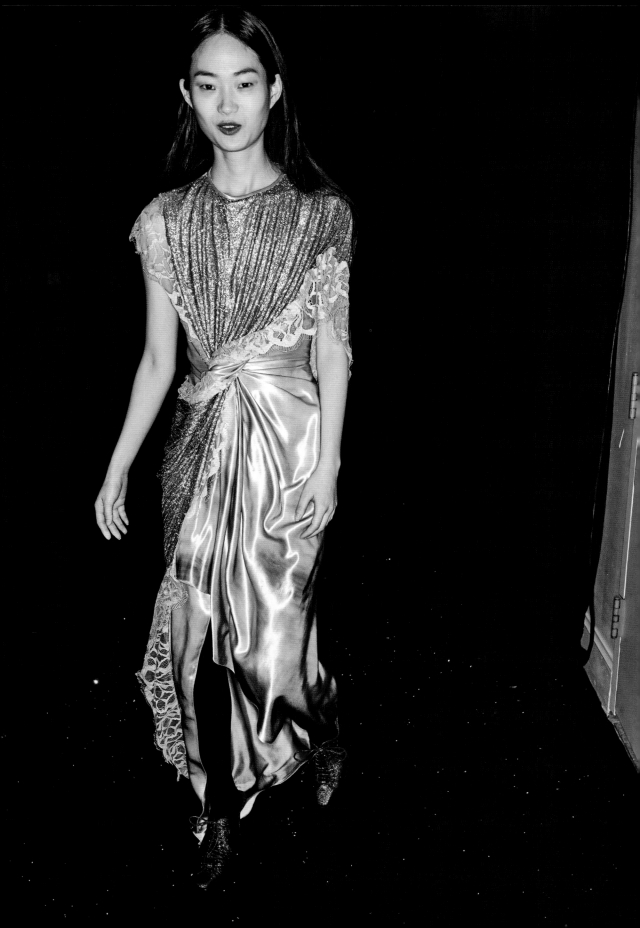

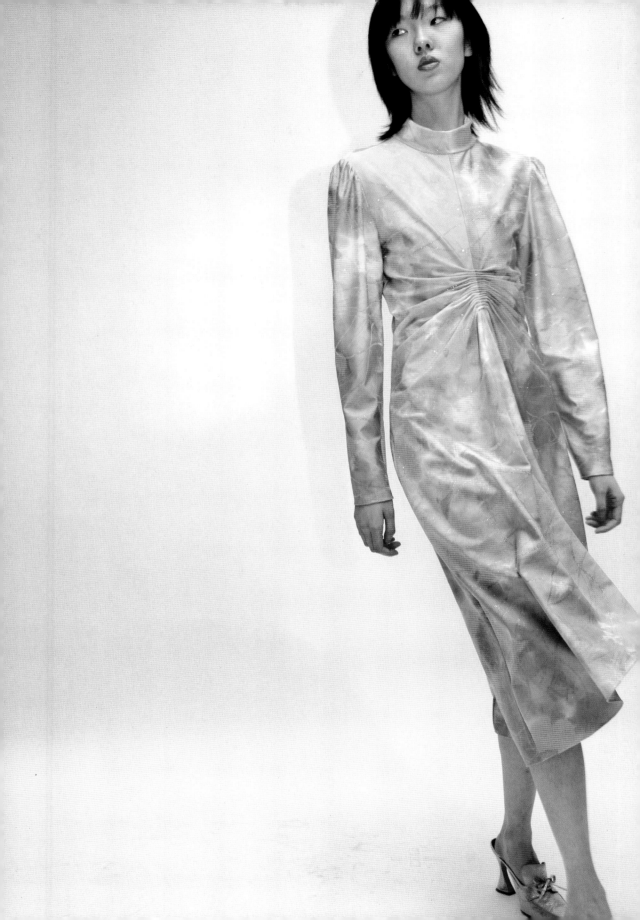

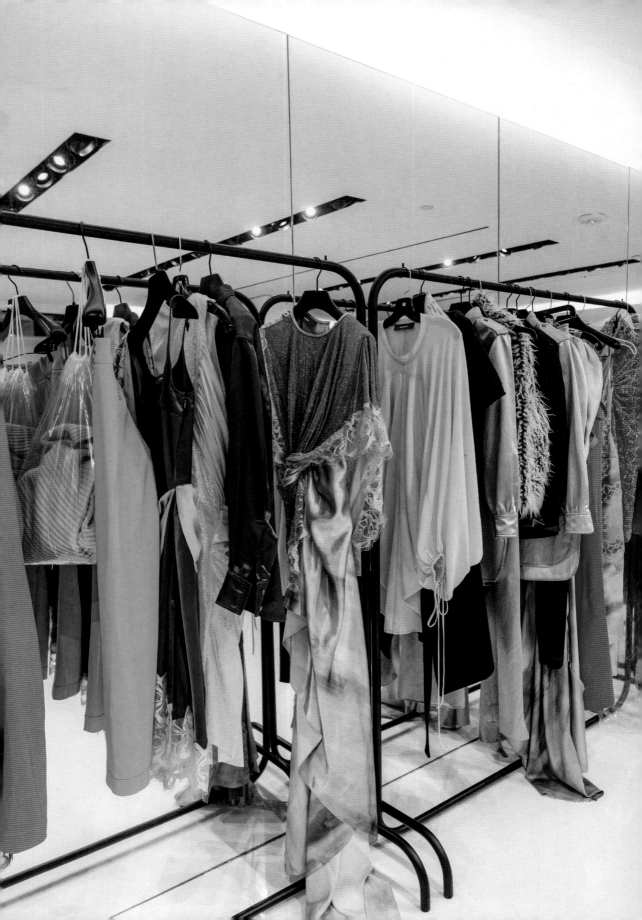

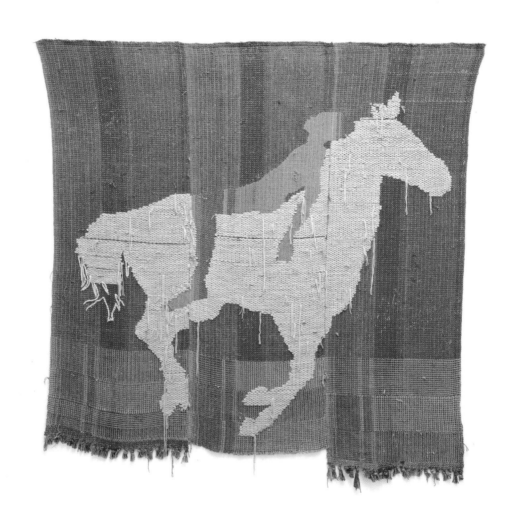

Diedrick Brackens, *when no softness came*, 2019.

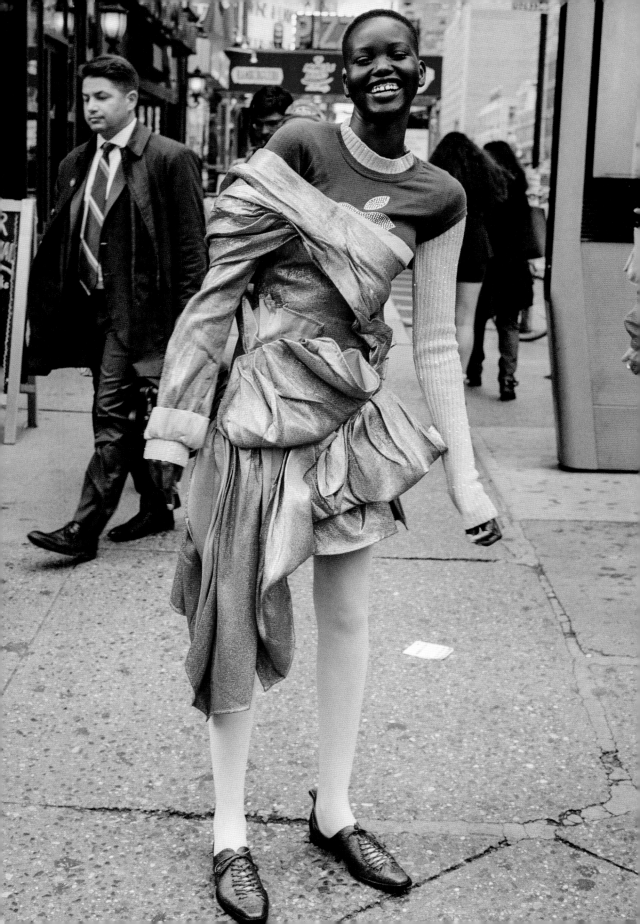

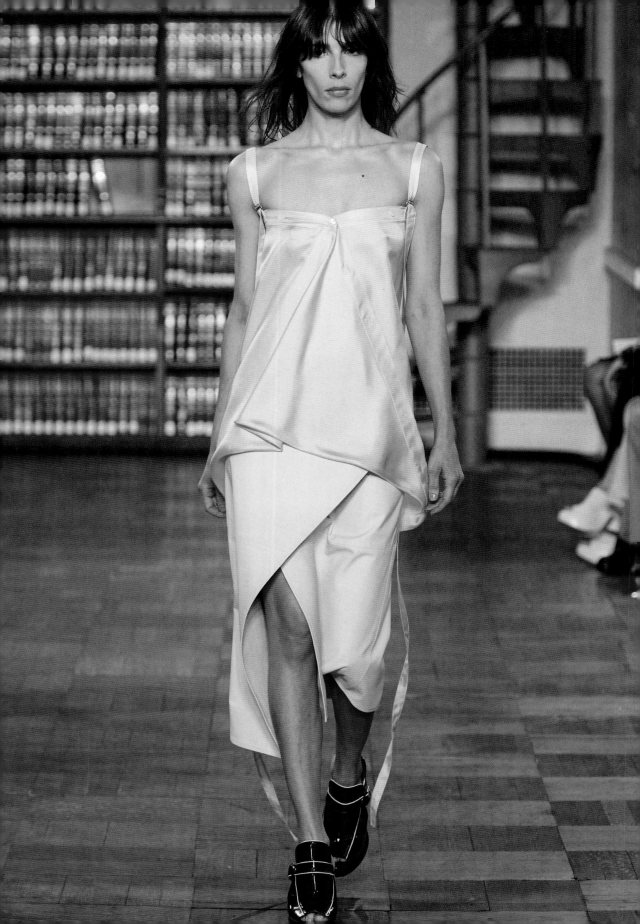

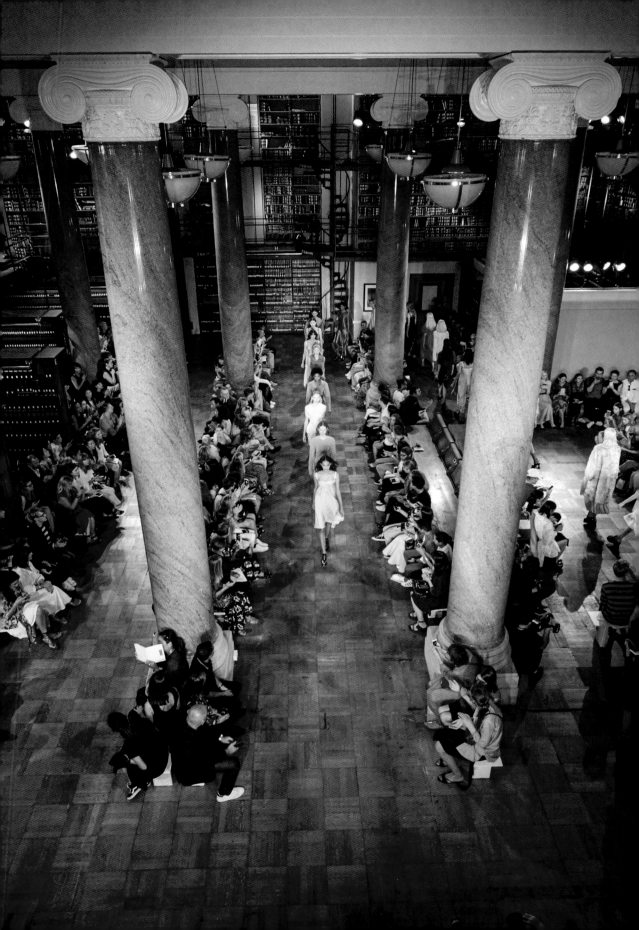

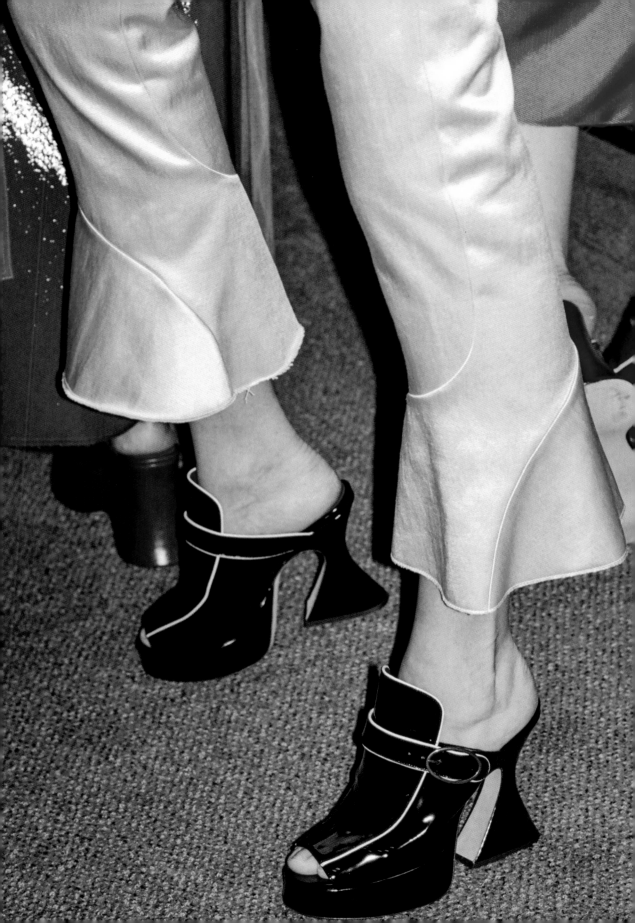

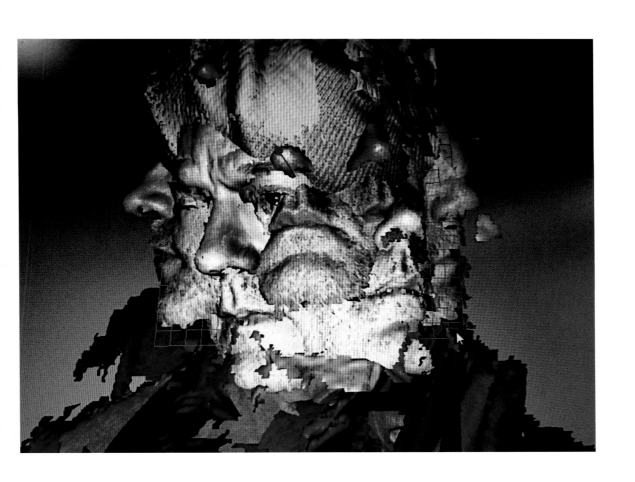

Michael Stipe, *3-D scan, early technology.*

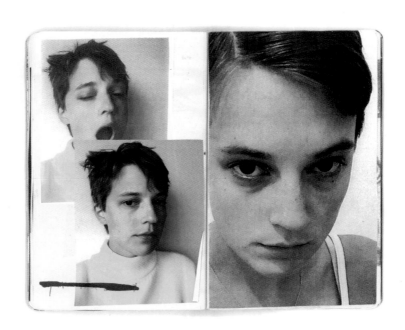

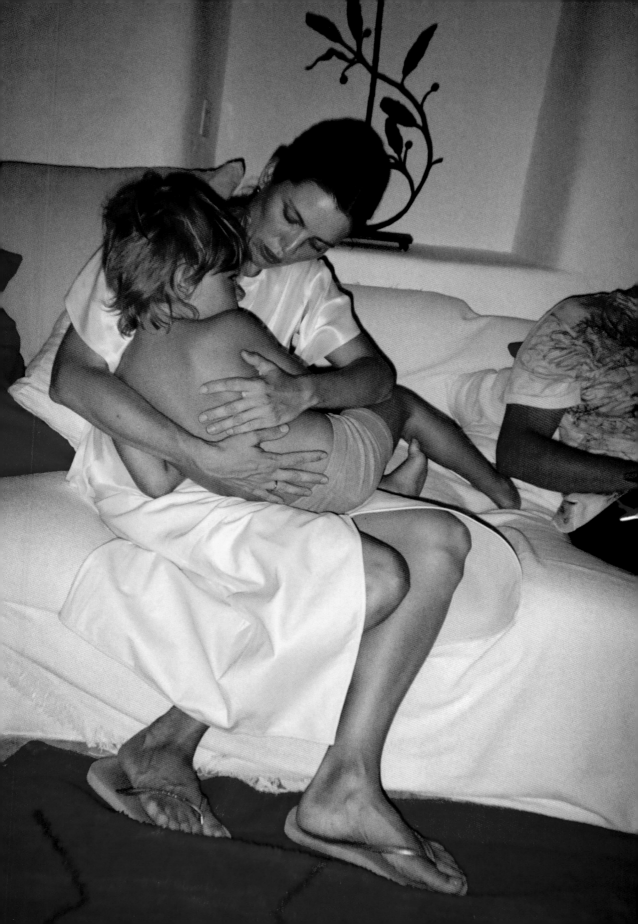

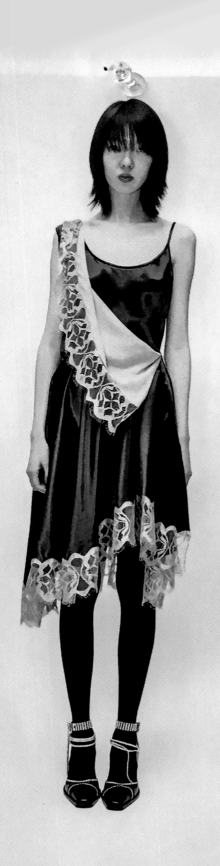
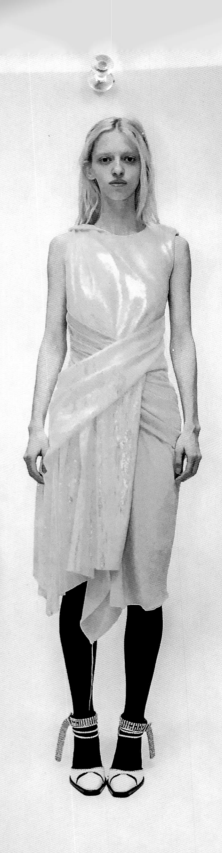

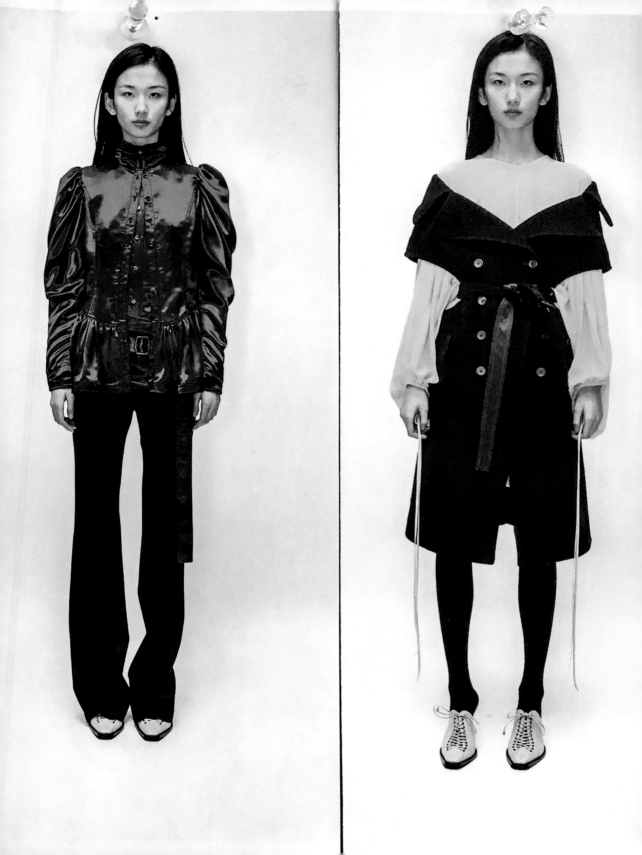

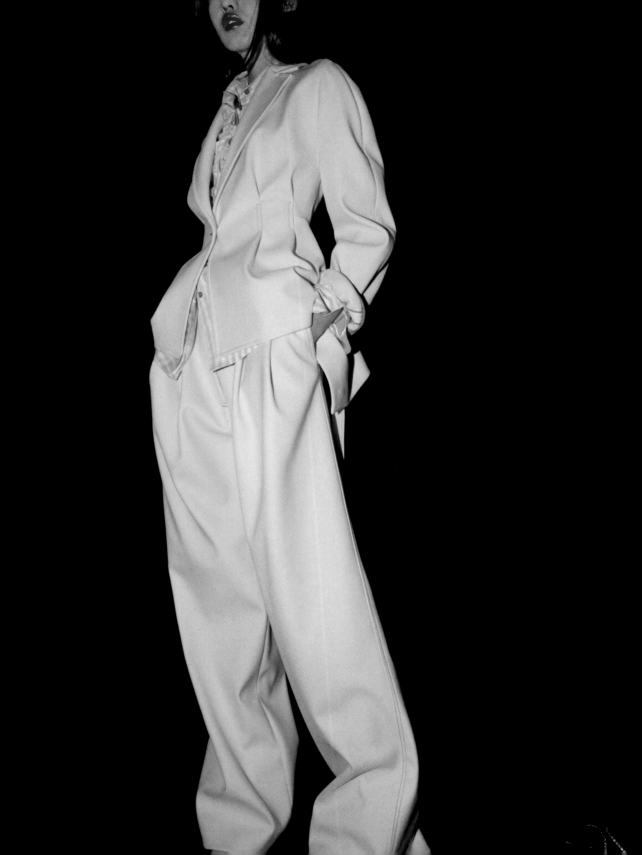

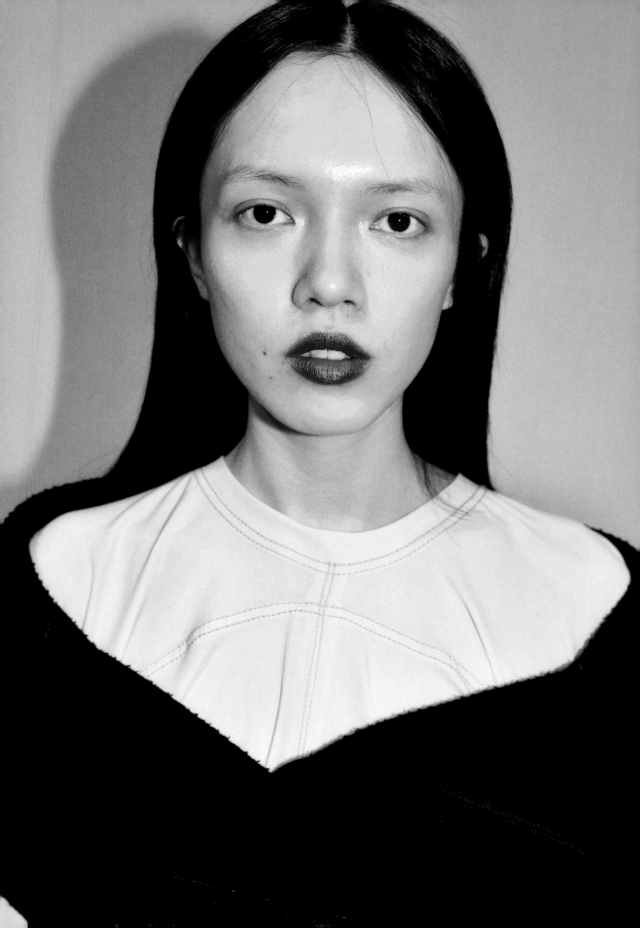

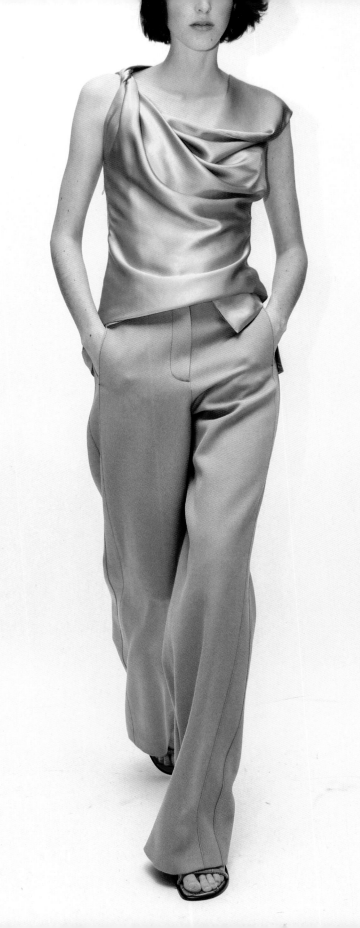

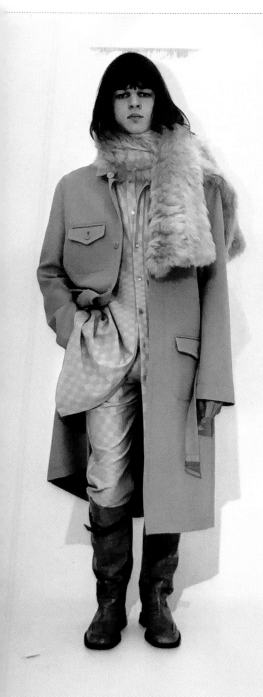
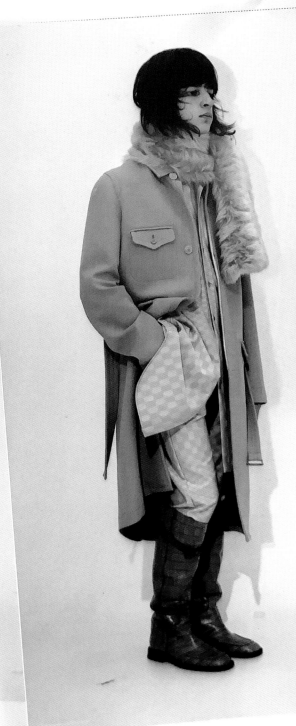

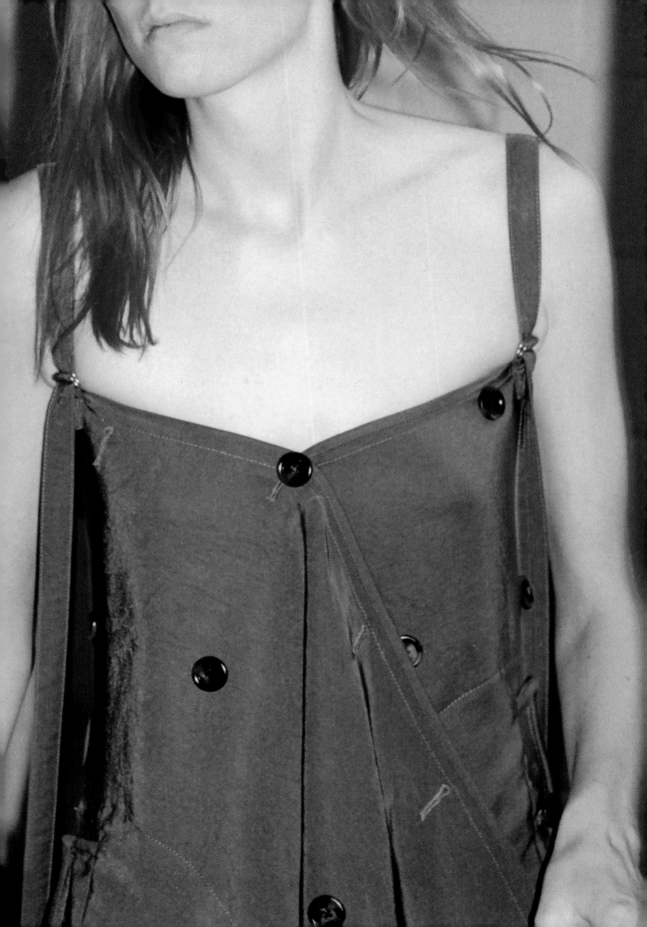

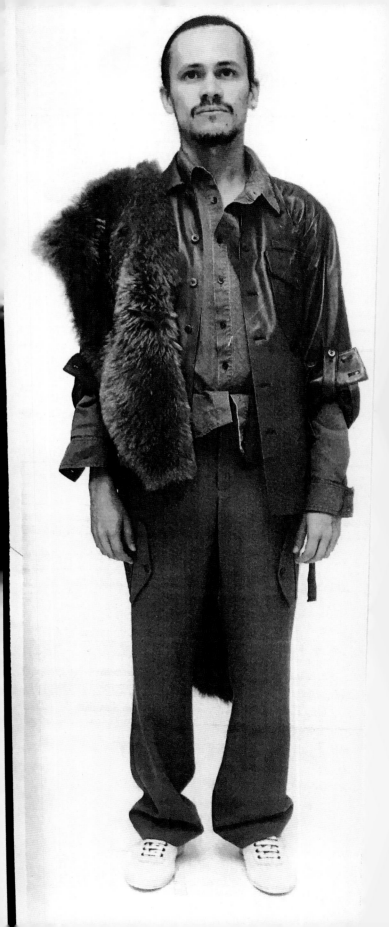

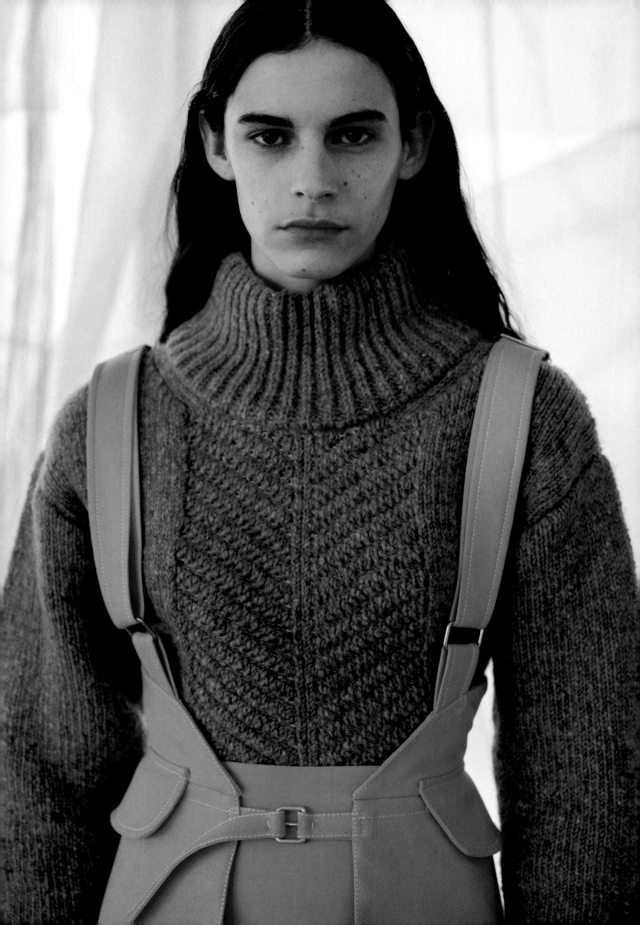

Living in Color

by Andrew Goldstein

When Sander Lak asked me to write an essay about color for this catalogue, I agreed on the condition that it could be a personal view on the subject. As someone who has worked as an art journalist for more than 15 years, I have grappled with the appearance and meaning of countless artworks across media and from throughout history, assessing their employment of color as a matter of course, but I don't know if that gives me any special expertise on color writ large. The experience of color has similarly suffused my 42 years of life on earth, sweetening my visual sense of the world in the same way music perfumes the passage of time, but that is not unusual. I am not a scientist, a scholar, or a theorist. So all I can offer is my personal view—to borrow Kenneth Clark's term—of a subject so encompassing and available to most of humanity that it's a bit like being a landscape photographer: You position the camera somewhere in the vastness, focus the lens, and capture the exposure.

My first vivid memory of color is from when I was 2 years old. My parents had rented a small house in the Hudson Valley, an hour and a half north of New York City, and one early summer morning after a rainstorm my mom took me out for a walk down a muddy road through a bright green forest and we found salamanders, blazingly orange, darting from puddle to puddle. This trip began my family's love affair with upstate New York, where my parents soon after bought a dilapidated farmhouse, and the colors of the countryside—especially the browns of the earth and tree bark, the greens of the foliage, and the blues of the sky—have since become my own terroir of beauty, just as someone raised on the Greek isles may favor ocean blues, shrub green, and the spare whiteness of sand and bleached rock.

When I was 15, my friend's curator mother invited me to the black-tie opening of a major Egon Schiele retrospective she had organized at MoMA, and the sensuality of his portraits—shit brown, sickly greens and yellows, and, again, fiery orange—was as electrifying as a cattle prod on my young sensibility, alerting me that art was a world I wanted to explore.

In college, studying ancient art and antiquity, I learned that classical statuary, far from being pure, stoically pared-down marble, was actually riotously polychromatic in its original painted state, and that Greece and Rome were Las Vegases of dazzling

optical overload. It was just that, over the millennia of weather and human history, the paint was stripped off. I also learned that color was hard-won and precious, with everyday hues wrested from the natural world through labor, and more rarified colors—imperial purple, for instance, with one ounce harvested from the mucus of 250,000 predatory Phoenician sea snails—acquired at great cost and difficulty, requiring the same trade networks as spices.

Living in Rome on a semester abroad to study classics and the Renaissance in situ, I fell for porphyry, the ultra-hard purple stone used by the Romans and cinquecento masters alike, and lapis lazuli, the blue semi-precious stone that artists ground up to paint the resplendent blue of the Virgin Mary's cloak—a deeply spiritual color that I discovered could also be found in the sky at 5 p.m. in the wintertime and 9 p.m. in the summertime, when the ultramarine evening sky mixes with the blackness of space.

Still to this day, when I think of color in art, my mind goes to the jewel tones of artists like Bellini, Raphael, Titan, Pontormo, and, to the North, Hans Holbein, the latter of whom continues to dazzle me with the rich, monochromatic backdrops to his portraits that anticipate the high-keyed, solid-hued backgrounds favored by portraitists (and photographers) today. To think that those sumptuous paintings are, in essence, the residue of wet dirt smeared on canvas rags—their base materiality transmuted into near-divine images that continue to speak powerfully to us today—makes color, and art, seem like a form of magic.

That magic, abstracted, refracted, distilled, and optimized, is with us everywhere today. As I write this now on my laptop, I know I can open Photoshop and play with chromatic gradients across the visible spectrum (a simple function that Cory Arcangel somehow still managed to harness as great art). In my household, color beautifies our daily life thanks to Sander's clothes, which I and especially my wife wear all the time. In fact, Sander taught me that color could and should be embraced every day, a lesson his many admirers seem to have absorbed as well. But as I look out the window at the 5 p.m. sky melding deep azure with the dark of the cosmos over the tree line, and as I look into the crystalline blue eyes of my baby daughter, I feel—as Kandinsky felt—that color can also be a portal to a transcendent religiosity.

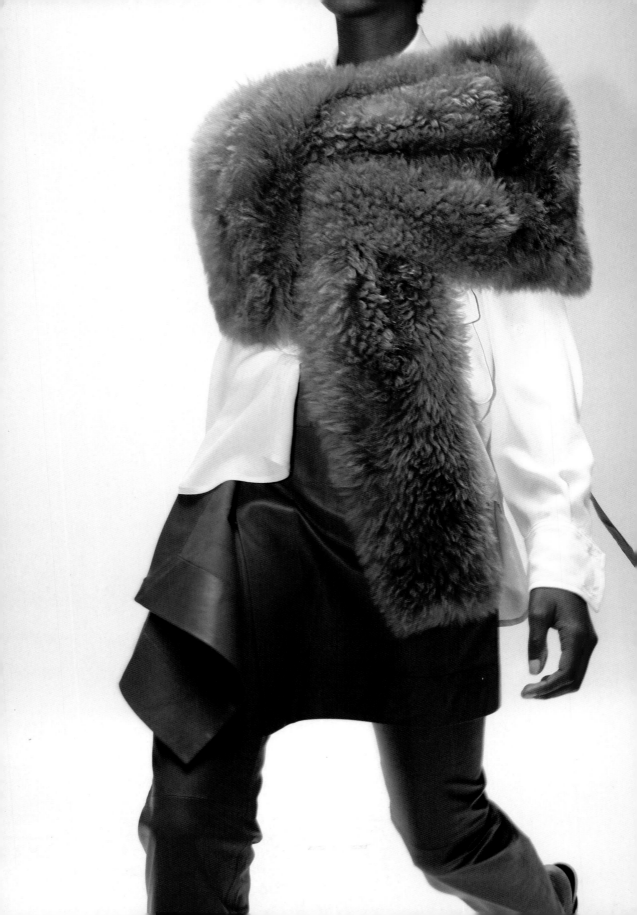

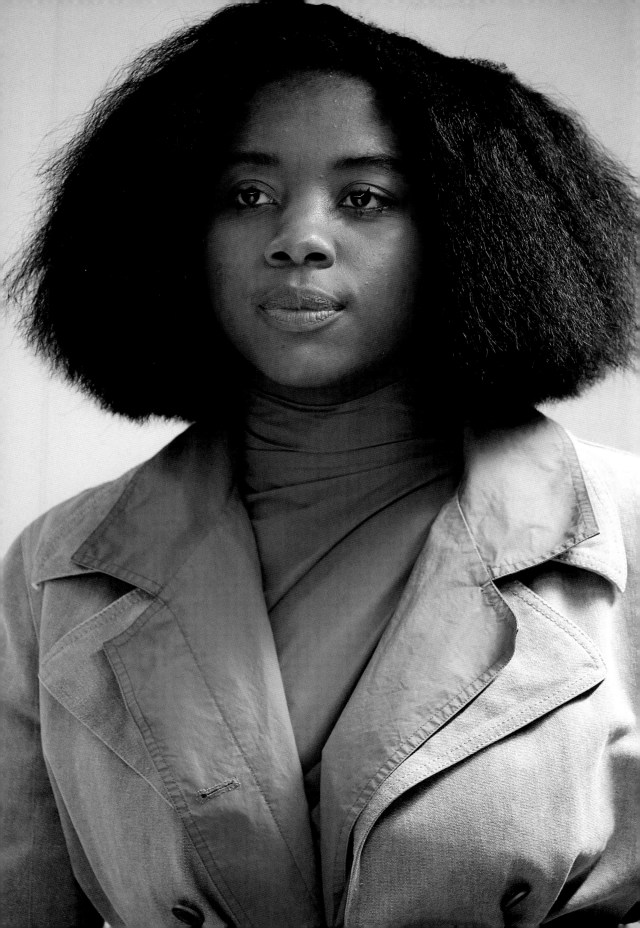

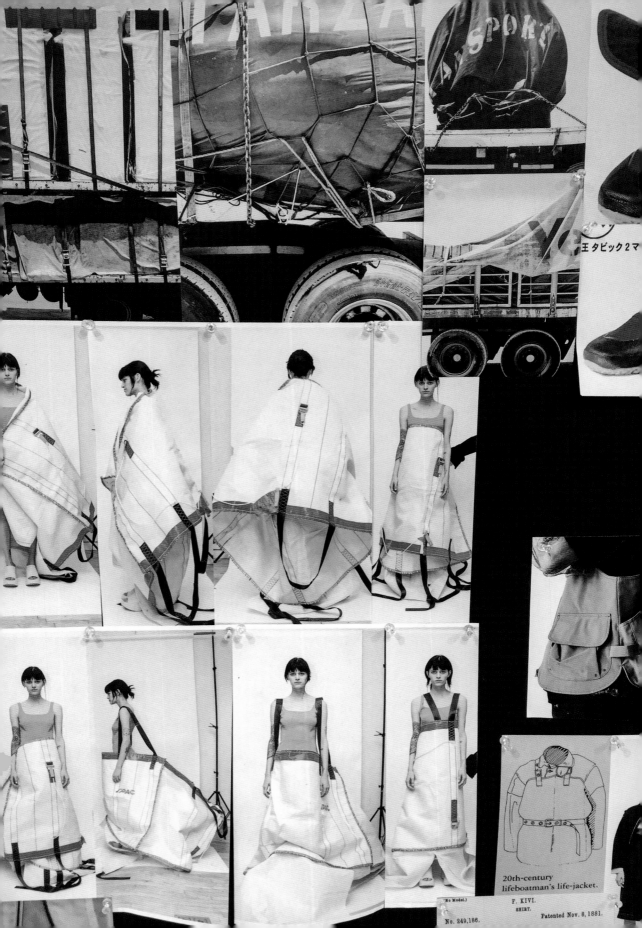

20th-century
lifeboatman's life-jacket.

F. KIVI.
SHIRT.
Patented Nov. 8, 1881.

(No Model.)

No. 249,186.

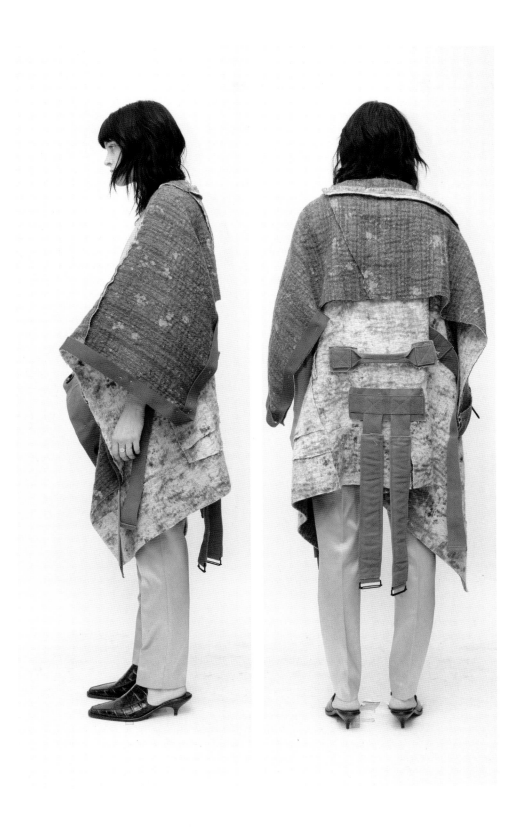

227

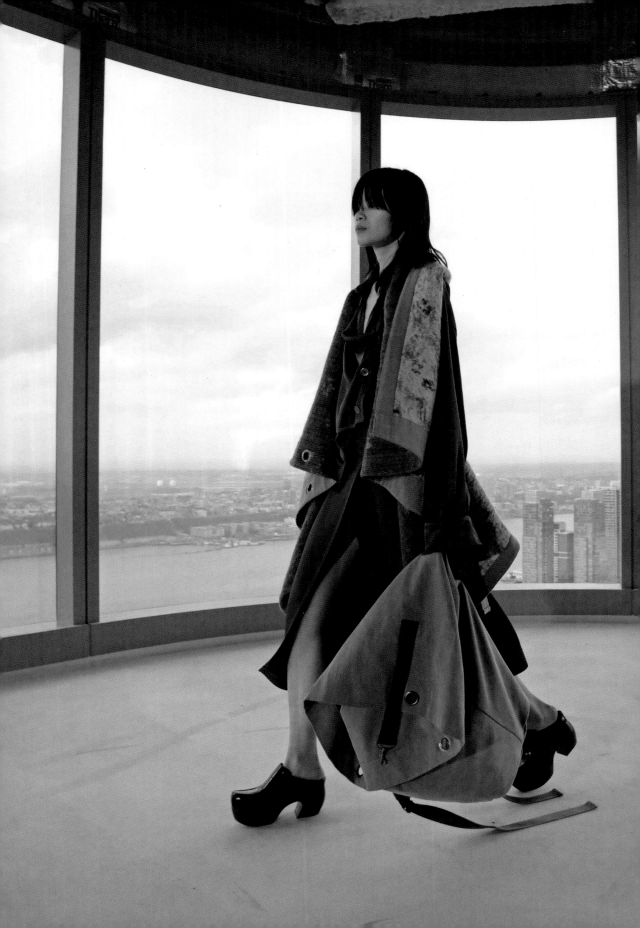

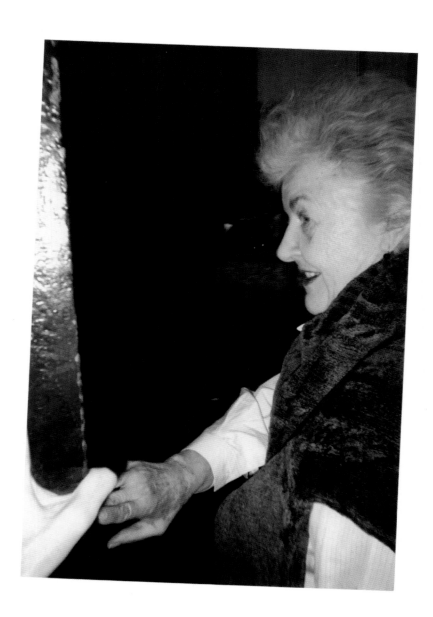

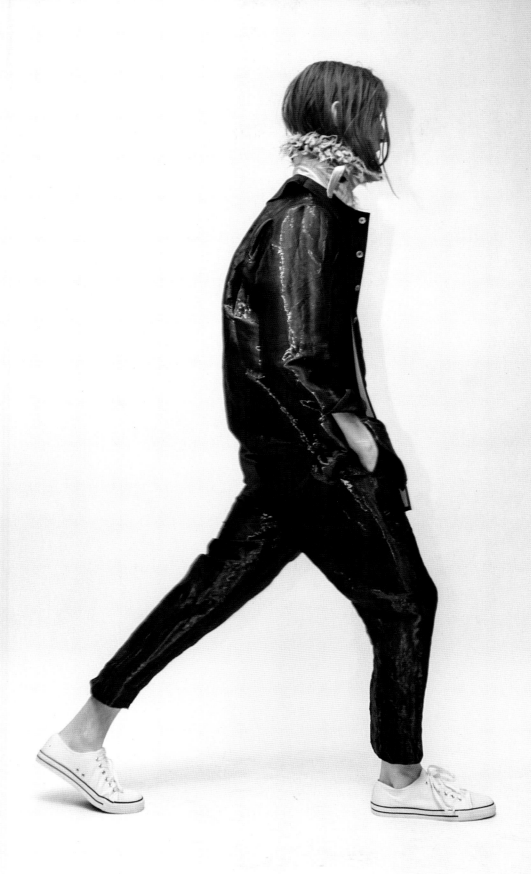

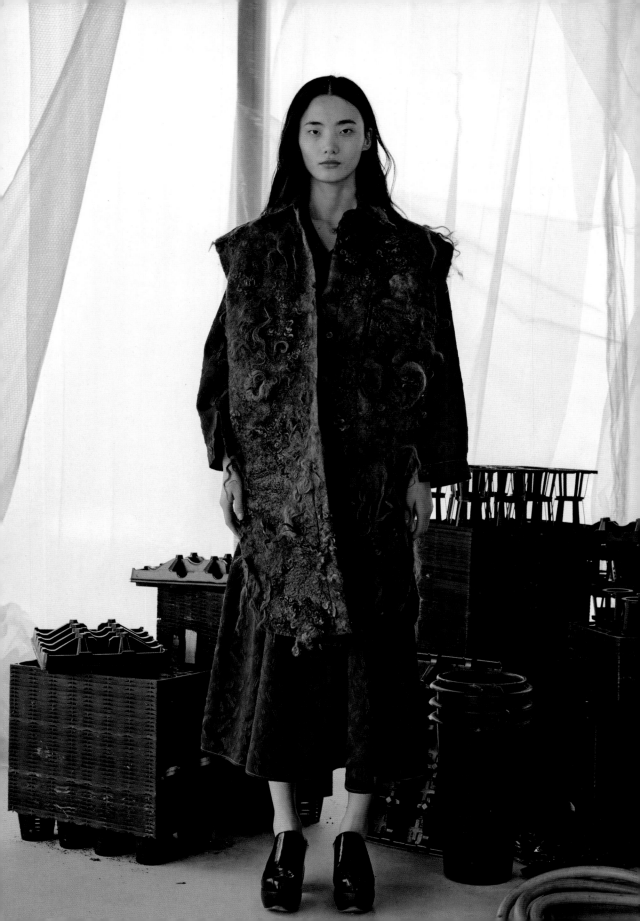

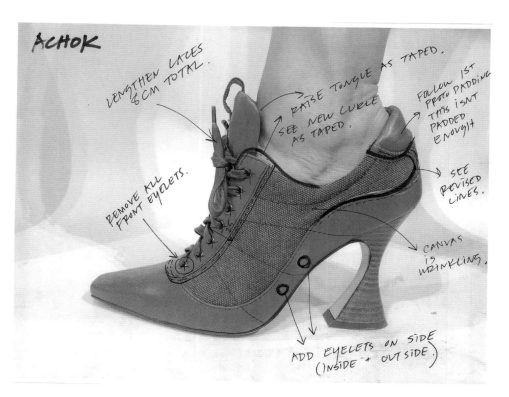

ACHOK

LENGTHEN LACES
8 CM TOTAL.

RAISE TONGUE AS TAPED.
SEE NEW CURLE
AS TAPED.

FOLLOW 1ST
PROTO PADDING
THIS ISNT
PADDED
ENOUGH

REMOVE ALL
FRONT EYELETS.

SEE
REVISED
LINES.

CANVAS
IS
WRINKLING.

ADD EYELETS ON SIDE
(INSIDE + OUTSIDE.)

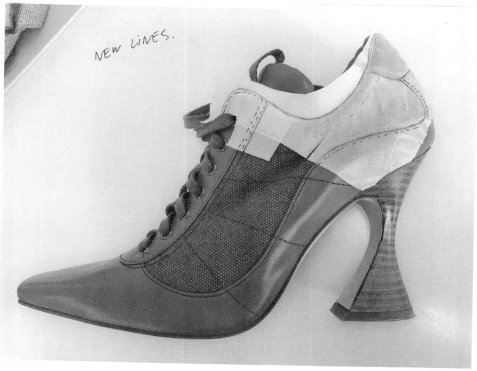

NEW LINES.

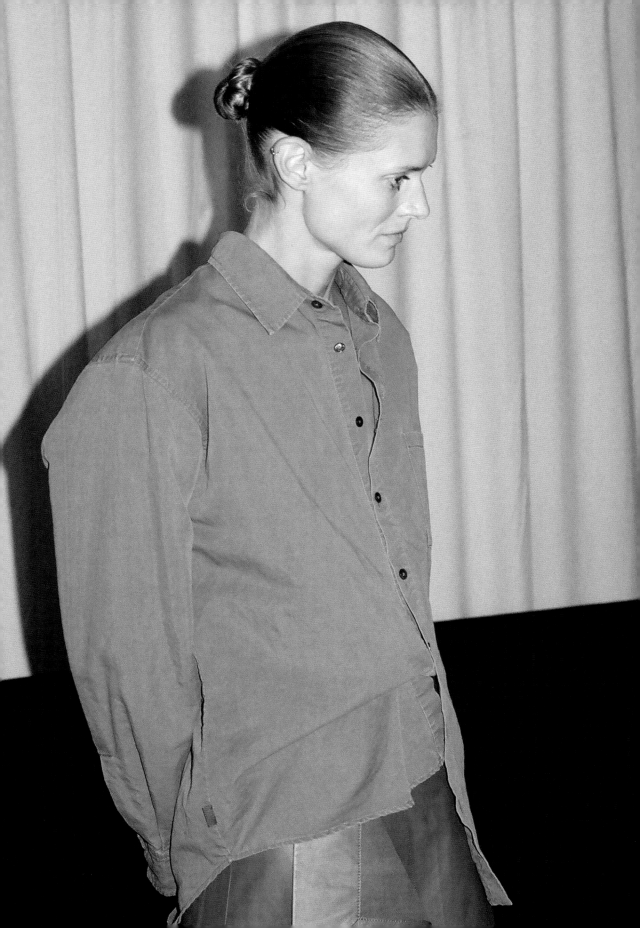

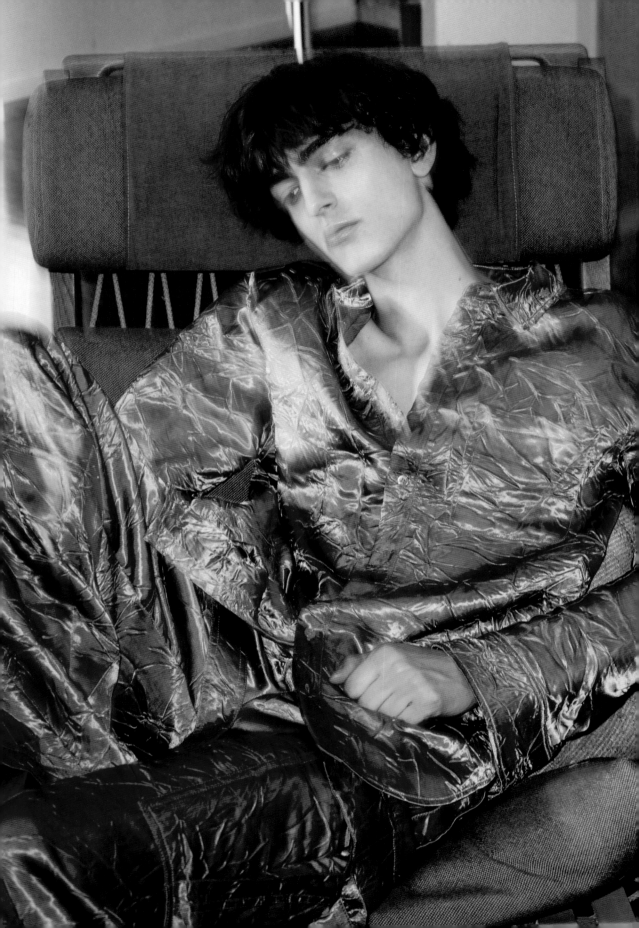

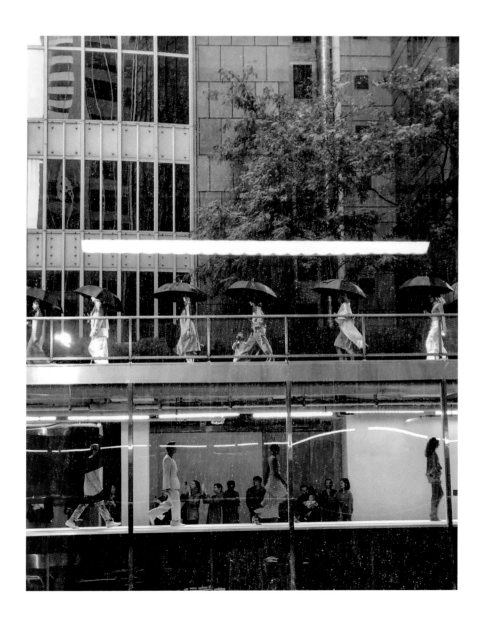

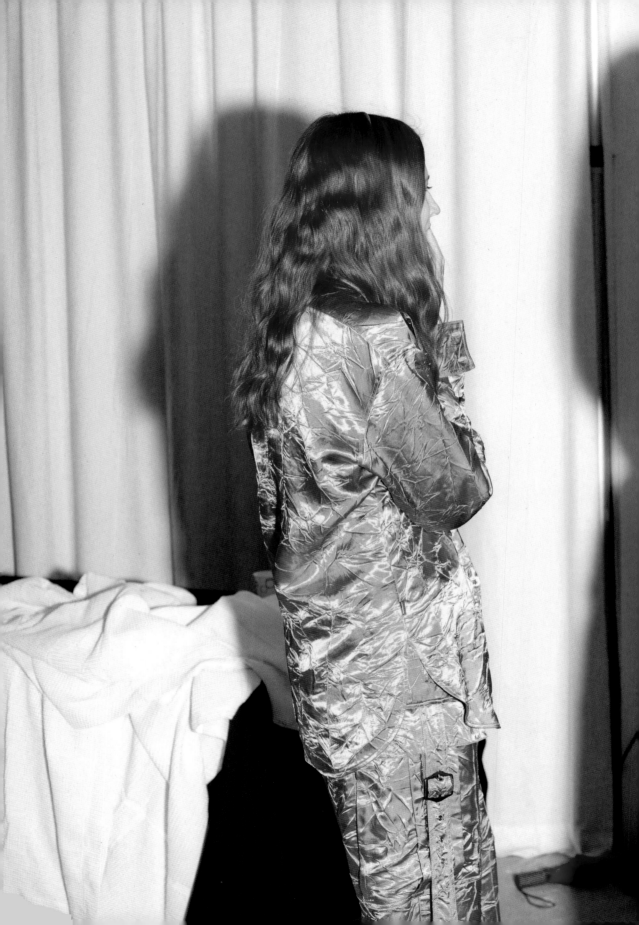

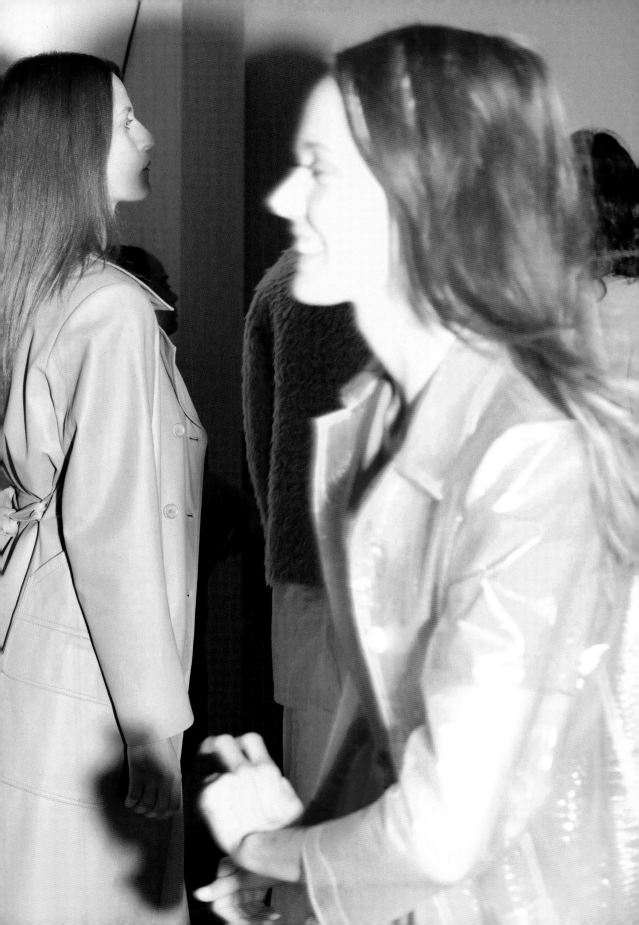

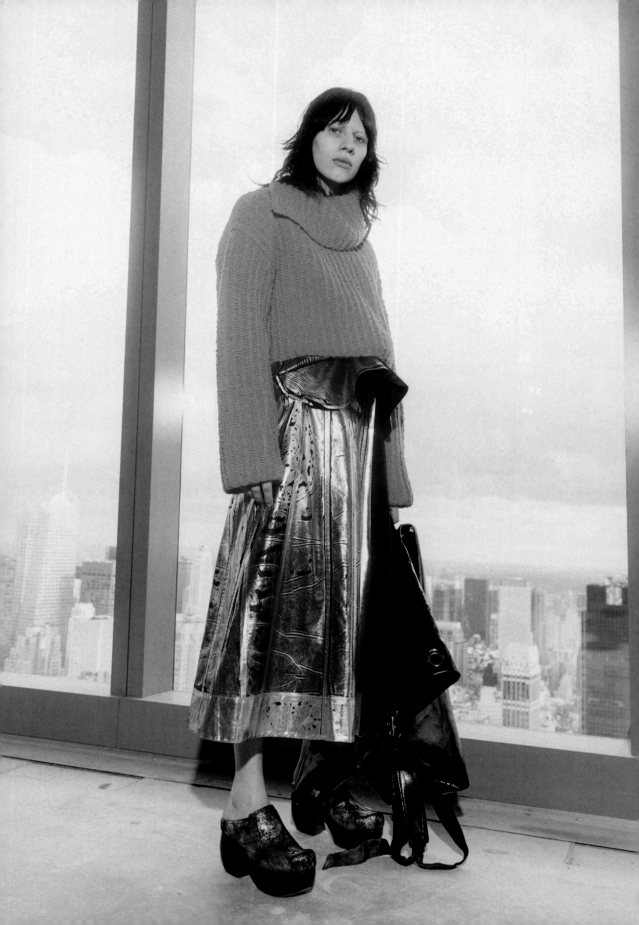

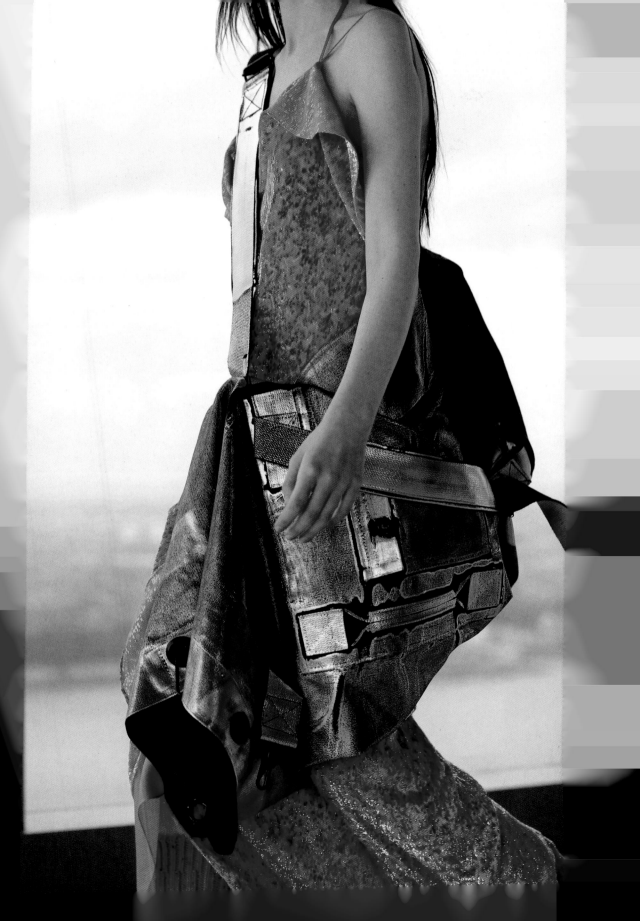

Sarah Sze, *Dews Drew (Half-life)*, 2018.

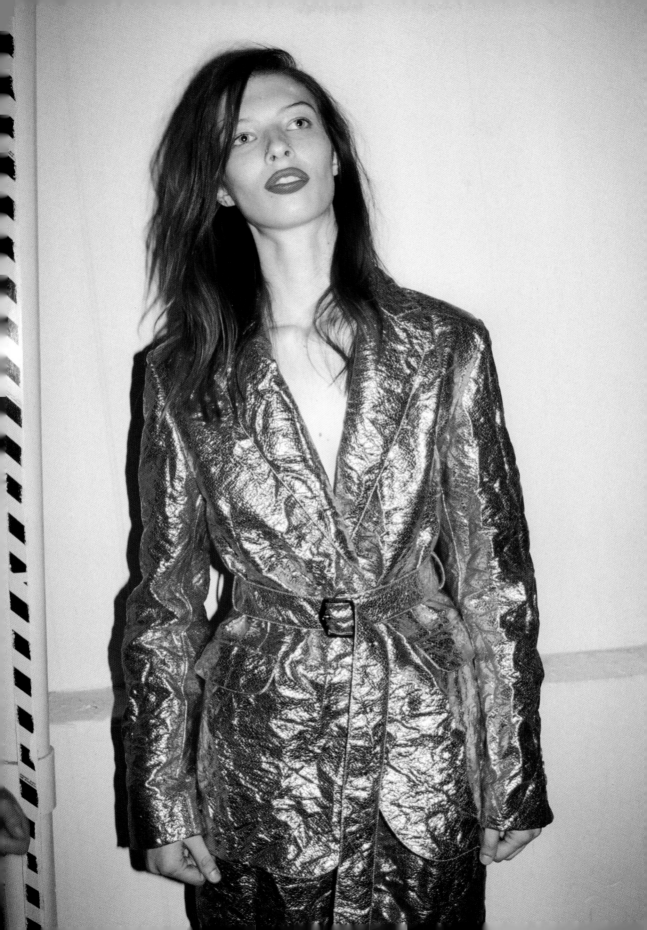

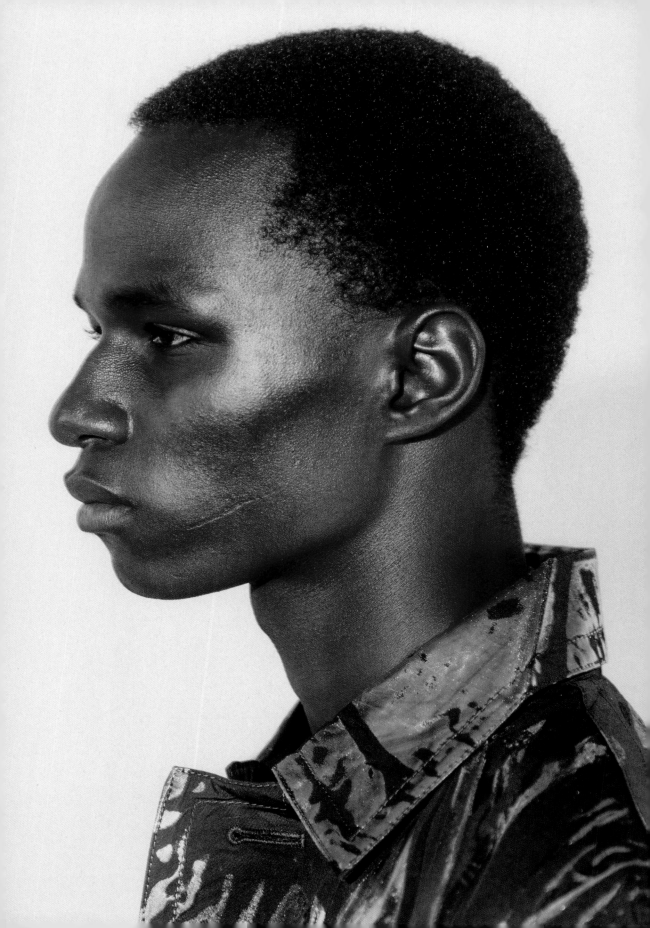

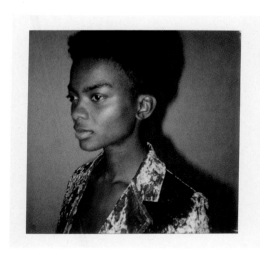

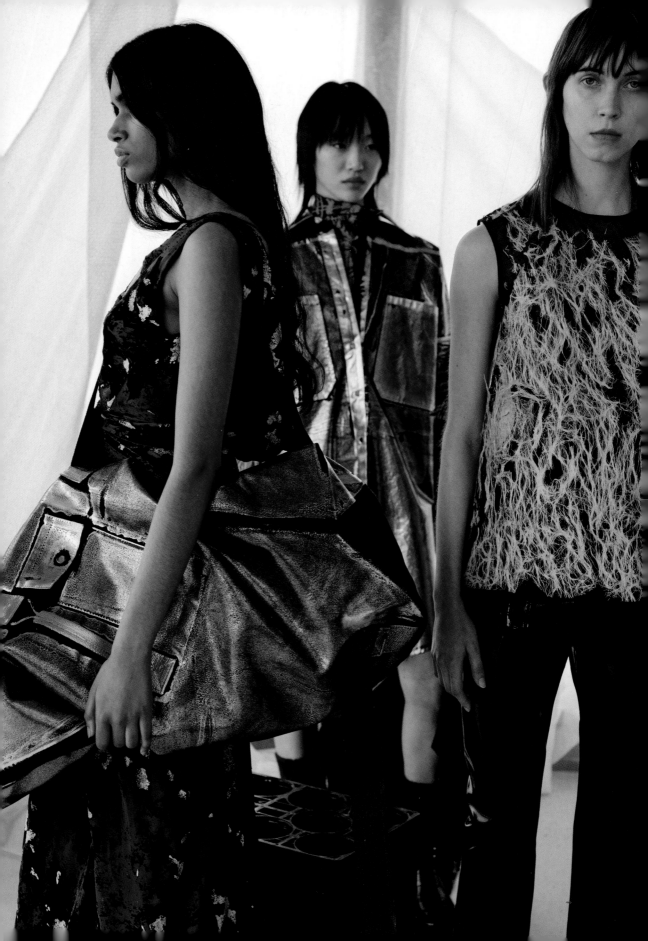

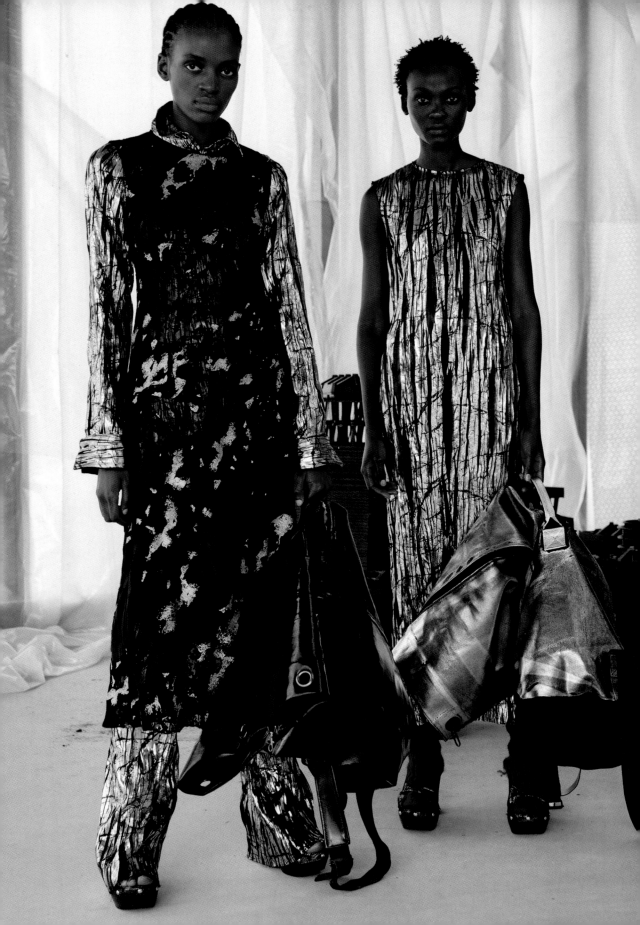

Julie Mehretu, *Of Other Planes of There (S.R.)*, 2018-2019.

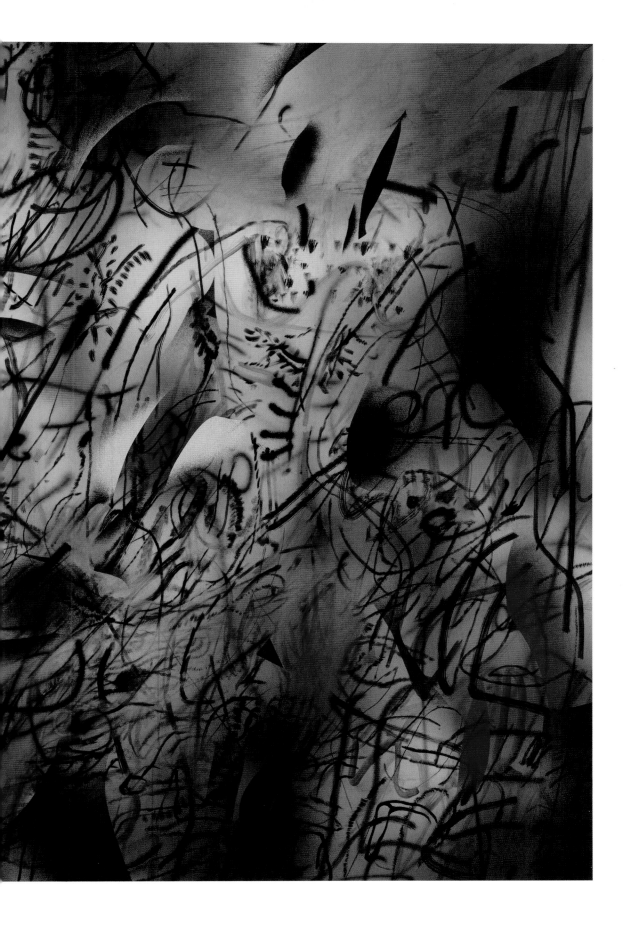

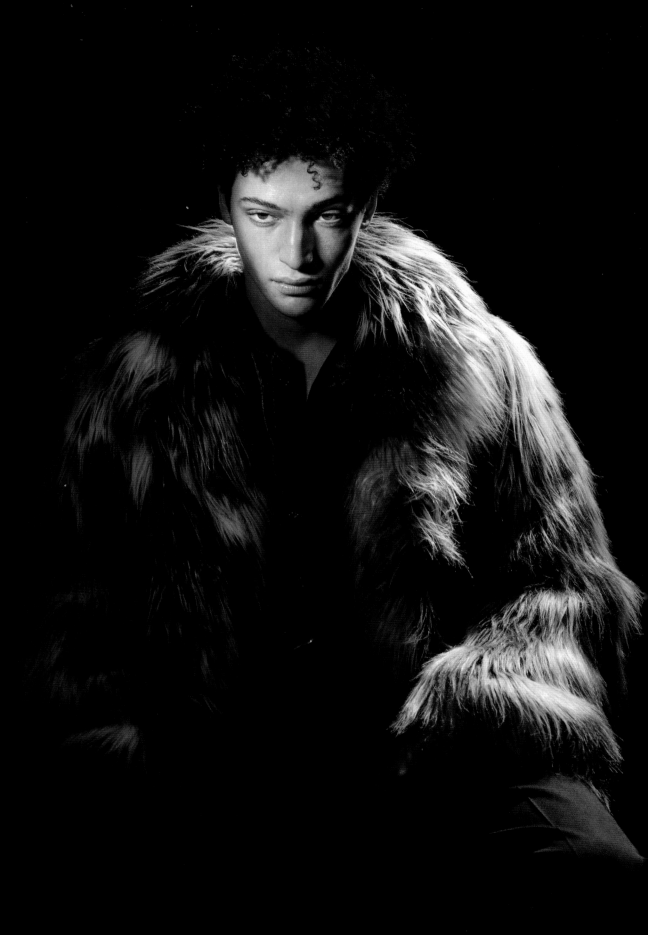

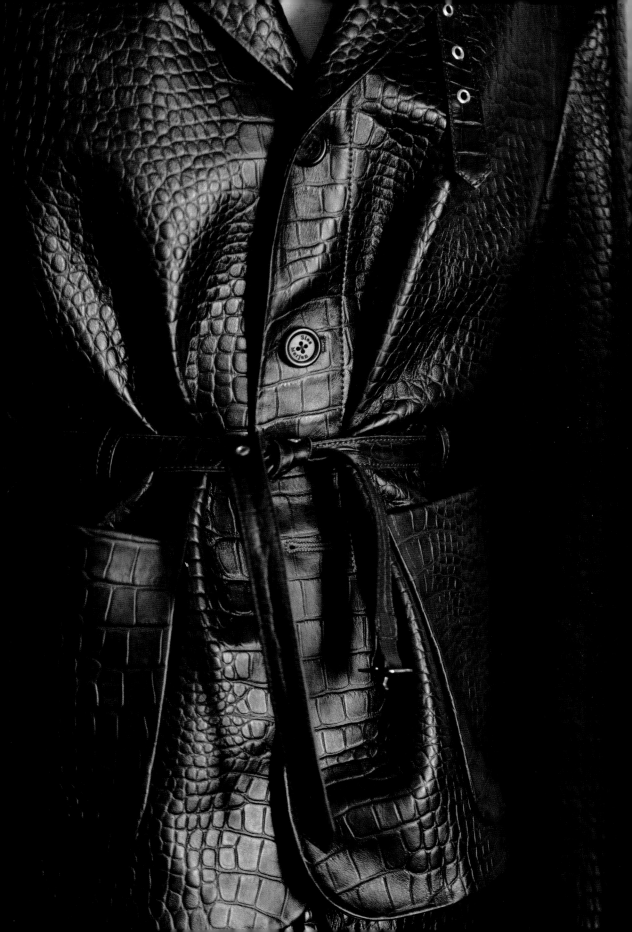

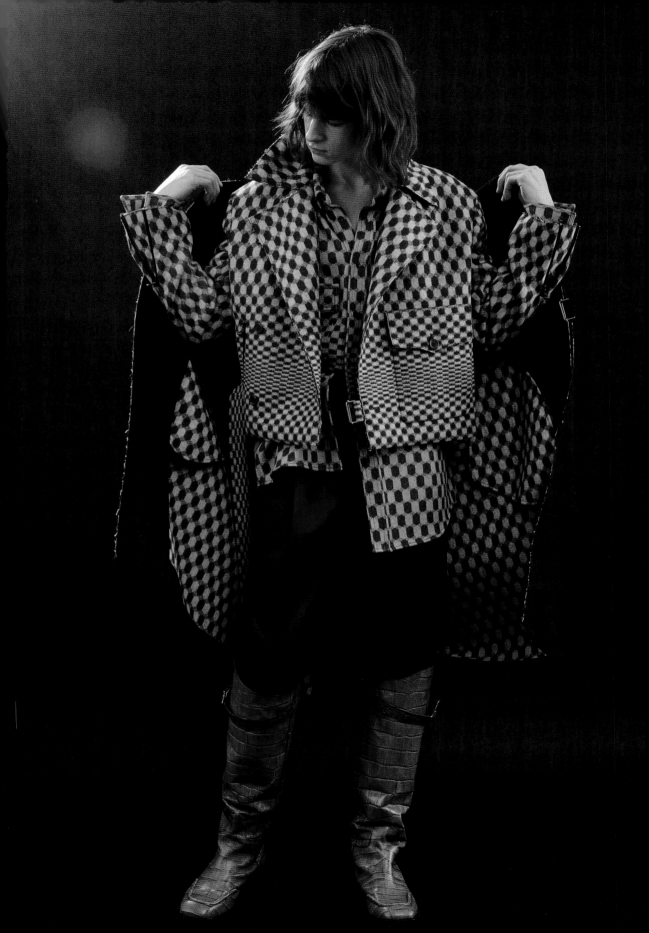

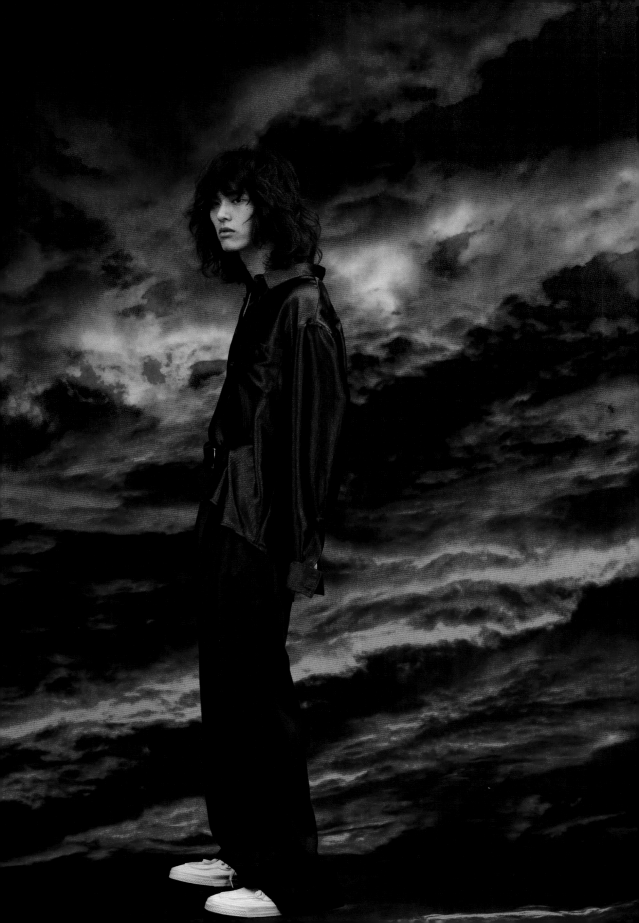

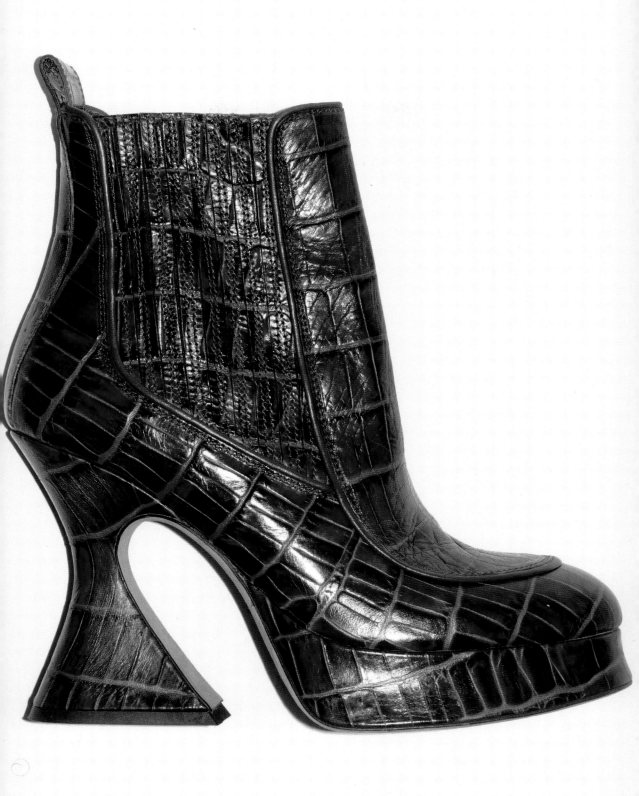

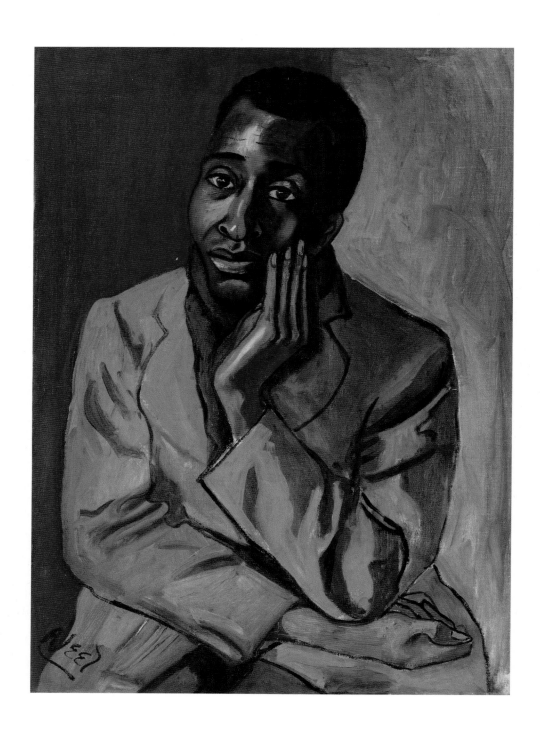

Alice Neel, *Harold Cruse*, 1950.

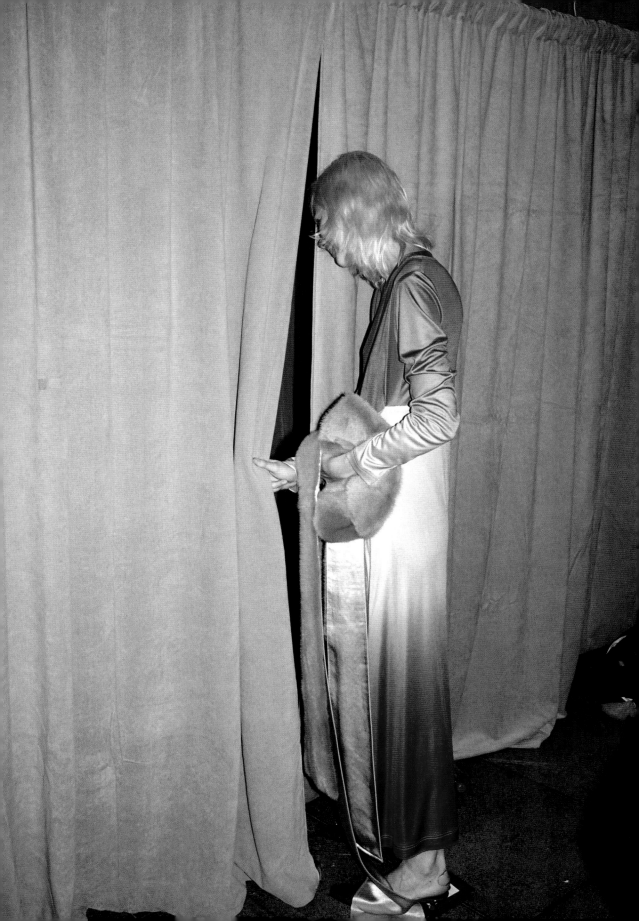

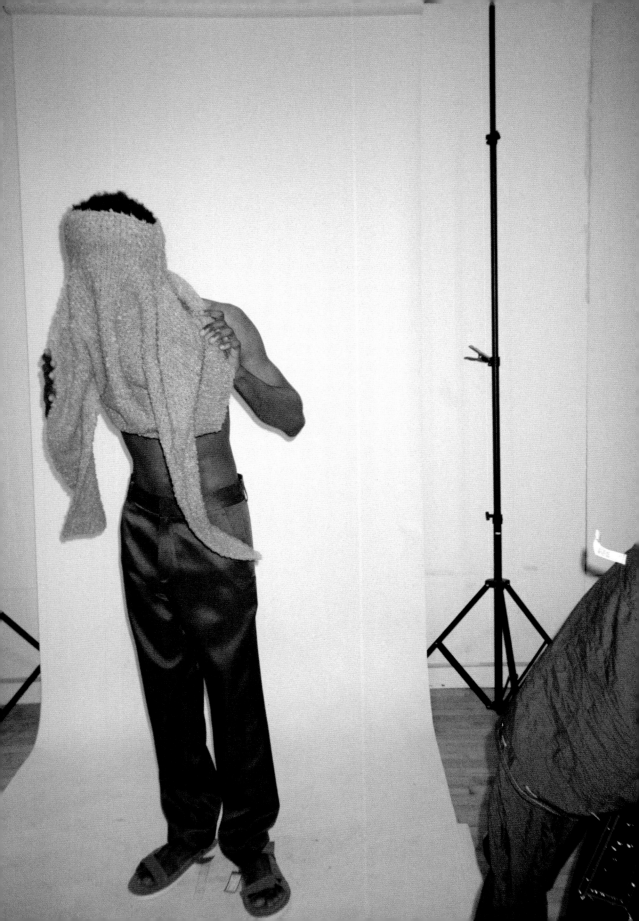

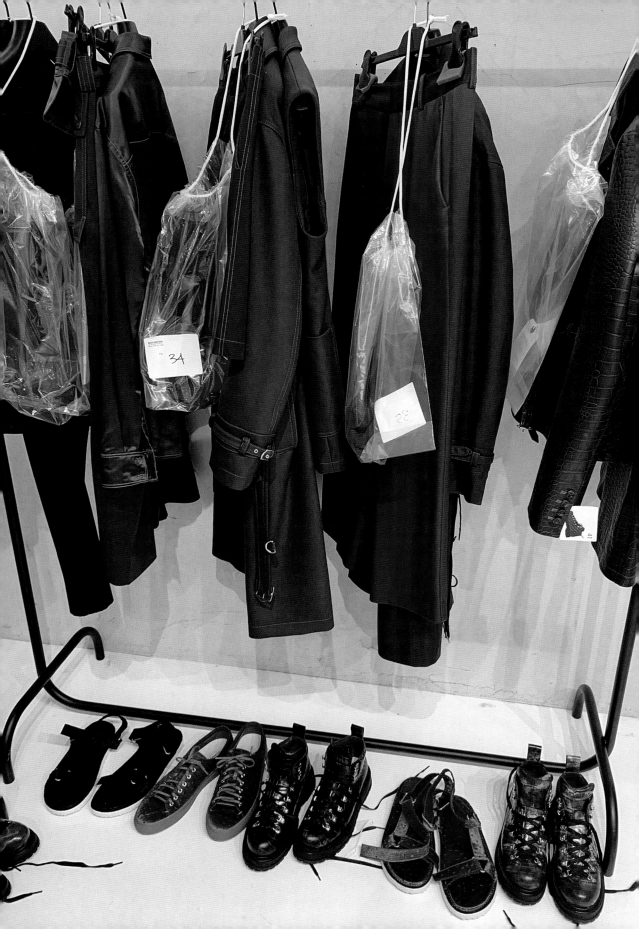

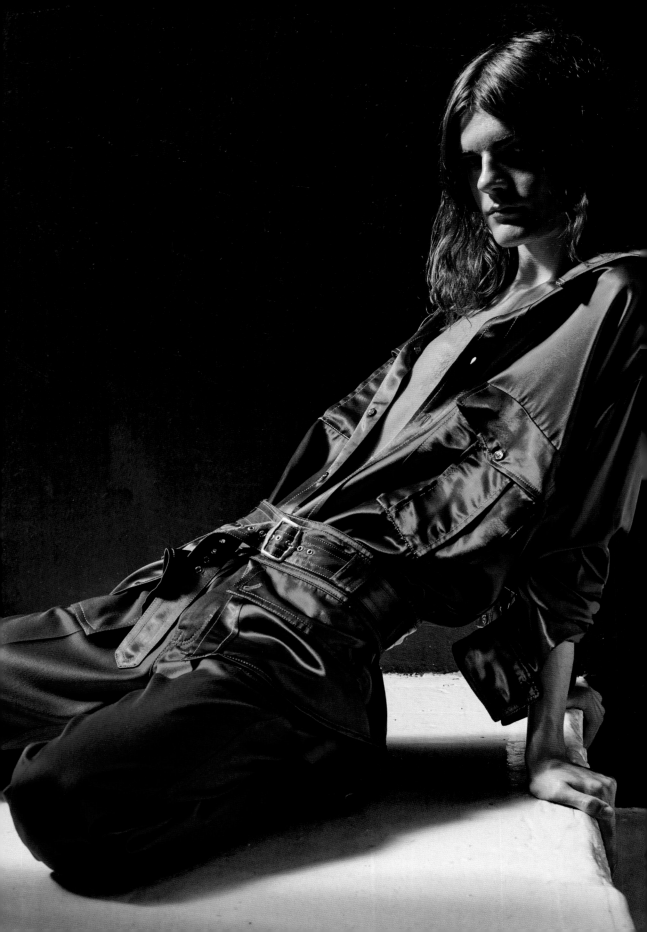

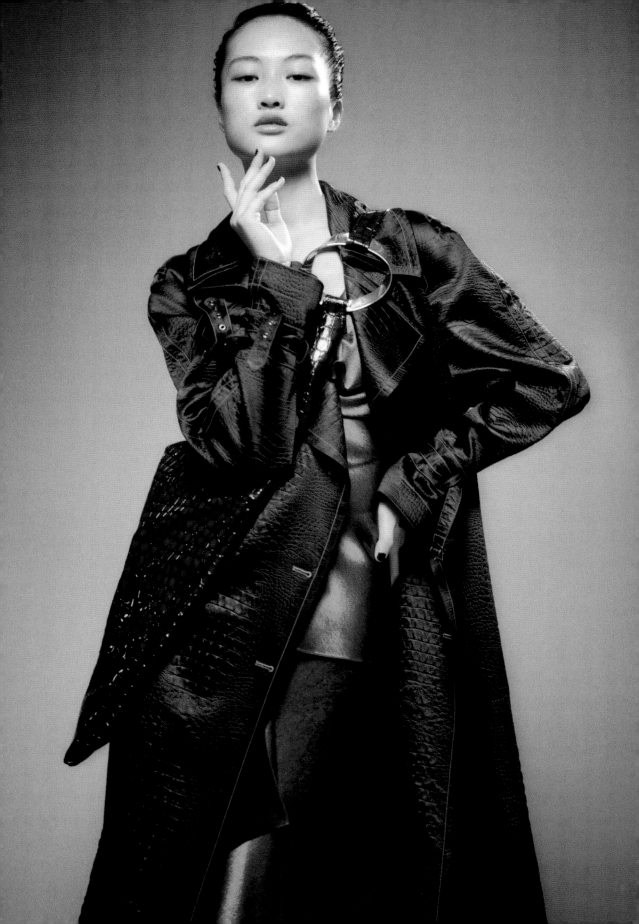

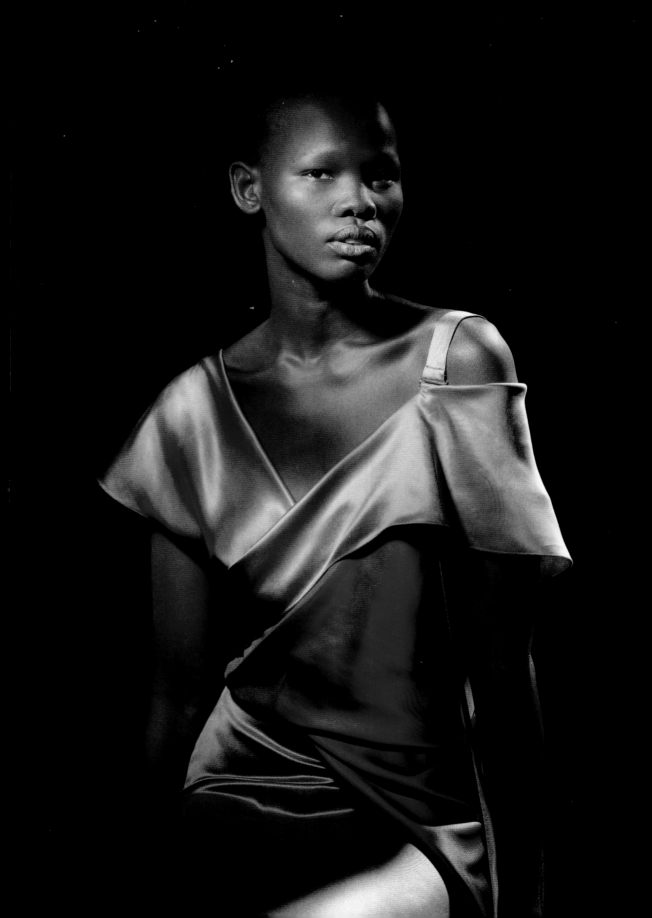

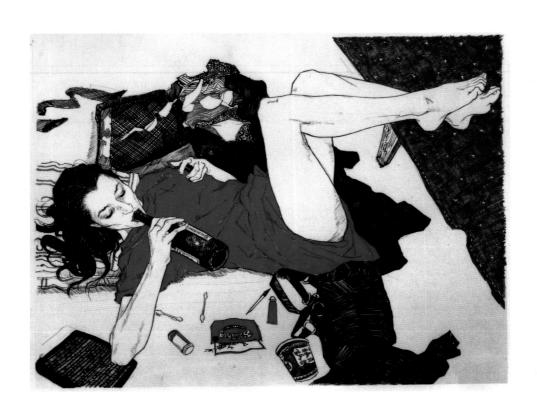

Hope Gangloff, *Captain Chaos*, 2008.

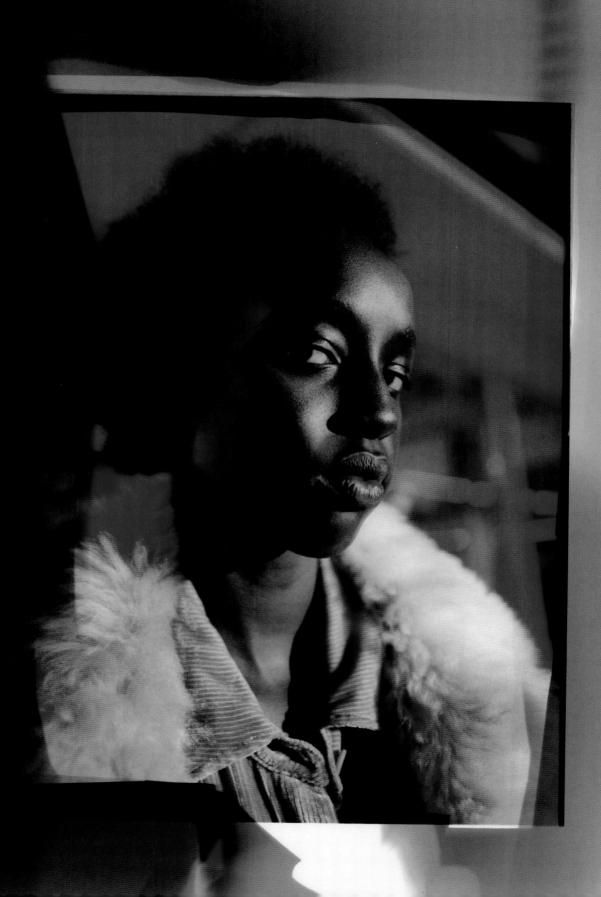

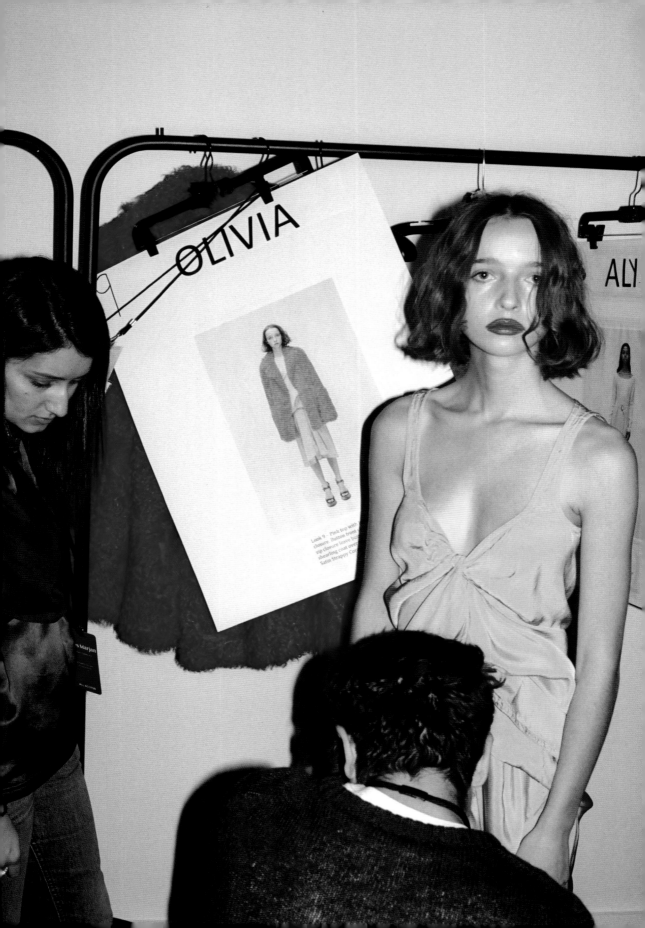

OLIVIA

ALY

Look 9 - Pink top with
closure button front
zip closure leave bel...
shearling coat ove...
Satin strappy Co...

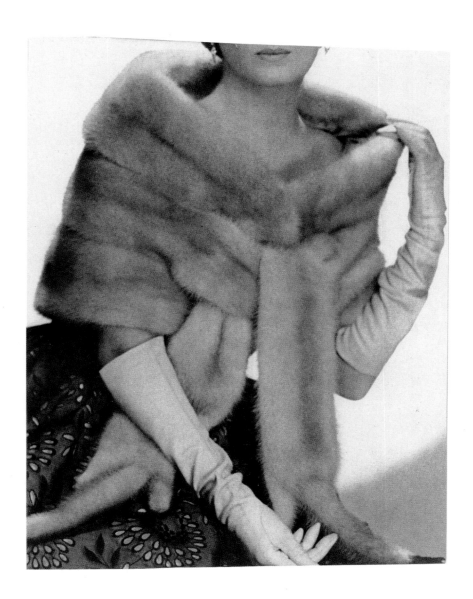

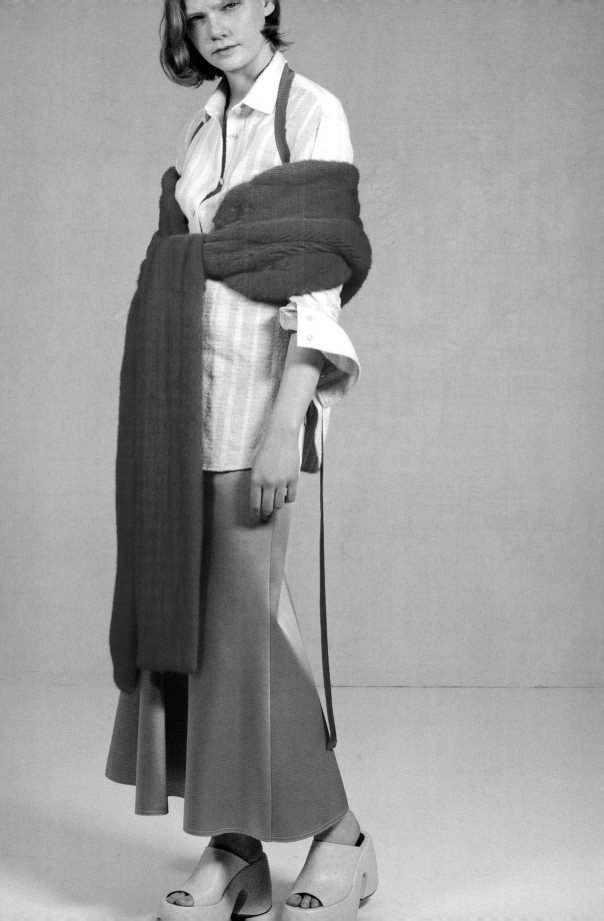

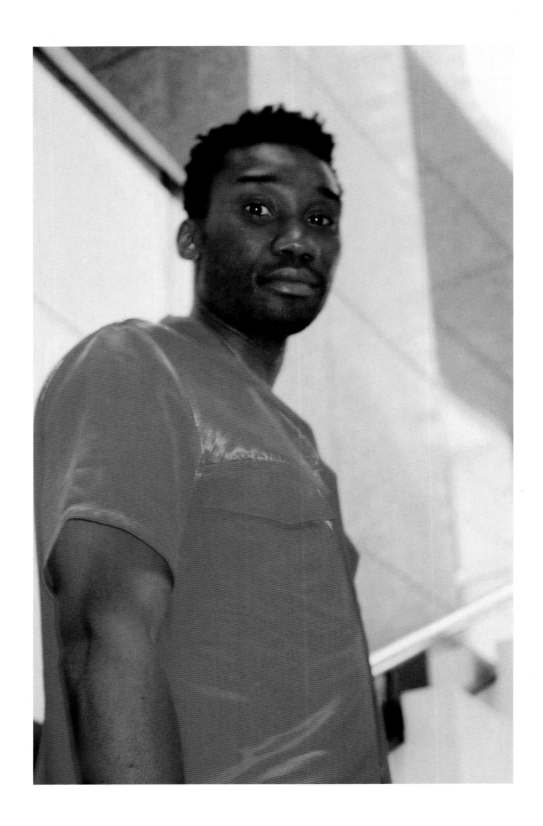

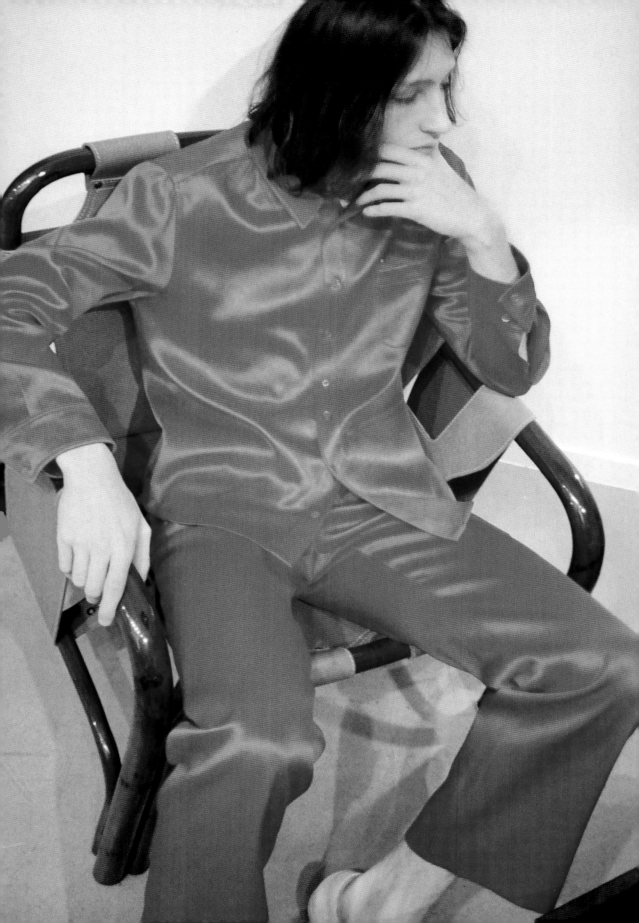

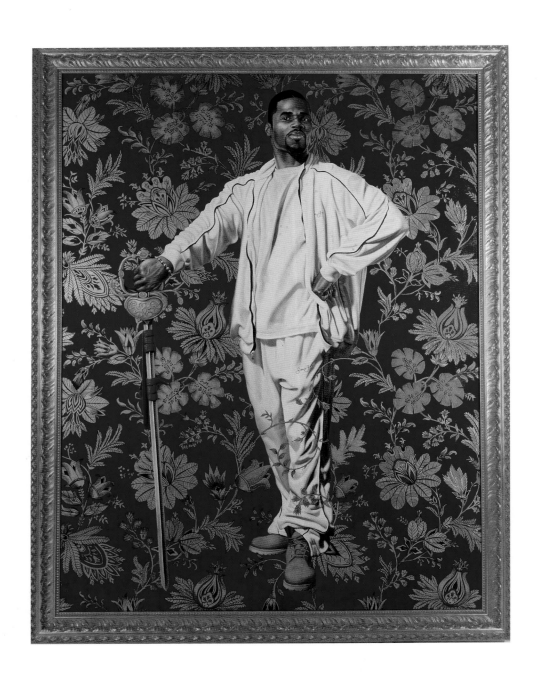

Kehinde Wiley, *Willian Van Heythuysen*, 2006.

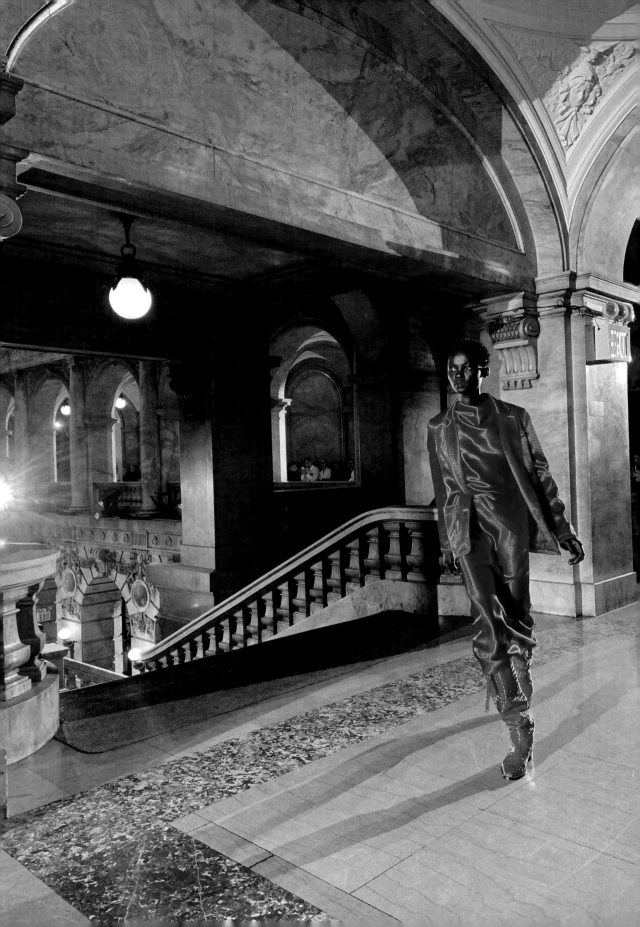

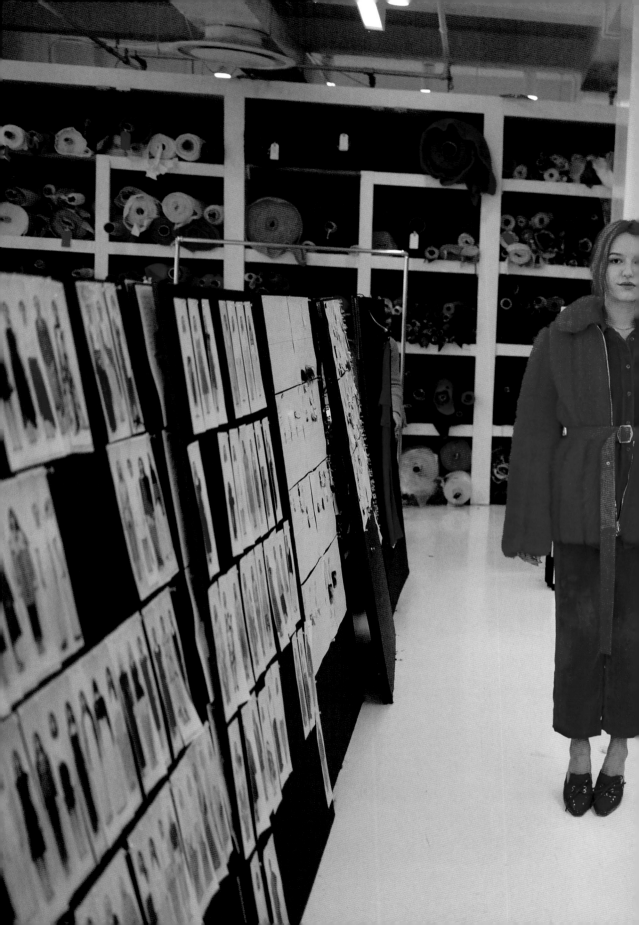

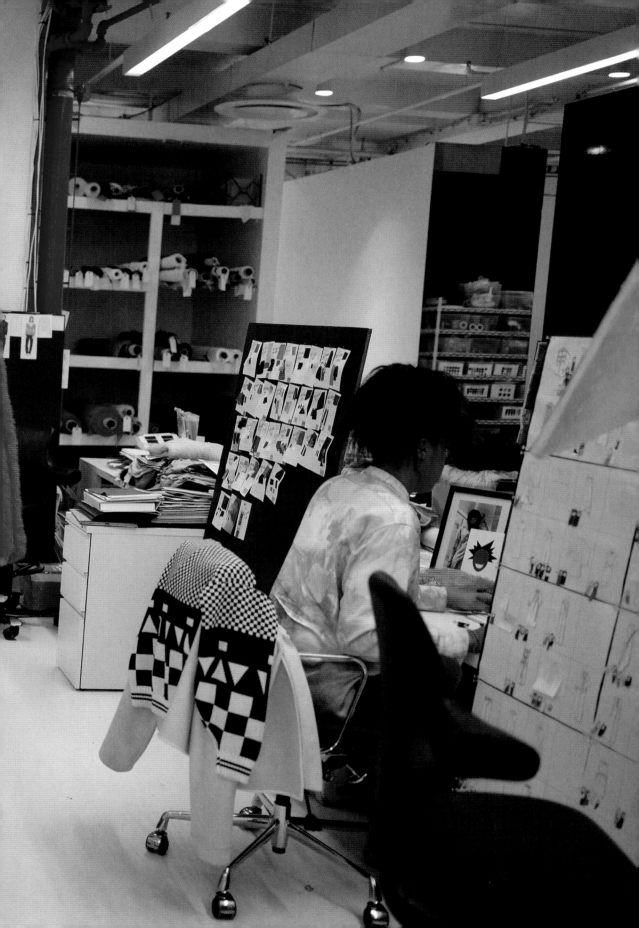

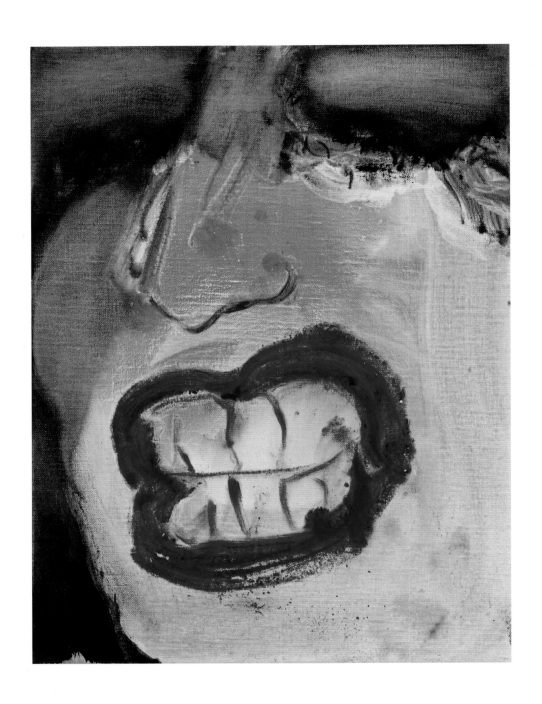

Marlene Dumas, *Teeth*, 2018.

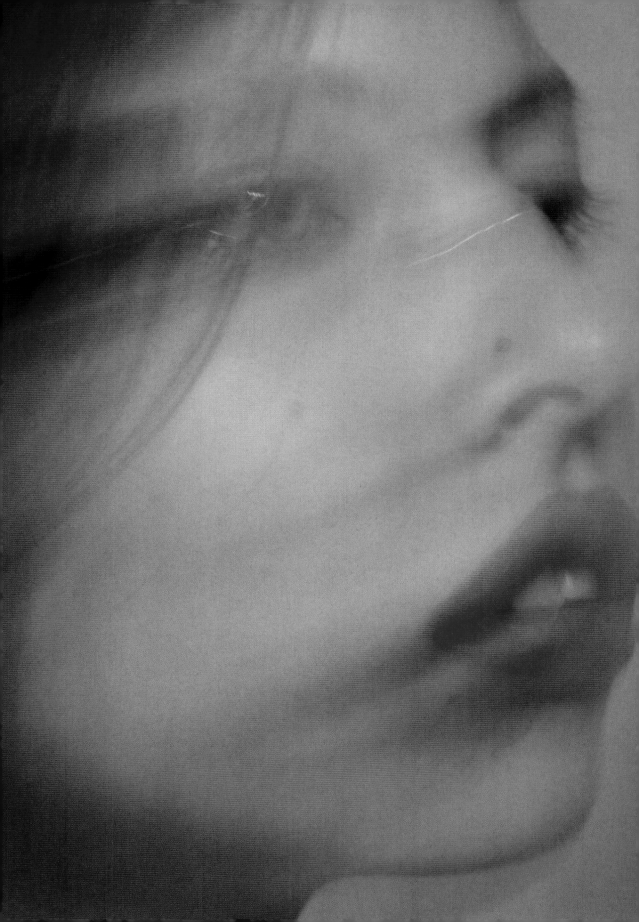

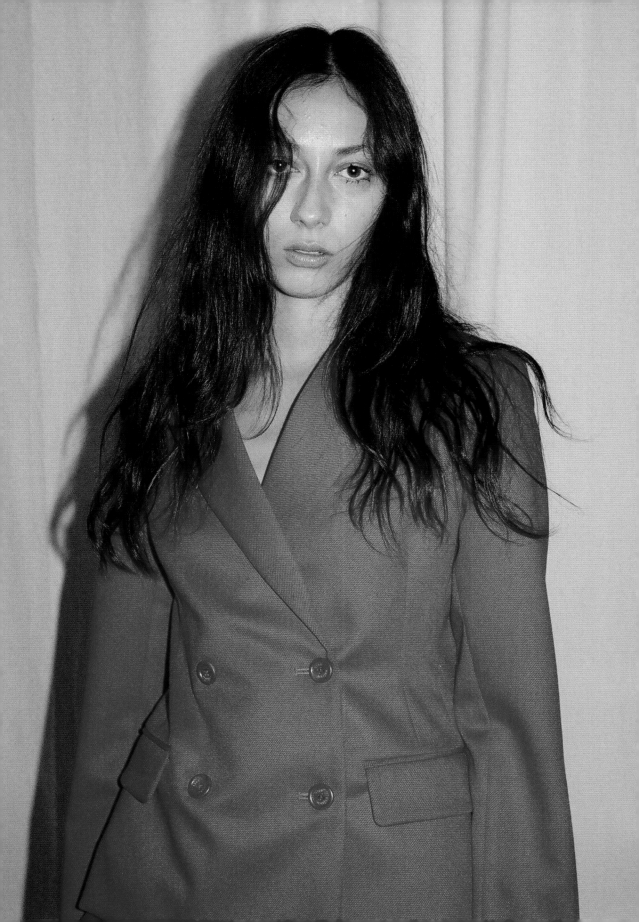

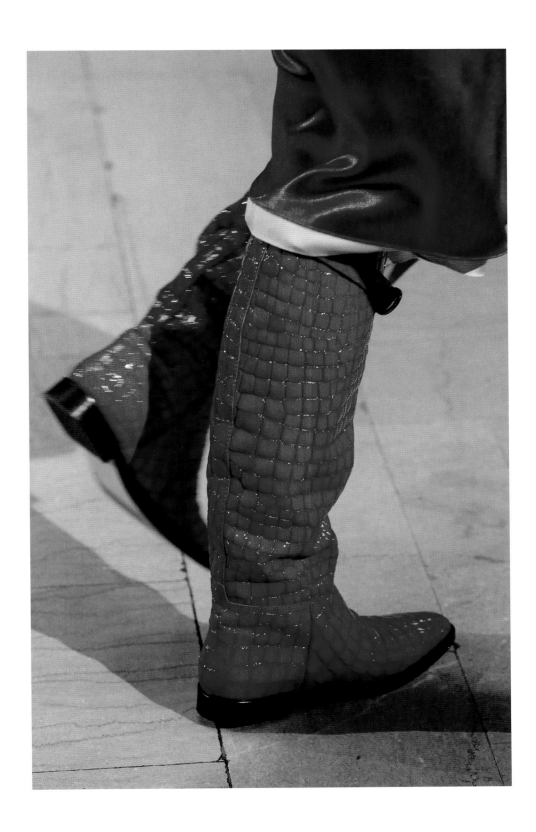

281

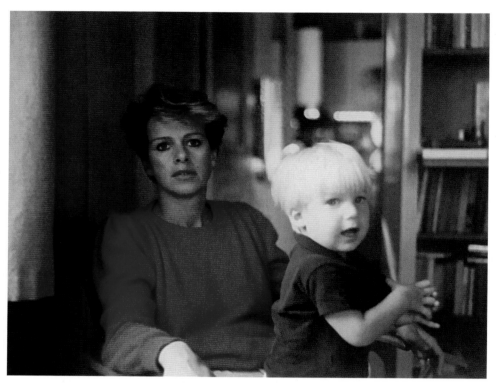

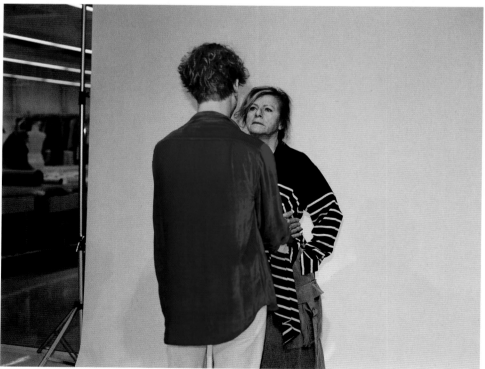

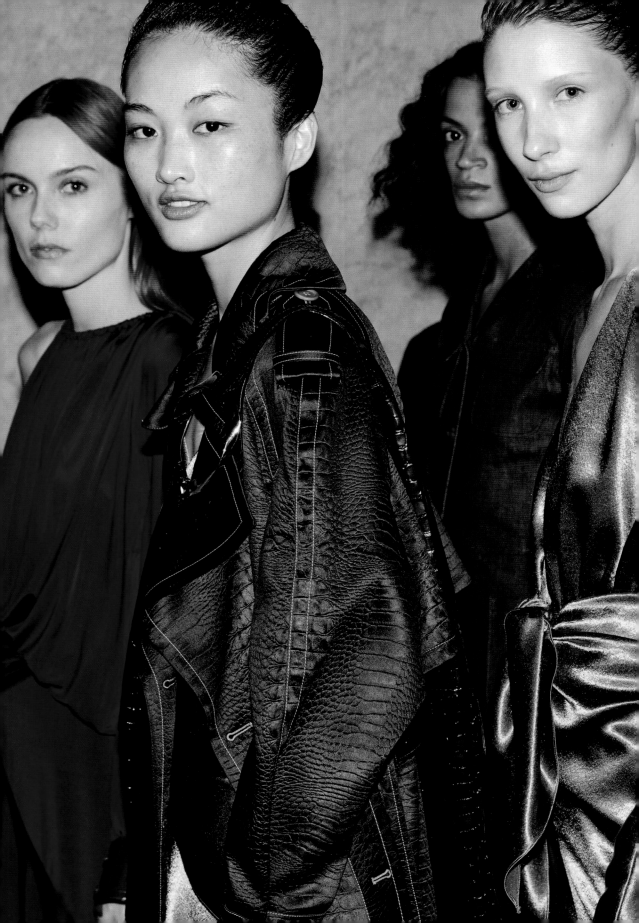

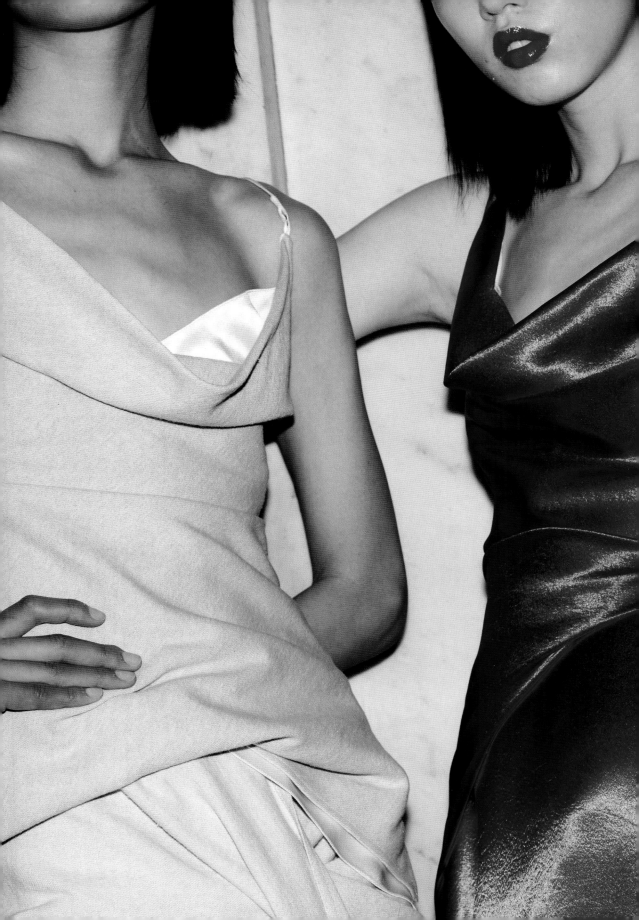

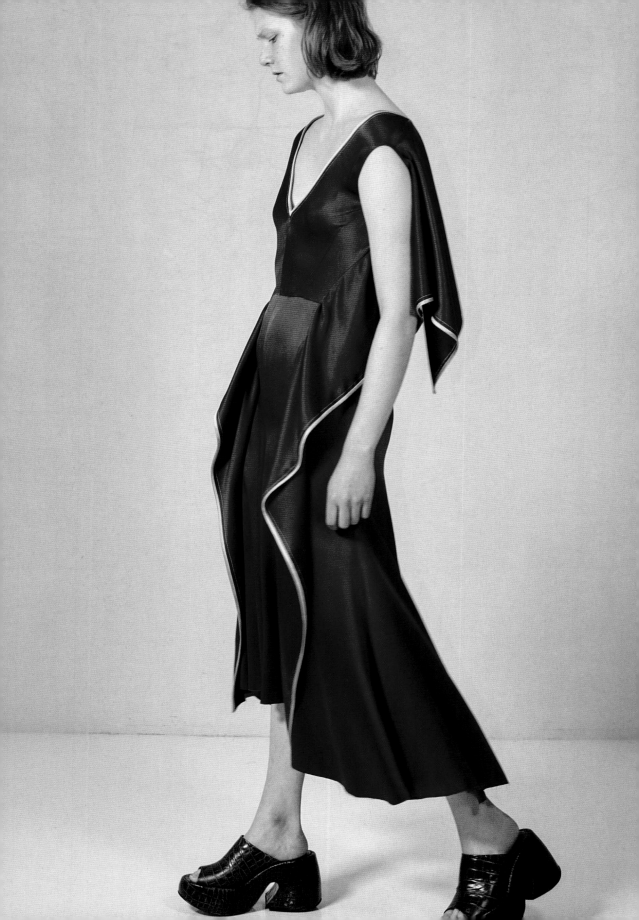

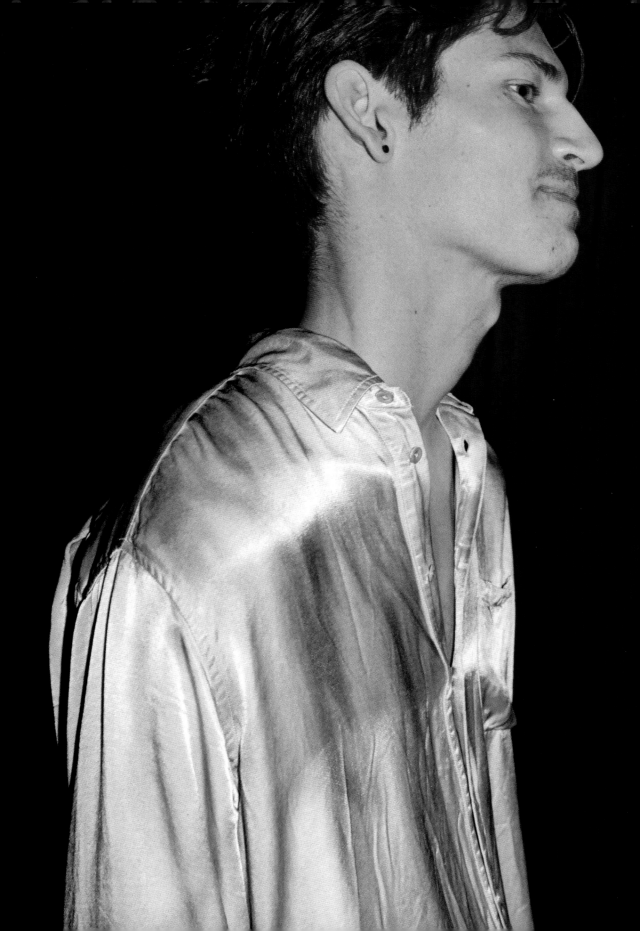

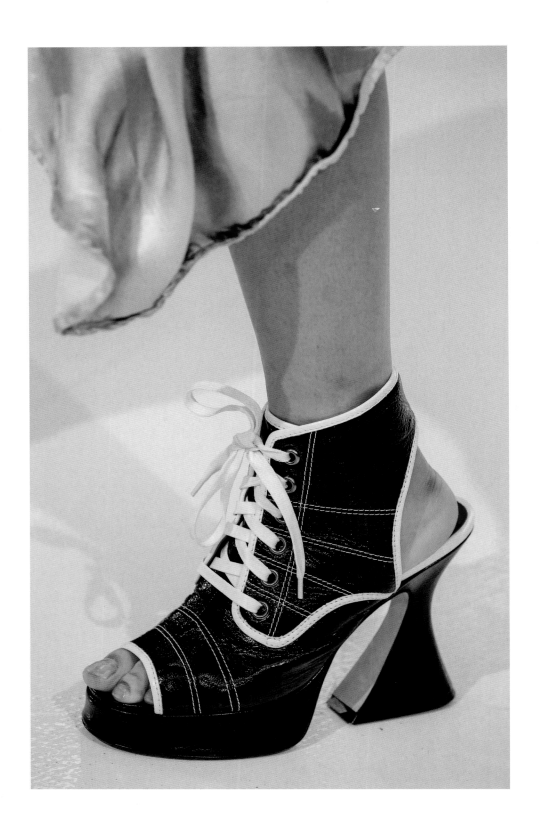

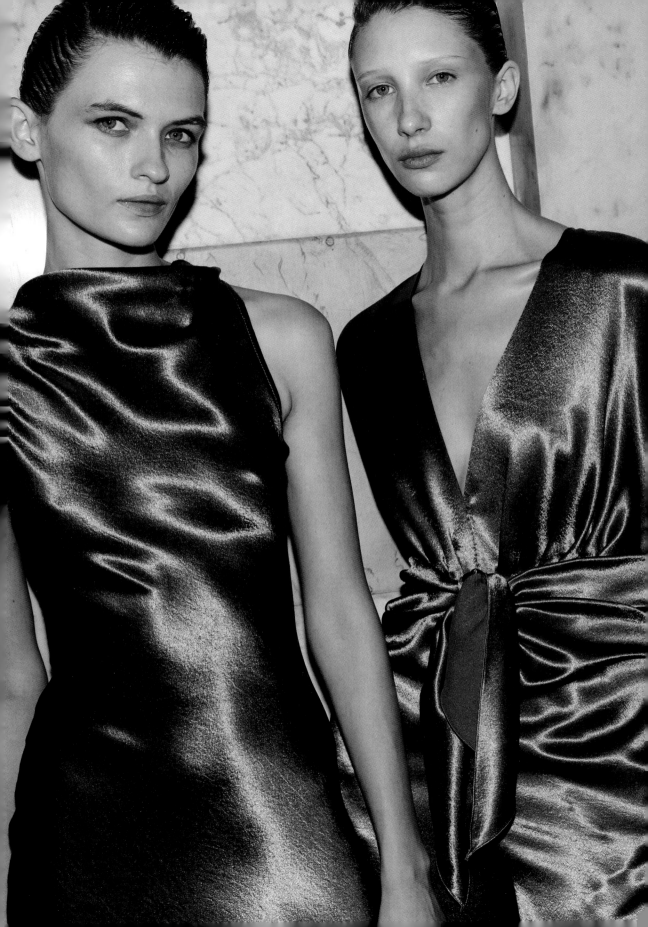

COLOR COPIES

REIKI OFFERED AFTER WALKING THE LABYRINTH

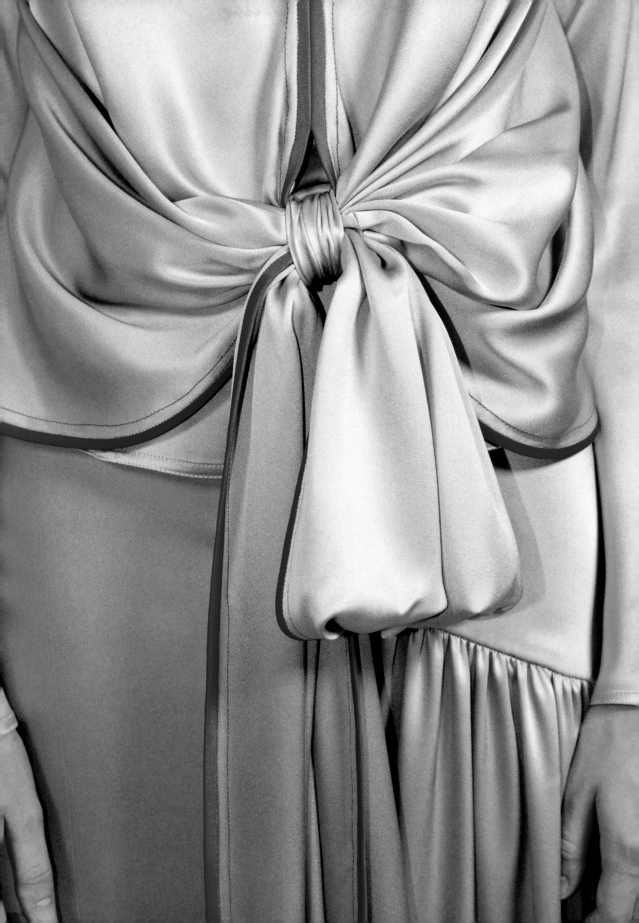

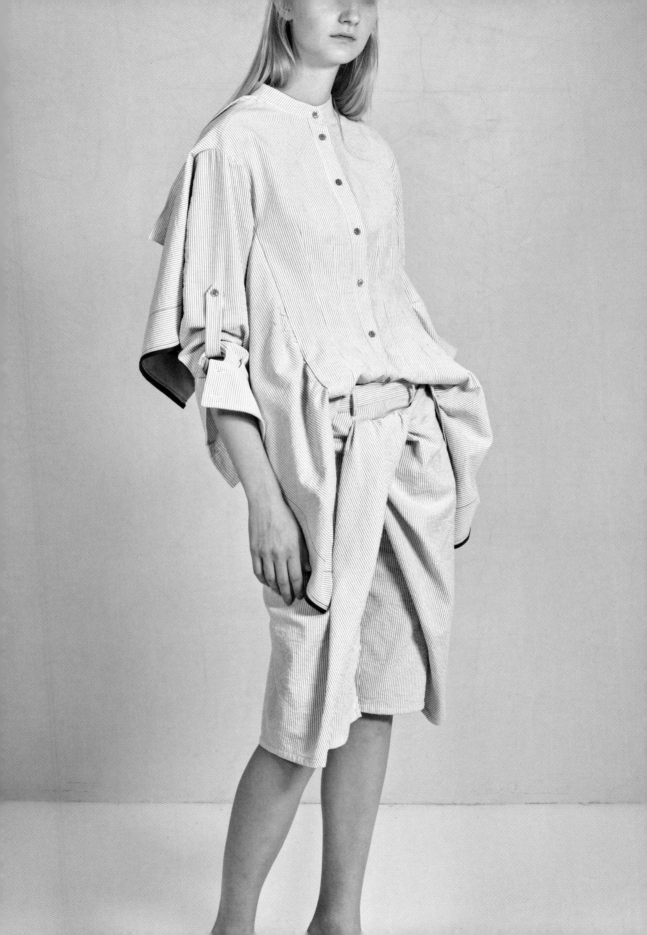

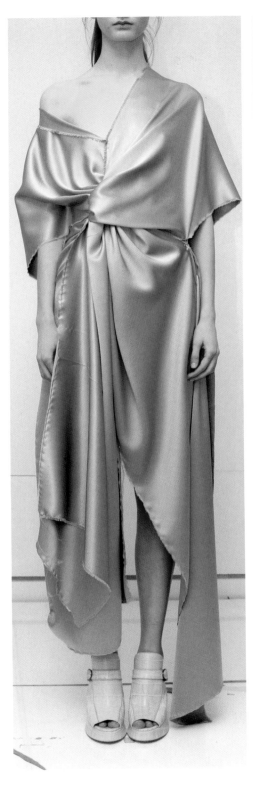
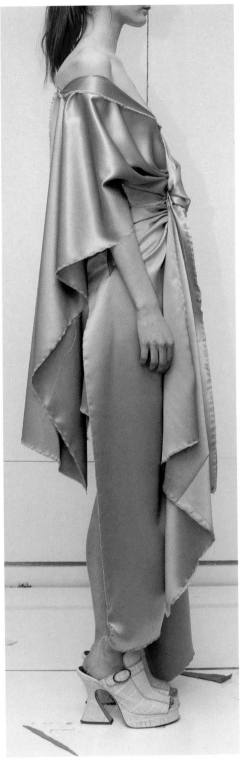

Girlfriends Project 2016, part 2
October 27th, New York

Sies

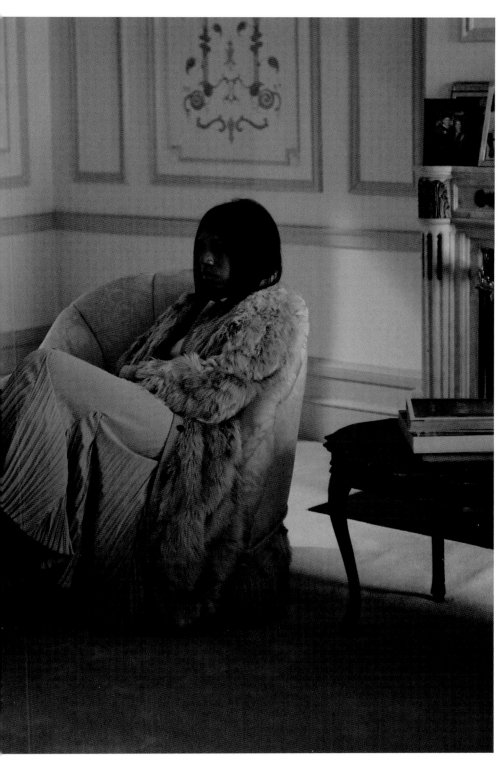

rjan

Photographed by Nigel Shafran
Boya, friend since 1996

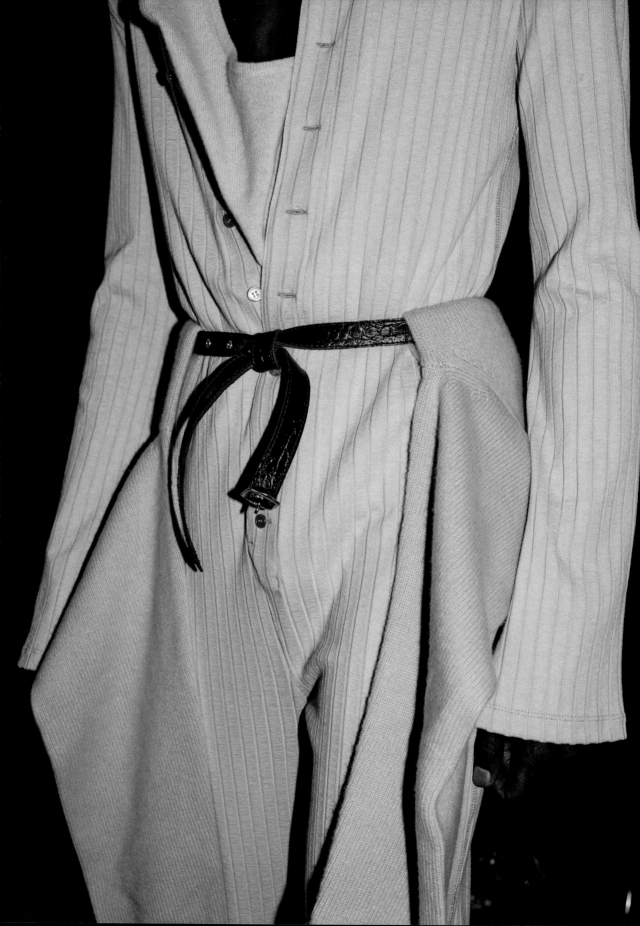

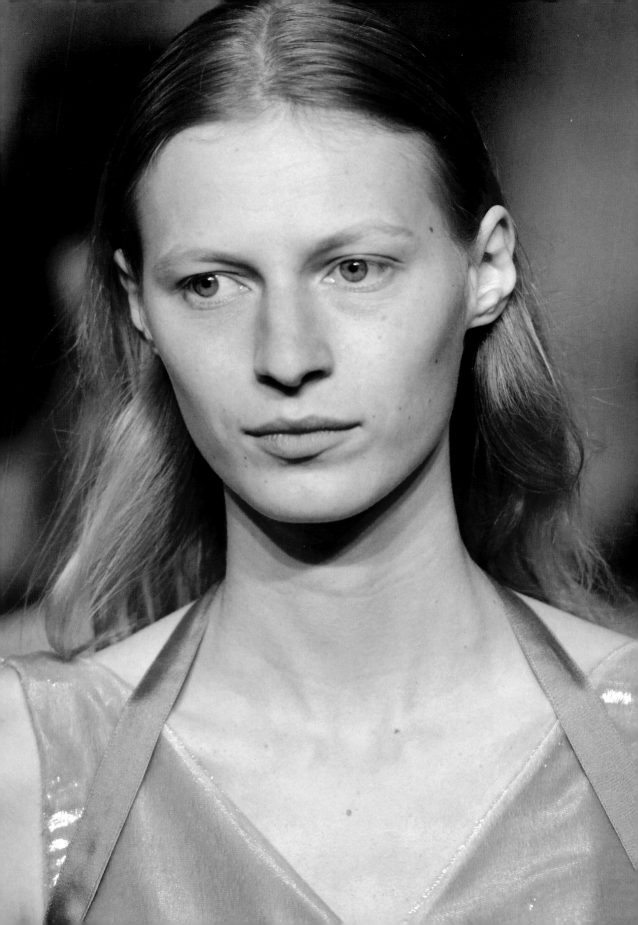

Conversations about color with...

Part 3: Fashion designer Marc Jacobs, writer/editor Hanya Yanagihara, model/actress Isabella Rossellini, and artist Sheila Hicks.

Marc Jacobs

Marc Jacobs is a fashion designer, the founder and head designer of his own fashion label, Marc Jacobs, and formerly the creative director of Louis Vuitton from 1997 to 2014. I met Marc the first time when I interned for his menswear line in 2006 and reconnected when I found my way back to New York to start Sies Marjan.

Sander Lak: What are some of your earliest memories of color?

Marc Jacobs: When I was about 9 years old there was a red mini-wale corduroy Lacoste button-down shirt that I just absolutely coveted. It was such a bright red. From very early on, red was the color I was most drawn to. As a child, I always had trouble sleeping, and I would envision folding this red corduroy shirt in my mind to try and put myself to sleep. And when it was all folding nice and neatly, it was like counting sheep, and I slept.

SL: Is color important for you?

MJ: Yes! Because I think it makes the world a more beautiful place, and it makes me feel something, which can be melancholic, or it can be happy or ecstatic. Looking out my window now and seeing the greens start to come back on some of the trees and the remainder of some of the fall browns, the colors of nature, I like my mood changes with the colors around me. Where I'm sitting today is not indicative, but in my environment, I also like

a particular palette of colors because it makes me feel warm and calm and comfortable. Also, in a much more personal way, I find that color reflects my mood in terms of what I wear and what I choose to wear. And I like to show how I'm feeling. And I do that through what I wear.

SL: Can you talk a little bit about your experience of wearing color?

MJ: First of all, I'm a shopper! I love to buy clothes, shoes, and accessories. I really enjoy fashion. On a personal level it just makes me feel good. And I'm very drawn to color. I have been known to buy a very bright red coat and think that I will never wear it, but because it's so much red, I'm just like, I love it and I have to have it! And then when I start to think about what I would wear it with and how I put it together, I get very, very excited. Creating a color story or styling myself—I love it. If I find a sweater or a pair of pants that I love and it comes in four colors, I buy all four colors. Sometimes I think of what a painter would have as a palette of colors, and you'd just pick the things that would transmit a kind of mood or a certain energy. And for me personally, my mood and the energy that I want to transmit, it's like I go to the closet, and I put it together to reflect that.

SL: When does color come into play in your design process?

MJ: I always envy how I imagine other designers work, because I always imagine that they have a very clear and focused vision of what they're working

toward, and that's not the case for me. So, in the beginning—and it's been like this for thirty-some odd years—I start a collection with fabric; the color part of the fabric choice is just instinctive. It has nothing to do with a kind of theme or an idea. We're very loose about it, like, this color looks really interesting to me right now or this color I really gravitate toward. I sort of start out sometimes saying like, I really love yellow. Yellow may not even end up in the final collection, but it's a catalyst for moving forward. And sometimes I have tried to be very specific about a color palette. Just a few seasons ago I was like, okay, we're doing black, white, red, yellow, and blue: the primaries and black and white. And I made this decision, but I couldn't live with it. So, the primary yellow became a very pastel yellow and the blue became almost gray and pearly. There were all these nuances because I really couldn't live with the strict rules that I thought I wanted to have. So, I do think my starting with fabric and color is just completely instinctive, and then it kind of morphs and changes as the work progresses.

SL: For me, it's roughly the same, except I always started with color, so I didn't even look at fabrics yet. I started building a color card and then would link the colors to the fabrics and work on the collection from there on out. Everyone's process is obviously very different, and it's always very envy-making to see the various end results and imagine how the people

got there. And most of the time they were struggling just as much as we were ourselves.

MJ: Totally! I remember one day our fitting model at the time came in wearing a soft fluorescent orange or melon-colored Sies Marjan sweater and I remember looking up that collection and when I looked at it, I thought, Oh, my God, he's got it so together, the color palette is so sophisticated, but so tight, it couldn't possibly have been any different than what it was because it was so concise, you know? And again, I look at that and I envy because I imagine that you were just completely sure of it from the very beginning.

SL: Which, ironically, is never the case, I promise! Do you see form without color or color without form?

MJ: Sometimes I have a specific shape in mind that needs to be in a certain color in order to be believable. And other times, I just love a color and I have no idea what I'm going to do with it, but it's like something that's really speaking to me at that moment. I think it kind of goes both ways. For me it's not either— it's both! Though sometimes I get so stuck, like with certain colors, I'm like, they're so beautiful, I just don't know what to do with them.

SL: I have that, too. Sometimes I have these beautiful colors I'm working with, but I don't know if I want to eat them or wear them or put them on my wall... I'm confused about their func- tion. But that internal conversation can lead to surprising end results.

Are there any colors you find hard to obtain?

MJ: Yes. And I should know better after years of experience there. I often like soft colors that are luminous, like a bleached-out fluorescent, but with a kind of luminosity that can only be achieved in a synthetic yarn. When I was a student at Parsons I used to go to these jobbers for fabric and I would see these bolts of pure wool or these gorgeous crepes in very pale fluorescent orange, a minty green, or a bright pistachio. But perhaps dyes have changed, we just can't use these dyes from the '60s and '70s that are toxic or have these restrictions. So yes, we struggle to try to achieve them in any kind of upscale natural yarns.

SL: What are some of your favorite colors and why?

MJ: I like staring directly at the sun. I don't know, I can't really explain it, but I love when there's a very, very bright sun, and I like looking up at it and I like what it does to my eyes. I feel something that I enjoy, and it's almost the same with artificial bright light but, of course, I prefer the sun. There's this neon yellow that comes on the outside of the white that I very much like. I also think yellow at the moment is my favorite color.

SL: Is there such a thing as an ugly color for you?

MJ: Well, in the world of fashion, and I'll speak for myself, I have a way of talking about things. The word *ugly* can be the most fantastic compliment, or it could be the biggest insult. So, to say an ugly

color could be magnificent.... There was a dress we made once a long time ago, and it was a very flat pink on the top and then this hideous ochre mustard color on the bottom. It was a color block. And I thought it was an incredible color combination—if the dress had been upside down, it would have been really ugly. But somehow, with that mustard color falling at the bottom, it wasn't. I think of Prada collections a lot when people talk about ugly colors in fashion. I think of Signora Prada's color sense, certain collections where she deliberately used "ugly colors" to make it cool because they were so *ringard*, or "out of fashion," or so typically associated with something that was in bad taste. But then in the right hands that becomes so magnificent. Wonderful. So, I think there really is no such thing as true ugly. There's only like, fashion ugly!

SL: Which is the star for you: shape, cut, color, or texture?

MJ: It all has to work. I mean, you never want to hear someone say, Oh, what a lovely color—it's a shame about the jacket, or, It's such a great jacket, but a hideous color—because as soon as there's a "but..." it doesn't have the appeal. So, I think they're all equally important. And when they all are really right on, that's when you feel really good about what you've made.

SL: Whose color use do you respect?

MJ: If it's fashion, it's one person, and that's Yves Saint Laurent; he was the best. He was brilliant with color and shape and form and everything. He's

my ultimate hero. I love when a film-maker uses color as a device, and it's kind of a signature. When I think of the films of Pedro Almodóvar, there's a very particular color palette and it projects a certain sensibility that's very his and slightly camp and it's not the kind of colors that I love, but it's remarkable that you know that it's his kind of color palette. I love the minimal and singular approach to shape and color of Ellsworth Kelly. I also love the colors that Elizabeth Peyton uses to portray people, and I have firsthand experience where I wasn't sitting in a room that was purple or blue, but she did this portrait of me in the purples and the blues, those inky colors. And then the red of the lips, none of them were real, but her usage of those colors was so extraordinary.

Hanya Yanagihara

Hanya Yanagihara is a novelist, editor, and travel writer. Her critically acclaimed, best-selling novel *A Little Life* was long-listed for the Man Booker Prize in 2015. I met Hanya at first through a feature I did for *T Magazine* in 2018.

Sander Lak: How important is color to you in your life, your work?
Hanya Yanagihara: You should see my apartment. It's very, very colorful, but my writing and my physical presen-tation are not necessarily informed by color the same way. You know those old cartoons and movies where everything is rendered in black and white and then explodes into color? I mean, I guess that's actually *The Wizard of Oz*. My life gets more colorful the more private it gets.

SL: Can you tell me something about color in your childhood?
HY: When you are from a tropical country or have lived in a tropical country like I have, you have a very intimate connection with color because every color there is so over-the-top and outsize. You could understand why Gauguin was so transformed when he went to Polynesia for the first time. The reds are redder, the pinks are pinker. It's very difficult to live a life in sedate colors when you're growing up in Hawaii.

I do think there's a kinship among people who grew up in tropical places—we're not scared of hot colors, we're not scared of bright colors. Color is not only an expression of defiance in a lot of ways, it's nature's expression of itself and a reminder of the relentlessness of nature.

That's why wearing neutral colors in Hawaii looks absurd—it looks like you're trying to deny the nature around you. When you're in a jungle, the greens are almost oppressive; if you're in New York, the palette is gray, and so anything that isn't gray stands out.

SL: Do you think about color in your work? In what way?
HY: It depends. I think, like many

creative people, I'm a little synesthetic. I mean, there are certain letters and certain words that I associate with different colors. My work is more image-based rather than color-based, but not always. My first book, *The People in the Trees*, was very, very much about color because it's set in a jungle, and it lent itself more naturally to expression through color. This is less the case with *To Paradise*, but I did think specifically about color when I was designing the jacket. The designer and I decided to use a neon-like Pantone, 922C. It's a very particular green—a sort of jadeite, a dark jadeite. Part of the reason we used it was because it felt so modern against the image *I'okepa, Hawaiian Fisher Boy* (1898), by the Dutch painter Hubert Vos. I was also drawn to this particular color because it seemed almost like a curdled-candy take on the word *paradise*. And I associate paradise with green: trees and fecundity and growth and natural abundance. There's something about this green we used on the cover that felt—because it's a neon—a little artificial, a little clinical, and a little created, which I thought was a good contrast. The words are rendered in a green that a human tampered with.

SL: How do you think you use color in your writing, then?

HY: Very rarely, actually, and I think because, as I was saying, color is actually quite a private thing for me. It feels like—and I regret this—that, in leaving behind Hawaii and then growing up, I gave up color as well. And it was only when I got to be a little more secure that I returned to it.

SL: Whose use of color in writing do you respect?

HY: One writer who I think does write about color very well is John Banville. He uses it sparingly, but he's able to name and describe color in a way that you've not thought of before—he can make you see the thing differently. Another person is Edith Wharton, particularly in her travel writing. *In Morocco* has some of the most vivid and compelling writing about color in any non-fiction.

Isabella Rossellini

Isabella Fiorella Elettra Giovanna Rossellini is an actress, author, philanthropist, and model. The daughter of the actress Ingrid Bergman and the film director Roberto Rossellini, she is known for her film roles in *Blue Velvet* and *Death Becomes Her* and her successful and reprised tenure as a Lancôme model. She is the creator and star of *Green Porno*, *Seduce Me*, and *Mammas*. Isabella modeled with her son Roberto for the first Sies Marjan campaign in 2017.

Sander Lak: Your parents, Ingrid Bergman and Roberto Rossellini's, most famous films, *Casablanca* and *Rome Open City*, were both in black and

white, when the film industry slowly started working in color. Did they ever comment on this transition to color?

Isabella Rossellini: I don't remember them saying anything specific about color. I think they just felt it was the progression of film technology. My father was not so concerned about aesthetics. I don't remember him ever having that as an inspiration. But he always thought that film was a very good way to inform people. He often gave the example that if you had to describe an elephant one would say, "It's a very big animal, gray, wrinkled and with a long nose"—who knows what someone conjures up in their head hearing that? But if you see a photo or a film of it, in one second, you have a lot of precise information. And if that photo or film is in full color, even better! So, I think my father was welcoming color, in film.

SL: You went on to earn a master's degree in animal behavior and conservation at Hunter College. What can you tell me about how animals see color?

IR: Different species might see color differently, and that is very important to take into consideration when you study animals and their color vision. It's useless to ask a dog to learn how to stop for a red light or walk if it's green because they cannot distinguish the two colors. For them, it's the same color. So, for example, I live in a big red barn surrounded by a green lawn. To my dog Pinocchio, my house and grass are the same color! I have about a hundred and fifty chickens on my farm. Chickens see some colors in the ultraviolet range, which is a range that we humans cannot perceive. The roosters are very, very colorful but the chickens are somewhat more subdued. But with their ultraviolet vision they might see themselves much more colorful than how we see them! Darwin, discussing the strong vibrant colors of many male birds, came up with his theory of evolution by sexual selection. He used the peacock as an example. He could not justify its long colorful tail as having evolved by natural selection, the theory of the survival of the fittest. Its beautifully colored and extravagant tail doesn't favor the peacock's survival. On the contrary, a predator can spot him more easily and, if it pounces on the peacock, he won't be able to fly away fast with this big thing dragging behind him. Darwin therefore thought there was a force other than natural selection that pushed evolution. Noticing that females prefer to mate with males who are most colorful and have the longest feathers, he proposed sexual selection, the power of seduction!

SL: As you have moved through several industries and have so much experience in front of and behind the camera, how has your appreciation of color changed?

IR: When I first started to direct my short films, I paid a lot of attention to color. It all started with going to Barcelona for the Mobile World Congress in 2008 with Robert Redford, the great actor, director, and founder of the Sundance Channel. The MWC is an annual trade show where

new technologies are presented. At the time, we were particularly curious about the smartphones that were not yet on the market. We looked at this new marvel with great admiration and felt the small screen deserved its own content. We decided that the best format for this small smartphone screen was a series of short videos, no longer than two minutes each, with sets and costumes dominated by three or four colors to allow easy detection. This is how my first series of *Green Porno* came to be. The videos went viral, and I ended up making more than forty short films. With my art directors, Andy Byers and Rick Gilbert, we spent hours selecting colors for each episode. I think the simple color scheme on the small screen is part of the reason they were so successful.

SL: Of all the incredible photographers you've worked with, who do you feel has a really good sense of color?

IR: Eve Arnold. She was one of the first women to work in photojournalism. She started to work right after the war and was very good friends with Robert Capa and Henri Cartier-Bresson. Everybody at the glorious Magnum photo agency back then worked in black and white. It must have been hard for the great photojournalists growing up during the war to switch to colors. But not Eve! Her colors were always beautiful and very vibrant.

SL: As an actress and model, what have you learned about color?

IR: As an actress I always experiment with makeup and costumes in creating the different characters. When I played Dorothy Vallens in *Blue Velvet*, for example, I used very strong blue on my eyelids and a very deep red on my lips. I also wore a pitch-black wig. Dorothy is a battered woman and, like all victims, she is ashamed of herself. I thought a heavy makeup and a wig could be like a mask—something to hide behind. Dorothy wanted to be like a doll, almost.

When I played Trudy in *Joy*, I wanted to quickly convey the completely incongruous relationship she had with her boyfriend Rudy, played by Bob De Niro. Bob's character was a mechanic; he repaired cars and his store was very dirty and full of grease. I wore cashmere sweaters and skirts that were all in delicate pastel colors!

When I started working in fashion, in the early '80s, everybody on set wore black. I assumed it was necessary. No colors should bleed onto the set, skewing the models' skin tones or the colors of the clothes that were being photographed. In Italy, where I was born, black is the color of mourning. Therefore, at first, I had a hard time wearing black: it made me sad. Then I started to appreciate how practical it is. As a model, I traveled a lot and, with all my garments being black, I could pack much less clothing! But I missed colors. I remember when Stephen Sprouse came out with that range of colors in the mid '80s, when everybody was dressed in black, and somehow that color felt more modern, more appealing than black. In the '90s Shanghai Tang came up with black Chinese pants and jackets that

were lined with bright colors. I bought a ton from this label. When I discovered Sies Marjan, I felt the colors were so liberating and daring!

Sheila Hicks

Sheila Hicks is an artist. Her sculptural textile art and experimental and innovative weavings incorporate distinctive colors, natural materials, and personal narratives. I interviewed Sheila in 2018 at her house in Paris for *Garage Magazine*.

SL: You've said before that you really respect the weaving cultures that exist around the Andes in South America, and I quote: "It's a culture that didn't have a written language. What interests me is that they could write their language in textiles." Do you find it easier to express yourself in words or colors and textiles? Or do you use them to express different things?
SH: Sometimes I can express the same thing by using either. If I were unable to speak, I could make something, and show it to you, and you would get the idea without my having to verbalize it. I still have time, and I'm trying to say everything I can say.
SL: What has been the hardest thing for you to express in your work?
SH: Invisibility. Photographers can do it, with the blank negative. If there's a photo you shot, and it turns out blank, that's pretty powerful; it's something

you missed. How can I do that? I can't. With my work, there's the material, and you might work it to express absence through the material. An advantage of what we do is that there's not only movement, there's also light. And with my pieces there tend to be slits and holes in the final piece. If you don't have light, you just see the façade of the piece, but as soon as you light it, a shadow gets cast, or you can see through it. And then the shadow might become more fascinating than the object.
SL: Is it instinctive for you to use certain materials, colors, or shapes?
SH: Can I ask you the same question? You go first.
SL: For me, the instinctual part comes at the beginning, when we start a collection. We began with color, and then think "What color works? What color doesn't work on what skin tone? What color is difficult? And what fabric?" And then we would go into textiles, and every step after that is seventy-five percent instinct, twenty-five percent knowledge. When we really start building the collection through garments, though, the balance of our approach shifts to the opposite. That initial compulsion gets smaller towards the end when you're finishing a collection, but I think that's because what we did as a fashion label is product-based, as opposed to what you do.
SH: Color comes later for me. You can't start with pure color. You start with light. Close your eyes and then try and tell me about color!

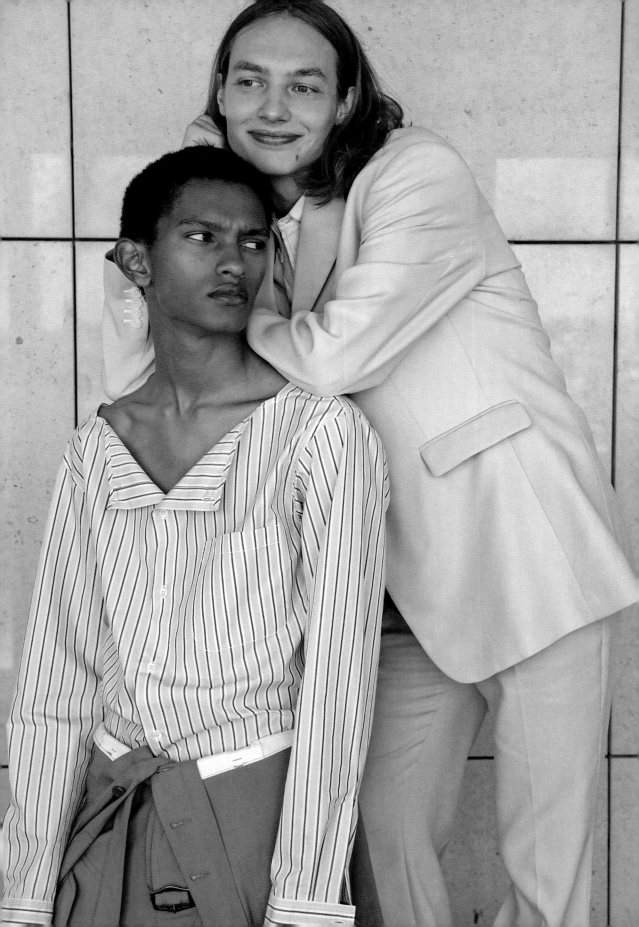

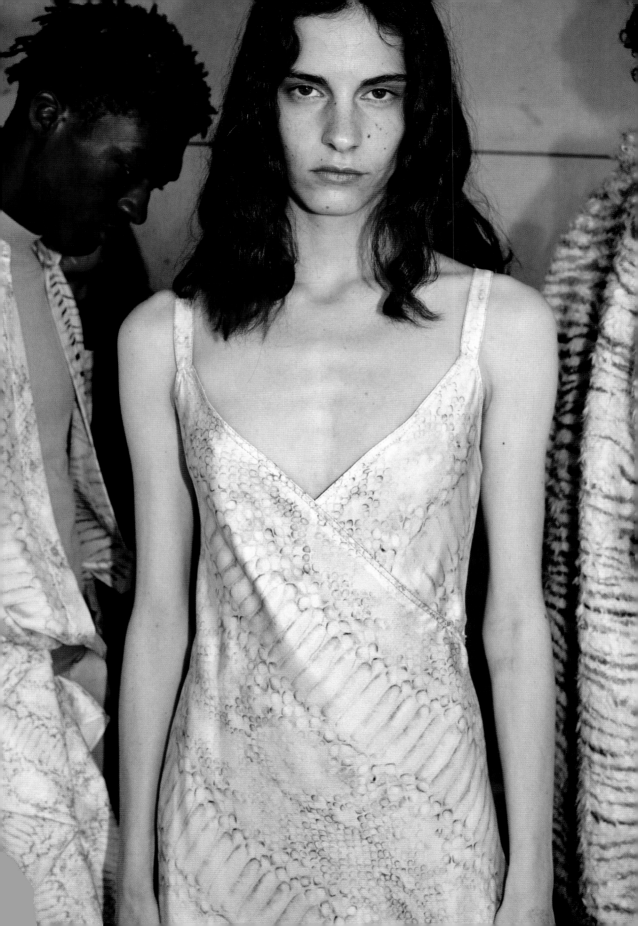

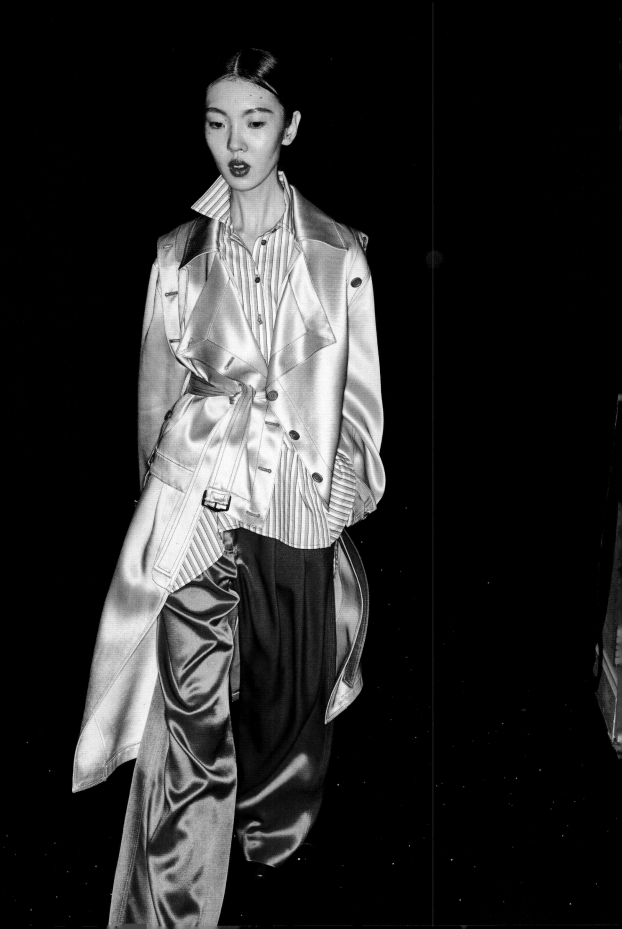

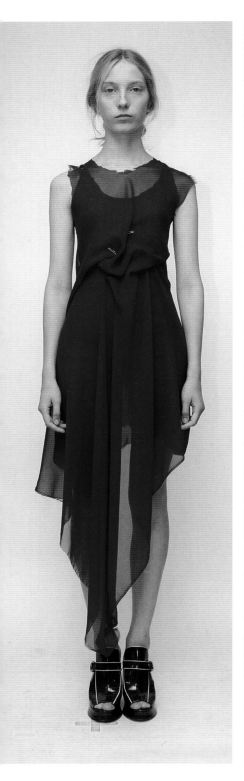
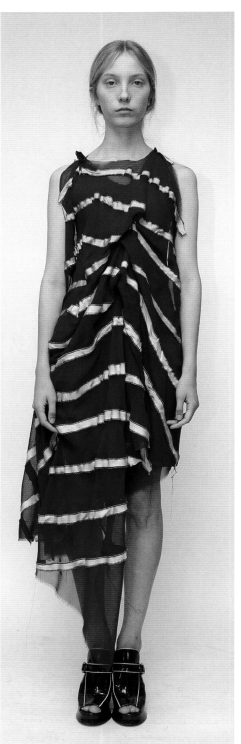
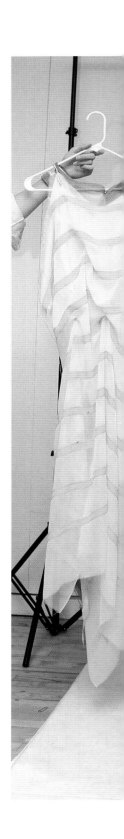

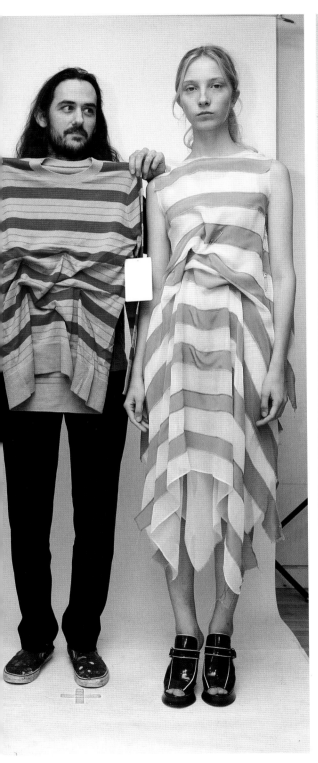
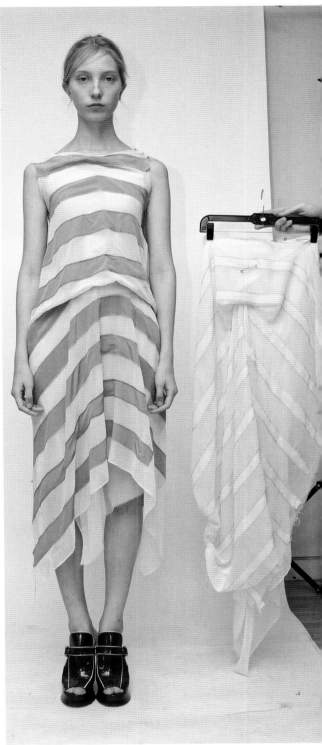

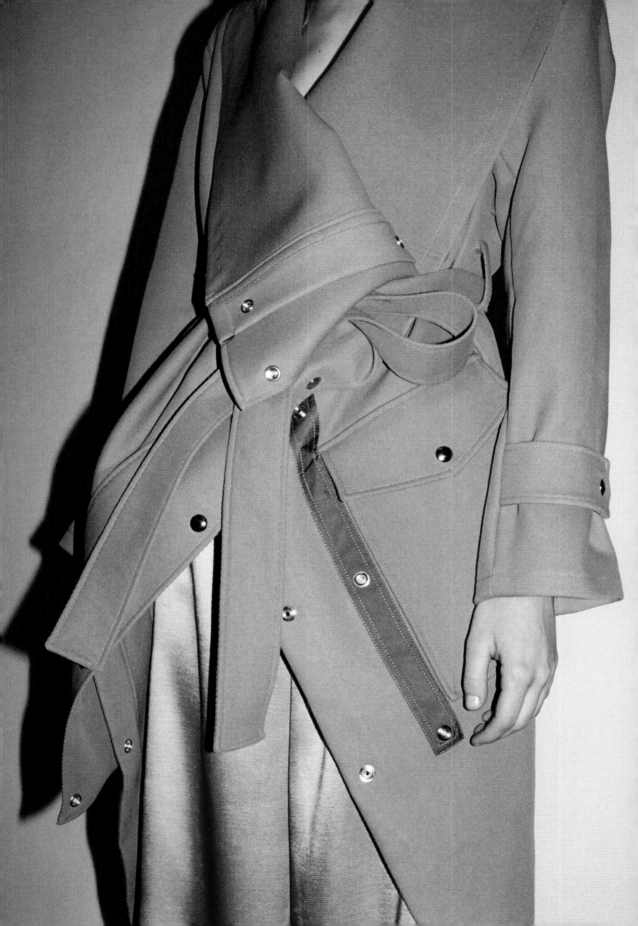

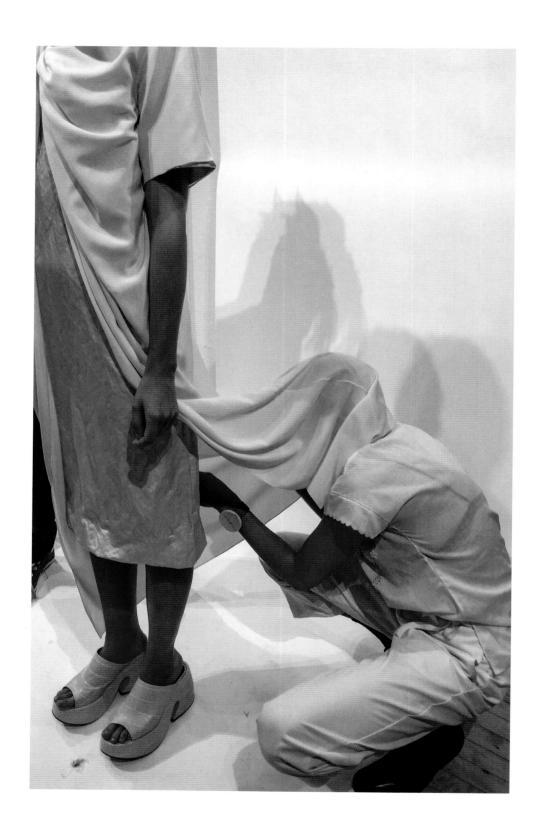

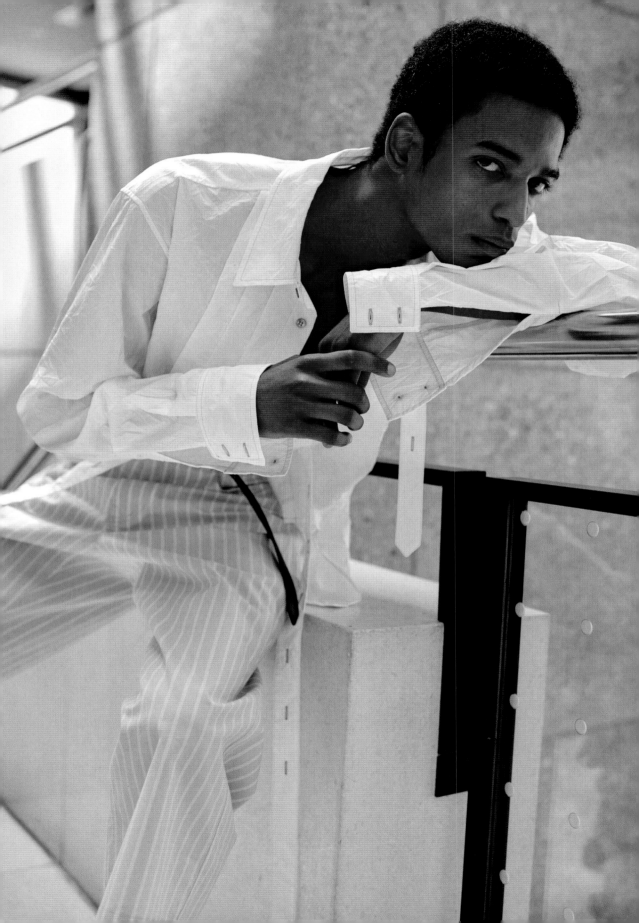

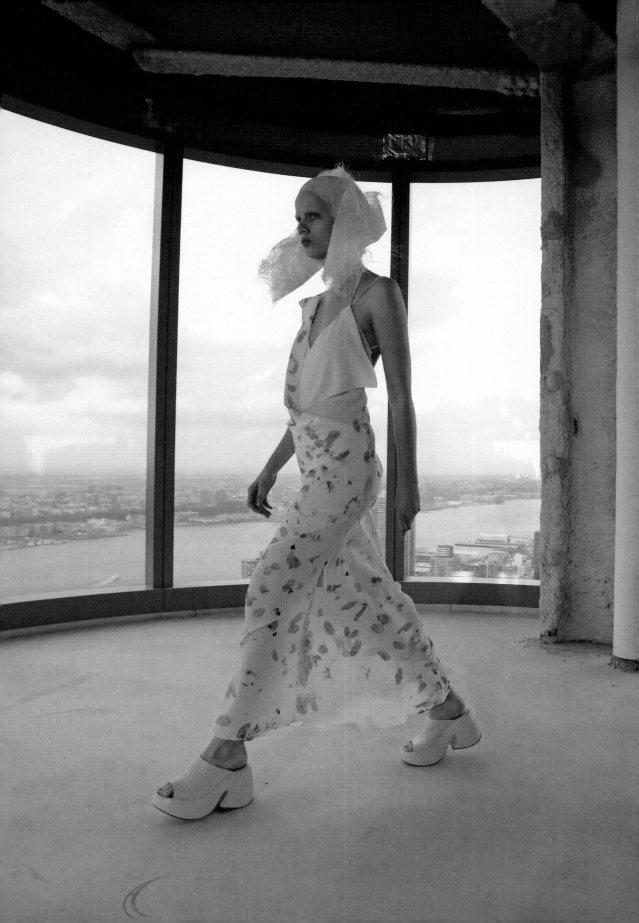

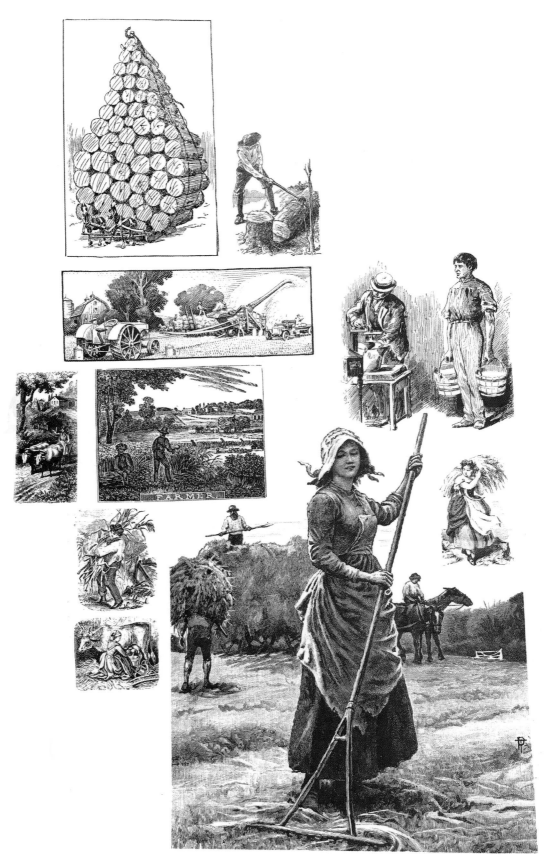

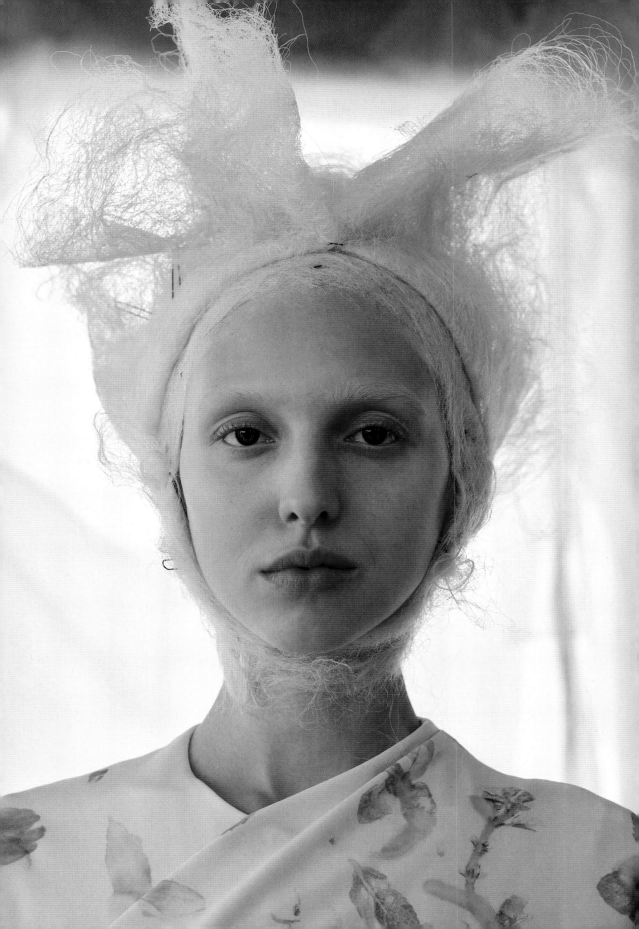

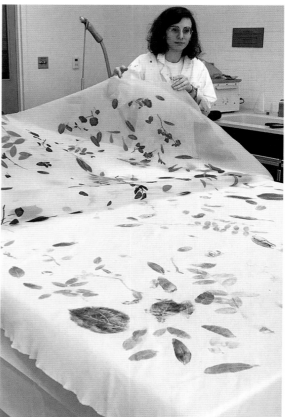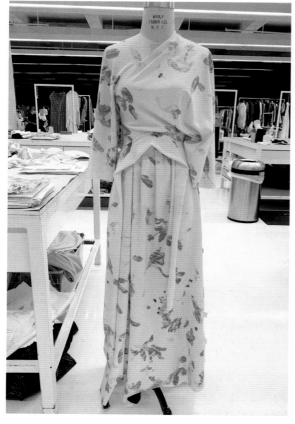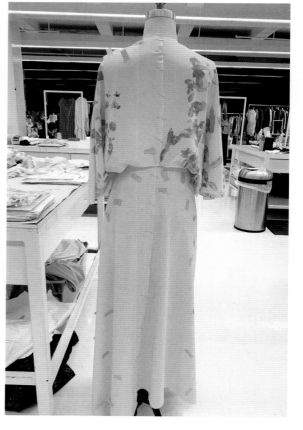

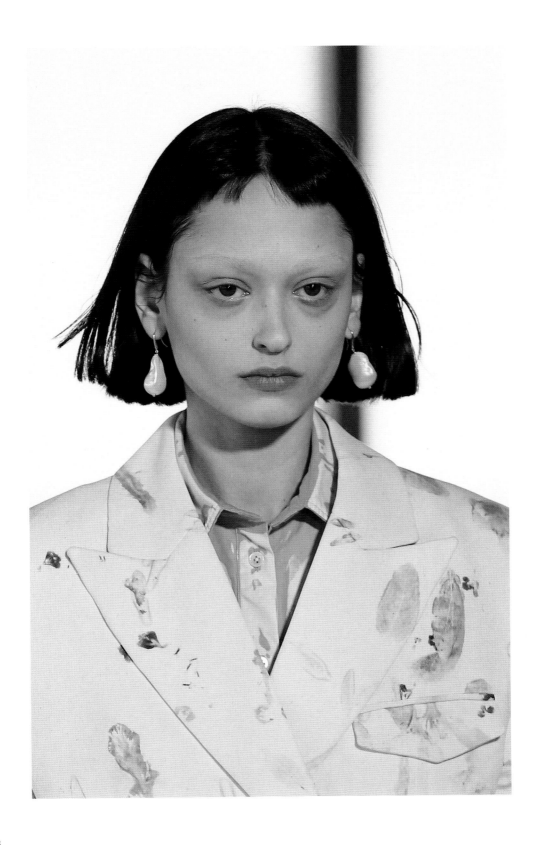

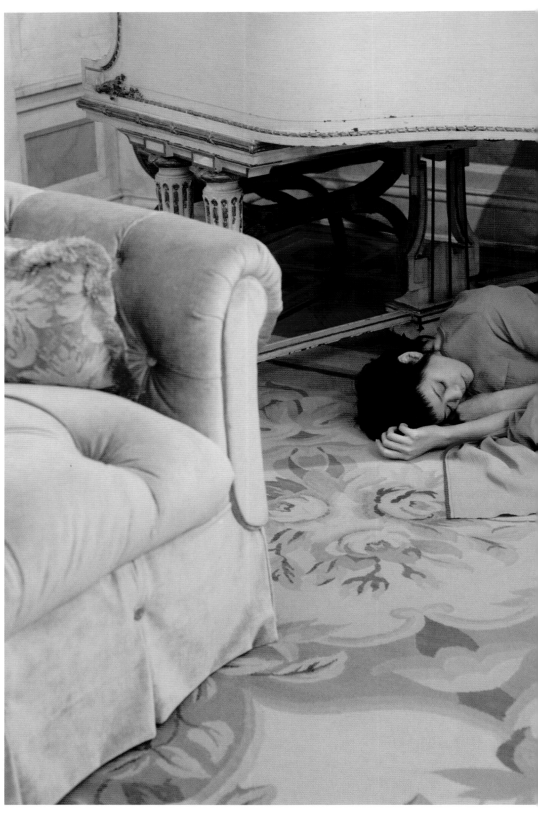

Girlfriends Project 2016, part 2
October 27th, New York

Sies

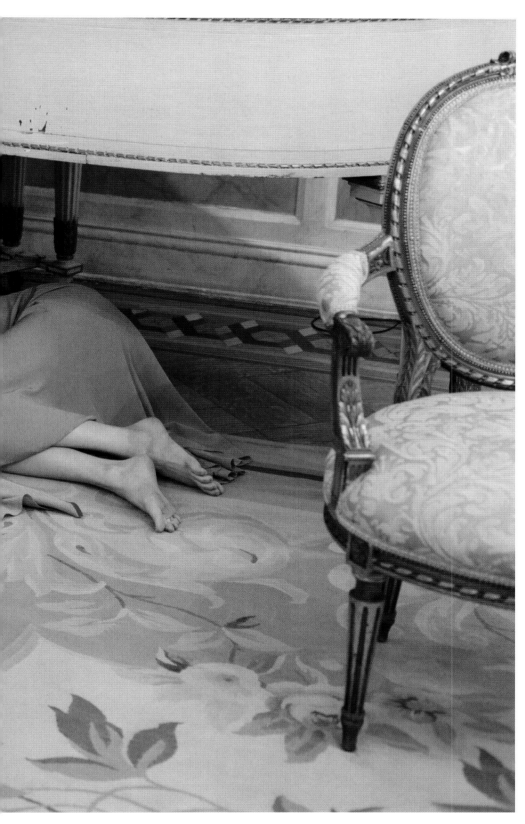

rjan

Photographed by Nigel Shafran
Patty, friend since 2008

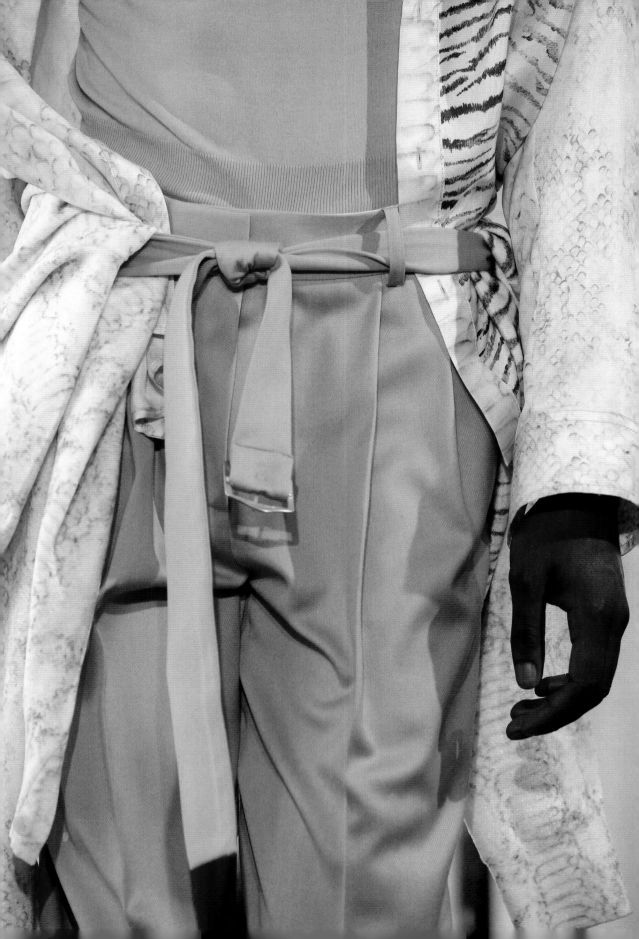

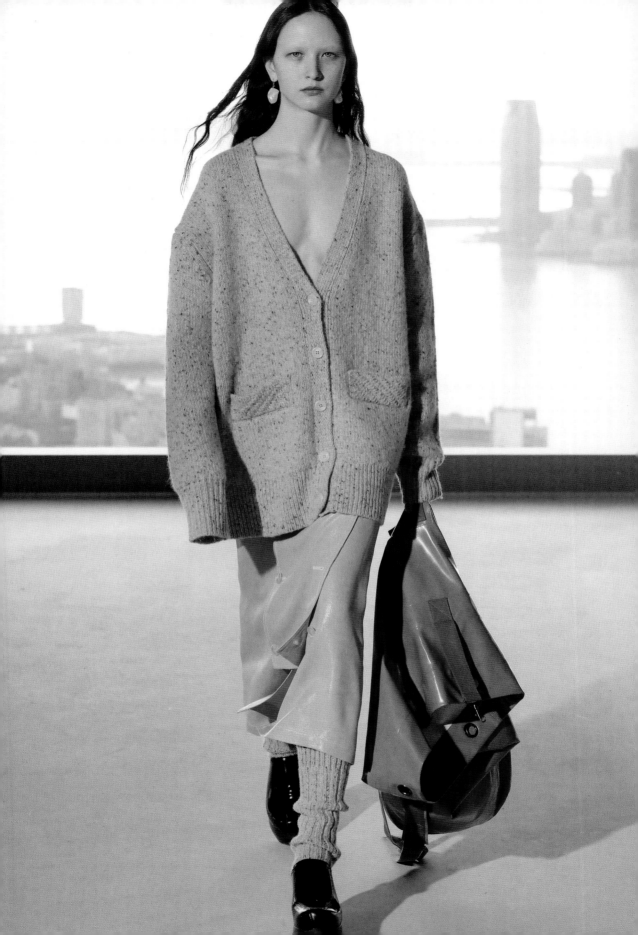

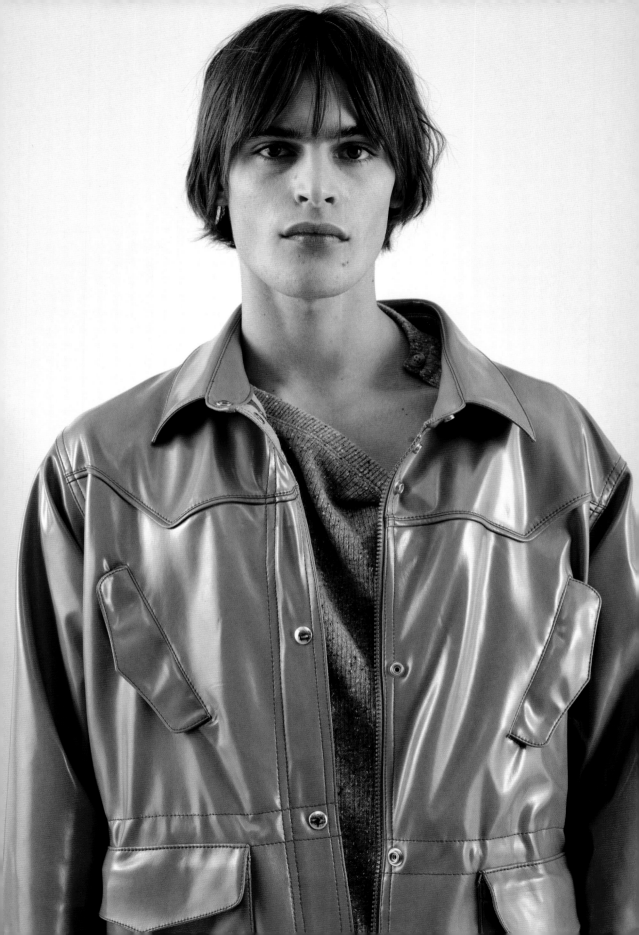

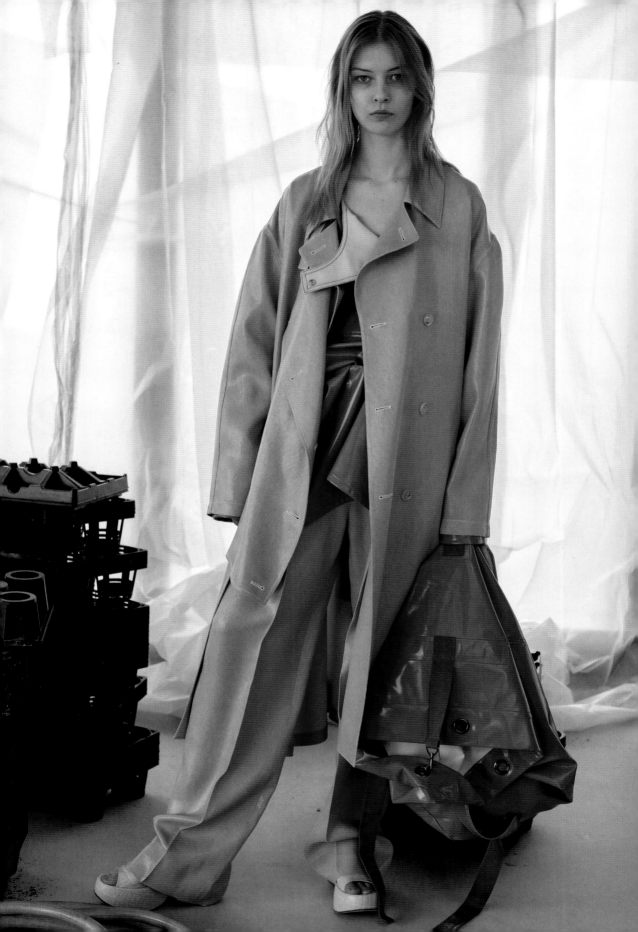

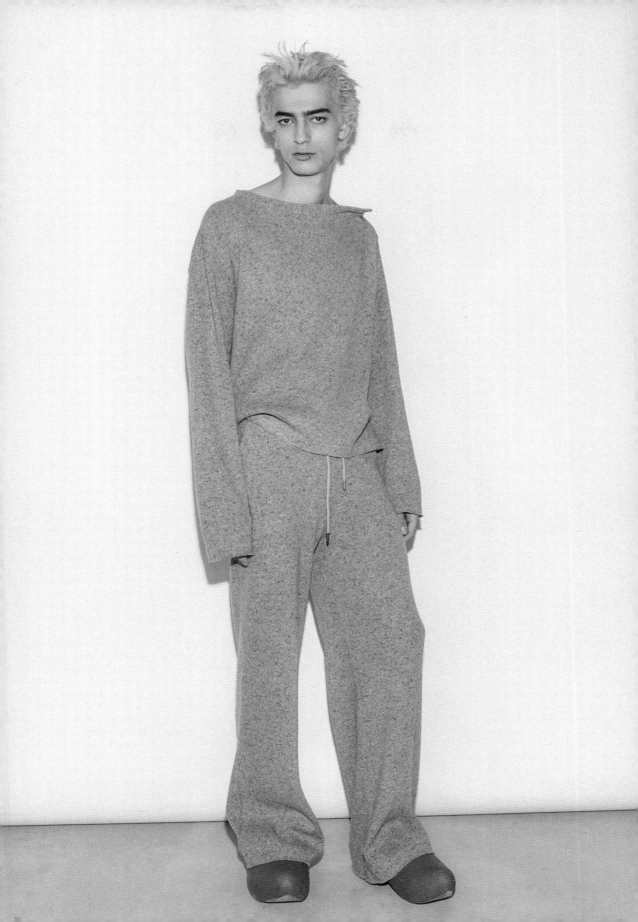

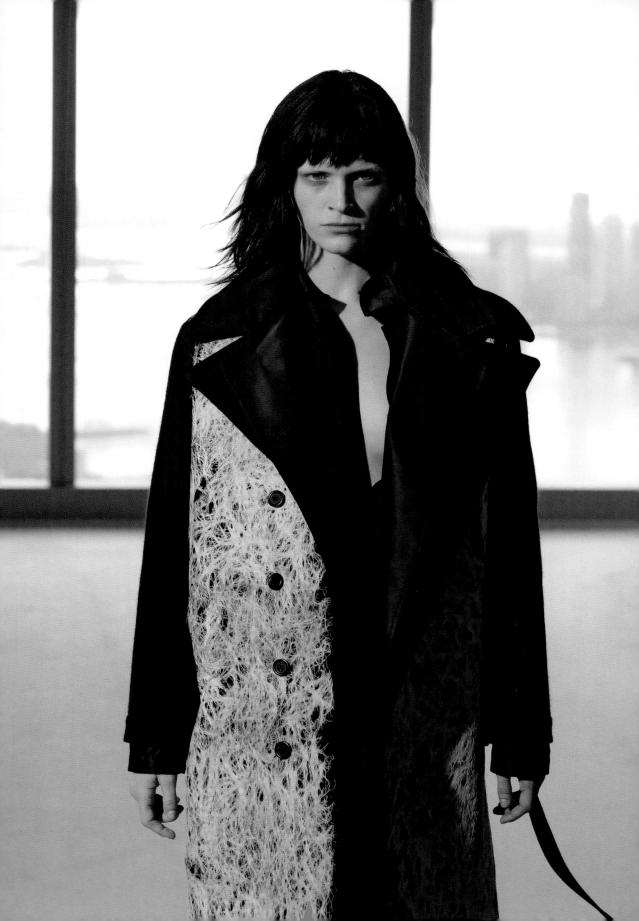

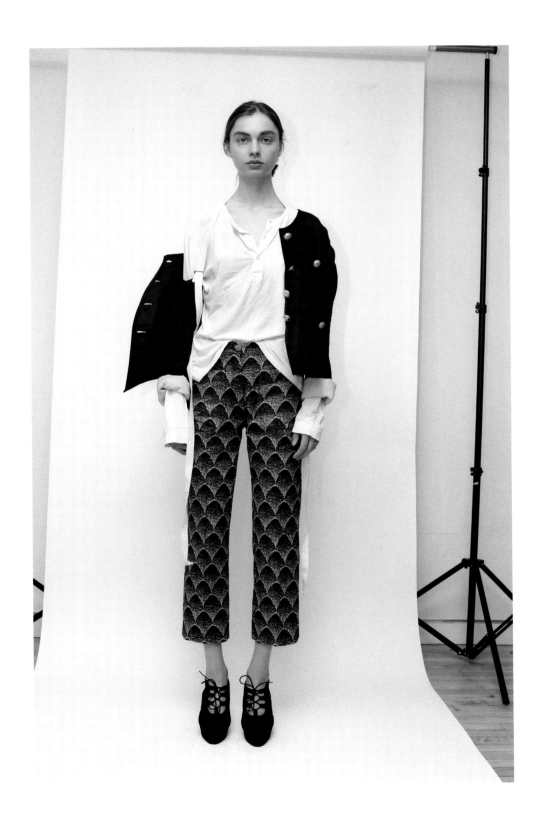

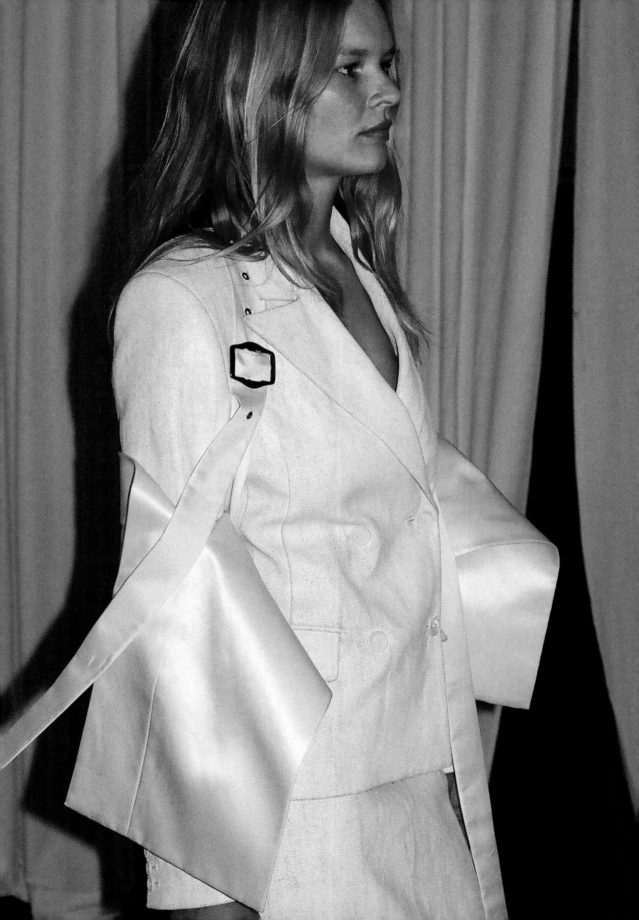

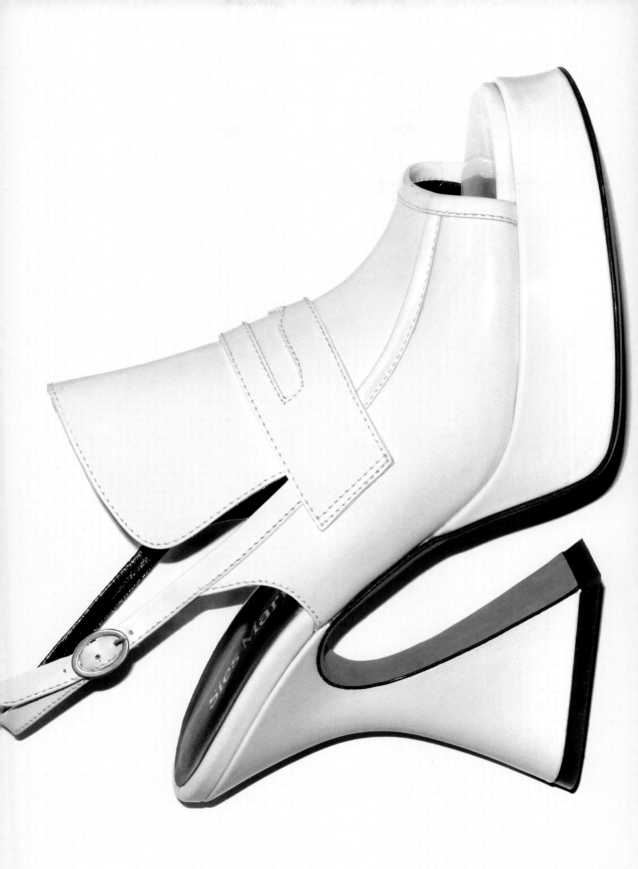

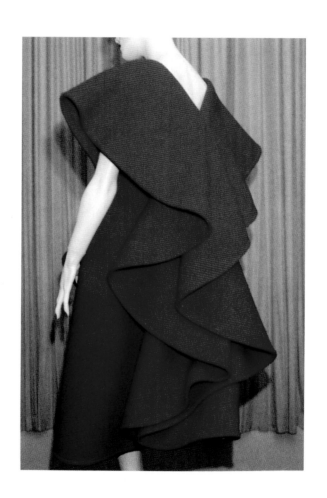

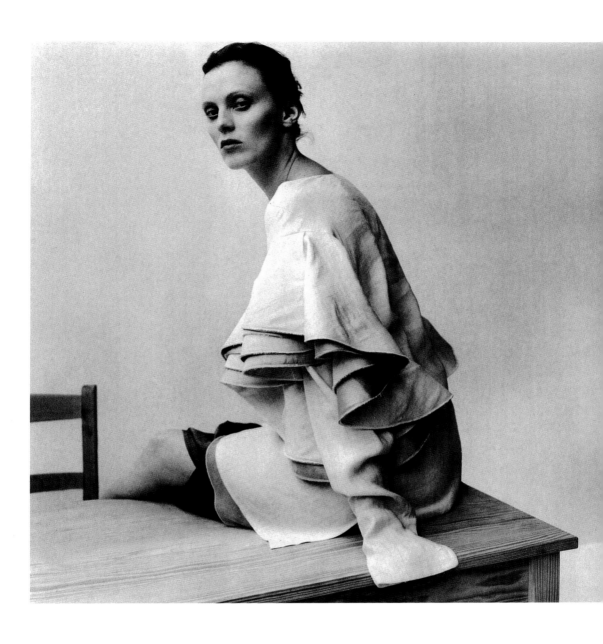

Everything about this SIES MARJAN
outfit is ruffled, from the layered shoul-
der detail of the pink-and-white linen
top to the undulating gathers of the Rose
viscose wrap skirt.

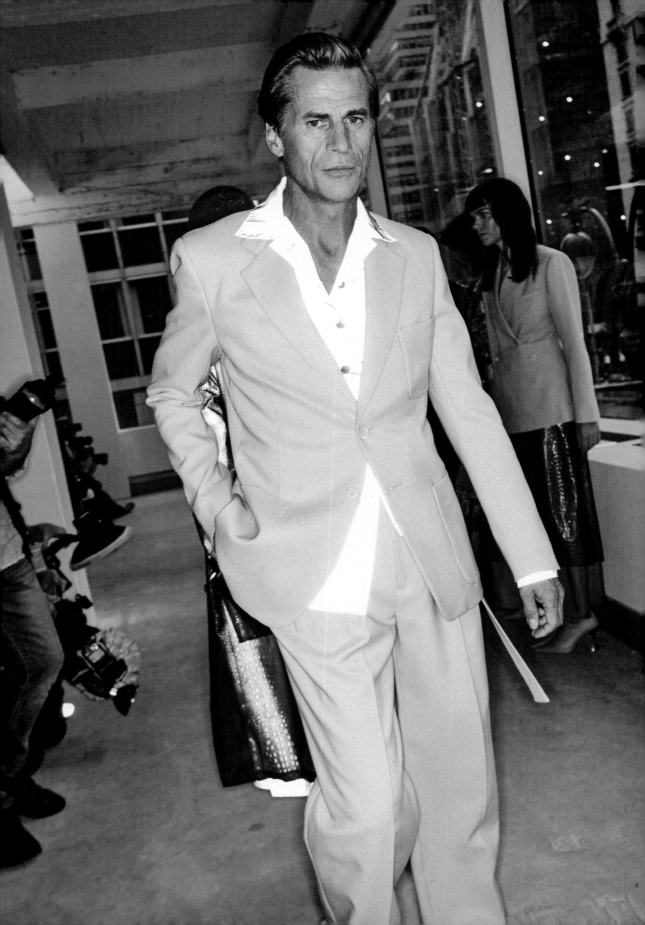

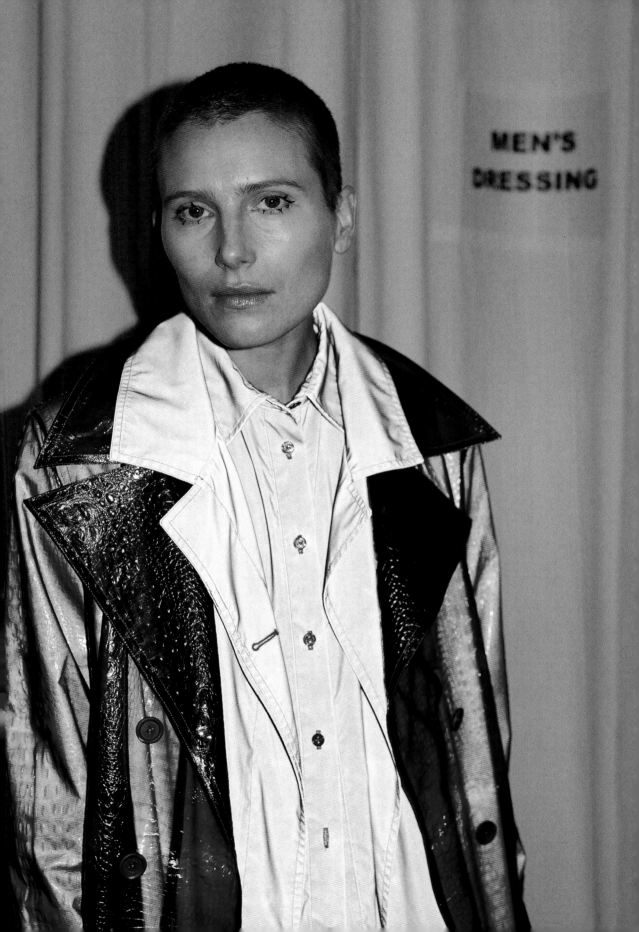

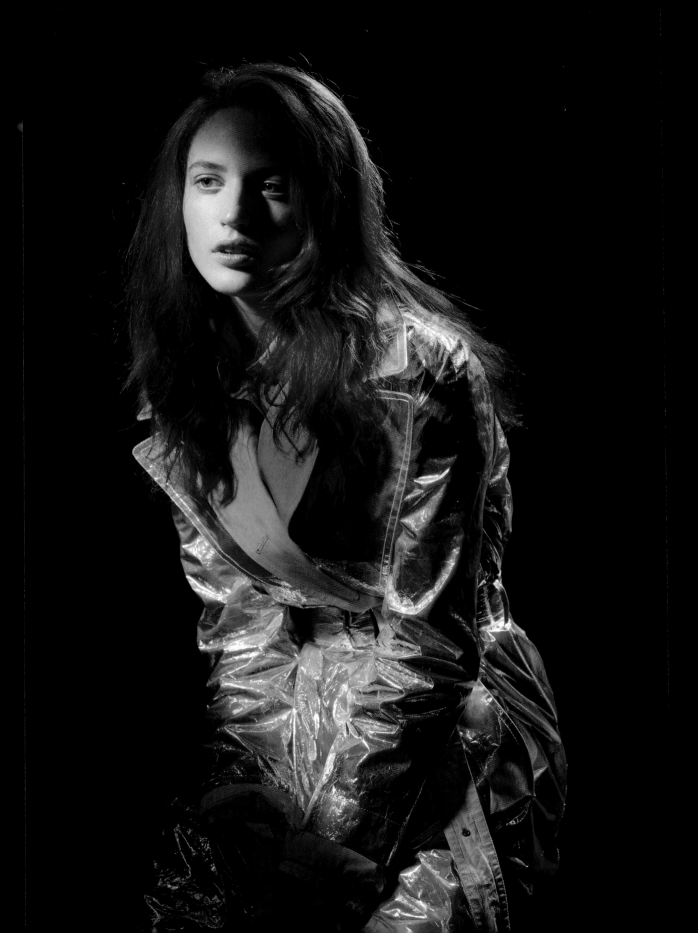

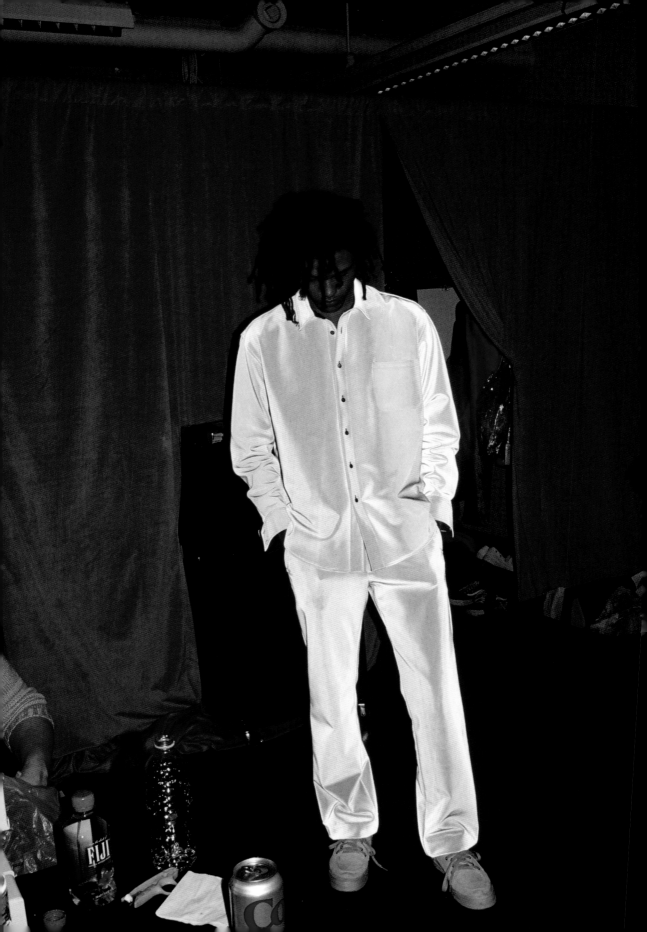

coat SIES MARJAN
photography ROE ETHRIDGE
fashion HALEY WOLLENS

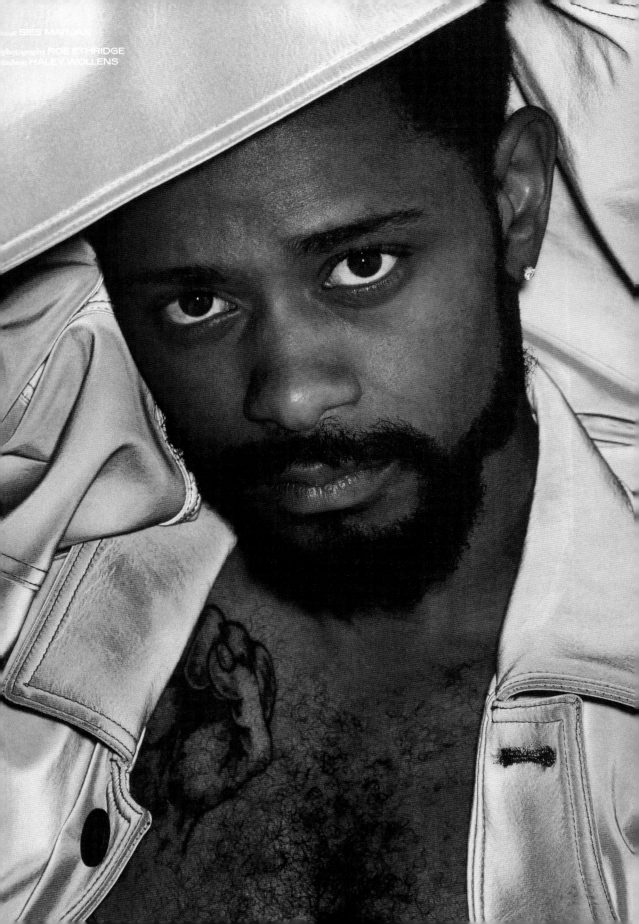

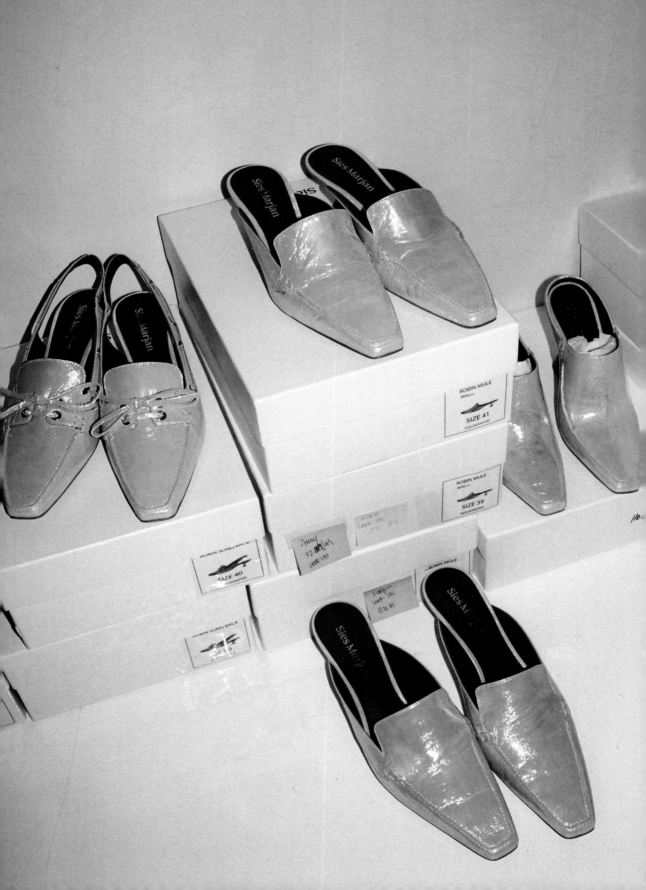

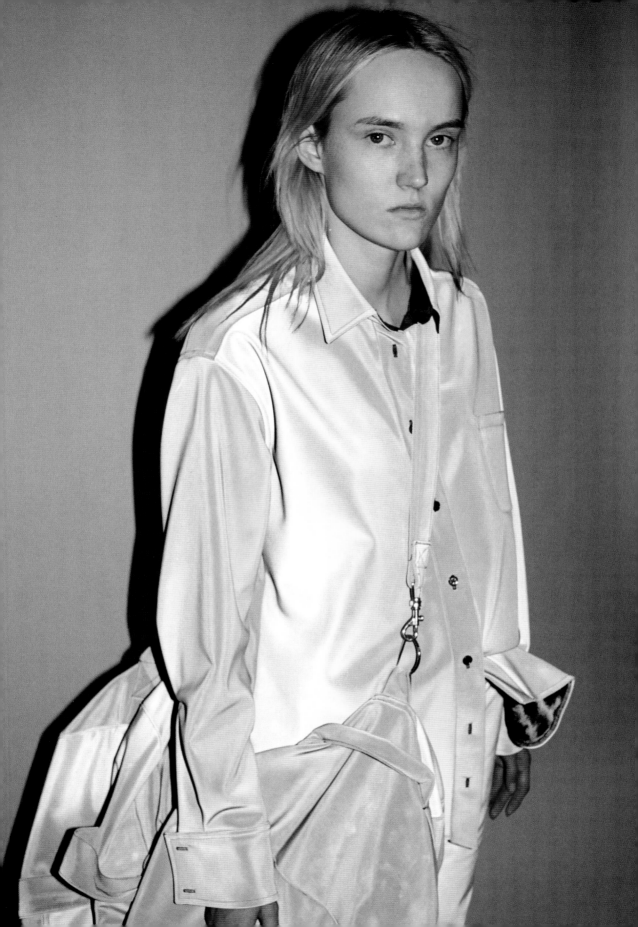

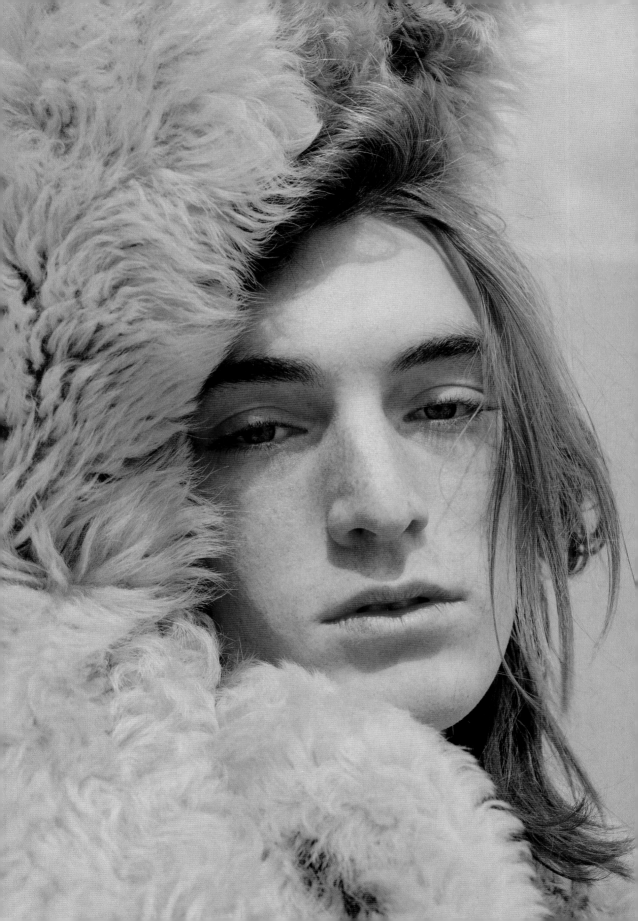

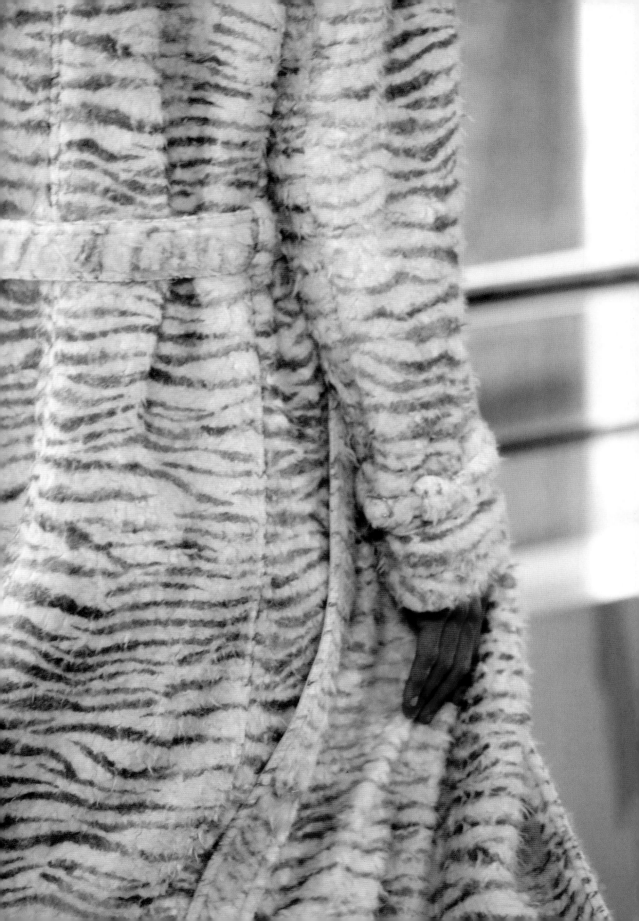

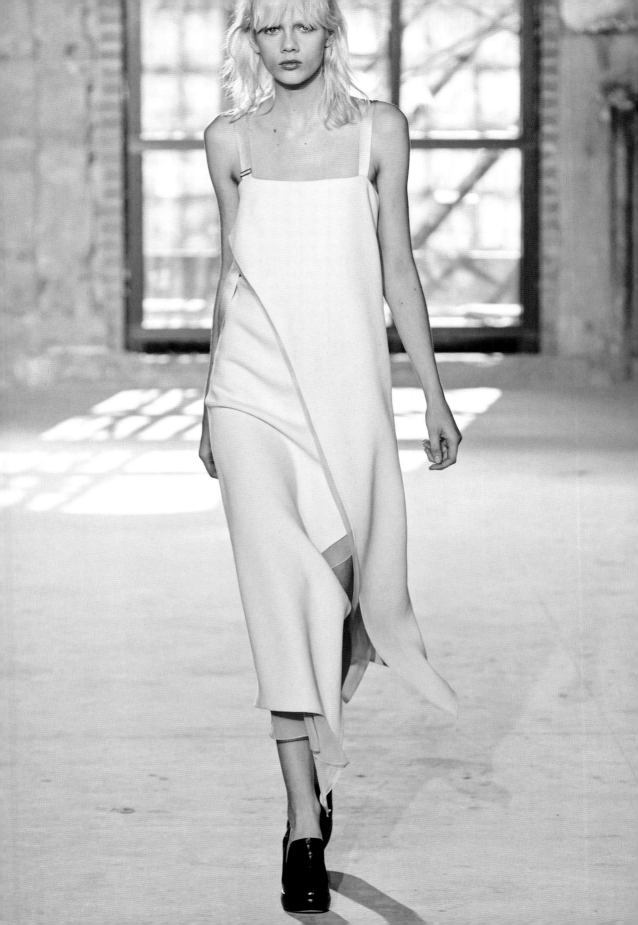

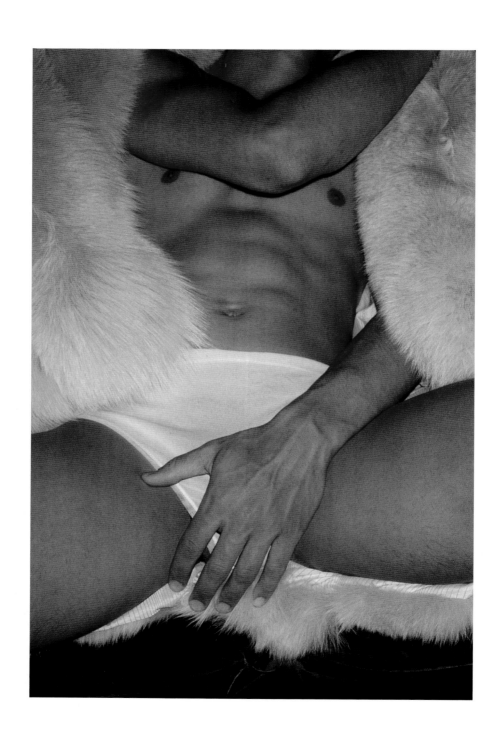

Matthias Vriens, *Furious issue #23 Dutch Magazine*, 1999.

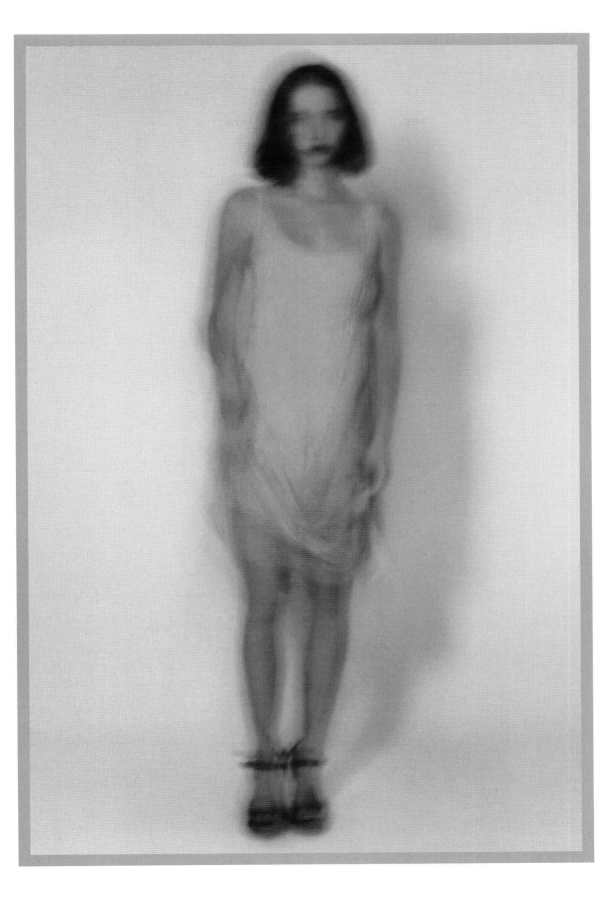

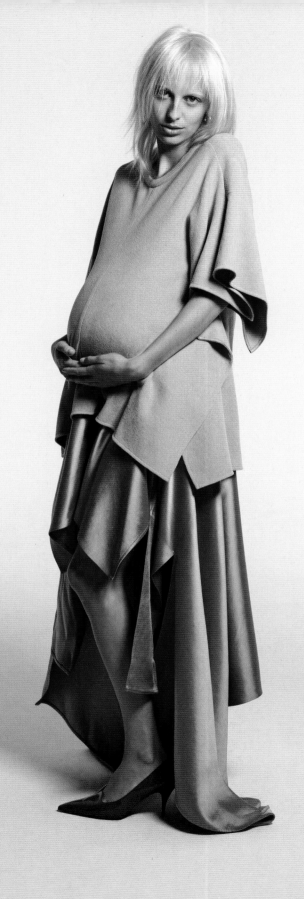

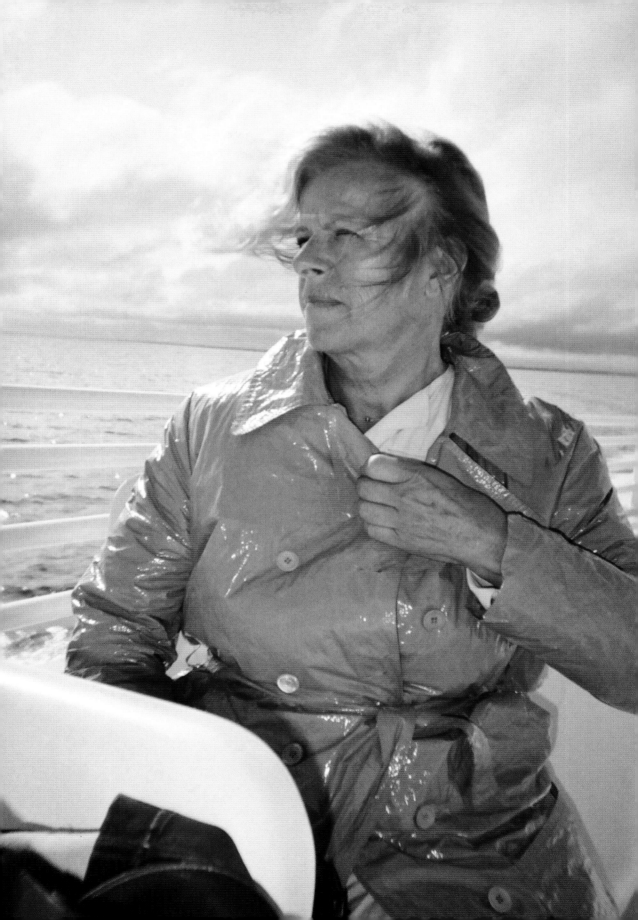

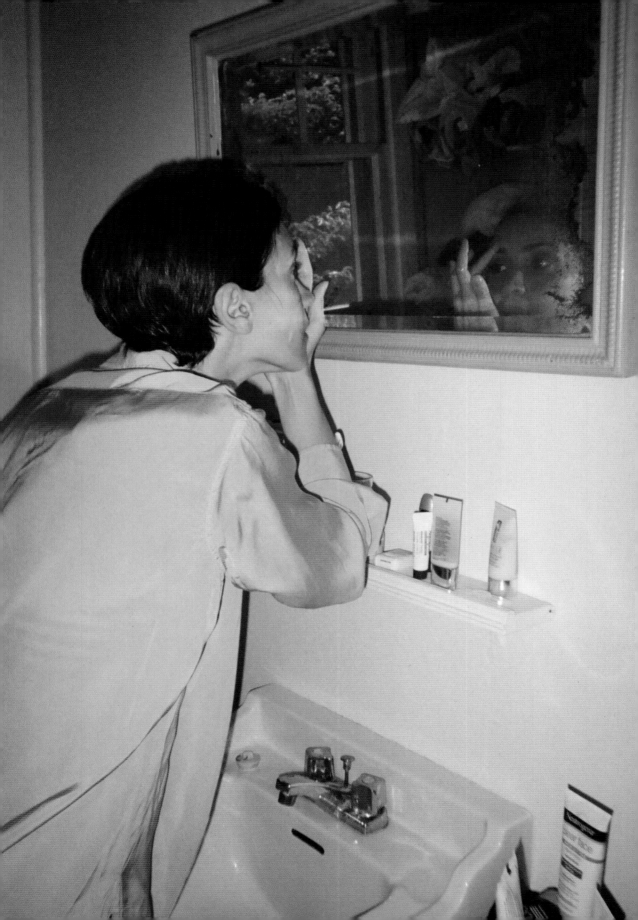

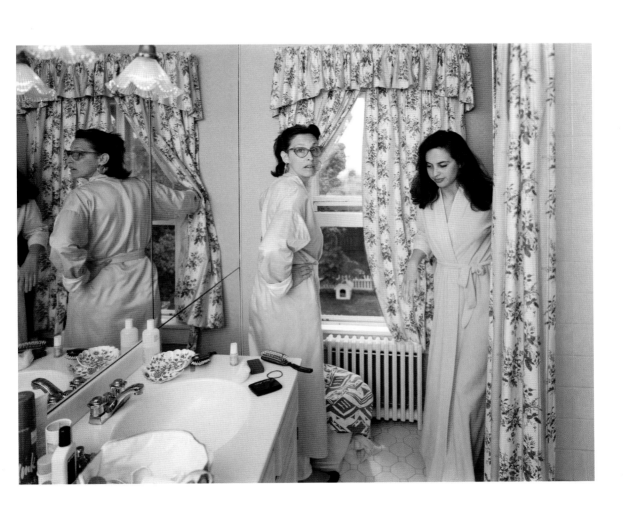

Tina Barney, *Jill + Polly in the Bathroom #3513*, 1987.

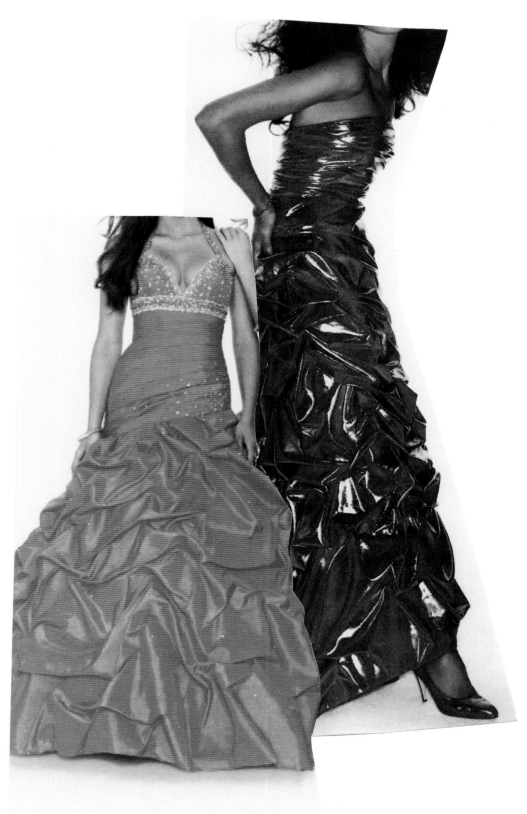

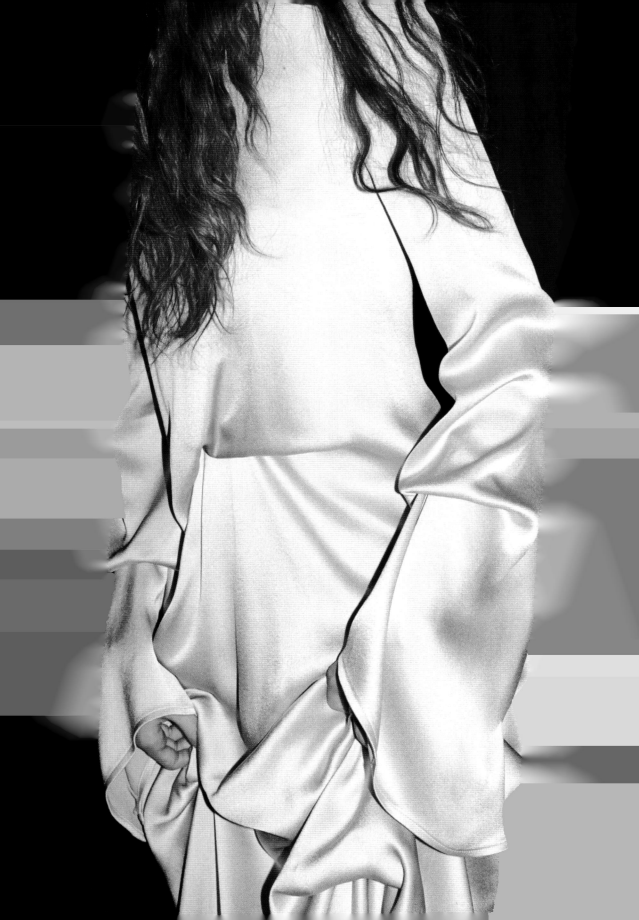

Photo Note	August 4, 2012
Amsterdam	city center
13.30 - 17.50	

Photo Note	August 4, 2012
Amsterdam	city center
13.30 - 17.50	

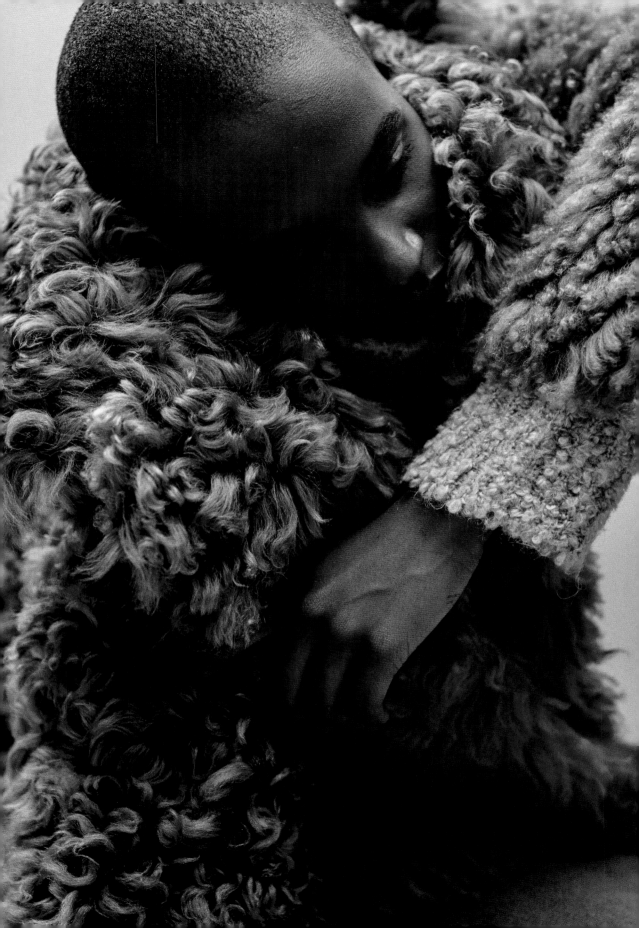

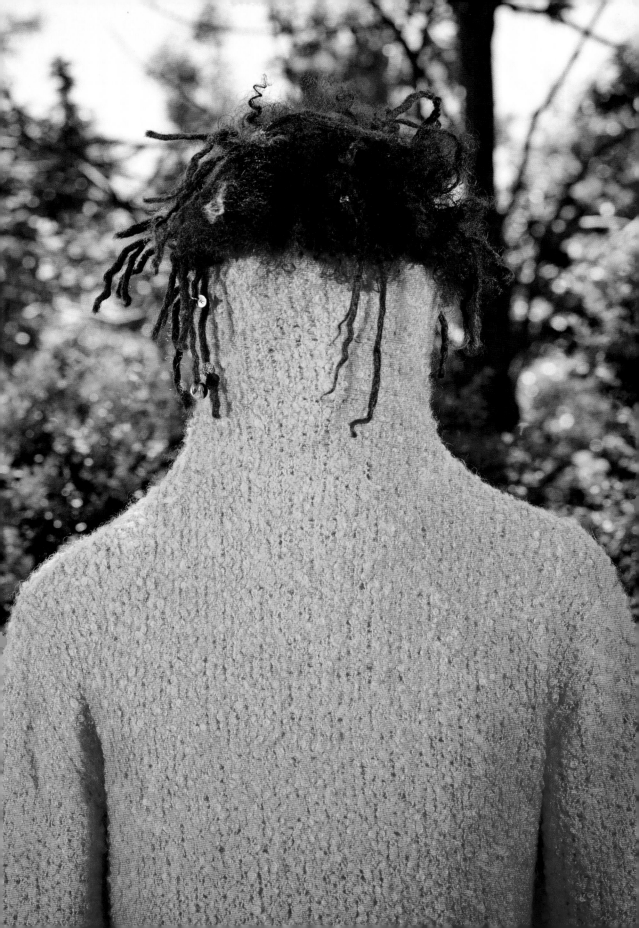

Sies Marjan

Girlfriends Project 2016
May 24th & 25th, New York
Photographed by Kacper Kasprzyk
Trish, friend since 2014

Julie Mehretu, *Conjured Parts (eye), Ferguson*, 2016.

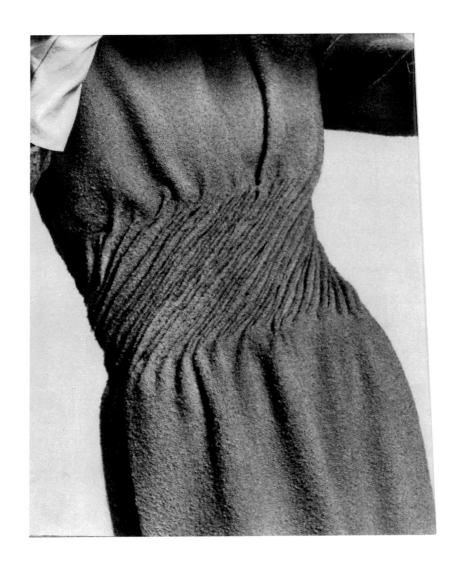

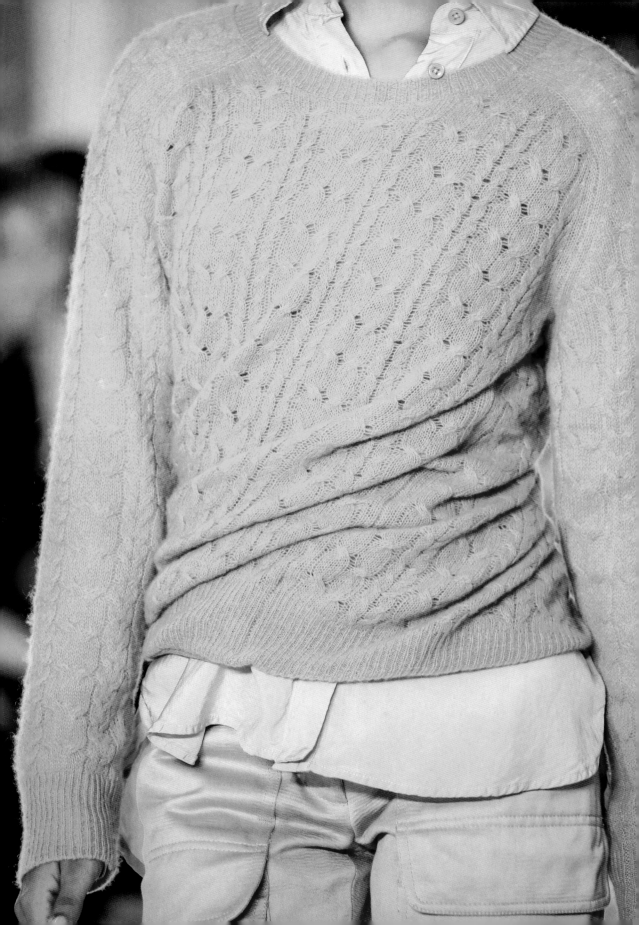

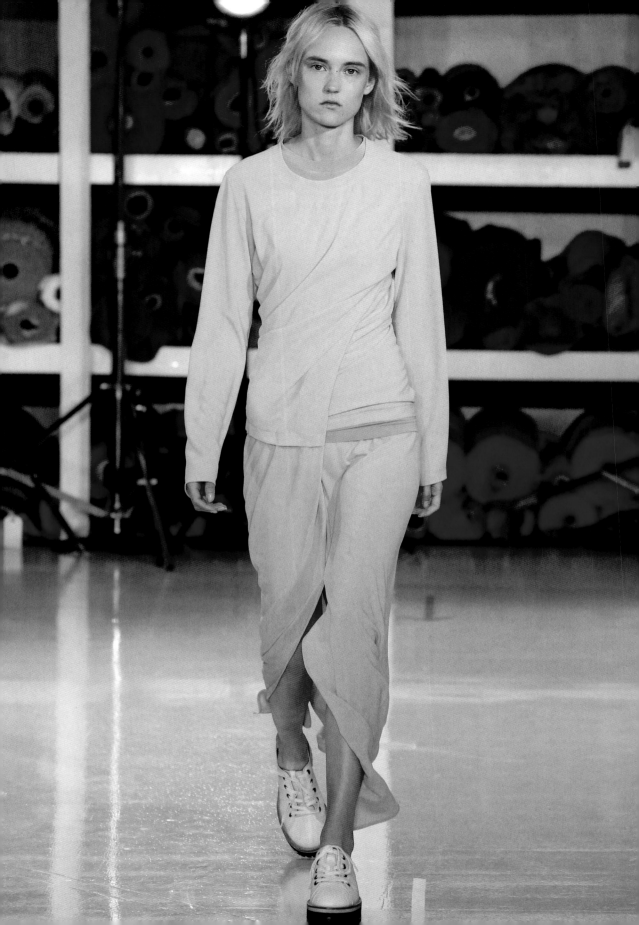

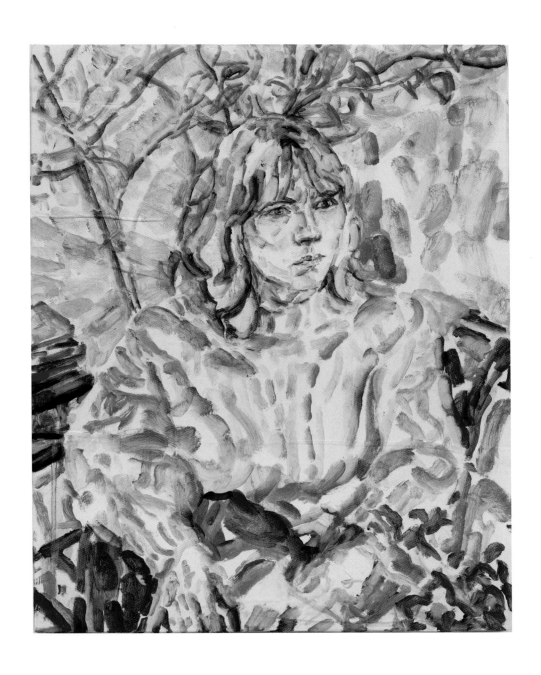

Elizabeth Peyton, *Winter (Lara Sturgis)*, 2020.

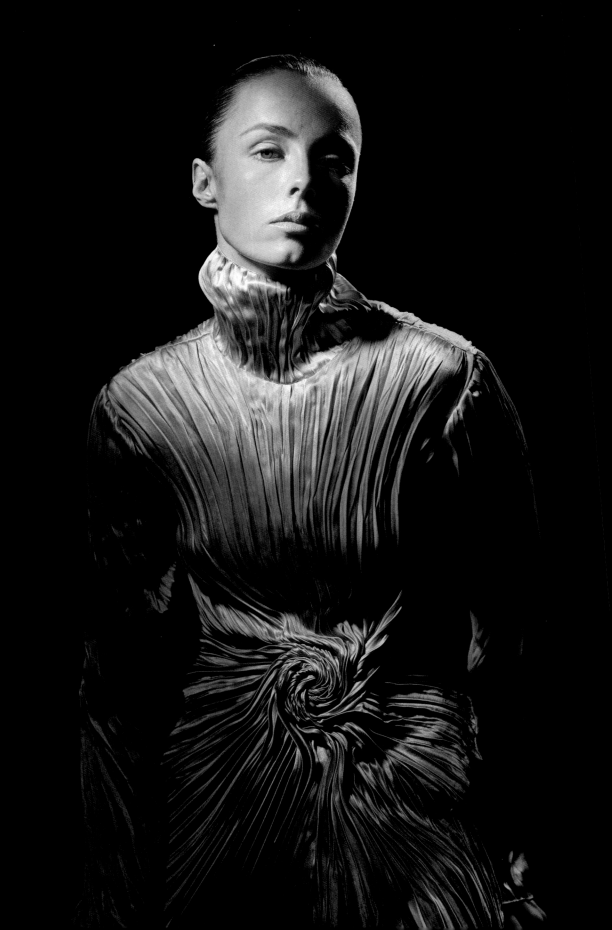

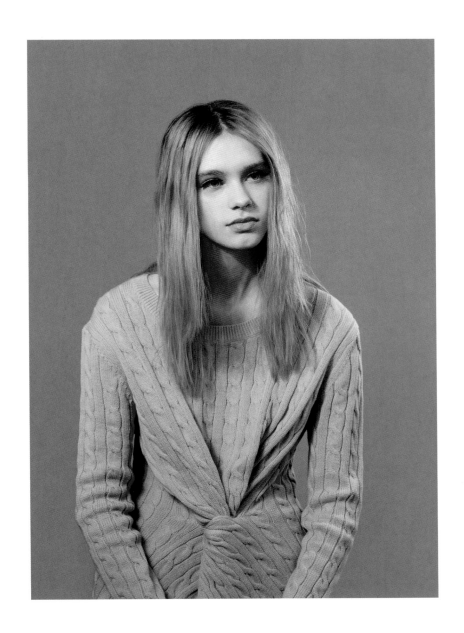

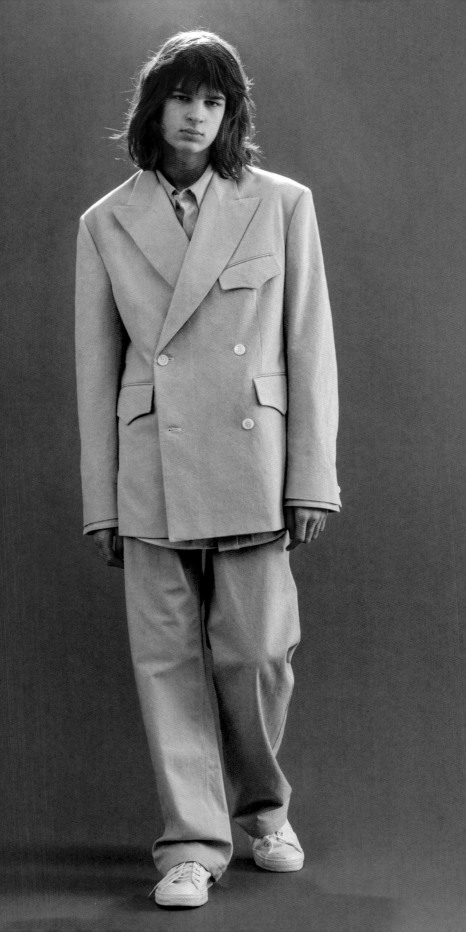

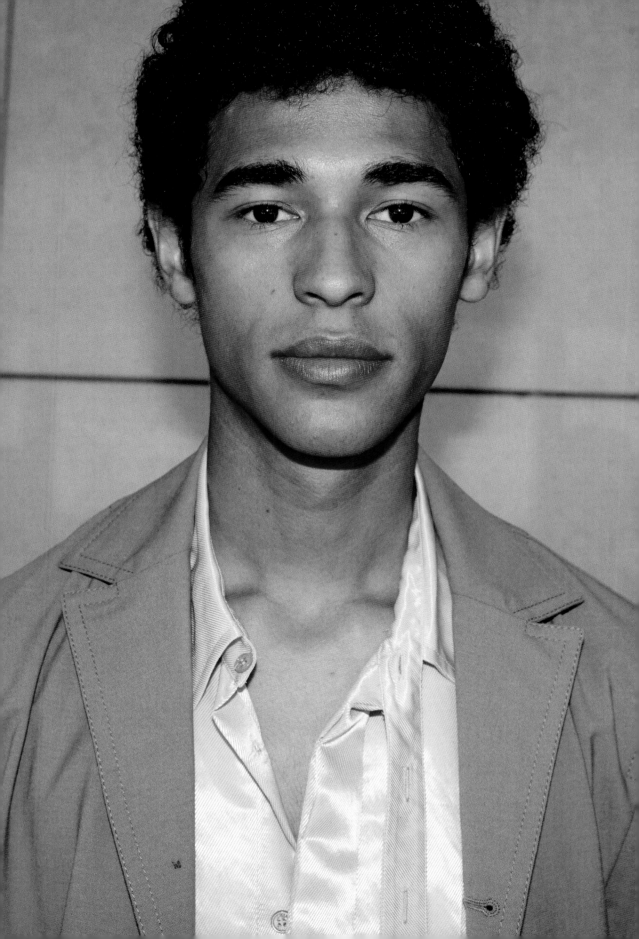

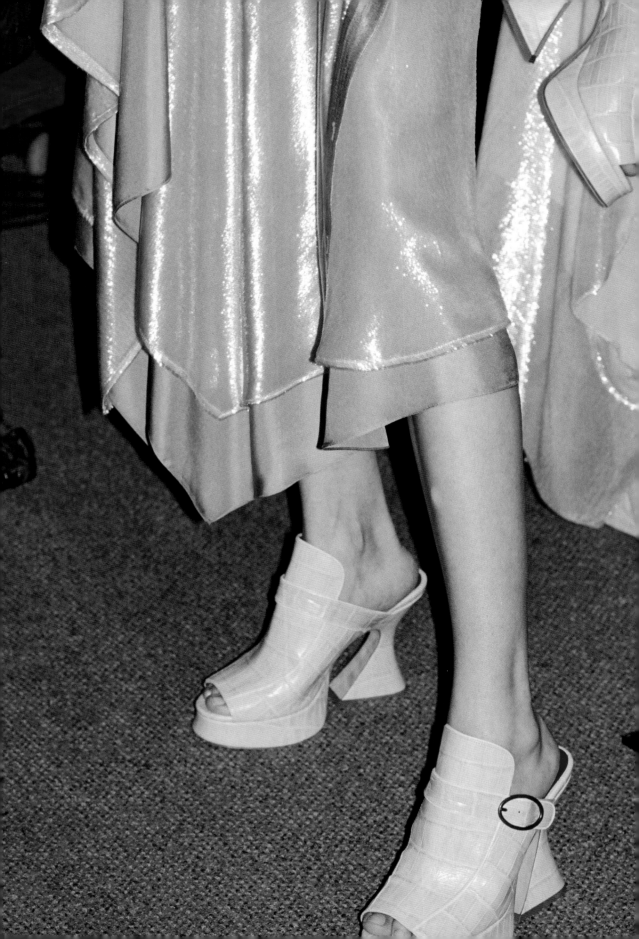

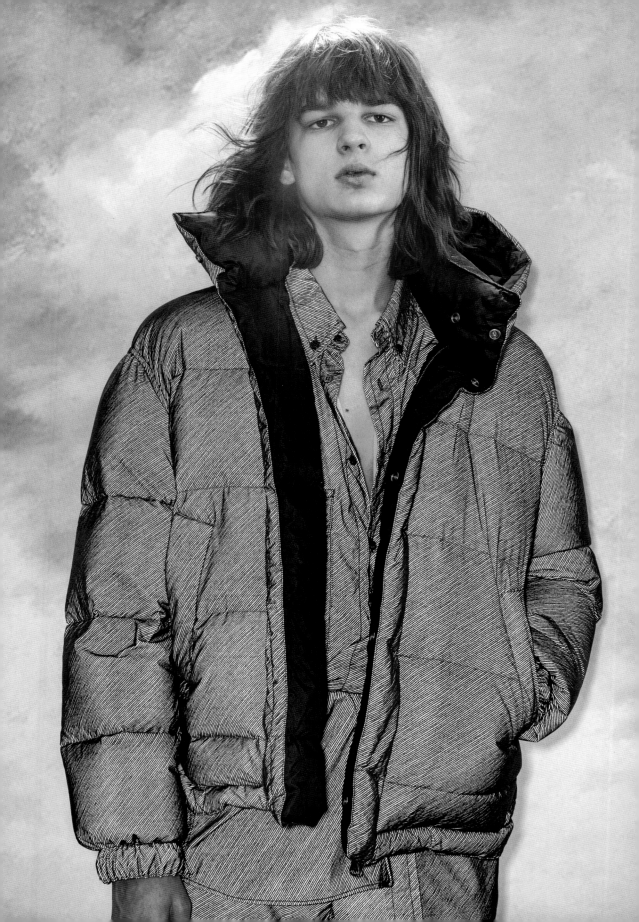

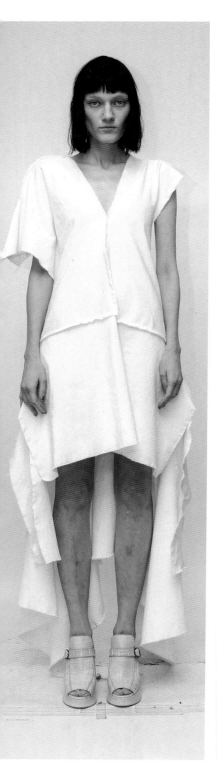
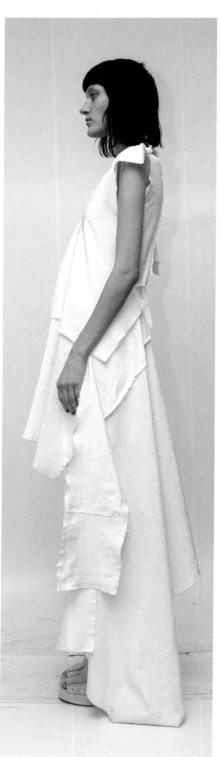
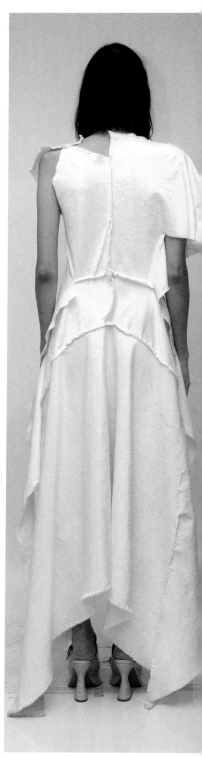

Giorgio Morandi, *Natura morta (Still Life)*, 1959.

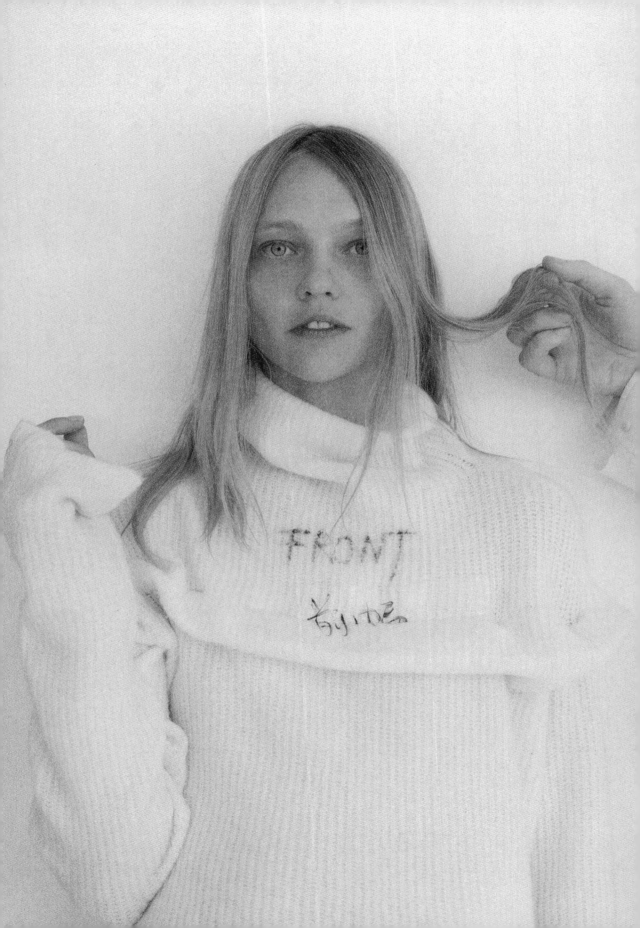

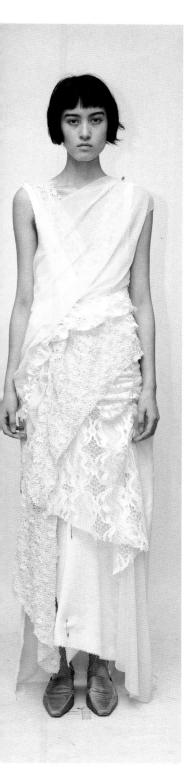
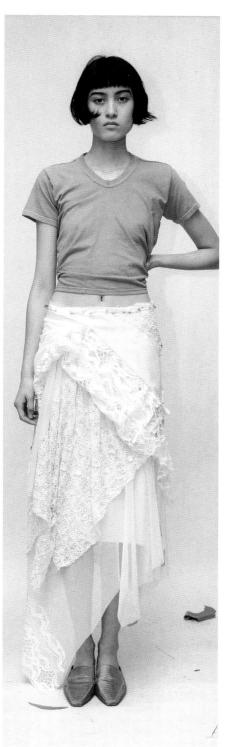
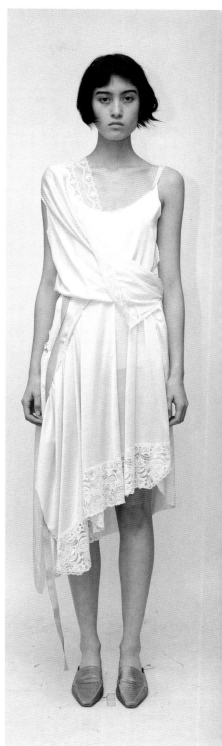

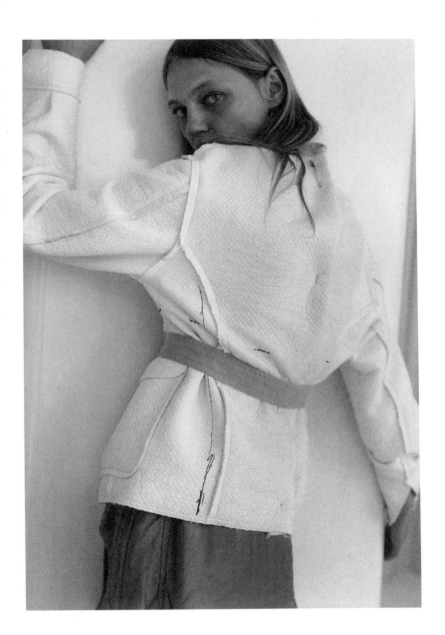

Marlene Dumas, *She speaks***, 2015-2016.**

Cover

6

7

10

13

15

16

17

18

19

20

21

22

23

24

25

26

27

28

29

30

31

32–33

34

35

36

37

38

39

40–41

42

43

44

45

50

51

52

53

54

55

56

57

58

59

60

61

62–63

64–65

66

67

68

69

70

71

72

73

74

75

76

77

78

79

80

81

82

83

84

85

86–87

Credits

Cover: First Sies Marjan teaser with Guinevere van Seenus, 2015 (back). Detail of Spring/Summer 2018 look 31, 32 and 33 backstage at the Sies Marjan office, 151 W. 26 St., NYC, on September 10, 2017. Styling by Marie Chaix (front). Photography by Kacper Kasprzyk .

6 Elizabeth Peyton, *Sander (Sander Lak)*, 2018. Pastel on paper, 17 3/4 x 14 inches. Image courtesy of the artist.

7 Gabby and Elizabeth Peyton wearing Fall 2019 at the Sies Marjan Atelier, 151 W. 26 St., NYC, 2018. Styling by Theo Wenner.

10 Marjan and Sies mini wedding photo album.

13 Photography by Dhaval Patel, 2016.

15 Aketch, Joy Winnie, Mia Brammer, Quinn Mora, Tessa Bruinsma, Sonya Maltceva, and Kristin Drab during the finale of the Spring/Summer 2020 on the runway at The Surrogate's Courthouse, 31 Chambers St., NYC, on September 8, 2019. Styling by Marie Chaix. Photography by Dan Lecca and team.

16 Spring 2017 Lookbook. Styling by Lotta Volkova. Photography by Kacper Kasprzyk.

17 Charlotte Lindvig wearing Spring 2017. Styling by Lotta Volkova. Photography by Kacper Kasprzyk.

18 Thalita Farias and Farhan Alam wearing Spring/Summer 2020 look 28 and 27 backstage at Opéra Bastille, Place de la Bastille, Paris, on June 22, 2019. Styling by Benjamin Kirchhoff. Photography by Sonny Van De Velde.

19 Miki Ehara wearing Spring/Summer 2019 look 32 backstage at Lever House, 390 Park Ave., NYC, on September 9, 2018. Styling by Marie Chaix. Photography by Michael James Fox.

20 *Vogue*, September 1962, 170. Photography by Irving Penn.

21 Joel Frampton wearing Fall/Winter 2020 Menswear. Photography by Blommers/Schumm.

22 Nathan Stewart-Jarrett wearing Fall/Winter 2020 menswear. Photography by Blommers & Schumm.

23 Eliseu Zimmer wearing Fall/Winter 2019 menswear. Styling by Megan Bowman Gray. Photography by Brianna Hawkins.

24 Bente Oort wearing Spring/Summer 2020 look 7 on the runway at The Surrogate's Courthouse, 31 Chambers Street, NYC, on September 8, 2019. Styling by Marie Chaix. Earrings by Pamela Love. Photography by Dan Lecca and team.

25 Kiki Willems wearing Spring/Summer 2020 look 4. Photography by Kacper Kasprzyk.

26 Detail of color reference board, 2019. Photography by Sander Lak.

27 Thomas Ruff, *Porträt (E. Denda)*, 1984. Chromogenic print. © 2021 Artists Rights Society (ARS), New York / VG Bild-Kunst, Bonn.

28 Fall 2020 Lookbook. Photography by Sander Lak.

29 Callum Stoddart wearing Spring/Summer 2020 look 26 backstage at Opéra Bastille, Place de la Bastille, Paris, on June 22, 2019. Styling by Benjamin Kirchhoff. Photography by Kacper Kasprzyk.

30 Teddy Edey wearing Spring/Summer 2020 look 25 at Opéra Bastille, Place de la Bastille, Paris, on June 22, 2019. Styling by Benjamin Kirchhoff. Photography by Kacper Kasprzyk.

31 In-house styling for Fall/Winter 2016 runway with Sander, Irina, Isaac, and Katie Moore, 2016. Photography by Kacper Kasprzyk.

32-33 Anna Ewers, Belle Piersson, Kaia Gerber, Anwar Hadid and Dasha Shevik wearing Spring/Summer 2019 look 1, 49, 48, 47 and 31 backstage at Lever House, 390 Park Ave., NYC, on September 9, 2018. Styling by Marie Chaix. Photography by Tina Barney.

34 Kiki Willems wearing Spring/Summer 2019 look 42. Photography by Lea Colombo.

35 Sies Lak with Sander Lak in Roses, Spain, 1988.

36 Shanelle Nyasiase wearing Spring/Summer 2019 look 45 at the Sies Marjan office, 151 W. 26 St., NYC, on September 8, 2018. Photography by Michael James Fox.

37 Image source unknown.

38 In-house knitwear fitting with Sasha Komarova, Sander, Autie, and Louise, 2017. Photography by Justin Stutzman.

39 Detail of the Sies Marjan Atelier. Photography by Kacper Kasprzyk.

40-41 Nur Elektra El Shami Goldstein wearing Fall/Winter 2016. Photography by Kacper Kasprzyk.

42 Nur Elektra El Shami Goldstein wearing Fall/Winter 2016. Art direction by Christopher Simmonds. Photography by Kacper Kasprzyk.

43 Gaia Orgeas wearing Spring/Summer 2019. Styling by Megan Bowman Gray. Photography by Kacper Kasprzyk.

44 Detail shot of look 29 at Fall 2020 runway show. Styling by Marie Chaix. Photography by Dan Lecca and team.

45 In-house collection fitting with Marjan Jonkman, 2015. Photography by Justin Stutzman.

50 Detail of Fall/Winter 2018 look 20 on the runway at Penn Plaza Pavilion, 401 Seventh Ave., NYC, on February 11, 2018. Photography by Mitchell Sams.

51 Mia Brammer wearing Spring/Summer 2020 look 18. Photography by Kacper Kasprzyk.

52 Jing Wen wearing Fall/Winter 2019 look 34 backstage at SIR Stage 37, 508 W. 37 St., NYC, on February 10, 2019. Styling by Marie Chaix. Photography by Kacper Kasprzyk.

53 Detail of Fall/Winter 2016 look 22 on the runway at 100 Barclay St., NYC, on February 14, 2016. Styling by Lotta Volkova. Photography by Mitchell Sams.

54 Color reference. Photography by Sander Lak.

55 Marjan Jonkman wearing Spring/Summer 2018 look 8 on the runway at the Sies Marjan office, 151 W. 26 St., NYC, on September 10, 2017. Styling by Marie Chaix. Photography by Dan Lecca and team.

56 Aube Jolicoeur wearing Spring/Summer 2018. Styling by Megan Bowman Gray. Photography by Theo Wenner.

57 Donna Tartt wearing Fall 2019 at the Sies Marjan Atelier, 151 W. 26 St., NYC, 2018. Photography by Theo Wenner.

58 Detail of Fall/Winter 2016 look 28 on the runway at 100 Barclay St., NYC, on February 14, 2016. Photography by Mitchell Sams.

59 Detail of development fitting board Fall/Winter 2020 with Aketch Joy Winnie and Quinn Mora. Photography by Sander Lak.

60 Jamison Stadie wearing Spring 2020 Menswear. Styling by Megan Bowman Gray. Art direction by Florentin Tuillier. Photography by Barrett Sweger.

61 Reilly Patton wearing Fall 2019 Menswear. Photography by Sander Lak.

62-63 Patty Lu wearing Fall/Winter 2016. Art direction by Christopher Simmonds. Photography by Kacper Kasprzyk.

64-65 Julia Nobis, Odette Pavlova, Lia Pavlova, Jay Wright, and Frida Westerlund during the finale of the Fall/Winter 2016 on the runway at 100 Barclay St., NYC, on February 14, 2016. Styling by Lotta Volkova. Photography by Mitchell Sams.

66 Jay Wright wearing Fall/Winter 2016 look 33 on the runway at 100 Barclay St., NYC, on February 14, 2016. Styling by Lotta Volkova. Photography by Mitchell Sams.

67 Detail of color reference board, 2020. Photography by Sander Lak.

68 Detail of Spring/Summer 2020 look 33 and 34 backstage at The Surrogate's Courthouse, 31 Chambers St., NYC, on September 8, 2019. Styling by Marie Chaix. Photography by Ulrich Knoblauch.

69 Detail of Spring/Summer 2017 look 22 backstage at the New York City Bar Association, 42 W. 44 St., NYC, on September 11, 2016. Styling by Lotta Volkova. Photography by Kacper Kasprzyk.

70 Detail of Spring/Summer 2020 look 20 backstage at Opéra Bastille, Place de la Bastille, Paris, on June 22, 2019. Styling by Benjamin Kirchhoff. Photography by Kacper Kasprzyk.

71 Shanelle Nyasiase wearing Spring/Summer 2020 look 36. Photography by Kacper Kasprzyk.

72 Aziz Dosso wearing Spring/Summer 2020 look 29 backstage at Opéra Bastille, Place de la Bastille, Paris, on June 22, 2019. Styling by Benjamin Kirchhoff. Photography by Kacper Kasprzyk.

73 Julia Banas, 2016. Photography by Kacper Kasprzyk.

74 Jakub Nowak wearing Fall/Winter 2020 Menswear. Photography by Blommers/Schumm.

75 In-house development fitting with Liene Podina, 2016. Photography by Justin Stutzman.

76 Color reference. Photography by Sander Lak.

77 Alina Bolotina wearing Spring/Summer 2020 look 23. Photography by Kacper Kasprzyk.

78 Jordy Ortiz wearing Fall/Winter 2020 look 36 on the runway at One Manhattan West, 395 Ninth Ave., NYC, on February 9, 2020. Styling by Marie Chaix. Photography by Dan Lecca and team.

79 Fall 2019 Menswear Lookbook. Photography by Sander Lak.

80 Joel Frampton wearing Fall/Winter 2020 Menswear. Photography by Blommers/Schumm.

81 Benjamin Kirchhoff with Serigne Lam wearing Spring/Summer 2020 look 30 backstage at Opéra Bastille, Place de la Bastille, Paris, on June 22, 2019. Photography by Kacper Kasprzyk.

82 Sander Lak and Rem Koolhaas, visit at the OMA Office in Rotterdam, Netherlands, 2019. Photography by Florentin Tuillier.

83 Detail of fabric, development and research boards Fall/Winter 2020. Photography by Sander Lak.

84 Alice Neel, *Ginny in Striped Shirt,* 1969. Oil on canvas, 59 3/4 x 40 inches. © The Estate of Alice Neel, courtesy The Estate of Alice Neel and David Zwirner.

85 Nur Electra El Shami Goldstein and Marjan Lak wear Spring/Summer 2019 look 21 and 20 backstage at Lever House, 390 Park Ave., NYC, on September 9, 2018. Photography by Nirva Derbekyan.

86-87 Dasha Shevik, Trenton Parrot, and Cami You-Ten wearing Spring 2019. Photography by Sander Lak.

88

89

90

91

92

93

94

95

96

97

98–99

100

101

102–103

104

105

106–107

108

109

110

111

112

113

114–115

116

117

118–119

128

129

130

131

132

133

134–135

136

137

138

139

140

141

142

143

144

145

146

147

148

149

150

151

152–153

154

155

156–157

158

159

160–161

162

163

164

165

166

167

168

88 Sarah Sze, *Shorter than the Day*, 2020. Powder-coated aluminum and steel Commissioned by LaGuardia Gateway Partners in partnership with Public Art Fund for LaGuardia Airport's Terminal B. © Sarah Sze, courtesy of the artist; LaGuardia Gateway. Partners; Public Art Fund, NY. Photo: Nicholas Knight.

89 Akito Mizutani wearing Spring/Summer 2020 look 36 on the runway at Opéra Bastille, Place de la Bastille, Paris, on June 22, 2019. Styling by Benjamin Kirchhoff. Photography by Brianna Hawkins.

90 Detail of Spring/Summer 2018 look 3 on the runway at the Sies Marjan office, 151 W. 26 St., NYC, on September 10, 2017. Styling by Marie Chaix. Photography by Dan Lecca and team.

91 Abdulaye Niang wearing Spring/Summer 2018 look 7 backstage at the Sies Marjan office, 151 W. 26 St., NYC, on September 10, 2017. Styling by Marie Chaix. Photography by Kacper Kasprzyk.

92 Adut Akech wearing Spring/Summer 2020 look 1. Photography by Kacper Kasprzyk.

93 Sora Choi wearing Fall/Winter 2019 look 32. Photography by Kacper Kasprzyk.

94 Benjamin Migsch wearing Spring/Summer 2020 look 35 backstage at Opéra Bastille, Place de la Bastille, Paris, on June 22, 2019. Styling by Benjamin Kirchhoff. Photography by Kacper Kasprzyk.

95 Harleth Kuusik wearing Fall 2017. Photography by Roe Ethridge.

96 Detail of Spring/Summer 2019 look 26 on the runway at Lever House, 390 Park Ave., NYC, on September 9, 2018. Styling by Marie Chaix. Photography by Mitchell Sams.

97 Sander Lak wearing Menswear capsule collection 2017. Photography by Justin Stutzman.

98-99 Patty Lu wearing Fall/Winter 2016. Art direction by Christopher Simmonds. Photography by Kacper Kasprzyk.

100 Serigne Lam wearing Spring/Summer 2020 look 30 backstage at Opéra Bastille, Place de la Bastille, Paris, on June 22, 2019. Styling by Benjamin Kirchhoff. Photography by Kacper Kasprzyk.

101 LaKeith Stanfield at the 2019 CFDA Fashion Awards. Photography by Kiki Willems.

102-103 Isabella Rossellini, Roberto Rossellini, Ben Allen, Dilone, Lexi Boling, Lorna Foran, Malcolm Evans, Matthew Sinnaeve, Sander Lak, Sasha Pivovarova, and daughter, Mia wearing Fall/Winter 2017. Styling by Marie Chaix. Photography by Bruce Weber.

104 Detail of color reference board, 2018. Photography by Sander Lak.

105 Rachel Feinstein, *Feathers*, 2018. Hand-applied color resin over foam with wooden base, 77 x 37 1/2 x 29 1/2 inches. © Rachel Feinstein. Photo: Jeff McLane. Courtesy Gagosian.

106-107 Leslie Bembinster, Nella Ngingo, Sasha Knysh, Alina Mikheeva, Chen Yuan, Chen Xi, Tang He, Remington Williams, Katia André, Hyun Ji Shin, Wangy, and Xin Yu wearing Fall/Winter 2019 on the runway at SIR Stage 37, 508 W. 37 St., NYC, on February 10, 2019. Styling by Marie Chaix. Photography by Mitchell Sams.

108 Remington Williams and Katia Andre wearing Fall/Winter 2019 look 5 and 13 backstage at SIR Stage 37, 508 W. 37 St., NYC, on February 10, 2019. Photography by Sander Lak.

109 Mariana Barcelos wearing Fall 2019. Styling by Megan Bowman Gray. Photography by Gareth McConnell.

110 Detail of Fall/Winter 2018 look 28 on the runway at Penn Plaza Pavilion, 401 Seventh Ave., NYC, on February 11, 2018. Styling by Marie Chaix. Photography by Mitchell Sams.

111 Detail of color reference board, 2018. Photography by Sander Lak.

112 Ziwei Cao wearing Fall/Winter 2019 look 14 backstage at SIR Stage 37, 508 W. 37 St., NYC, on February 10, 2019. Styling by Marie Chaix. Photography by Sonny Vandevelde.

113 Monica working on Fall/Winter 2019 look 14 at the Sies Marjan Atelier, 2018. Photography by Happy Monday.

114-115 In-house development fitting, 2016. Photography by Justin Stutzman.

116 Remington Williams wearing Spring/Summer 2020 look 12. Photography by Kacper Kasprzyk.

117 Frederikke Sofie wearing Spring/Summer 2017 look 5 on the runway at the New York City Bar Association, 42 W. 44 St., NYC, on September 11, 2016. Styling by Lotta Volkova. Photography by Mitchell Sams.

118-119 Detail of Spring/Summer 2018 look 15 backstage at the Sies Marjan office, 151 W. 26 St., NYC, on September 10, 2017. Styling by Marie Chaix. Photography by Kacper Kasprzyk.

128 In-house Spring/Summer 2018 runway fitting with Lexi Boling, 2017. Styling by Marie Chaix. Photography by Justin Stutzman.

129 Amelia Rami wearing Spring/Summer 2018 backstage at the Sies Marjan office, 151 W. 26 St., NYC, on September 10, 2017. Styling by Marie Chaix. Photography by Kacper Kasprzyk.

130 Anita Bitton and Ken Paquier at the Sies Marjan Atelier, 2018. Photography by Kacper Kasprzyk.

131 Sasha Pivovarova wearing Fall/Winter 2019 look 26 backstage at SIR Stage 37, 508 W. 37 St., NYC, on February 10, 2019. Styling by Marie Chaix. Photography by Sonny Vandevelde.

132 Sora Choi wearing Fall/Winter 2017 look 15 backstage at the New York Hilton Midtown, 1335 Avenue of the Americas, NYC, on February 12, 2017. Styling by Marie Chaix. Photography by Kacper Kasprzyk.

133 Sasha Pivovarova wearing Fall/Winter 2017 look 36 backstage at the New York Hilton Midtown, 1335 Avenue of the Americas, NYC, on February 12, 2017. Photography by Blommers/Schumm.

134-135 Yanan Li, Layla Ong, and Anniek Verfaille wearing Fall/Winter 2019. Photography by Justin Stutzman.

136 Detail of the Sies Marjan Atelier. Photography by Kacper Kasprzyk.

137 Detail of Fall/Winter 2019 look 15 on the runway at SIR Stage 37, 508 W. 37 St., NYC, on February 10, 2019. Styling by Marie Chaix. Photography by Mitchell Sams.

138 Detail of Fall/Winter 2019 look 3 backstage at SIR Stage 37, 508 W. 37 St., NYC, on February 10, 2019. Styling by Marie Chaix. Photography by Kacper Kasprzyk.

139 Detail of Fall/Winter 2019 look 21 on the runway at SIR Stage 37, 508 W. 37 St., NYC, on February 10, 2019. Styling by Marie Chaix. Photography by Mitchell Sams.

140 Detail of Fall/Winter 2019 Footwear. Photography by Kacper Kasprzyk.

141 Detail of the Sies Marjan Atelier. Photography by Kacper Kasprzyk.

142 Fernanda Ly wearing Fall/Winter 2019 look 17 backstage at SIR Stage 37, 508 W. 37 St., NYC, on February 10, 2019. Styling by Marie Chaix. Photography by Pola Ester for *Purple* magazine.

143 Color reference. Photography by Sander Lak.

144 Tina Barney, *Man on Beach in Sies Marjan*, 2021.

145 Olivia Forte wearing Fall/Winter 2017 look 9 backstage at the New York Hilton Midtown, 1335 Avenue of the Americas, NYC, on February 12, 2017. Photography by Blommers/Schumm.

146 Fall/Winter 2017 Lookbook. Styling by Marie Chaix. Photography by Roe Ethridge.

147 Frederikke Sofie wearing Spring/Summer 2018. Styling by Megan Bowman Gray. Photography by Theo Wenner.

148 Robin Cocco wearing Fall 2019 Menswear. Photography by Pakting Leung.

149 Cynthia Scholten behind the scenes of Fall/Winter 2016 campaign shoot. Photography by Sander Lak.

150 Kiki Willems wearing Fall/Winter 2019 look 17 backstage at SIR Stage 37, 508 W. 37 St., NYC, on February 10, 2019. Styling by Marie Chaix. Photography by Pola Ester for *Purple* magazine.

151 Daniel working on Fall/Winter 2019 look 17 at the Sies Marjan Atelier, 2018. Photography by Kacper Kasprzyk.

152-153 Cynthia Scholten wearing Fall/Winter 2016. Art direction by Christopher Simmonds. Photography by Kacper Kasprzyk.

154 Dasha Shevik wearing Spring/Summer 2020 look 11. Earrings by Pamela Love. Photography by Kacper Kasprzyk.

155 In-house styling for Fall/Winter 2018 runway with Remington Williams, 2017. Styling by Marie Chaix. Photography by Justin Stutzman.

156-157 Anniek Verfaille, Lucas Jayden Satherly, Dasha Shevik wearing Fall/Winter 2018. Photography by Justin Stutzman.

158 Katia André wearing Fall/Winter 2019 look 13 backstage at SIR Stage 37, 508 W. 37 St., NYC, on February 10, 2019. Styling by Marie Chaix. Photography by Kacper Kasprzyk.

159 Neo Rauch, *Der Türmer*, 2017. Oil on canvas, 118 1/2 x 86 3/4 inches. © Courtesy Galerie EIGEN + ART, Leipzig/Berlin / Artists Rights Society (ARS), New York, 2021.

160-161 Edie Campbell wearing Fall/Winter 2018 look 1 on the runway at Penn Plaza Pavilion, 401 Seventh Ave., NYC, on February 11, 2018. Styling by Marie Chaix. Photography by Kacper Kasprzyk.

162 Isaac working on Fall/Winter 2019 look 35 at the Sies Marjan Atelier, 2018. Photography by Kacper Kasprzyk.

163 Liu Wen wearing Fall/Winter 2019 look 35 on the runway at SIR Stage 37, 508 W. 37 St., NYC, on February 10, 2019. Styling by Marie Chaix. Photography by Mitchell Sams.

164 Adut Akech wearing Fall/Winter 2019. Styling by Danny Reed. Photography by Angelo Pennetta for *Love* Magazine, "New York City Kid" article, Issue 22.

165 Drew Hubert wearing Fall 2019 Menswear. Photography by Sander Lak.

166 Adam Osborne wearing Fall 2019 Menswear. Photography by Sander Lak.

167 Meghan Collison wearing Spring/Summer 2019. Styling by Megan Bowman Gray. Photography by Kacper Kasprzyk.

168 Detail of Fall/Winter 2017 look 9 backstage at the New York Hilton Midtown, 1335 Avenue of the Americas, NYC, on February 12, 2017. Styling by Marie Chaix. Photography by Kacper Kasprzyk.

169

170

171

172–173

174

175

181

182–183

184

185

186

187

188–189

190

191

192

193

194

195

196

197

198

199

200

201

202

203

204

205

206

207

208

209

210

211

212–213

214

215

216

217

218

219

220

221

224

225

226

227

228–229

230

231

232

233

234

235

236–237

238

239

240–241

242

243

244

169 Harleth Kuusik wearing Fall/Winter 2017. Styling by Marie Chaix. Photography by Roe Ethridge.

170 Jing Wen wearing Fall/Winter 2017 look 23 backstage at the New York Hilton Midtown, 1335 Avenue of the Americas, NYC, on February 12, 2017. Styling by Marie Chaix. Photography by Kacper Kasprzyk.

171 Raquel Zimmermann wearing Fall/Winter 2017. Styling by Elizabeth von Guttman and Alexia Niedzielski. Photography by Juergen Teller for *System* magazine No 9 Supplement, 2017. "At Moments I Felt like Being in a Strange Dream No. 63," © Juergen Teller, all rights Reserved.

172-173 Sander with Lexi Boling, Harleth Kuusik, Karly Loyce, and Ally Ertel wearing Fall/Winter 2017 look 4, 5, 6 and 7 backstage at the New York Hilton Midtown, 1335 Avenue of the Americas, NYC, on February 12, 2017. Styling by Marie Chaix. Photography by Kacper Kasprzyk.

174 Color reference. Photography by Sander Lak.

175 Aube Jolicoeur and Remington Williams wearing Fall 2019. Photography by Sander Lak.

181 (Deep Purple) Sarah Sze, *Night Shift (Times Zero)*, 2020 (detail). Oil paint, acrylic paint, acrylic polymers, ink, aluminum, archival paper, graphite, diabond, and wood. 73½ x 49 x 2½ inches. Photography: courtesy Sarah Sze studio.

(Hot Pink) Sarah Sze, *Archival Image (Volcano)*, 2019. Photography: courtesy Sarah Sze Studio

(Green) Sarah Sze, *Fifth Season*, 2021 (detail). Mixed media, oil paint, acrylic paint, ink, canvas, projectors, plants, clay, archival paper, aluminum, plastic, wood, water, lights, fan, string, video, photographs, dirt, metal mirrors, stones. 117 x 113 x 600 inches. Photography: courtesy Sarah Sze Studio.

(Orange) Sarah Sze, *Tracing Fallen Sky*, 2020 (detail). Mixed media, stainless steel, salt, archival pigment prints, video projector, pendulum. Dimensions variable. Photography: Luc Boegly, courtesy Sarah Sze Studio.

182-183 Praise Nicholas, Adam Osborne, and Drew Hubert wearing Fall 2019 Menswear. Photography by Sander Lak.

184 Detail of Fall/Winter 2017 Footwear. Photography by Kacper Kasprzyk.

185 Cindy Sherman, *High on Life*, 2017.

186 Detail of the Sies Marjan Atelier. Photography by Kacper Kasprzyk.

187 Harleth Kuusik wearing Fall/Winter 2017 look 5 backstage at the New York Hilton Midtown, 1335 Avenue of the Americas, NYC, on February 12, 2017. Styling by Marie Chaix. Photography by Kacper Kasprzyk.

188-189 Detail of development fitting board Spring/Summer 2020 with Jaron Baker. Photography by Sander Lak.

190 Lex Herl, Julia Nobis, and Marjan Jonkman wearing Fall/Winter 2017 look 1, 2, 3 backstage at the New York Hilton Midtown, 1335 Avenue of the Americas, NYC, on February 12, 2017. Styling by Marie Chaix. Photography by Kacper Kasprzyk.

191 Color reference. Photography by Sander Lak.

192 Sunniva Vaatevik wearing Fall/Winter 2017 look 12 backstage at the New York Hilton Midtown, 1335 Avenue of the Americas, NYC, on February 12, 2017. Styling by Marie Chaix. Photography by Kacper Kasprzyk.

193 Marlene Dumas, *Amy -Back to*, 2015. Lithograph, 16 x 18 3/8 inches. © Marlene Dumas.

194 In-house collection fitting with Marjan Jonkman, 2015. Photography by Justin Stutzman.

195 Kiki Willems and Adesuwa Aighewi wearing Fall/Winter 2018 look 21 and 22 backstage at Penn Plaza Pavilion, 401 Seventh Ave., NYC, on February 11, 2018. Styling by Marie Chaix. Photography by Pier Nicola Bruno.

196 Nur Elektra El Shami Goldstein wearing Spring/Summer 2018, Water Island, 2018. Photography by Sander Lak.

197 Sander Lak's personal notebook. Artwork source unknown.

198 Hyunji Shin wearing Fall/Winter 2019 look 11 backstage at SIR Stage 37, 508 W. 37 St., NYC, on February 10, 2019. Styling by Marie Chaix. Photography by Sonny Vandevelde.

199 Yanan Li wearing Fall 2019. Photography by Sander Lak.

200 Fall/Winter 2019 collection at the Sies Marjan Atelier, 2018. Photography by Happy Monday.

201 Sander Lak's personal notebook. Artwork by Gareth McConnell.

202 Diedrick Brackens, *when no softness came*, 2019. Woven cotton and acrylic yarn, 96 x 96 inches. Image courtesy of Various Small Fires, Los Angeles and Jack Shainman Gallery, New York.

203 Adut Akech wearing Fall/Winter 2019. Styling by Danny Reed. Photography by Angelo Pennetta for *Love* magazine, "New York City Kid" article, Issue 22.

204 Jamie Bochert wearing Spring/Summer 2017 look 6 backstage at the New York City Bar Association, 42 W. 44 St., NYC, on September 11, 2016. Styling by Lotta Volkova. Photography by Mitchell Sams.

205 Ellen Rosa, Maria Zakrzewska, Zosia Cychol, Karly Loyce, and Frederikke Sofie during the finale of the Spring/Summer 2017 runway show at the New York Bar Association, 42 W. 44 St., NYC, on September 11, 2016. Photography by Mitchell Sams.

206 Tran, Ga-Hee, Kristina, Samantha, Lanae, Isaac, Christine, and Brianna in the Sies Marjan kitchen, 2019. Photography by Sander Lak.

207 Detail of Spring/Summer 2017 look 13 backstage at the New York City Bar Association, 42 W. 44 St., NYC, on September 11, 2016. Styling by Lotta Volkova. Photography by Kacper Kasprzyk.

208 Abdou Fall wearing Fall/Winter 2019 Menswear. Styling by Megan Bowman Gray. Photography by Brianna Hawkins.

209 Michael Stipe, *3-D scan, early technology*, with Michael Oliveri, Athens.

210 Sander Lak's personal notebook with Cynthia Scholten.

211 Karolina Isomaki Kasprzyk wearing Spring/Summer 2017 and Edward in Ibiza, 2018. Photography by Sander Lak.

212-213 Yanan Li, Alina Mikheeva, and Chen Xi wearing Fall/Winter 2019. Photography by Justin Stutzman.

214 Tang He wearing Fall/Winter 2019 look 4 backstage at SIR Stage 37, 508 W. 37 St., NYC, on February 10, 2019. Styling by Marie Chaix. Photography by Pola Ester for *Purple* magazine.

215 Chen Yuan wearing Fall/Winter 2019. Photography by Kacper Kasprzyk.

216 Fall 2020 Lookbook. Photography by Sander Lak.

217 Jakub Nowak wearing Fall 2020 Menswear. Photography by Justin Stutzman.

218 Kiki Willems wearing Spring/Summer 2017 look 11 backstage at the New York City Bar Association, 42 W. 44 St., NYC, on September 11, 2016. Styling by Lotta Volkova. Photography by Kacper Kasprzyk.

219 Color reference. Photography by Sander Lak.

220 Ken Paquier wearing Spring/Summer 2019. Photography by Justin Stutzman.

221 Cyrielle Lalande wearing Fall/Winter 2020 look 27. Photography by Kacper Kasprzyk.

224 Spring 2019 Lookbook. Photography by Sander Lak.

225 Gabby Bennett wearing Spring/Summer 2019 look 17 on the runway at Lever House, 390 Park Ave., NYC on September 9, 2018. Styling by Marie Chaix. Photography by Mitchell Sams.

226 Detail of development board for Fall/Winter 2020. Photography by Sander Lak.

227 In-house development fitting with Makenna Kart, 2019. Photography by Justin Stutzman.

228-229 Mengge Yi wearing Fall/Winter 2020 look 25 on the runway at One Manhattan West, 395 Ninth Ave., NYC, on February 9, 2020. Styling by Marie Chaix. Photography by Dan Lecca and team.

230 Sheila Hicks wearing Fall/Winter 2018 Menswear. Photography by Sander Lak.

231 Drew Hubert wearing Fall 2019 Menswear. Photography by Sander Lak.

232 Liu Huan wearing Fall/Winter 2020 look 34. Photography by Kacper Kasprzyk.

233 Claudy Jongstra x Sies Marjan x Maharam for Fall/Winter 2020. Drenthe Heath pelt by Claudy Jongstra. Handmade felt using wool from the rare Drenthe Heath breed and dyes from native plants. 35% Drenthe Heath Wool, 25% Mulberry Silk, 20% Merino Wool, 20% Wensleydale Wool.

234 Development of Spring/Summer 2019 shoes.

235 Malgosia Bela wearing Spring/Summer 2019 look 14 backstage at Lever House, 390 Park Ave., NYC, on September 9, 2018. Styling by Marie Chaix. Photography by Michael James Fox.

236-237 Detail of Spring/Summer 2019 backstage at Lever House, 390 Park Ave., NYC, on September 9, 2018. Photography by Michael James Fox.

238 Gena Malinin wearing Spring/Summer 2019. Styling by Megan Bowman Gray. Photography by Kacper Kasprzyk.

239 Finale of Spring/Summer 2019 runway at Lever House, 390 Park Ave., NYC, on September 9, 2018. Styling by Marie Chaix. Photography by Nirva Derbekyan.

240-241 Louise Du Toit, Julia Banas, and Kiki Willems wearing Spring/Summer 2019 look 7, 6, 42 backstage at Lever House, 390 Park Ave., NYC, on September 9, 2018. Styling by Marie Chaix. Photography by Tina Barney.

242 Dasha Shevik wearing Fall/Winter 2020 look 31 backstage at One Manhattan West, 395 Ninth Ave., NYC, on February 9, 2020. Styling by Marie Chaix. Photography by Robert Lindholm.

243 Detail of Fall/Winter 2020 look 30 on the runway at One Manhattan West, 395 Ninth Ave., NYC, on February 9, 2020. Styling by Marie Chaix. Photography by Dan Lecca and team.

244 Sarah Sze, *Dews Drew (Half-life)*, 2018. Oil paint, acrylic paint, archival paper, adhesive, tape, ink, acrylic polymers, shellac, water-based primer and wood. 73.5 x 49 x 3 inches. © Sarah Sze.

245

246

247

248

249

250–251

252

253

254

255

256

257

258

259

260

261

262

263

264

265

266

267

268

269

270

271

272

273

274

275

276–277

278

279

280

281

282

283

284

285

286

287

288

289

290

291

292

293

294

295

296–297

298

299

308

309

310

311

312–313

314

315

316

317

318

319

245 Remington Williams wearing Spring/Summer 2018 look 14 on the runway at the Sies Marjan office, 151 W. 26 St., NYC, on September 10, 2017. Styling by Marie Chaix. Photography by Kacper Kasprzyk.

246 Malick Bodian wearing Fall/Winter 2020 look 32 backstage at One Manhattan West, 395 Ninth Ave., NYC, on February 9, 2020. Styling by Marie Chaix. Photography by Robert Lindholm.

247 Aube Jolicoeur and Remington Williams wearing Fall 2019. Photography by Sander Lak.

248 Andrea Ramali, Sora choi, and Vaughan Ollier wearing Fall/Winter 2020 look 35, 33, 3. Photography by Kacper Kasprzyk.

249 Aliet Sarah and Aketch Joy Winnie wearing Fall/Winter 2020 look 1 and 2. Photography by Kacper Kasprzyk.

250-251 Julie Mehretu, *Of Other Planes of There (S.R.)*, 2018-2019. Ink and acrylic on canvas, 108 x 120 inches. Collection Whitney Museum of American Art, New York; purchased with funds from Anna and Matt Freedman and an anonymous donor. Photo Credit: Tom Powel Imaging. © Julie Mehretu.

252 Zavian Desoto wearing Fall/Winter 2018 look 29 backstage at Penn Plaza Pavilion, 401 Seventh Ave., NYC, on February 11, 2018. Photography by Blommers/Schumm.

253 Detail of Spring/Summer 2020 look 36 backstage at Opéra Bastille, Place de la Bastille, Paris, on June 22, 2019. Styling by Benjamin Kirchhoff. Photography by Jerome Sessini.

254 Jakub Nowak wearing Fall/Winter 2020 Menswear. Photography by Blommers/Schumm.

255 Color reference. Photography by Sander Lak.

256 David Yang wearing Fall/Winter 2018 menswear. Photography by Blommers/Schumm.

257 Detail of Fall/Winter 2017 Footwear. Photography by Kacper Kasprzyk.

258 Alice Neel, *Harold Cruse,* 1950. Oil on canvas, 31 x 22 inches. Courtesy The Estate of Alice Neel and David Zwirner.

259 Marjan Jonkman wearing Fall/Winter 2018 look 5 backstage at Penn Plaza Pavilion, 401 Seventh Ave., NYC, on February 11, 2018. Styling by Marie Chaix. Photography by Kacper Kasprzyk.

260 Darron Clarke in a fitting at the Sies Marjan Atelier, 2019. Photography by Brianna Hawkins.

261 Spring/Summer 2020 Menswear runway order. Styling by Benjamin Kirchhoff. Photography by Sander Lak.

262 Teddy Edey wearing Spring/Summer 2020 Menswear. Styling by Megan Bowman Gray. Photography by Kacper Kasprzyk.

263 Jing Wen wearing Spring/Summer 2020 look 3. Photography by Kacper Kasprzyk.

264 Shanelle Nyasiase wearing Fall/Winter 2018 look 37 backstage at Penn Plaza Pavilion, 401 Seventh Ave., NYC, on February 11, 2018. Photography by Blommers/Schumm.

265 Detail of color reference board, 2017. Photography by Sander Lak.

266 Hope Gangloff, *Captain Chaos*, 2008. Dip pen on claycoat, 14 x 17 inches.

267 Nyaueth Riam wearing Spring/Summer 2019. Styling by Megan Bowman Gray. Photography by Lea Colombo.

268 Jenn and Isaac with Olivia Forte wearing Spring/Summer 2018 look 9 backstage at the Sies Marjan office, 151 W. 26 St., NYC, on September 10, 2017. Styling by Marie Chaix. Photography by Kacper Kasprzyk.

269 Sjaak Hullekes wearing Spring 2019 Menswear, Water Island, 2019. Photography by Sander Lak.

270 Detail of *L'art et la Mode* magazine, March 1959, 99. Photography by Georges Saad.

271 Marland Backus wearing Spring 2017. Styling by Lotta Volkova. Photography by Kacper Kasprzyk.

272 Nathan Stewart-Jarrett wearing Spring/Summer 2019. Photography by Brianna Hawkins.

273 Robin Cocco wearing Fall 2019 Menswear. Photography by Pakting Leung.

274 Kehinde Wiley, *Willian Van Heythuysen,* 2006. Oil on canvas. 96 x 72 inches.

275 Aliet Sarah wearing Spring/Summer 2020 look 33 on the runway at The Surrogate's Courthouse, 31 Chambers St., NYC, on September 8, 2019. Photography by Nur Elektra El Shami Goldstein.

276-277 Gabby with Bria Vinaite wearing Fall 2019 at the Sies Marjan Atelier, 151 W. 26 St., NYC, 2018. Styling by Megan Bowman Gray. Photography by Theo Wenner.

278 Marlene Dumas, *Teeth*, 2018. Oil on canvas, 15 3/4 x 11 7/8 inches. © Marlene Dumas.

279 Remington Williams wearing Spring/Summer 2018. Styling by Megan Bowman Gray. Photography by Theo Wenner.

280 Gaia Orgeas wearing Spring/Summer 2019 look 33 backstage at Lever House, 390 Park Ave., NYC, on September 9, 2018. Styling by Marie Chaix. Photography by Michael James Fox.

281 Detail of Spring/Summer 2020 look 35 on the runway at The Surrogate's Courthouse, 31 Chambers St., NYC, on September 8, 2019. Styling by Marie Chaix. Photography by Dan Lecca and team.

282 Marjan Lak and Sander Lak in Seria, Brunei, 1986.

Marjan Lak and Sander Lak in Spring/Summer 2019 runway show fitting at the Sies Marjan Atelier, 2018. Photography by Michael James Fox.

283 Spring/Summer 2019 runway at Lever House, 390 Park Ave., NYC, on September 9, 2018. Photography by Sander Lak.

284 Kiki Willems, Jing Wen, Milliana Maalim, and Sasha Knysh wearing Spring/Summer 2020 look 4, 3, 5, 6 at The Surrogate's Courthouse, 31 Chambers St., NYC, on September 8, 2019. Styling by Marie Chaix. Photography by Ulrich Knoblauch.

285 Yilan Hua and Chen Yuan wearing Spring/Summer 2020 look 28 and 35 backstage at The Surrogate's Courthouse, 31 Chambers St., NYC, on September 8, 2019. Styling by Marie Chaix. Photography by Ulrich Knoblauch.

286 Marland Backus wearing Spring 2017. Styling by Lotta Volkova. Photography by Kacper Kasprzyk.

287 Eric Martin wearing Spring/Summer 2018 look 31 backstage at the Sies Marjan office, 151 W. 26 St., NYC, on September 10, 2017. Styling by Marie Chaix. Photography by Kacper Kasprzyk.

288 Detail of Spring/Summer 2018 look 11 on the runway at the Sies Marjan office, 151 W. 26 St., NYC, on September 10, 2017. Styling by Marie Chaix. Photography by Dan Lecca and team.

289 Lara Mullen and Sasha Knysh wearing Spring/Summer 2020 look 2 and 5 backstage at The Surrogate's Courthouse, 31 Chambers St., NYC, on September 8, 2019. Styling by Marie Chaix. Photography by Ulrich Knoblauch.

290 Color reference. Photography by Sander Lak.

291 Detail of spring 2017. Styling by Lotta Volkova. Photography by Kacper Kasprzyk.

292 Detail of Paris Hilton at the 2003 MTV Awards. Photographer unknown.

293 Charlotte Lindvig wearing Spring 2017. Styling by Lotta Volkova. Photography by Kacper Kasprzyk.

294 Marjan Jonkman wearing Spring/Summer 2017 look 18 backstage at the New York City Bar Association, 42 W. 44 St., NYC, on September 11, 2016. Styling by Lotta Volkova. Photography by Kacper Kasprzyk.

295 In-house development fitting with Ali Honcharuk, 2016. Photography by Justin Stutzman.

296-297 Boya Latumahina wearing Fall/Winter 2016. Styling by Megan Bowman Gray. Art direction by Christopher Simmonds. Photography by Nigel Shafran.

298 Detail of Spring/Summer 2020 look 1 backstage at Opéra Bastille, Place de la Bastille, Paris, on June 22, 2019. Styling by Benjamin Kirchhoff. Photography by Kacper Kasprzyk.

299 Julia Nobis wearing Spring/Summer 2017 look 35 on the runway at the New York City Bar Association, 42 W. 44 St., NYC, on September 11, 2016. Styling by Lotta Volkova. Photography by Mitchell Sams and team.

308 Matthew Peterson and Reilly Patton wear Spring/Summer 2020 look 5 and 10 backstage at Opéra Bastille, Place de la Bastille, Paris, on June 22, 2019. Styling by Benjamin Kirchhoff. Photography by Jerôme Sessini.

309 Cyrielle Lalande wearing Spring/Summer 2020 look 13 backstage at Opéra Bastille, Place de la Bastille, Paris, on June 22, 2019. Styling by Benjamin Kirchhoff. Photography by Kacper Kasprzyk.

310 Detail of Fall/Winter 2019 look 25 backstage at SIR Stage 37, 508 W. 37 St., NYC, on February 10, 2019. Styling by Marie Chaix. Photography by Kacper Kasprzyk.

311 Yanan Li wearing Fall/Winter 2019 look 25 backstage at SIR Stage 37, 508 W. 37 St., NYC, on February 10, 2019. Styling by Marie Chaix. Photography by Sonny Vandevelde.

312-313 In-house development fitting with Sasha Komarova and Justin, 2017. Photography by Justin Stutzman.

314 Detail of color reference board, 2016. Photography by Sander Lak.

315 Detail of Fall/Winter 2017 look 4 backstage at the New York Hilton Midtown, 1335 Avenue of the Americas, NYC, on February 12, 2017. Styling by Marie Chaix. Photography by Kacper Kasprzyk.

316 In-house fitting with Autie, 2016. Photography by Sander Lak.

317 Darron Clarke wearing Spring/Summer 2020 look 4 backstage at Opéra Bastille, Place de la Bastille, Paris, on June 22, 2019. Styling by Benjamin Kirchhoff. Photography by Kacper Kasprzyk.

318 Marjan Jonkman wearing Fall/Winter 2020 look 14 on the runway at One Manhattan West, 395 Ninth Ave., NYC, on February 9, 2020. Styling by Marie Chaix. Photography by Dan Lecca and team.

319 Sander Lak's personal notebook.

320

321

322

323

324–325

326

327

328

329

330

331

332

333

334

335

336

337

338

339

340

341

342

343

344

345

346

347

348

349

350

351

352

353

354

355

356

357

358

359

360–361

362

363

364

365

366–367

368

369

370

371

372

373

374

375

376

377

378

379

380

381

382

383

384

385

386

387

388–389

320 "Countryside, The Future" exhibition and collection research, 2019. Sources unknown.

321 Delilah Koch wearing Fall/Winter 2020 look 11. Photography by Kacper Kasprzyk.

322 Development of pressed plant print with Lucila at the Cornell Natural Dye studio of Cornell University, Ithaca, NY, 2019. In-house development for Fall/Winter 2020 look 11 at the Sies Marjan Atelier.

323 Ivana Trivic wearing Fall/Winter 2020 look 10 on the runway at One Manhattan West, 395 Ninth Ave., NYC, on February 9, 2020. Earrings by Marlo Laz. Styling by Marie Chaix. Photography by Dan Lecca and team.

324-325 Patty Lu wearing Fall/Winter 2016. Styling by Megan Bowman Gray. Art direction by Christopher Simmonds. Photography by Nigel Shafran.

326 Detail of Spring/Summer 2020 look 14 on the runway at Opéra Bastille, Place de la Bastille, Paris, on June 22, 2019. Styling by Benjamin Kirchhoff. Photography by Dan Lecca and team.

327 Polina Zavialova wearing Fall/Winter 2020 look 12 on the runway at One Manhattan West, 395 Ninth Ave., NYC, on February 9, 2020. Styling by Marie Chaix. Photography by Dan Lecca and team.

328 Parker van Noord wearing Fall/Winter 2020 look 7 backstage at One Manhattan West, 395 Ninth Ave., NYC, on February 9, 2020. Styling by Marie Chaix. Photography by Kacper Kasprzyk.

329 Remington Williams wearing Fall/Winter 2020 look 9. Photography by Kacper Kasprzyk.

330 Color reference. Photography by Sander Lak.

331 Gena Malinin wearing Fall/Winter 2020 Menswear. Photography by Robert Lindholm.

332 Makenna Cart wearing Fall/Winter 2020 look 5 on the runway at One Manhattan West, 395 Ninth Ave., NYC, on February 9, 2020. Styling by Marie Chaix. Photography by Dan Lecca and team.

333 In-house collection fitting with Tina Veshaguri, 2015. Photography by Justin Stutzman.

334 Anna Ewers wearing Spring/Summer 2019 look 1 backstage at Lever House, 390 Park Ave., NYC, on September 9, 2018. Styling by Marie Chaix. Photography by Michael James Fox.

335 Detail of Fall/Winter 2017 Footwear. Photography by Kacper Kasprzyk.

336 Detail of Frans Molenaar *Haute Couture* book, 1986, 64.

337 Karen Elson wearing Fall/Winter 2016. Styling by Francesca Burns. Photography by Zoë Ghertner for *The Gentlewoman*, issue no. 14, Autumn/Winter 2016.

338 Mark Vanderloo wearing Spring/Summer 2019 look 46 backstage at Lever House, 390 Park Ave., NYC, on September 9, 2018. Styling by Marie Chaix. Photography by Sonny Vandevelde.

339 Dree Hemingway wearing Spring/Summer 2019 look 38 backstage at Lever House, 390 Park Ave., NYC, on September 9, 2018. Styling by Marie Chaix. Photography by Michael James Fox.

340 Julia Banas wearing Fall/Winter 2018 look 19 backstage at Penn Plaza Pavilion, 401 Seventh Ave., NYC, February 11, 2018. Photography by Blommers/Schumm.

341 Club Kids jacquard fabric, developed by Clerici Tessuto & C. SpA.

342 Roberto Rossellini wearing Fall/Winter 2018 look 30 backstage at Penn Plaza Pavilion, 401 Seventh Ave., NYC, on February 11, 2018.

Styling by Marie Chaix. Photography by Kacper Kasprzyk.

343 LaKeith Stanfield wearing Fall/Winter 2018. Styling by Haley Wollens. Photography by Roe Ethridge for *CR Men*, Issue 7, September 2018.

344 Detail of Fall/Winter 2018 Footwear. Photography by Kacper Kasprzyk.

345 Harleth Kuusik wearing Fall/Winter 2018 look 31 backstage at Penn Plaza Pavilion, 401 Seventh Ave., NYC, on February 11, 2018. Styling by Marie Chaix. Photography by Kacper Kasprzyk.

346 Color reference. Photography by Sander Lak.

347 Niko Traubman wearing Spring/Summer 2018 Menswear. Photography by Thomas McCarty.

348 Detail of Spring/Summer 2020 look 18 on the runway at Opéra Bastille, Place de la Bastille, Paris, on June 22, 2019. Styling by Benjamin Kirchhoff. Photography by Dan Lecca.

349 Marjan Jonkman wearing Fall/Winter 2016 look 26 on the runway at 100 Barclay St., NYC, February 14, 2016. Styling by Lotta Volkova. Photography by Mitchell Sams.

350 Matthias Vriens, *Furious issue #23 Dutch Magazine*, 1999.

351 Olivia Forte wearing Spring/Summer 2018. Styling by Megan Bowman Gray. Photography by Theo Wenner.

352 *Lili Pregnant*, 2017. Lili Sumner wearing Fall/Winter 2017 for *Double Magazine*. Styling by Marie Chaix. Photography by Roe Ethridge.

353 Marjan Lak wearing Spring/Summer 2018, Water Island, 2018. Photography by Sander Lak.

354 Nur Elektra El Shami Goldstein wearing Spring/Summer 2018, Water Island, 2018. Photography by Sander Lak.

355 Tina Barney, *Jill + Polly in the Bathroom #3513*, 1987. The Kasmin Gallery.

356 Reference board imagery. Right: Image by promgownonline.com. Left: Detail of *Vogue Italia*, September 1994. Photography by Michel Comte.

357 Detail of Spring/Summer 2018 look 29 backstage at the Sies Marjan office, 151 W. 26 St., NYC, on September 10, 2017. Styling by Marie Chaix. Photography by Kacper Kasprzyk.

358 Color reference board imagery. Top: Barbara Cartland photo by *Mail On Sunday*. Bottom: image unknown.

359 Detail of Fall/Winter 2017 look 33 backstage at the New York Hilton Midtown, 1335 Avenue of the Americas, NYC, on February 12, 2017. Photography by Kacper Kasprzyk.

360-361 Hans Eijkelboom, Photo Note: August 4, 2012, Amsterdam 13.30 - 17.50.

362 Nella Ngingo wearing Fall/Winter 2018. Styling by Megan Bowman Gray. Photography by Kacper Kasprzyk.

363 Roberto Rossellini wearing Fall/Winter 2017 Menswear. Styling by Marie Chaix. Photography by Bruce Weber.

364 Trish Goff wearing Fall/Winter 2016. Art direction by Christopher Simmonds. Photography by Kacper Kasprzyk.

365 Color reference. Photography by Sander Lak.

366-367 Julie Mehretu, *Conjured Parts (eye), Ferguson*, 2016. Ink and acrylic on canvas, 84 x 96 inches. © Julie Mehretu. Collection Broad Art Foundation, Los Angeles, CA. Photo Credit: Cathy Carver.

368 Detail of *L'art et la Mode* magazine, March 1962, 69. Photography by Georges Saad.

369 Detail of Spring/Summer 2018 look 12 on the runway at the Sies Marjan office, 151 W. 26 St., NYC, on September 10, 2017. Styling by Marie Chaix. Photography by Dan Lecca and team.

370 Harleth Kuusik wearing Spring/Summer 2018 look 16 on the runway at the Sies Marjan office, 151 W. 26 St., NYC, on September 10, 2017. Styling by Marie Chaix. Photography by Dan Lecca and team.

371 Elizabeth Peyton, *Winter (Lara Sturgis)*, 2020. Oil on board, 14 x 11 x 1 1/8 inches. Photography by Tom Powell Imaging. Image courtesy the artist.

372 Edie Campbell wearing Fall/Winter 2018 look 1 backstage at Penn Plaza Pavilion, 401 Seventh Ave., NYC, on February 11, 2018. Photography by Blommers/Schumm.

373 Sasha Belyaeva wearing Fall/Winter 2017 look 10 backstage at the New York Hilton Midtown, 1335 Avenue of the Americas, NYC, on February 12, 2017. Photography by Blommers/Schumm.

374 Jakub Nowak wearing Fall/Winter 2020 Menswear. Photography by Blommers/Schumm.

375 Kaissan Ibrahima wearing Spring/Summer 2020 look 7 backstage at Opéra Bastille, Place de la Bastille, Paris, on June 22, 2019. Styling by Benjamin Kirchhoff. Photography by Kacper Kasprzyk.

376 Detail of Spring/Summer 2017 look 31 backstage at the New York City Bar Association, 42 W. 44 St., NYC, on September 11, 2016. Styling by Lotta Volkova. Photography by Kacper Kasprzyk.

377 Sies Marjan Atelier, 2018. Photography by Sander Lak.

378 Sander and Justin with Eric Martin wearing Spring/Summer 2018 look 31 backstage at the Sies Marjan office, 151 W. 26 St., NYC, on September 10, 2017. Photography by Kacper Kasprzyk.

379 Jakub Nowak wearing Fall/Winter 2020 Menswear. Photography by Blommers/Schumm.

380 In-house development fitting with Liene Podina, 2016. Photography by Justin Stutzman.

381 Giorgio Morandi, *Natura morta (Still Life)*, 1959. Oil on canvas, 10 1/8 x 16 inches. © 2021 Artists Rights Society (ARS), New York / SIAE, Rome.

382 Sasha Pivovarova wearing Spring/Summer 2018 collection development, 2017. Photography by Colin Dodgson for *System* magazine issue No. 10.

383 In-house development fitting with Cami You-Ten, 2018. Photography by Justin Stutzman.

384 Sies Marjan Atelier, 2018. Photography by Kacper Kasprzyk.

385 Sasha Pivovarova wearing Spring/Summer 2018 knitwear development, 2017. Photography by Colin Dodgson for *System* magazine issue No. 10.

386 Marlene Dumas, *She speaks*, 2015–2016. Ink wash on paper. 11 7/8 x 9 1/4 inches. © Marlene Dumas.

387 Sies Marjan Atelier, 2020. Photography by Sander Lak.

388-389 First Sies Marjan teaser with Guinevere van Seenus, 2015. Photography by Kacper Kasprzyk.

Thank You!

This book would not have been possible without the help of the following people:

Anita Bitton and her amazing team at Establishment NYC.

Nirva Derbekyan for helping with organizing and keeping track of everything.

Isaac Raine for his critical eye and unfiltered opinions.

Ian Luna and Meaghan McGovern at Rizzoli for their support from day one.

Mary Murphy at Maharam, Robert Kloos at Dutch Culture USA and Megan and Hunter Gray.

Everyone who worked on the many Sies Marjan shows, including the teams at Bureau Betak, KCD, PR Consulting, TCS and Lucien Pagès Communication. Clara 3000, Michel Gaubert, Lotta Volkova, Marie Chaix, Benjamin Kirchhoff, Anthony Turner, Duffy, Aaron de Mey, Thomas de Kluyver and Nami Yoshida.

A special thanks to David Bonnouvrier, Dan Thawley, Francois Chateau, Kacper Kasprzyk, Michael Rock, Veronique Ansorge, and all the agents, models, artists, and photographers who appear in this book.

All my closest friends and family, you know who you are.

And a very special thanks to my partner, Nathan Stewart-Jarrett, for always believing in me and making me a happy man.

ICE BLUE

ICE BLUE

RED

COBALT

COBALT

COCOA

RED

• RUST

• BRONZER

MUSTARD

KHAKI

• SHELL

MILKY BLUE

CRIMSON RED

DUSTY BLUE

SEAWEED

Rose Petal

AMETHYST

PURPLE

BARNEY'S PURPLE

GRAPE

GREEN APPLE

NEON GREEN

• SAGE

PINK

FLAIMNGO

SALMON

• MAUVE